PLAIN PICTURES

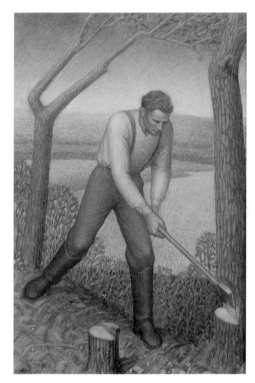

PLAIN PICTURES

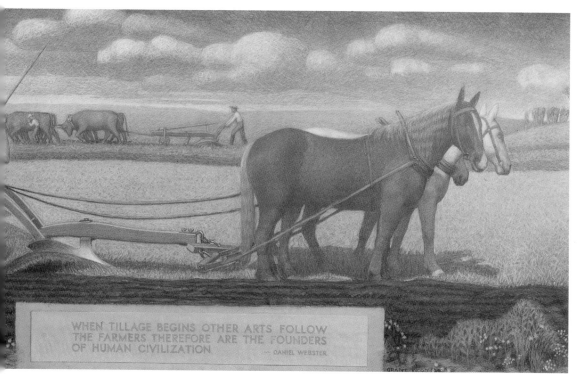

WHEN TILLAGE BEGINS OTHER ARTS FOLLOW
THE FARMERS THEREFORE ARE THE FOUNDERS
OF HUMAN CIVILIZATION
— DANIEL WEBSTER

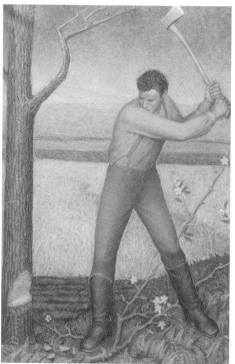

IMAGES OF THE AMERICAN PRAIRIE

JONI L. KINSEY Published for the University of Iowa Museum of Art by the Smithsonian Institution Press · Washington and London

Excerpt from "Land of the Free," by Archibald MacLeish. Copyright 1938, © renewed 1966 by Archibald MacLeish. Reprinted by permission of Houghton Mifflin Co. All rights reserved.

COPY EDITOR: Lorraine Atherton
PRODUCTION EDITOR: Jenelle Walthour
DESIGNER: Janice Wheeler

This volume was published in conjunction with the exhibition *Plain Pictures: Images of the American Prairie*

THE UNIVERSITY OF IOWA MUSEUM OF ART
August 17 to November 3, 1996

AMON CARTER MUSEUM
November 23, 1996, to February 25, 1997

JOSLYN MUSEUM OF ART
April 19 to July 27, 1997

Library of Congress Cataloging-in-Publication Data
 Kinsey, Joni.
 Plain pictures : images of the American prairie / Joni L. Kinsey.
 p. cm.
 Includes bibliographical references and index.
 ISBN 1-56098-630-1 (pbk.)
 1. Middle West in art. 2. Prairies in art. 3. Pastoral art—United States. I.
Title.
 N8214.5.U6K56 1996
 760'.0443678—dc20 95-49898

British Library Cataloguing-in-Publication Data available
Manufactured in Singapore not at government expense.

03 02 01 00 99 98 97 96 5 4 3 2 1

∞ The paper used in this publication meets the minimum requirements of the American National Standard for Information Sciences—Permanence of Paper for Printed Library Materials Z39.48-1984.

For permission to reproduce illustrations appearing in this book, please correspond directly with the owners of the works, as listed in the individual captions. The Smithsonian Institution Press does not retain reproduction rights for these illustrations individually or maintain a file of addresses for photo sources.

ON THE COVER: Keith Jacobshagen, *Crow Call* [*Near the River*], 1990–1991; oil on canvas, 46⅛ x 80¼". Nelson-Atkins Museum of Art, Kansas City, Missouri, purchase: acquired through the generosity of the National Endowment for the Arts and the Nelson Gallery Foundation. © The Nelson Gallery Foundation. All reproduction rights reserved.

ON THE TITLE PAGES: Grant Wood (1882–1942), *Breaking the Prairie* [*When Tillage Begins*], ca. 1935–1937; colored pencil, chalk, and graphite on paper, 22¼ x 80¼". Whitney Museum of American Art, New York, gift of Mr. and Mrs. George D. Stoddard.

CONTENTS

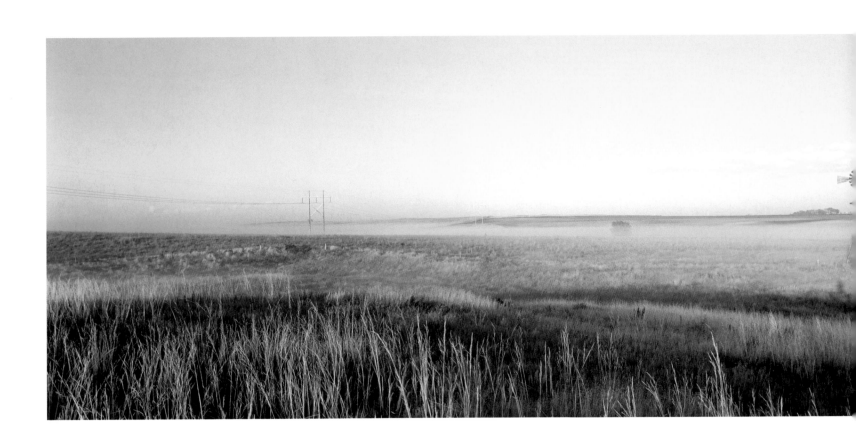

FOREWORD
THE AMERICAN PRAIRIES AND THE LITERARY AESTHETIC

Gary Irving (b. 1953)

Windmill, Western Nebraska, 1995

Cibachrome photograph, 13 x 39"

Collection of the artist, Wheaton, Illinois

Consider them both, the sea and the land; and do you not find a strange analogy to something in yourself?

Herman Melville, *Moby Dick*

European explorers and settlers reached the prairie by way of the woods. That seems as well the appropriate route for this consideration of the American grasslands, appropriate not only because of the historical path that led us to that region but also because, once we had arrived there, we found it more difficult to see what the landscape contained than what it lacked. We came to the prairies with centuries of forests in our heads, and our relation to the land, any land, is inseparable from the power those trees exert over our thinking and our seeing.

In the geography of fairy tales the world is divided into realms of darkness and realms of light. The king in his castle, the beautiful princess, the miller and his daughter, the fisherman and his wife, all live in a cultivated landscape, one in which there are meadows and farms, towns and houses. Everyday life along with all its political and economic activities—civilization—is conducted in the world's cleared spaces, those places under a king's authority or a husbandman's cultivation. But always this terrain is defined by a bordering forest, a place both tangled and dark, where travelers lose their way and the rules of natural and human behavior are suspended. It is in these woods that the woodsman father abandons Hansel and Gretel to their fate; it is here that the huntsman is ordered to take Snow White before murdering her: this is the place of robbers and witches, of enchantments and transformations.

The division—trees on one side, cleared land on the other—is one between the primitive and the civilized, between chaos and order, with the dark of the great forest an essential counterpoint to the light that illuminates the cultivated lands that have been redeemed by human discipline and ingenuity. When these old stories tell us "near the king's castle was a big dark forest" or that

a little girl's grandmother lives "in a great wood," we are being located in a plot as well as a setting, and we know that the line between the worlds of safety and of danger is about to be transgressed, that the child in question, whatever its rank or condition, is about to be tested by forces over which kings and fathers lack all authority.

As much as anything the woods of Old World stories mark the limits of human influence. Traversed only by meandering and unreliable trails, they separate communities as well as stories and are the dark ground in which people lose their bearings and themselves. So it was as well with the forests of the New World, the haunt of savages and witches whether in the swampy timber of the South or the colder wilds of New England, whether the "dark and bloody ground" of Kentucky or the long contested Mohawk Valley. If the woods around the Puritan plantation at Salem were filled with demonic power, so was the wilderness of trees everywhere confronting the first European settlers, and for all, though in varying degrees, these timbered tracts were at once filled with promise (the trees themselves were an invaluable commodity) and alive with risk, dangerous because of internal weakness as well as external enemies.

Our best stories of these times and places, consequently, embrace the old fairy-tale division. Nathaniel Hawthorne's Puritans live in clearings, battling the "untamed wilderness" with ax and plow, disciplining their lives and this new land simultaneously to God's demanding will. They measure their progress in the acres they have broken through this cultivating work. In the treeless towns they have created, places where the sun's exposing light strikes without the interference of leaf or branch, they find physical and spiritual safety, protected from both the forest and their own dark natures. In story after story they hold to the unrelenting glare and the hard-baked soil, fearful of the temptation and misrule that surrounds them.

But it is in James Fenimore Cooper's wilderness writings that we find the most expansive version of the geography of light and dark. *The Deerslayer,* the novel D. H. Lawrence singled out as the definitive version of frontier mythos, the novel in which a young Leatherstocking is initiated into manhood, opens with a vision of half a continent. "A bird's-eye view of the whole region east of the Mississippi," Cooper wrote, "must then [1740–1745, the time of the story] have offered one vast expanse of woods, relieved by a comparatively narrow fringe of cultivation along the sea, dotted by the glittering surface of lakes and intersected by the waving lines of rivers." As the narrator descends from this lofty view, he brings his reader to a break in the forest, "a small opening that appeared to have been formed partly by the ravages of the wind and partly by those of fire." Almost immediately we hear voices, and then the first of two men traveling by different routes steps into the clearing. "'Here is room to breathe in!' exclaimed the liberated forester as soon as he found himself under a clear sky, shaking his huge frame like a mastiff that has just escaped from a snowbank. 'Hurrah! Deerslayer, here is daylight, at last.'"

The relation between people and woods is complex and contradictory. This has been especially true for Americans. At first the woods *were* America, indication of the abundance and natural wealth European intruders so desperately sought. The plenitude of trees promised that the trip had not been made in vain, that resources long depleted in the Old World could be had in abundance in the New. Forests, too, were evidence of an unpeopled place, at least unpeopled by a European standard that made of deforestation an essential act in cultural assertion. By felling trees societies made their claim upon a place, and the presence of unbroken timber they took as an indication of land still morally and practically unpossessed.

Thus it was by clearing a woodland wilderness that the New World was claimed for Old World ambitions and presumptions. The trees were important, then, not only for their intrinsic worth as lumber but also because their felling provided proof of ownership, an irrefutable sign of possession. In a country where the right to pursue happiness is declared inalienable, and where the possibility of finding a new life is central to our economic as well as spiritual credo, the woods are a sense of hope, a promise that there is more chaos to be redeemed, more raw material from which to build selves and societies. Wilderness—and through most of our history that has been synonymous with woods—proves that nothing has been settled once and for all, that we are still "becoming" and not fixed in our present condition. The forests provide the stuff of our new beginnings.

In the early decades of the nineteenth century, Euro-Americans

crossed the boundary line by which Cooper measured his wilderness, crossed the Mississippi and left behind the woodlands that had defined their New World experience since the seventeenth century. They entered the western grasslands, for which neither previous experience nor their cosmology had prepared them. While *The Deerslayer*'s woodsman entered the small clearing with relief, those who first looked upon the prairies did so with chagrin. Here there was all too much space, too much sky, too much light. What farther east had been precious for its rarity now became a waste of abundance. Precisely because those early arrivals had spent their lives in a culture carved from timber, there was nothing here to tell them who or where they were, nothing to measure themselves against, no obvious way to take possession. Not surprisingly, they declared it a nonplace, an absence rather than a presence, and hurried the course of empire westward, returning to their civilizing work when they reached new trees to cut.

All of this fascinated Cooper. So reluctant was he to believe that anything other than human effort could account for so many missing trees that he had Natty Bumpo declare the origin of the prairie landscape to be some forgotten ancient civilization that despoiled the continent's interior. His notion of the past was based upon a present in which eastern forests were being leveled at a remarkable rate. The excesses that Leatherstocking condemned in his first appearance in print (*The Pioneers*), in regard to the slaughter of wildlife (the killing of spawning bass and roosting passenger pigeons is depicted as mindless bloodlust), are extended in his second fictional appearance (*The Prairie*) to trees. "They," the aged Leatherstocking says of his countrymen,

scourge the very 'arth with their axes. Such hills and hunting grounds as I have seen stripped of the gifts of the Lord, without remorse or shame! I tarried till . . . my hounds were deafened by the blows of the chopper, and then I came west in search of quiet. It was a grievous journey that I made; a grievous toil to pass through falling timbers and to breathe the thick air of smoky clearings, week after week, as I did.

Then, casting an ironic eye to the grasslands around him, he suggests a more cosmic explanation than vanished people, and he declares the prairie a divine judgment.

Look around you, men; what will the Yankee choppers say, when they have cut their path from the eastern to the western waters, and find that a hand, which can lay the 'arth bare at a blow, has been here and swept the country, in very mockery of their wickedness. They will turn on their tracks like a fox that doubles, and then the rank smell of their own footsteps will show them the madness of their waste.

Natty, the lover of trees, who has come to the only place in America where he can hope to escape the sound of the ax, imagines a forest-consuming culture arriving at the prairie and only then recognizing the preciousness of what it has so wantonly destroyed. His—and Cooper's—is a respectful and reverential view of the interior grasslands, but its power is derived from emptiness and loss. It embodies less a "waste" in the sense of desert and more a "waste" in the sense of squandered resources. It is judgment rather than blessing. The "garden of the Lord," Natty insists, "was a forest." The prairie, then, signifies our fall.

This absence of trees was a matter of great curiosity to nineteenth-century geographers and agriculturalists, who, in their search for a more natural explanation than either of Leatherstocking's alternatives, were eager to determine which was the more aggressive presence. Were trees encroaching upon the grasslands or was grass pushing back the forests? Their studies along the margins were ambiguous, sometimes suggesting that scrub oaks were on the advance, at others identifying trees as the party in retreat. Their efforts to determine which way things were headed nearly always implied a bias for timber. This suggests how deep runs our fear of naturally unforested land and how little that emotion is predicated upon such practical concerns as our dependence upon wood products. It is, rather, a matter of our concern as to whether things are moving toward fullness or emptiness.

The psychological impact of the prairie differs from that of any other wilderness form save, perhaps, that of desert. Charles Dickens, when he came for his American visit, asked his Saint Louis hosts to take him to a prairie. Since one was conveniently located a short and regularly traveled distance away in Illinois, they happily obliged. Dickens did not find the place to his liking. "I could never abandon myself to the scene, forgetful of all else: as I should do instinctively, were the

heather underneath my feet, or an iron-bound coast beyond; but should often glance towards the distant and frequently-receding line of the horizon and wish it gained and passed." Only out for a day trip and within easy reach of a city and society, the English writer described the profound uneasiness the "solitude and silence" of the place produced, the eagerness to put it all behind and get on to someplace else. "It is not," he concluded, "a scene to be forgotten, but it is scarcely one, I think . . . to remember with much pleasure, or to covet the looking-on again, in after life."

Perhaps that "after life" merely means afterward, but there is, nonetheless, a hint of connection with the soul and its fate. Since the place Dickens described was locally designated the Looking-Glass Prairie, that association seems to have been more generally perceived. For Americans entering the continent's interior at a time when Transcendentalism was declaring all of nature a window to the self, what one saw and what one was might well be indistinguishable.

Melville placed this conjunction at the heart of his work and, in a wonderful reversal in *Moby Dick,* illuminates the power the sea holds on the human psyche with allusions to the prairie. In both it is the same, what the Bible termed "the abomination of desolation," the fear not of immediate but of ultimate vacancy. This is the power of the preacher's proclamation in Ecclesiastes when he declares, "Vanity, all is vanity," or as it might more literally be translated, "Emptiness, all is emptiness." Thus when Melville entitles the great head of the whale a "praire," he plays on the idea of absence ("He has no proper nose") but even more on the ambiguous implications of all that vast blankness. Joking that there is no room for face when all is brow, he interprets the whale as encompassing intelligence, though of a sort indecipherable and unreachable to humans. If, as conventional wisdom and physiognomists of Melville's time held, great men had correspondingly great foreheads, what are we to make of the whale's amplitude in that which "in man, is Laveter's mark of genius?" "Genius in the sperm whale?" the narrator asks. "Has the sperm whale ever written a book, spoken a speech? No, his great genius is declared in his doing nothing particular to prove it. It is moreover declared in his pyramidical silence."

When Melville's metaphor is reversed and we see the prairie as the counterpart of the whale, in the mocking seriousness of his logic the central challenge of all perceived emptiness becomes more obvious. While the enormity of the whale's brow may imply an intelligence on the order of Shakespeare's multiplied by the relative size of their foreheads, it may more easily suggest the absence of any intelligence, may indicate only a brute nature concealed by a blank visage. If, like Ahab, we are trying to read the ultimate nature of things from the world around us, emptiness is a terrifying prospect unless we are able to imagine it as other than a void. "Whiteness," Melville's novel informs us, is optically a combination of all color, but for the painter it is just the opposite. So the sea, the cosmos, God—and the prairie—contain these contradictory possibilities: fullness or emptiness, all or nothing.

Halfway through *Moby Dick* the narrator presents a more congenial image of an ocean prairie, describing "vast meadows of brit" spread like "boundless fields of ripe and golden wheat," with attending whales as mowing harvesters. As this pastoral reassurance closes Ishmael warns, "Consider the subtleness of the sea; how its most dreaded creatures glide underwater, unapparent for the most part, and treacherously hidden beneath the loveliest tints of azure." It is the same with greener gardens.

What rightly disturbed Dickens was not what he saw in those Illinois grasslands but what that vision implied. Never has the issue of the prairie been simply its own nature. Always it has been something more, something about the viewer and his or her assumptions about the world. The excitement and danger of wilderness experience is the risk it poses for the self, the uncertainty of whether, in entering an uncharted and undefined territory, we will lose or find ourselves. Mystic and entrepreneur alike go into such a place hopeful of self-realization but—if they are not naive—aware that they might be themselves undone. If, as Americans have so often believed, the world is filled with meaning and possibilities, the venture promises fulfillment; but if, as we fear in our moments of despair, that is not the case, then we are turned toward dissolution and nihilism.

No prairie enthusiast better illustrated the psychological impact of the grasslands than did George Catlin, who spent his best years there. Traveling alone amid this vastness, he understood the double message

the narrator of Willa Cather's *My Antonia* delivered when he remarked that, lying among the prairie grasses, "I was entirely happy. Perhaps we feel like that when we die and become a part of something entire, whether it is sun or air, or goodness and knowledge. At any rate, that is happiness; to be dissolved into something complete and great. When it comes to one it comes as naturally as sleep." Such, too, is the attraction of the water-gazer in *Moby Dick,* he who keeping watch at the masthead becomes enchanted by the sea.

There you stand, lost in the infinite series of the sea, with nothing ruffled but the waves. The tranced ship indolently rolls; the drowsy trade winds blow; everything resolves you into languor. For the most part, in this tropic whaling life, a sublime uneventfulness invests you; you hear no news; read no gazettes; extras with startling accounts of commonplaces never delude you into unnecessary excitements; you hear of no domestic afflictions; bankrupt securities; fall of stocks; are never troubled with the thought of what you shall have for dinner—for all your meals for three years and more are snugly stowed in casks, and your bill of fare is immutable.

In the same way does the prairie figure infinity, drowning the commonplaces of mundane life. The indolence of eternity can be felt among its grasses as easily as among sea breezes and Pacific waves, and even if the voyager's food is not stored in casks below deck, it is ever present, if no longer in buffalo then in endless fields of corn and wheat.

But all this reverie on things eternal puts the temporal in jeopardy, and with it the mortal self. Melville's watchers on the masthead often lose themselves in the seduction of such grandeur, and they fall from their perch, unnoticed, to be drowned. Catlin tells how on one of his prairie outings he checked his own slide into such temptation by turning to precisely those details the water-gazer let drift away. Stopping at last from his travels, he stretched out on the grass and looked up

into the blue heavens that were over me, with their pure and milk white clouds that were passing—with the sun just setting in the West, and the silver moon rising in the East, and renewed the impression of my own insignificance, as I contemplated the incomprehensible mechanism of that *wonderful clock,* whose time is infallible, and whose motion is eternity! I trembled, at last, at the dangerous expanse of my thoughts, and turned them again, and my

eyes, upon the little and more comprehensible things that were about me. One of the first was a *newspaper,* which I had brought from the Garrison, the *National Intelligencer,* of Washington, which I had read for years, but never with quite the zest and relish that I now conversed over its familiar columns, in this clean and sweet valley of dead silence.

His initial exultation passed, the fear of being lost in all of this seizes him, and then, even the bold Catlin grabs up a newspaper whose date, though long past, and whose news, though of far-off cities, confirms the mundane world and reminds him of who, in more conventional terms, he is and—if not where he is—at least where he is from.

If vacancy was (and to some extent remains) the first complaint about the prairies, it is an objection partly based on the nineteenth-century preoccupation—whether reflected in the Arctic wastes at the end of *Frankenstein,* the vortex that sucks down the *Pequod* at the end of *Moby Dick,* or the maelstrom of Poe's short story—with the annihilating power of emptiness. Not surprisingly, then, prairie travelers concentrated on its limits as well as its vastness, filled it at least with the hours it required in passing. Wide as it was, its crossing could be measured, and so it became, like the Atlantic for earlier generations, a kind of inconvenience on the way from here to there, a nonplace separating East from West. For some like Missouri's first senator, Thomas Hart Benton, the terrain was fortuitous, if not for agriculture then for what he valued even more, a passage to India by way of the Columbia Valley. The national highway he imagined running from Saint Louis to Astoria would be greatly facilitated on this side of the mountains by a country already cleared and leveled, only the paving still to come.

Grand as Benton's aspirations were—and it was in their service that the senator's son-in-law, John C. Frémont, was commissioned to lead his western expeditions—they were mundane by comparison with Catlin's time-escaping reveries, mere matters of commerce and gain. But this, on the authority of both Melville and Catlin, is how vastness is to be managed and made thinkable, and in the process emptiness becomes only a passing condition between more fulsome states and not itself our destination.

Politically this view was manageable only until the 1850s. If the opening waves of trans-Mississippi migration had rushed as quickly as

possible from Missouri to Oregon and California, setting sail from Westport intent on docking only on the far side of the Rockies, by the middle of the century prairie settlement was under way in earnest. The issue that would at last break the Union's back was not slavery in the South as much as slavery in the grasslands. Kansas and Nebraska, not Mississippi and Georgia, were where the firestorm that was about to overtake the United States first sprang into flame. The midlands could no longer be dismissed as simply way stations on the path toward our manifest destiny. They were part of the national design and part of its dilemma.

An earlier generation of politicians (including South Carolina's Senator George McDuffie, who thought the degree of civilization to be signified by the regularity and proximity of our cultivating boundaries) saw waste in the prairies and plains or, when their view was larger, looked merely to the other side for the advantages of a continental nation. As late as 1843 McDuffie lamented the purchase of Louisiana, insisting that it was largely uninhabitable, rainless, and cursed with "a barren, sandy soil." "I would not," he continued, "give a pinch of snuff for the whole territory. I wish to God we did not own it." Exasperated, he asked of his colleagues, "Who are we to send there?" By the 1850s, whether or not they were commissioned by senators, settlers had arrived in Kansas and Nebraska in sufficient number to press for statehood and with enough political significance to tip the slavery issue off its precarious balance.

The first prairie president, Abraham Lincoln, in his annual message of 1862, argued the case for the Union's political integrity, his justification for militarily opposing secession, by insisting on the nation's geographical integrity. "There is," he argued,

no line, straight or crooked, suitable for a national boundary upon which to divide. Trace through, from east to west, upon the line between the free and slave country, and we shall find a little more than one-third of its length are rivers, easy to be crossed, and populated, or soon to be populated, thickly upon both sides; while nearly all its remaining length are merely surveyor's lines, over which people may walk back and forth without any consciousness of their presence. No part of this line can be made any more difficult to pass, by writing it down on paper, or parchment, as a national boundary.

This recognition of how fragile is the influence of mere surveyor's lines, lacking the force of natural obstacles, over human conduct and imagination carried special resonance for the prairie states at the center of our national experience. "The great interior region" provided Lincoln with his most compelling evidence. So vast as to be "the great body of the republic" and so rich in "the production of provisions, grains, grasses, and all which proceed from them," this area "is naturally one of the most important in the world" and yet "has no sea-coast, touches no ocean anywhere." It is linked to the world by the geography that surrounds it, by the states with which it shares national identity. "Our national strife," Lincoln reminded Congress, "springs not from our permanent part; not from the land we inhabit; not from our national homestead. There is no possible severing of this." What had earlier been empty, Lincoln filled with social significance; what had been peripheral, he placed at the center.

That era and the changing sense of the prairie's role in national life are recalled in a remarkable book by Francis Grierson called *The Valley of Shadows* (1909). In it the author, who in the 1850s was a boy in Sangamon County, Illinois, recalls the historical moment in which a critical addition was being prepared for America's mythology, a piece that would be completed only after the Civil War. In it Abraham Lincoln is turned into the embodiment of prairie values and vision, and simultaneously in the circuitous logic of myth-making, the prairies are themselves Lincolnized and interpreted in his romanticized image. "The prairie," Grierson begins, "was a region of expectant watchfulness." All the winds and currents that rose across the nation found their way here, and the people who settled these districts became skilled at reading both the political and meteorological weather. "The prairie here in Illinois," he continues, "in the heart of Lincoln's country had a spirit of its own, unlike a forest." The people who settled it had been prepared by an education gained on previous migrations, had arrived at a maturation that matched the soulful face of the Lincoln who sits in his Washington, D.C., memorial. Theirs, Grierson argues, was a spirit "freed for ever from the trammels and tumults of the world," liberated by the long view that sometimes frightened newcomer Catlin. They are in this version representatives of America's larger education, a process that began at Plymouth and continued on toward Springfield.

In the tribulation that followed the successive generations were stripped of the superfluities of life. One by one vanities and illusions fell from the fighters like shattered muskets and tattered garments. Each generation, stripped of the tinsel, became acquainted with the folly of plaints and the futility of protests. Little by little the pioneers began to understand, and in the last generation of all there resulted a knowledge too deep for discussion and a wisdom too great for idle misgivings.

Such is the wisdom Cather attributes to the grandmother in *My Antonia*, a quiet woman who seems always to be "looking at something, or listening to something, far away."

After trees, the absence so troubling to prairie newcomers is that of elevation. Surveyors—amateurs as well as professionals—require vantage points, heights of land from which to locate themselves and organize the surrounding terrain. The longer view that height affords brings a feeling of control, a comforting illusion of knowing what lies ahead, of being able to place "here" in relation to some discernible "there." So gradual and consistent is the rise of the prairie between Missouri and the Rockies, however, that the land seems level, broken only by slight swells and ridges and rarely offering a perspective that reassures the viewer with a larger sense of shape and form.

The inability to get above it all, combined with the shortage of landmarking trees, gives to the heartlands of America at once a sense of vacancy and oppression. No longer constrained by the eastern forests, migrating Americans did not typically feel liberated as they came into the openness of the grasslands; rather they consistently complained of the heavy burden accompanying so much space. Freed from the claustrophobic thicket of trees, they found the elements celebrated by Cooper's forester when he stepped into his New York clearing overwhelming and weighing down upon them. Sky, land, light, even air in these expanses they regarded less as reason for delight than as cause for despair.

Francis Parkman, Harvard professor and cultivator of roses, found the "naked landscape" he crossed in 1846 on the Oregon Trail "dreary and monotonous," "a gloomy plain," "a barren and trackless waste." It was to his Brahmin eyes a disorderly and ill-composed place and, except for the scenic contributions of buffalo herds and Indian villages, offered little visually to admire. Not until Parkman finally arrives in the Black Hills does he discover what he found most wanting along the way. There, wandering off from a Dacotah village, he spots an Indian friend, Mene-Seela, climbing the ridge ahead. When Parkman at last catches up, he finds the man "seated alone, immovable as a statue."

Looking for a while at the old man, I was satisfied that he was engaged in an act of worship, or prayer, or communion of some kind with a supernatural being. I longed to penetrate his thoughts, but I could do nothing more than conjecture and speculate. I knew that though the intellect of an Indian can embrace the idea of an all-wise, all-powerful Spirit, the Supreme Ruler of the universe, yet his mind will not always ascend into communion with a being that seems to him so vast, remote, and incomprehensible; and when danger threatens, when his hopes are broken, and trouble overshadows him, he is prone to turn for relief to some inferior agency, less removed from the ordinary scope of his faculties.

Thus it is, Parkman insists, that the Indian requires something specific and substantial to embody his sense of the spiritual.

Unable to discern the object of Mene-Seela's reverence, Parkman continues on until, "looking up," he sees "a tall peak rising among the woods."

Something impelled me to climb; I had not felt for many a day such strength and elasticity of limb. An hour and a half of slow and often intermitted labor brought me to the very summit; and emerging from the dark shadows of the rocks and pines, I stepped forth into the light, and walking along the sunny verge of a precipice, seated myself on its extreme point. Looking beyond the mountain-peaks to the westward, the pale blue prairie was stretching to the farthest horizon, like a serene and tranquil ocean. The surrounding mountains were in themselves sufficiently striking and impressive, but this contrast gave redoubled effect to their stern features.

Whatever the object and nature of Mene-Seela's meditation, Parkman's religious sense requires a grander view, a mountain-top perspective in which the chaos of grass and ravines that plagued his prairie crossing is resolved by height and distance into a more congenial and cooperative background. Convinced that—in matters of aesthetics as well as religion—the larger view is the superior one, Parkman needs space for his epiphany, room for abstraction; he cannot be bound by the proximity and specificity he presumptuously assumes Mene-Seela requires.

His mountain vision contains the central elements of prairie complaint—light, and long and uninterrupted vistas—but here all is redeemed by a composing loftiness. Viewed from sufficient height the "waste" finds its proper place; it becomes the serene ocean the traveler crosses in order to attain this summit. With all its particularity obscured, emptiness loses its depressing power. So long as it is viewed from this superior vantage point, treelessness ceases to be a problem, and all that grass becomes simply a swath of soothing color, calming and restoring the soul that has found its proper place.

Parkman's prairie is finally reconciled with his eastern aesthetic as he finds, a continent away, another Hudson Valley view. But for those who are not merely passing through, those for whom flatness and the absence of trees are not simply a passage along the way, a different vision is required. Artistic high-mindedness, apart from the vantage of airplanes, satellites, and grain elevators, will not do. In this place breadth counts for more than height or depth, and cultivating a prairie requires different methods, regardless of vocation, than those that work in other, more conventional landscapes. But what Grierson and other prairie romantics regarded as the moral superiority of "flat-landers" is derived precisely from what one does not overlook. It is a wisdom rooted in the particular and the immediate as well as an awareness of what is looming on the horizon. The reason Americans have taken this opinion so much to heart is that it combines the mystical with common sense; it is at once down to earth and farseeing.

There is, in the "magisterial gaze" required by Parkman's eastern aesthetic and Christian assumptions, a reflection as well of the dominant view of woodland settlement as a form of conquest. This assertion of individual and collective power, celebrated by twentieth-century presidents from Teddy Roosevelt to Ronald Reagan, this conquering of a continent, was first asserted in the destruction of forests. In this paradigm of settlement an army of masculine pioneers, armed with axes, enters a wilderness and does battle until all the opposition are fallen. In victory, through perseverance and hard work, they replace what they have vanquished with more docile and domesticated life in a world, thanks to their cultivating labor, grown more pastoral and less intimidating.

It is an accomplishment that suffers in the absence of trees, but it suffered as well from the fact that the western sod, once broken by new tools and machines, did not at once release its bounty. If the hard work of clearing had been eliminated, transplanted eastern farmers found the land's reluctance, once plowed, confusing. Typical of their frustration is the account Cather provides in the first section of *O Pioneers!* The homesteader, already grown old at forty-six, is dying, contemplating his life and the farm that has at last absorbed it.

In eleven long years John Bergson had made but little impression upon the wild land he had come to tame. It was still a wild thing that had its ugly moods; and no one knew when they were likely to come, or why. Mischance hung over it. Its Genius was unfriendly to man. The sick man was feeling this as he lay looking out of the window, after the doctor had left him. . . . There it lay outside his door, the same land, the same lead-colored miles. He knew every ridge and draw and gully between him and the horizon. To the south, his plowed fields; to the east, the sod stables, the cattle corral, the pond,—and then the grass.

Perhaps in registering its unfriendliness "to man" Cather does not mean to be gender exclusive, yet when the dying farmer calls his children to his bedside, it is to admonish his sons not only to keep the land but also to be governed in its cultivation by their sister.

In this novel, as elsewhere in Cather, men do not make good prairie farmers, in large part because the land does not respond to their old methods of domination. Like John Bergson they break the sod only to find it still unyielding, and after a few years of poor crops from soil still choked by the roots of the vanished prairie, they surrender and go off to other trades in other places. Farming in the interior regions is neither the mastering work of earlier frontiers nor the image of self-sufficiency so dear to nineteenth-century agrarians. Agriculture here requires a more subtle cooperation between farmer and land, a shared work of nurturing in which excess will be met by excess. Similarly, it requires community. Prairie farms are necessarily part of a vast web of interconnected dependencies of market and transportation, of buying and selling. They produce products to be sold elsewhere rather than consumed at home, and the profits produced in these

transactions are in turn spent for essential goods that cannot be self-supplied. None of this quite fits the old image of the yeoman farmer, dependent only on his own labor and the support of his immediate family. None of this quite matches the masculine ethos of virgin land overpowered and richly yielding. So it is in Cather's work that women are the better cultivators, women and Old World immigrants more comfortable with delayed gratification than their American-born predecessors who rushed across the region on the track of more obvious riches in Oregon and California.

For politics and national self-discovery, the prairie region posed special problems and challenges. These in time were met, with varying degrees of success, simply because the place would not go away and because Americans, whatever our deficiencies, are very good at turning a profit, at finding a way to sell what is at hand—and the interior grasslands were very much at hand. Eventually what once seemed at best an enormous inconvenience was turned into a model of national industry and productivity, an exemplary place whose spaces were healthful and whose people, if a little dull and provincial, were full of moral rectitude and self-control. But social accommodation is not the same as artistic rendering, and though the prairie has found its artists as well as its population, that required a different process, one equally revolutionary in matters of aesthetics as well as technique.

Since writing is, after all, a horizontal art, it has enjoyed certain advantages in the struggle to capture grasslands. Its own flow across the page broken only by the slight lift of taller letters, the frequent *t* or *h* and their calligraphic kin, the rarer plunge of *q* and *p* and *y,* writing is good at leading the eye from left to right, at recreating the horizon with every line. When Theodore Dreiser tells us in *Sister Carrie,* "Across wide stretches of flat, open prairie they could see lines of telegraph poles stalking across the fields towards the great city," or Mark Twain reports in *Roughing It,* "Just here the land was rolling—a grand sweep of regular elevations and depressions as far as the eye could reach," the parallel lines of the landscape are simply extensions of those that fill the page, the eye crossing both simultaneously.

This landscape also offers the literary advantage of metaphors so readily available, so aggressive that they threaten to give away the story before it has even begun. Here the setting, more often than not, *is* the plot. Such is the work Kathleen Norris allows the setting to do when she announces at the beginning of *Dakota: A Spiritual Geography,* "This book is an invitation to a land of little rain and few trees, dry summer winds and harsh winters, a land rich in grass and sky and surprises." Stephen Crane introduces his surrealist story "The Blue Hotel" with an equally evocative preview of the incongruous narrative: "The Palace Hotel at Fort Romper was painted a light blue, a shade that is on the legs of a kind of heron, causing the bird to declare its presence against any background. The Palace Hotel, then, was always screaming and howling in a way that made the dazzling winter landscape of Nebraska seem only a grey swampish hush. It stood alone on the prairie, and when the snow was falling the town two hundred yards away was not visible."

That subgenre of prairie literature, the accounts of mass murder and the men who commit them so popular in recent years, also depends upon the ease with which flat, wind-filled expanses lend credibility to acts of madness, an advantage brilliantly exploited by Truman Capote and Norman Mailer. *In Cold Blood* begins with precisely such an implied explanation of the mayhem, a backdrop that remains largely in place throughout the book's dissection of a crime and its participants: "The village of Holcomb stands on the high wheat plains of western Kansas, a lonesome area that other Kansans call 'out there.' Some seventy miles east of the Colorado border, the countryside, with its hard blue skies and desert-clear air, has an atmosphere that is more Far West than Middle West."

For the writer, all that emptiness is ready to be filled by his or her own needs and intentions, and uninterrupted by an awaiting frame, the land can be allowed to unroll indefinitely; unchecked by visual specificity, its contents can remain vague and suggestive. Capote's hard sky does not require a particular tint or shade, nor need it end at the edge of a finite canvas. All of this suggests the added burden visual artists encounter in these regions, for theirs is a vocation with more obvious limits when the subject is vast expanses. The obstructing wood that sur-

rounds their work may, like a framing forest, offer some relief from the threat of going on forever, but so does it introduce an unsettling curiosity about what lies just beyond and why it was excluded from our view. The need to give concrete substance to the emptiness, which literature need only remark in some poignant phrase, presents an even greater challenge.

Painters have had to work against the same assumptions that so often serve writers. If the latter make do with what is absent (*My Antonia* begins with a typical catalogue of absences—"I couldn't see any town," "If there was a road, I could not make it out," "There was nothing," "No there was nothing," not even "a familiar mountain ridge"), the former must do with what is there. The challenge for prairie painters and photographers has been to see and represent presence rather than absence. This has required skill and vision to move from the dominance of the vertical, so central to previous aesthetic notions, toward an accommodation of the horizontal. Even more, it has demanded a material art that makes light and air substantial components, in some cases the central presences. Above all, it has challenged a capacity to represent distance, psychological as well as physical, to accommodate a world in which foreground, middle distance, and background refuse to keep their assigned places, intertwining in an elaborate choreography that has, from our first surviving reports, confused and dislocated those who have entered this country's grass-filled interior.

This feat of imagination and craft provides one of the great chapters in America's history of self-realization. It is, as much as the agricultural and social dimensions of heartland settlement, an essential part of our effort to cultivate, and be cultivated by, the prairie. In our continuing attempt to claim and be claimed by the land we inhabit, to find ourselves in the enormity of this place, no matter how frequently plowed and harvested, the visual artists have given us both their accomplishment and the struggle it required, their success and failure in this envisioning work at the heart of America's experience.

AUTHOR'S ACKNOWLEDGMENTS

A project of the size and scope of *Plain Pictures: Images of the American Prairie* could not be possible without the help of many people. From the outset, the staff at the University of Iowa Museum of Art have been enthusiastic and committed to the project and deserve special recognition. Stephen Prokopoff, the museum director, has been supportive from the first meeting in the fall of 1993, when I proposed the topic. Pamela Trimpe, curator of paintings and sculpture, has provided unparalleled energy and assistance at every stage of the process. Jo-Ann Conklin, curator of graphic art, has performed the invaluable service of acquiring the reproductions in this book and coordinating its publication. To them, and to the rest of the staff at the museum, I offer my profound gratitude.

In the summer of 1994 I, along with Rebecca Roberts (University of Iowa Department of Geography) and Robert Sayre (Department of English), received an interdisciplinary faculty research grant at the University of Iowa's Obermann Center for Advanced Studies to study the prairies together. From the experience we produced an article that formed the foundation for much of this book. During that summer and since, Dr. Sayre and Dr. Roberts have contributed unique and valuable insights and perspectives on the grasslands to my own understanding of the region, and they have also served as consultants throughout the course of the project. For this and for their unfailing generosity and friendship, they have my warm appreciation.

At the Obermann Center, where I was privileged to maintain an office after the initial grant's completion, Director Jay Semel and his assistant, Lorna Olson, were always a ready source of enthusiastic support. Without their delightful collegiality, not to mention the assistance with computers and countless other necessities, the research and writing of this book would not have been nearly so comfortable and pleasant. Not to be ignored are the countless Obermann Center scholars and other members of the Oakdale community who have, over the past three years, listened patiently and with good-humor to my developing ideas. Just as important was the semester's leave of absence granted by the University of Iowa and the School of Art and Art History, which allowed me to take advantage of the Obermann's haven and devote my attention solely to prairies and their representations.

A major exhibition planning grant from the National Endowment for the Humanities has

enabled me, over the last three years, to consult with a number of important scholars of American art and culture who have in various ways contributed to the project. Wanda Corn, professor of American Art and director of the Humanities Center at Stanford University; William Truettner, curator of painting and sculpture at the National Museum of American Art in Washington; Thomas Southall, former curator of photography at the Amon Carter Museum, Fort Worth; John Rohrbach, assistant curator of photography, Amon Carter Museum; and Wayne Fields, professor of American Literature, Washington University, all offered suggestions, encouragement, and support at critical times during the planning and preparation of this book and its accompanying exhibition. Each of these leading scholars has added substantially to my understanding of American landscape and culture and provided unparalleled expertise when it was most needed. A special thanks goes to Wayne Fields, whose foreword to this volume eloquently considers the prairies from a literary perspective, so essential to Americans' understanding of the region.

Many others have offered assistance and guidance. In addition to the countless librarians, curators, and museum personnel who provided access to their collections and knowledge, I would like to thank Gerald Adelman, Openlands Project, Chicago; William Bengtson, Phyllis Kind Gallery, Chicago; Hans Breder, University of Iowa; Nan Brewer, Indiana Art Museum; Gerald Carr, University of Delaware; John Carter, Nebraska State Historical Society; Andrew Connors, National Museum of American Art; Daphne Deeds, George Neubert, and Karen Williams, Sheldon Memorial Art Gallery, Lincoln; Sherry French, Sherry French Gallery, New York; John Hoover, Mercantile Library Association, Saint Louis; Lawrence Jonson, Curator, Deere and Company; Louise Lincoln, Minneapolis Institute of Arts; Francine Marcel, South Dakota Art Museum; Ane McBride, Nebraska State Historical Society; John McKirahan, Director/Curator, Museum of Nebraska Art; Ignazio Mendieta, Cedar Rapids, Iowa; Larry Mensching, Joslyn Art Museum; Anne Morand, Gilcrease Museum; Diane Mullin, Minneapolis; James Nottage, Autry Museum of Western Heritage; Victoria Post-Ranney, Prairie Crossing, Illinois; Novelene Ross, Curator, Wichita Art Museum; Rick Stewart, Amon Carter Museum; Gray Sweeney, Arizona State University; and Lesley Wright, Cedar Rapids Art Museum.

In many cases the artists themselves have contributed material, thoughts, and ideas. It is a privilege to have met, spoken to, or corresponded with Robert Adams, James Butler, Terry Evans, Frank Gohlke, Harold Gregor, Stan Herd, Drake Hokanson, Gary Irving, Keith Jacobshagen, Stuart Klipper, and Genie Patrick. Their art and their comments have been a constant inspiration throughout this study.

Not to be forgotten, several research assistants have put in innumerable hours and contributed substantially to the final outcome. Stacey Robinson was instrumental in the early collection stage of gathering ideas and images; Gail Hollander assisted at the Obermann Center for Advanced Studies in the summer of 1994, and Celia Stahr, Robin Braun, Kristin King, and Kristina Martin have steadily provided invaluable curatorial assistance at the museum.

At the Smithsonian Institution Press my acquisitions editor Amy Pastan has been unfailingly supportive, enthusiastic, and encouraging, and copy editor Lorraine Atherton masterfully performed the painstaking work of correcting my mistakes. Without them and the rest of the staff at the press this book could not have been produced. While much of the final product must be attributed to their capable work, any omissions or errors, however, are wholly mine.

Finally, I would like to thank my family, with whom I first experienced the prairies and through whom I learned to love them. For my father, Barry, whose experience and patience gave me endless hours of childhood pleasure on the horse he helped me own; for my mother, Carmen, whose own girlhood in the Osage County tallgrass prairies has offered a constant touchstone for my own associations with "God's Country"; and for my grandparents, Jess and Gladys Kinsey and Glen and Maude Ward, who in different ways each pioneered the Oklahoma prairies and helped me to know them, I gratefully dedicate this book.

EXHIBITION ACKNOWLEDGMENTS

Thoughts of the American landscape as seen in our art inevitably lead to visions of mountains and forests, lakes and cataracts, and the sea. Missing from this list are the vast expanses of prairie, which account for a large part of the continent's land surface. Why are the plains such an exotic subject in the representations of the American landscape? The simplest answer is that the challenges endless stretches of flat earth posed for artists trained to fill up their compositions with incident required the development of new ways of seeing. However, art never exists in a vacuum, and on the prairie new artistic strategies were intimately joined to the transformation of the land. The theme of this beautiful exhibition, then, is the history of how people lived on and saw the plains.

Thanks beyond measure are due to the individuals and organizations whose help made the dream of this large and complex exhibition a reality.

Joni L. Kinsey, assistant professor of American Art at the University of Iowa, conceived this project and organized the exhibition. Dr. Pamela White Trimpe, curator, worked closely with Dr. Kinsey in realizing the large number of practical matters connected with its preparation; she was aided in this task by Donald J. Martin, registrar, and Jo-Ann Conklin, who facilitated the preparation of the text and photographs. Emily J. G. Vermillion, curator of education, planned the interpretive programs at the University of Iowa Museum of Art. Jo Lavera Jones, Betty Breazeale, and Charlene Miller assisted with administrative matters. David Dennis, technical director, designed the exhibition's handsome installation. Robin Braun, Kristina Martin, Celia Stahr, and Kristin King, graduate assistants, were accomplished researchers and facilitated many practical details. We are grateful to the Smithsonian Institution Press for assistance with the production of this accompanying publication and particularly to Amy Pastan, acquisitions editor, and Jenelle Walthour, production editor. Our thanks go, too, to the National Endowment for the Humanities for the grant making the planning and presentation of *Plain Pictures: Images of the American Prairie* possible.

Finally, I would like to express our gratitude to the many lenders to the exhibition who so willingly and generously shared their possessions with us.

STEPHEN PROKOPOFF

Amon Carter Museum, Fort Worth

Autry Museum of Western Heritage, Los
 Angeles

Buffalo Bill Historical Center, Cody

James Butler

Chemical Bank, New York

The Cleveland Museum of Art

Cline Fine Art Gallery, Santa Fe

Coe College, Cedar Rapids

Comstock Stock Photography, New York

Dallas Museum of Art

Deere and Company Corporation, Moline

Diplomatic Reception Rooms, United States
 Department of State, Washington, D.C.

Terry Evans

Fraenkel Gallery, San Francisco

Frederick R. Weisman Art Museum,
 Minneapolis

Frank Gohlke, courtesy of Bonni Benrubi
 Gallery, New York

Great Plains Art Collection, Center for Great
 Plains Studies, Lincoln

Emerson Head

Stan Herd

Drake Hokanson

Indiana University Art Museum, Bloomington

Gary Irving

Keith Jacobshagen

Joslyn Art Museum, Omaha

Mr. and Mrs. William J. Kirby

Stuart Klipper

Library of Congress, Washington, D.C.

Ignazio Mendieta, Cedar Rapids

Jeff Mercer and Linda Glass

The Metropolitan Museum of Art, New York

Mid American Energies, Davenport

Museum of Nebraska Art, Kearney

National Anthropological Archives,
 Smithsonian Institution, Washington, D.C.

National Archives of Canada, Ottawa

National Museum of American Art,
 Smithsonian Institution, Washington, D.C.

Nebraska State Historical Society, Lincoln

Nelson-Atkins Museum of Art, Kansas City

New Britain Museum of American Art, New
 Britain

Openlands Project, Chicago

Page Imageworks, Tony and Merrily Page,
 San Francisco

Genie Patrick

The Philbrook Museum of Art, Tulsa

David Plowden

The Regis Collection, Minneapolis

Richard Gray Gallery, Chicago

Royal Ontario Museum, Toronto

The Saint Louis Art Museum

Saint Louis Mercantile Library Association

Smithsonian Institution Libraries,
 Washington, D.C.

The South Dakota Art Museum, Brookings

Spencer Museum of Art, Lawrence

State Historical Society of Iowa, Iowa City

Thomas Gilcrease Institute of American
 History and Art, Tulsa

University of Iowa Libraries, Iowa City

Valparaiso University Museum of Art,
 Indiana

The Walters Art Gallery, Baltimore

The Wellington Management Company,
 Boston

Wichita Art Museum

James Winn

INTRODUCTION

These are the gardens of the Desert, these
The unshorn fields, boundless and beautiful,
For which the speech of England has no name—
The Prairies. I behold them for the first,
And my heart swells, while the dilated sight
Takes in the encircling vastness.

William Cullen Bryant, "The Prairies," 1833

Prairies extend, or did extend, over one third of the American continent, and at least since the first European encounters with them (beginning with Cabeza de Vaca's and Coronado's expeditions in the mid-sixteenth century), they have alternately confused, dismayed, overwhelmed, depressed, and inspired those who would contend with their contradictions.[1] They have been described as being both nothing and everything, empty as well as diverse, monotonous and endlessly varied. In virtually every way—scientifically, historically, economically, politically, and artistically—the prairies' most consistent characteristic is that of paradox. Disparities between appearance and actuality, idea and fact, are extreme in this landscape, but what is remarkable in comparison to other regions is the central role prairies have played in the development of the United States and Canada and the influence that their perceptual contradictions have had on that development. The sweeping grasslands have provided the setting for battles between cultures, a homeland for some of the continent's most distinctive animals, a promised land for hopeful settlers and a cruel disappointment to others, a nurturing ground for commercial development, and a focal point for national values. At the same time, the prairies are considered by many Americans to be devoid of visual interest and cultural significance. No other landscape has been, or continues to be, as important and as frequently misunderstood as the American grasslands.

Figure 1

The Original American Prairies

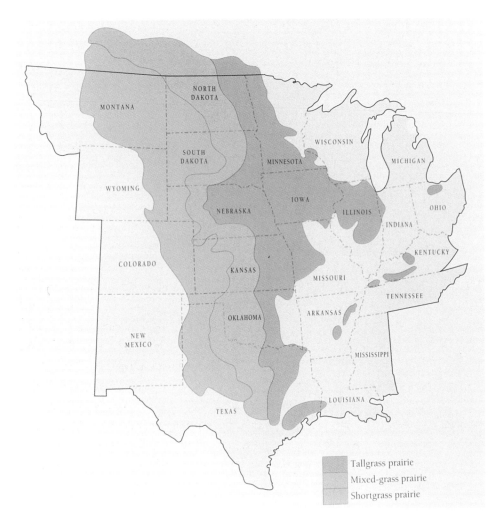

Tallgrass prairie
Mixed-grass prairie
Shortgrass prairie

PRAIRIES AND PLAINS

Even the most superficial attempts to discuss prairies require labyrinthine negotiations of shifting locations, grassland types, varying species of plants, annual rainfall, longitudinal orientation, and the maze of associations that shape cultural understandings of this most perplexing of regions (fig. 1).[2] Far from being truly plain, a monolithic simplicity, the terrain is in fact exceptionally complex.[3] Tallgrass prairie once covered much of Illinois, Iowa, parts of Missouri, Indiana, Texas, Minnesota, Wisconsin, Kansas, Nebraska, Oklahoma, and the Dakotas; mixed-grass prairie and plains dominated the center portions of those latter states, from North Dakota to Texas; and in the drier region west of the hundredth meridian, short-grass high plains extend to the Rocky Mountains. Grassland of various sorts originally encompassed some 750 million

acres, extending north and south from Texas through southern Canada. In addition to the great horticultural variety, the terrain supported more than three hundred types of birds, eighty different species of mammals, and thousands of kinds of insects and other animals that varied by specific location.[4] Today the original prairies have been so dramatically transformed—mostly by the importation of trees, the prevalence of large-scale agriculture, the vigilant control of fire, and the regular presence of towns, buildings, and highways—that it is difficult to find what our predecessors in the region often felt they could not escape. Except in a few remarkable places, the uninterrupted view in all directions has been mediated to an extreme. Just as artists modify their compositions to suit their aesthetic preconceptions, the very character and appearance of the land have been shaped and manipulated to conform to the needs and tastes of those who live in it.

While differences between the prairie and plains regions and their respective characteristics are significant, the grasslands may also be more generally considered as a single, distinct landscape form that has provoked a tremendous array of responses, both aesthetic and cultural, throughout human history. In both the nineteenth and twentieth centuries the term "prairie" (a French word, as poet William Cullen Bryant noted, with no early English equivalent[5]) has been the popular appellation for any territory that is distinguished by the predominance of grass and a general lack of trees, but even small meadows surrounded by timber could be called prairies. Typical was Meriwether Lewis and William Clark's description: "about two miles back a Prarie com[mences] which is rich and interspursed with groves of timber."[6] In the nineteenth century and even today, "plains" is often used as a synonym for "prairies," broadly applied to describe exceptional flatness and treelessness.[7] For most artists, scientific and etymological distinctions between landscape forms are only as important as they are visually evident. For that reason, this study considers responses to the prairie as a general *type* of landscape and not as a group of discrete ecological systems.

PRAIRIE PARADOXES

The tremendous expanse and diversity of prairies and their importance in the history of the United States place them among the most intriguing of landscapes. In keeping with their paradoxical nature, however, they are among the most underappreciated and even ignored, both in regard to the land itself and representations of it. A frequent complaint is that prairies appear too simple, too monotonous, and, befitting their form, too plain. The terrain offers neither the pastoral tranquility of eastern American landscapes nor the drama of far western ones so prized in our geographical stereotypes. The absence of landmarks and other points of interest and the sheer extent of its apparent emptiness renders even this ironic appeal tedious. Today most people cross the region by car or by air as quickly as possible (treating it as something to be "gotten through"), and they value it primarily through metaphorical abstraction ("amber waves of grain")

or as a means to an end (as in agricultural production). These tendencies date at least to the early nineteenth century, when central North America was designated the Great American Desert for its lack of trees and apparent barrenness, and such mythologizing has persisted with the more recent, albeit opposite characterization, "the breadbasket of America." The prairies are simultaneously considered nowhere (at least by the most provincial of coastal inhabitants) and the heartland, where cherished cultural archetypes are thought to retain their purest form, perhaps because there seem to be no temptations of the sort endured and enjoyed by more complicated places.[8] In contrast to the featureless virgin landscape, the cultivated prairie, a large area of central North America carved and molded from original grassland, may be just as monotonous in its expanse, but it is often deemed more interesting for its visual variety. The sectioned fields and regular landmarks of homesteads and towns that mark its interior have endowed the terrain with the elements and qualities of more conventional landscapes at the same time that they seem to maintain the region's arcadian character, at least in contrast to urban areas. This initial impression of the contemporary prairie, however, can be deceptive. The transformed landscape is actually a monoculture, reduced to a few basic (and usually hybridized and highly fertilized) species where hundreds had grown before, and it is essentially a factory, an industrial if pastoral region that is highly valued for its production of critical raw and finished materials that fuel the nation's economy and food supply.[9] Paradoxically, what seems monolithic in the natural prairie is, on closer scrutiny, almost infinitely diverse, and what appears more complex in the agricultural modification is in fact a radical simplification.

THE PRAIRIE AESTHETIC

The contradictions of the prairie region and visual embodiments of them since the 1830s constitute the focus of this study. Attitudes and reactions to the treeless grasslands have developed in conjunction with Euro-American settlement of the United States and Canada, and as with other landscape types, the ways prairies have been utilized are inseparable from how they have been seen, described, and ultimately understood. The converse is equally true; aesthetic responses are intricately connected with and dependent on land use or what is perceived as its potential.[10] Perceptions of land are therefore based as much on aesthetics as they are on practical or economic concerns. In other words, agricultural, commercial, or cultural development of a region follows (and in turn influences) visual and conceptual consideration.[11] If a landscape is believed to be barren because it contains no trees, for example, one might conclude that it is incapable of supporting grains and other crops and look elsewhere for potential farmsteads. But if the lushness of the grass and the lack of obstacles is interpreted as fertility waiting to be plowed and planted, the outcome will be much different. Similarly, artistic and theoretical preconceptions have influenced the responses of painters and photographers to prairies, sometimes turning them

away from the paucity of material and at other times inspiring them with visions to be realized. Unlike forests, mountains, or other landscapes of Europe and the American East, extensive and treeless plains were unprecedented in the experience of most immigrants and artists. Coping with them entailed psychological adjustment and entirely different practical strategies from those needed in more conventional landscapes. For early settlers the change spanned everything, from fashioning their initial dwellings from sod instead of logs to using innovative machinery specifically designed for the soil and climatic conditions (such as the sod-breaking plow and commercially manufactured windmills). For interpreters of the landscape, the artists and writers who arrived with and sometimes even before the settlers, it meant confronting the inadequacies of traditional expressive and representational techniques and adapting new ones for the unique characteristics of the prairie scenery.

As Wayne Fields has explained in the foreword to this book, writers who struggled to express their awe of the unbroken expanse could always resort to classic metaphors such as "oceans of grass," which transform the prairie into something else but at least by association convey an image of uninterrupted horizons and undulating motion. They could also abstract ideas in clarifying ways, a tactic mostly unavailable to visual artists. Especially evocative in this regard is Willa Cather's characterization from *My Antonia:* "There seemed to be nothing to see; no fences, no creeks or trees, no hills or fields. If there was a road, I could not make it out in the faint starlight. There was nothing but land: not a country at all, but the material out of which countries are made."[12] Cather articulates the recurring theme of the prairies' potential, explaining the landscape in terms of its prospects, its productive future. In its original condition the land lacks identity and seems so formless as to be unintelligible. Thus it can be defined only by what it may become.

While the prairies' prospects were as fundamental to visual treatments of the landscape as they were to literary ones, artists encountered special difficulties with grassland scenery. Without geographical elements to constitute a view, it was exceptionally difficult to convey the land's imagined potential concretely, much less to make that seem attractive.[13] This might at first seem a consequence of the land's inherent deficiencies, but the problem actually lay more with the artists' preconceptions of what constituted a suitable subject. European conventions for composing landscape images dominated painting styles and formats until the twentieth century (and they continue to influence aesthetic judgments today), although they were designed for a much different terrain and were completely unsuited to such a featureless region. The metaphorical alternatives available to literary portrayers (as in evoking the future) were largely nonvisual. As a result, many artists avoided depicting pure prairies, even those committed to documenting their experiences and who in their travels encountered the scenery daily for long periods. Instead, they focused on rivers and the scenic terrain that lined them or on portraits of the region's native inhabitants.

Some strategies for dealing with the uninterrupted horizon were more enterprising, however, both in the nineteenth century and more recently, and these visual solutions form an important, if little recognized, genre of landscape art.

Much like America itself in the eyes of early European settlers, the prairie was so formless that it could be manipulated or filled at will to incorporate an entire range of ideas, cultural values, and metaphorical allusions. As the landscape itself began to change according to the tastes and requirements of its inhabitants, it fulfilled the promise of those early visions but also brought new challenges of other sorts. Because the work of prairie artists throughout the past 160 years is inseparable from those developments, it provides compelling insights into Americans' ingenious aesthetic accommodations to this special and problematic subject, accommodations that responded to the prairie's unique qualities and, in turn, provided it with a new identity.

PRAIRIE EXPLORATIONS

The earliest artistic encounters with the central grasslands occurred in the context of expeditions, both private and government-sponsored, that explored, perused, and surveyed the American West throughout much of the nineteenth century. In many ways the work of these explorer-artists was practically and theoretically the most difficult of that confronted by the prairie portrayers, as they struggled to give form to a landscape that had neither the constituent parts with which to compose a scene nor any established cultural significance from which they might construct a narrative or suggest an allegorical response. The artists were charged with documenting their experiences and their settings but lacked conceptual and aesthetic preparation for the task. To compensate they adapted to their surroundings by essentially importing or highlighting focal points in the landscape, such as prairie fires, the movement of animals, Native Americans, and their own survey teams, to provide interest and visual comprehensibility to their works. Their images, in conjunction with the written accounts of the period that describe comparable themes, settings, and episodes, provided the foundation for the early and persistent conception of the prairies as a region that seemed at once so monotonous that it could lull even the most interested into a stupor and so intense, surprising, and sometimes exotic as to be terrifying.

NATIVE AMERICAN PERSPECTIVES

For Euro-American artists Native Americans were an important part of the prairies' early identity, but their depictions of the landscape and its inhabitants could not have been more different from the understandings and perceptions of the land held by those inhabitants. Native American cultures traditionally had no equivalent to the Renaissance-derived emphasis on the horizon line and its corresponding suggestion of an imperialist point of view, at least not until sustained contact with whites effectively instilled that authoritarian concept into their consciousness and

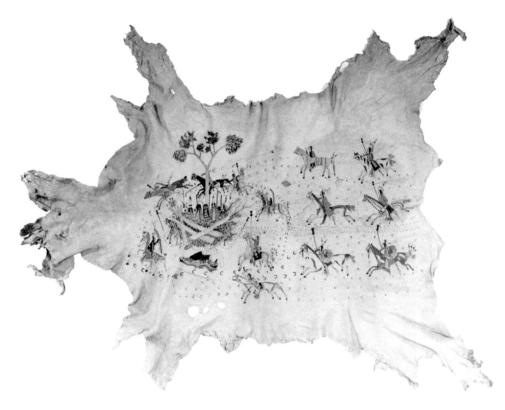

Figure 2

Silverhorn (Haungooah) (ca. 1861–ca. 1941)

The Sham Battle to Capture the Central Pole
(one in a series of five paintings of the
Medicine Lodge Ceremony, Kiowa-Gaigwa),
1902

hide, pigment, 50 x 56 x 52½ x 56 x 56"

National Museum of Natural History, Department
of Anthropology, Smithsonian Institution

vocabulary.[14] Indeed, except for highly allusive and symbolic diagrams, descriptions of place or landscape in the native tradition were nonvisual or at least nonrepresentational in the sense of perspectival depictions (fig. 2). Instead, those schematic allusions suggest a more cosmic and less proprietary view of space, time, and terrain, one that is much less dependent on specific location, either of the viewer or of the event depicted, and that in many ways is more appropriate for the prairie.[15] While such images make fascinating contrasts to Euro-American landscape representations—contrasts that highlight the very cultural presumptions that have ultimately shaped the American prairies—the profound dissimilarity of the objects and the cultures that fostered them complicates sustained comparison, potentially to the point of minimizing the aspirations, achievements, and ultimately the innate conceptual integrity of each. For that reason this study focuses primarily on Euro-American approaches to landscape, which have had such a major influence on the prairie region and societal attitudes toward it.

At the same time, it is important to consider the implications of representations by Euro-Americans of Native Americans in the landscape and how these have contributed to the evolving characterization of the prairies, as well as to perceptions toward Indians themselves. Equally

significant are postcontact treatments of the landscape by Native American artists that parallel those of their contemporaries in many ways, while presenting a counterpoise that recalls the traditional relationship between the land and the native peoples.

GARDENS IN THE GRASS

With settlement and development of the prairie region intensifying after the Civil War, large portions of the grasslands were transformed, filled with visual articulation and cultural associations that provided artists significantly more material with which to compose their views. The land was sectioned and plowed, trees were planted by the millions, and farmsteads and towns were raised with increasing frequency and permanence. These alterations were more than visually superficial; they changed the very nature of the land—literally, as they disrupted the fragile balance that keeps trees in check in the prairie ecosystem, and figuratively, as they provided the developmental opportunities, economic and otherwise, that had only been envisioned by the most imaginative and optimistic viewers of the virgin prairie. Such profound transfigurations altered many of the fundamental qualities of the prairie landscape that had affected its early viewers, not the least of which was aesthetic.

As the arcadian garden ideal that had captivated the attention of artists early in the nineteenth century in the East was recreated in large areas of the prairie region, and with it the attendant cultural trappings of cultivated society, the prospects that writers could so easily conjure through word associations were finally realized in visual form. Artists and photographers could at last approach and portray the landscape without struggling to import or invent elements to enliven the unbroken horizon.[16] The notion of living in harmony with nature (or, to give the more American version, of being in control of it) had to a considerable extent overcome the alienating relationship with the virgin prairies that had prevailed earlier. Although that ideal remained elusive in fact and has always been ambiguous and problematic, the association of the cultivated prairies with pastoral values was finally attained and has become an important regional characterization and a cherished part of midwestern identity.[17]

RETURN OF THE DESERT

Although the prairie-as-garden notion has endured, it was seriously threatened after World War I by a series of economic downturns, farm crises, and crop failures that culminated with the Great Depression. The innovations that had brought about the agricultural revolution in the region were not only at risk but were also partly to blame for the financial misery that was widespread by the early 1930s. It seemed, at least in some areas, that the garden was becoming precisely the desert early explorers had mistakenly thought it to be.

At the same time and for a whole host of reasons, both political and cultural, the prairie landscape in its most idealized pastoral form was being newly appreciated, especially through Regionalist art and the work of the New Deal programs such as the Farm Security Administration photography project, which focused the public's imagination on the American landscape as it had not been since the heyday of the genre in the 1850s. The paradoxes of the prairies were the subject of many of these artists' work. Eroded land and withered crops present a powerful counterpart to fecund fields and verdant valleys in their paintings and photographs, and although these contrasts were sometimes due to the different conditions throughout the agricultural region, they nevertheless convey the prairie landscape's old power, reminders of its prerogative to assert its primacy regardless of efforts to subdue it.

THE CONTEMPORARY PRAIRIE

While the abstract painting that dominated the postwar period in the United States has been considered a type of sublime landscape, modernist art was for the most part nonrepresentational and virtually ignored the prairie, ironically perhaps, since it is a remarkably minimal and abstract subject.[18] At the same time, however, the developments of modernism profoundly contributed to artists' ability to return to the grasslands for inspiration and finally to be comfortable with its limited formal offerings. Since the 1980s, with the profusion of subject matter and media and the renewal of figurative style, coupled with increasing attention to environmental issues and other contemporary concerns that have strong roots in the Midwest, the landscape has reemerged as a significant artistic focus, but the prairies have been so thoroughly altered, become so conflicted and paradoxical visually and culturally, that they can finally be considered a postmodern subject. The land has been filled and rearranged to the point of losing its old identity; instead of looking in vain for something to break the expanse as our predecessors did, we must search for the uninterrupted view and are constantly diverted by distractions. Competing forces—from environmentalists to agribusiness, industrialists to suburban dwellers—vie for the prairies' future, and except in times of natural catastrophe such as tornadoes, droughts, or floods, it seems as if humans have gained the upper hand.

More than just nostalgia for a simpler place by an increasingly urban public, attitudes and artistic responses toward the mid-American landscape are incorporating aspects of the region's complexity into a new identity. The prospects of the prairies have improved, multiplied, artistically and otherwise, and in some ways the art world has at last grown into the subject. As contemporary Americans struggle ever more vainly to locate themselves within an increasingly complex society, prairies have become a point of cultural identification, embodying long-cherished ideals of harmony with the land and, for those with more fortitude, pragmatism, or insight, the vainest follies and tragic mistakes of culture and history.

In spite of being obscured by other types of landscapes, prairie pictures constitute a significant genre within American art that is as subtle, challenging, and fascinating as the land and the history it depicts.[19] It has long been acknowledged that landscape constituted the defining genre of nineteenth-century American art, but prairie paintings and photographs are rarely included in the countless studies and exhibitions that have examined the subject. More often the grassland images are considered in the context of American western art, where they are usually positioned within the very different category of "frontier life" or as rather plain counterparts to more dramatic western landscapes. In either case the significance of the works themselves and the aesthetic they embody is diminished, not because the art is overshadowed in those contexts or considered inferior by comparison to more formally dramatic scenes (although some critics have considered them so), but rather because the criteria for judgment, or even for interest, are predicated on different concerns from those required by prairie subjects. The prairie is a beguilingly subtle landscape with attributes unto itself.

Although this book considers the prairie and its portrayals across a century and a half, it is hardly a comprehensive history of the subject. Rather it attempts to initiate a consideration of the aesthetics of plainness in the American Midwest and the efforts that have contended with that landscape and its development. It is hoped that this modest beginning encourages additional study of a visual genre that has been too long undervalued and that it might prompt scholars to probe more deeply into this fascinating aspect of our national heritage. As in encountering the land itself, confronting, delighting in, and ultimately understanding prairie imagery entails acknowledging the special characteristics of the subject and appreciating the aesthetic accommodations it requires. Only when the "plain pictures" are placed in context, aesthetically, theoretically, and historically, can they take their rightful place amid the more traditional landscapes that have so long held the central position in the pantheon of American art and national identity. In direct contrast to their initial impression, prairies and representations of them are not so plain. They offer an artistic paradigm of sublime proportions: the significance of the subject is equaled only by the struggle to express it.

1 · PRAIRIE PROSPECTS

THE AESTHETICS OF ABSENCE

The prairie is striking and never fails to cause an exclamation of surprise. The extent of the prospect is exhilarating. The outline of the landscape is sloping and graceful. The verdure and flowers are beautiful; the absence of shade, and consequent appearance of profusion of light, produce a gaiety which animates the beholder.

Judge James Hall, on the Iowa landscape, 1839

To the traveller, who for several days traverses these prairies and barrens, their appearance is quite uninviting, and even disagreeable. . . . No pleasant variety of hill and dale, no rapidly running brook delights the eye, and no sound of woodland music strikes the ear; but in their stead, a dull uniformity of prospect, spread out immense.

C. Atwater, on the Ohio prairies, 1818

When artists confronted the expansive prairies before settlement significantly altered the land's appearance, their reactions, like those of the writers quoted above, ranged from exultation to despair, but all acknowledged with chagrin the lack of visual elements with which to construct pictorial compositions. As the Canadian painter Edward Roper joked in the 1890s, "There's a good deal more scenery wanted in this country, ain't there."[1] The grasslands seemed an almost sublime void, "a view so vast that endless space seems for once to find embodiment."[2] The place both compelled and defied representation, and the artists, no matter how well trained or talented, were ill equipped for the challenge.

THE LEGACY OF LANDSCAPE THEORY

In contrast to the popular assumption that landscape artists simply reproduce what they see in nature, composing a scene has historically been a highly theorized activity with strict rules for

spatial organization, formal ingredients, and implied ideological content. This was especially true in the early nineteenth century, when American artists first began venturing westward to portray the lesser-known parts of their country to eastern audiences. Until the twentieth century, style and content were strictly regulated by art theorists, critics, and ultimately the galleries and art market that those individuals controlled. Landscape depictions, although derived from nature, were to be constructed and idealized no less consciously than anything else. The problem for artists of prairie scenes, of course, was that their subject lacked almost all the elements in traditional landscapes and did not conform to any of the rules.

The rules, although espoused consistently by American theorists and artists who, paradoxically, called for an art that would be distinctly nationalistic, were largely of European origin and had been conceived for Europe's terrain. They had evolved at least since the seventeenth century, based on Renaissance theories of perspective, with Dutch landscape paintings and the particular work of French landscapists Claude Lorrain (Claude Gellée) and Nicolas Poussin, the Italian Salvator Rosa, and Flemish painter Peter Paul Rubens as the most representative and exalted manifestations.[3] Coupled with the eighteenth-century obsession with theorizing nature in all its forms, these models contributed to a series of aesthetic treatises that attempted to examine and explain the natural world and human responses to it, and to instruct those who would presume to act as interpreters, visually or otherwise.

The literature of and about this movement is vast and complex, but essentially, artists, writers, landscape architects, and others were taught that landscapes of various sorts evoked certain emotions, ideas, attitudes, and even behaviors from viewers, and that these could be manipulated according to the elements in a scene, their arrangement, and technical handling. The landscape types were not equal in their effectiveness or in their value, and the highest esteem was reserved for those views that prompted the noblest sentiments or the profoundest intellectual reactions.[4]

In painting, these included landscapes that conformed to three basic categories: the beautiful, the sublime, and the picturesque. Numerous and exhaustive treatises were written about the categories and their characteristics; debates were carried on for decades about the relative merits, meanings, and applications of the concepts; and artists searched tremendous distances for subject matter that would epitomize the cherished ideals. Although this vastly simplifies the subtlety of the types and their relationships, the beautiful may be represented by formal gardens with their carefully manicured lawns, topiaries and pavilions, regularized patterns and conformations. The beautiful, most notably defined by Edmund Burke's *Philosophical Enquiry into the Origins of Our Ideas of the Sublime and the Beautiful* (1756), is characterized (and not only in landscape) by smoothness, refinement, and sensuous curves, among other things. The picturesque, added to Burke's premises by William Gilpin in 1792, is a more natural scene, with irregularities, incon-

sistencies, and varying textures, but it too is prized for its aesthetic diversity.[5] While it appears natural, it is not necessarily so; as in landscape gardening, the artist must exert taste and judgment in choosing or placing various elements, their proportions, and their degree of emphasis to provide an impression of nature that is preferred over pure unruly nature. The sublime is the most extreme category, one characterized by scenes that provoke fear or awe by their vastness, immensity, extraordinary roughness, or other such pronounced qualities. Precipitous views into gorges, over mountains, across endless tempestuous seas, or into cataclysmic weather would qualify as sublime, but a key condition of this concept is that such encounters are perceived from a distance sufficiently removed to render the experience delightful rather than truly terrifying.[6]

The prairies were sometimes referred to as beautiful or more frequently sublime; rarely were they called picturesque.[7] Their apparent smoothness and regularity coupled with the delicacy of their minutiae (as in wildflowers, for example) sometimes qualified for the former; their vastness and perceived emptiness often fit the second designation; but their lack of irregular focal points on which the gaze could rest before moving on to another equally intriguing element usually prevented their being characterized as fitting for a picture, which was Gilpin's definition for his theoretical model. Gilpin emphasized this in his treatise with an etching, *Scene without Picturesque Adornment,* that could easily pass for a prairie scene with its rolling undulations and featureless expanse.[8] The beautiful, too, was laden with expectations that the early prairies did not usually fulfill. As the Canadian artist Paul Kane (1810–1871) wrote in 1858, "The country here is not very beautiful; a dead level plain with very little timber, the landscape wearing more the appearance of the cultivated farms of the old country with scarcely a stick or stump upon it."[9] Lacking picturesque cultivations or the foliage of a more embellished terrain, Kane's prairies were ironically compared to the only familiar landscape available, farms stripped of their bounty.

Added to theoretical distinctions in the practice of landscape depiction, and allied with the prescription for picturesqueness, were compositional ideals that by the nineteenth century amounted to formulas that could be applied generally to any of the three categories. For what has become known as a "classic landscape," "idealized landscape," or "Claudian formula" (after its best-known French practitioner, Claude Lorrain), the artist was to include framing devices such as trees or rocks on the sides of the composition; a meandering road, path, or stream that wound its way into the scene from the foreground; figures or other elements throughout that would provide a sense of scale and cultural reference, known as staffage, coulisses, or *repoussoir;* and finally a view toward a distant horizon that was usually suffused with light or misty atmosphere.[10] Such compositional details could be, and were advised to be, applied to all landscapes regardless of location or type, with local variation of detail providing the desired specificity, or "truth." Audiences expected these visual devices in art, critics required them for their approval, and with rare exceptions few successful paintings were without them until the twentieth century.[11]

As American artists adhered to European formal conventions and aesthetic theories that would insure acceptance of their work, they sought subject matter that would distinguish their art as undeniably and characteristically American. By the early nineteenth century it was clear that while the young country could not claim cultural superiority through the mythology, history, or literature that distinguished Europe, it could boast of one asset it had more of and in greater variety and richness than the Old World: land. The nationalistic notion of American exceptionalism lay within the rocks, rivers, trees, and sheer expanse of the continent and would bring acclaim to any artist willing and able to portray it.[12]

The earliest efforts at this were, of course, oriented toward eastern subject matter. The Hudson River Valley became a favored area and the center of the first acknowledged school of American art, and Niagara Falls was universally hailed as a national wonder and an unparalleled visual subject, but artists soon recognized that even greater opportunities and material lay west. Beyond the Mississippi, however, as Meriwether Lewis and William Clark had recognized on their famous expedition of 1804–1806, the landscape was distinctly different from the East. Although western landscapes would eventually triumph as visual symbols of American national identity, conventional means of description, either visual or verbal, often proved woefully inadequate in conveying the appearance or effect of these unusual scenes.[13]

These deficiencies were nowhere as problematic as in the prairies. As Walt Whitman and other writers recognized, in verbal descriptions the grasslands could represent American ideals (indeed to many they seemed the very embodiment of them), but it was through metaphor, allusions, and comparison that such analogies were possible:

While I know the standard claim is that Yosemite, Niagara Falls, the upper Yellowstone and the like, afford the greatest natural shows, I am not so sure but the prairies and plains, while less stunning at first sight, last longer, fill the esthetic sense fuller, precede all the rest, and make North America's characteristic landscape. Indeed through the whole of this journey . . . what most impressed me, and will longest remain with me, are these same prairies. Day after day, and night after night, to my eyes, to all my senses—the esthetic one most of all—they silently and broadly unfolded. Even their simplest statistics are sublime.[14]

Whitman's statement (especially appropriate for one whose greatest achievement was a collection of poetry called *Leaves of Grass*) and others like it are compelling, but the techniques that make it so—those phrases that suggest the grasslands' temporal and emotional power—are, of course, inherently nonvisual and therefore unavailable to pictorial artists. Whitman himself seemed to recognize the dilemma, at the same time hoping for a day when open land would be accepted and exalted as the quintessential American artistic subject:

The pure breath, primitiveness, boundless prodigality and amplitude, strange mixture of delicacy and power, of continence, of real and ideal, and of all original and first-class elements, of these prairies, the Rocky Mountains, and of the Mississippi and Missouri Rivers—will they ever appear in and in some sort form a standard for our poetry and art?[15]

Before this desire could come to pass for prairie landscapes, however, artists would have to overcome their predetermined notions of what constituted an ideal view. Quite clearly, the terrain's inconsistency with conventional preconceptions for artistic landscapes presented challenges, but just as important, the prairie's unique characteristics posed other formal and conceptual problems that prevented it, at least for a time, from becoming either an attractive visual subject or a compelling representation of American nationalism.

THE GARDEN-DESERT PARADOX

The most obvious characteristic of the prairies that excluded them from the pantheon of American landscapes was their lack of landmarks. It was "a situation from which the eye could not rest upon a tree, or even a humble shrub, throughout the entire range of vision, to interrupt the uniformity of a far outspreading, gently undulated surface."[16] A conundrum certainly to artists, this deficiency was just as problematic to explorers (who worried about getting lost without landmarks to pinpoint their location) and, later, to scientists who were charged with interpreting the apparent barrenness and suggesting possible uses for the land. The absence of trees was especially perplexing, and although various theories were proposed, the question was not resolved for many years (and still is not understood well by many Americans).[17] Neither did the mystery intrigue artists. If a landscape did not contain trees, many people simply concluded, it must not be fertile, and a wasteland did not fit anyone's notion of America's future.

These observations and preconceptions prompted more than one visitor to call the region a "vast desert."[18] The notion had been public at least since 1810, when Zebulon Pike, of Pikes Peak fame, called the plains "internal deserts" in the published accounts of his 1806–1807 expedition to the Rocky Mountains.[19] More important, however, was the enduring designation of a large portion of what is now the central United States as the "Great American Desert," a term that originated in the maps and reports of Major Stephen Long, who explored the prairies and plains as far as the Rocky Mountains in 1819–1820.[20] Long's account, actually written by his assistant, Edwin James, is especially eloquent in its conviction that the land lacked potential:

[There are] but sandy wastes, and thirsty inhospitable steppes, . . . wide sandy desert stretching westward to the base of the Rocky Mountains. We have little apprehension of giving too unfavorable an account of this portion of the country. Though the soil is, in some places fertile, the want of timber, of navigable streams, and of water for the necessities of life, render it an unfit residence for any but a nomade

population. The traveller who shall, at any time, have traversed its desolate sands will, we think, join us in the wish that this region may for ever remain the unmolested haunt of the native hunter, the bison, the prairie wolf, and the marmot.[21]

The only benefit such a large, desolate region could offer the United States, Long and Pike both argued in their federal reports, would be as a barrier to overexpansion and protection against invasion.[22]

Although it is easy to dismiss those interpretations as misguided, since they were so quickly proved wrong, to be fair to Long and his contemporaries (as Walter Prescott Webb, William Goetzmann, and others have pointed out) it should be recognized that when the early explorers encountered the prairies and plains, the country was without transportation systems, water retrieval methods, and even plows that could penetrate the thick root system of the grass. The prairies' potential for agricultural development was indeed severely limited.[23] It took decades and many technological and social innovations to make the land inhabitable by any but the most nomadic peoples, and as a result the perception of the prairies as a great desert or a massive waste dominated most discussions of the region until after the Civil War.

It is also important to understand the nuances of the terms "prairie" and "desert" and the rationale with which they were applied. "Prairie" was in many ways a simpler concept in the nineteenth century than it has become today, and "desert" a more complex one. For the early explorers, a prairie was any treeless grassy landscape but could extend even into areas of the Southwest that would probably not be so called today. In his highly influential book *Commerce of the Prairies* (1844), for example, Josiah Gregg delineated the scope of the nineteenth-century understanding of the region: "If we look at the Great Western Prairies, independently of the political powers to which portions of them respectively belong, we shall find them occupying the whole of that extensive territory lying between the spurs of the [Canadian] Rocky Mountains on the North, and the rivers of Texas on the south."[24] Distinctions were seldom made between tallgrass prairies and the more arid high plains, and the term "prairie" also applied to smaller meadows in the eastern states. In 1827 for example, James Fenimore Cooper, relying on Edwin James's account of the Long expedition for his landscape descriptions in *The Prairie,* did distinguish between the prairies east of the Mississippi, which he described as "comparatively small, and exceedingly fertile, and always surrounded by forests," and the "Great Prairies" on the west side, which extended uninterrupted to the Rocky Mountains; but he emphasized that the Great Prairies were simply a "broad belt, of comparable desert . . . appearing to interpose a barrier to the progress of the American people westward."[25] Cooper had never actually seen the prairies west of the Mississippi and was simply echoing the comments of those who had, but he reflected the tendency to consider the grasslands an essentially homogeneous region, regardless of their aridity and real promise for development. Although the notion of the prairies as desert would later be challenged

vigorously and largely overcome, the image and its foreboding implications would persist as an ever-present threat to the prairie and its settlers.[26]

Not everyone was as dismissive of the prairie's initial possibilities. In contrast to the pessimistic forecasts that dominated the early nineteenth century, as early as 1673 the French explorer Louis Jolliet had recognized that an empty landscape did not necessarily mean a barren one:

At first, when we were told of these treeless lands, I imagined that it was a country ravaged by fire, where the soil was so poor that it could produce nothing. But we have certainly observed the contrary; and no better soil can be found, either for corn or for vines, or for any other fruit whatever.[27]

Even as he described the appearance of the land, Jolliet envisioned its use, reporting,

prairies three, six, ten, and twenty leagues in length and three in width, surrounded by forests of the same extent; beyond these, the prairies begin again, so that there is as much of one sort of land as the other. Sometimes we saw grass very short, and, at other times, five or six feet high; hemp, which grows naturally here, reaches a height of eight feet. A settler would not there spend ten years in cutting down and burning the trees; on the very day of his arrival he could put his plow in the ground.[28]

Jolliet's optimistic prophecy would be echoed in the following centuries by countless individuals who saw the open landscape as a beckoning opportunity. The garden they imagined and eventually realized in the region would counteract the concept of the land as desert or empty, but the earlier characterizations would nevertheless persist as a central component of the prairies' paradoxical nature.

THE PROSPECT PROBLEM

Even as they described very different futures for the prairies, Jolliet and Edwin James were reacting to the grasslands' most dominant characteristic. Without traditional defining elements the land was a tabula rasa, a blank slate on which could be written a tremendous variety of assumptions, misconceptions, and aspirations. Instead of denying future possibilities altogether, the prairies' openness invited visions, leaving viewers utterly free to invent them, constrained only by their own imaginations and preconceptions, and resulting in markedly different images and competing outcomes. Ultimately, it was this openness that facilitated Americans' proprietary and imperialistic response to the prairies. The land seemed empty and, all skepticism about its barrenness aside, tantalizingly waiting to be claimed and remade.

The suggestion of futurity is a fundamental requirement of a landscape, either an actual one or a representation, for its psychological and cultural appropriation by viewers. In other words, we interpret the land's relevance to ourselves, individually and culturally, by understanding not only its appearance but also its prospects, which include its present condition and its possibilities.

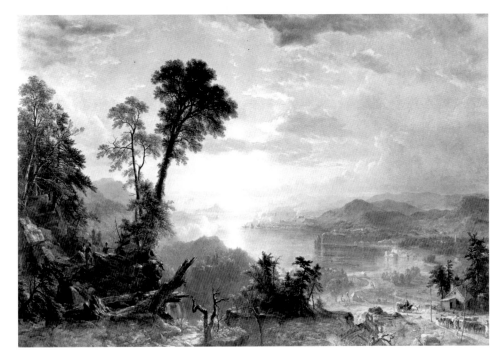

Figure 3

Asher B. Durand (1796–1886)

Progress, 1853

oil on canvas, 48 x 71¹⁵⁄₁₆"

The Warner Collection of Gulf States Paper Corporation, Tuscaloosa, Alabama

Especially from an elevated vantage point (a prospect that offers a panoramic view and enables a "magisterial gaze," as art historian Albert Boime has described it), our understanding of a landscape is accentuated by the panorama's scenic breadth, a visual phenomenon, and also by a conceptual domination over the land, an almost omnipotent glimpse into its potential.[29]

The issue of prospect, with all of its definitions and applications, is central to understanding the prairies as an artistic subject and as an American cultural region. It is a theoretical matrix that conditions perceptions of land generally, at the same time it connotes specific interpretations that have shaped aesthetic responses to the environment. Fundamental to appropriating land in any sense, prospect in regard to prairies is particularly intriguing since the terrain seemed at first to defy such definitions and then, ironically, to be defined *by* that issue. Moreover, the concept is critical in exploring visual responses to the grasslands since it is a multivalent artistic term that has served as a foundation for formal and theoretical constructions of landscape since the Renaissance.

Literally describing a point of view (a rocky outcropping, for example), as well as the scene surveyed from it, "prospect" in the eighteenth- and nineteenth-century art world also referred to the depiction of a scene (i.e., the painting itself) that was composed from a promontory or that included one in its composition. Implied in these applications was the conceptual claiming of the

landscape and dominion over its potential, or prospects, an interpretation that relies on the more conventional modern meaning of the word with its economic allusions.

Incorporating all those understandings were estate and town portraits known as prospect pictures. Extremely fashionable on both sides of the Atlantic since at least the seventeenth century, these were usually paintings or prints presenting a bird's-eye view of property as an overt expression of possession by the owner or, in the case of urban scenes, the inhabitants. By the mid-nineteenth century, with the proliferation of publishing houses and a surge in local boosterism and regional pride, panoramic prints of town views were sold by the thousands throughout the United States.[30] The term "prospect" was also, however, used more generically to describe any landscape picture that presented a sweeping or elevated perspective and, by extension, suggested movement into the future and some aspect of participation in it.[31] The search for a good prospect became a quest for a location that provided not only a scenic overlook but also a view that contained all the elements of a classic composition; would fit into the beautiful, picturesque, or sublime categories; and, most important, would suggest promise, evoke expectation, and often inspire an authoritative or proprietary impulse.

Stated simply, the early prairies had few prospects. In their most extreme form the vast plains lacked even the first requirement—elevated vantage points—and they were largely bereft of compositional features, much less the cultural promise that could distinguish them in the manner, for example, of Asher B. Durand's *Progress* (1853, fig. 3), a quintessential prospect picture. Just as the grassland's presumed emptiness suggested a dismal future to Pike, Long, and James, many artists saw only limited possibilities for successful pictures in this most nontraditional landscape and deemed it an artistic desert.

At the same time, the terrain's openness presented as many artistic opportunities as it did problems. Artists were liberated to import or invent defining features for the prairie landscape, within the limitations, of course, of artistic acceptability and the equally uncompromising requirements of truthful representation. Through their constructions and adaptations they could embody the formal dictates of landscape theory, impart the cherished notions of nationalism, and incorporate the paradoxes of the grasslands as they understood them. In all these ways their work became an important influence on Americans' evolving comprehension of the region's prospects.

THE SEARCH FOR PROSPECTS

Until the land could be put to use through Euro-American settlement and endowed with new promise, however, artists struggled with the prairies' meager and confusing formal offerings. The openness and expansiveness of the land distorted scale and conceptions of space and time in strange and disquieting ways, adding to their inability to assimilate its characteristics into their

own preconceptions. Other than the occasional lone tree, small hill, or fortuitously located river, few opportunities were available for rising above the treeless terrain to gain a visual perspective. Some individuals went to great trouble to construct vantage points or went out of their way to find them, and their impressions from such positions differed dramatically from those at ground level. For example, Alexander Henry the Younger, a fur trader in North Dakota just after 1800, wrote that for entertainment and psychological relief he regularly "climbed up a tall oak, which I had trimmed for that purpose at the entrance of the plain, from the top of which I had an extensive view of the country."[32] Zebulon Pike, who had attributed the treelessness of the prairies to barrenness, reported going miles off course just to scale an isolated hill. There his party was "amply compensated for toil by the sublimity of the prospect below. The unbounded prairie was overhung with clouds, which appeared like the ocean in a storm; wave piled on wave and foaming, whilst the sky was perfectly clear where we were."[33] Although he was usually unenthusiastic about the landscape and wrote disparagingly of the flat land—for him this was the desert—from elevations Pike was effusive, especially if distant mountains were present to frame the grassy meadows. From one particularly compelling spot, he wrote, "we had a view of all the prairie and rivers to the north of us; it . . . was one of the most sublime and beautiful inland prospects ever presented to the eye of man. . . . The great and lofty mountains covered with eternal snows, seemed to surround the luxuriant vale, crowned with perennial flowers, like a terrestrial paradise shut out from the view of man."[34]

Even after settlement provided artists with useful compositional material, they would frequently climb to the top of a windmill or stand on the bed of a wagon to gain a better angle on their subject, as did Nebraska photographer Solomon Butcher. Many painters improvised similar prospects by inventing a raised perspective that provided viewers with an implied heightened position from which to survey the scene.

Without opportunities to rise above the landscape, even time could seem meaningless and emotionally draining in the prairies. One of the first Euro-American artists to travel through and paint the region, George Catlin (1796–1872) was ecstatic about his occasional discoveries of elevated views, calling them both beautiful and sublime, but from his usual position amid the flat or rolling grasses, the experience was entirely different:

For two or three of the first days, the scenery was monotonous, and became exceedingly painful from the fact that we were (to use a phrase of the country) "out of sight of land," i.e. out of sight of anything rising above the horizon, which was a perfect straight line around us, like that of the blue and boundless ocean. The pedestrian over such a discouraging sea of green, without a landmark before or behind him; without a beacon to lead him on, or define his progress, feels weak and overcome when night falls; and he stretches his exhausted limbs, apparently on the same spot where he has slept the night before, with the same prospect before and behind him.[35]

The earthbound prospect was unchanging, endless, and ultimately depressing. For Catlin in this passage the land seemed literally timeless, locked in a continuous present, where no progress could be made and no future was available. In his description he echoed the despair of many in the early prairie who found themselves apparently making little headway in what seemed to be a vast and almost unendurable sameness.

A SEA OF GRASS

Immensity combined with monotony does not translate to canvas intelligibly or interestingly, even on canvases of panoramic dimensions and especially without something in the composition to provide a sense of proportion. In literature and travel journals the apparent endlessness and the land's undulating movement from wind currents and ground swells drew comparisons most consistently with seascapes. As Edwin James observed about the prairie, "For a few days, the weather had been fine, with cool breezes, and broken flying clouds. The shadows of these, coursing rapidly over the plain, seemed to put the whole in motion, and we appeared to ourselves as if riding on the unquiet billows of the ocean."[36] Although others were more eloquent and

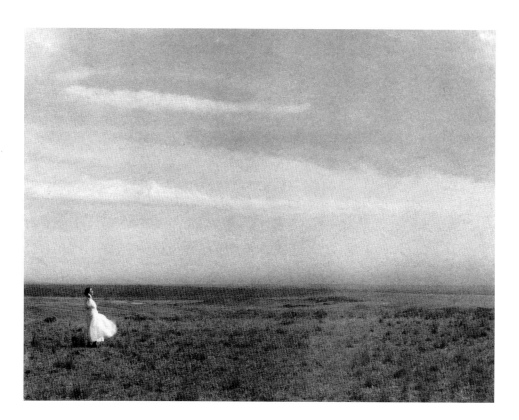

Figure 4

Laura Gilpin (1891–1979)

The Prairie, 1917

platinum print 5⅞ x 7⅝"

© 1981, Laura Gilpin Collection, Amon Carter Museum, Fort Worth, Texas (P1979.119.8)

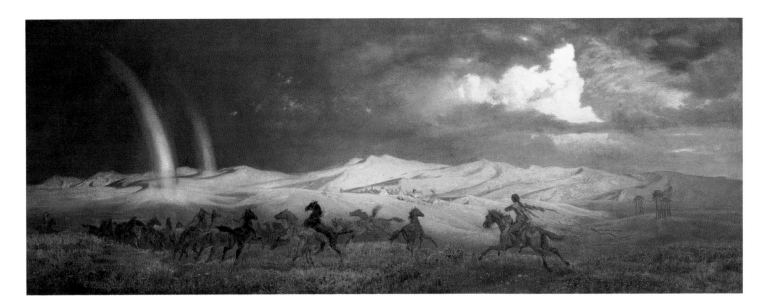

inspired by such likenesses, literary references to the "sea of grass" were so ubiquitous that the allusion itself became as predictable and monotonous as the land that was being described.

In art oceans could be made legible and more interesting by the presence of ships, their endless variety, and the high vantage points they offered; and the sea's minimalism could be rendered sublime, as German painter Caspar David Friedrich's *Monk by the Sea* (1809–1819, Nationalgalerie, Berlin) or French artist Gustave Courbet's *Seaside at Palavas* (1854, Musée Fabre, Montpellier) demonstrate. The juxtaposition of a small figure against a vast watery horizon provided scale, psychological intrigue, and formal clarity, but an inland sea made of earth and grass was so alien to most people's experience that early depictions of it in this manner would have had little meaning or perhaps would even have been misinterpreted as actual seascapes. Similar views of the prairies, such as Laura Gilpin's remarkable *The Prairie* (1917, fig. 4), had to wait until the twentieth century, when people had become more familiar with the landscape through direct experience or through photographs.[37] Even with this sort of composition, the favorite literary metaphor for the grasslands—the sea—was of little use to visual artists, with the possible exception of their depictions of prairie schooners, the covered wagons that streamed across the region throughout much of the second half of the nineteenth century.

Even the indigenous creatures that could distinguish the grassland from an ocean were problematic for artists because they could contribute to the spatial distortions that complicated visual comprehension of the prairies. As Edwin James explained,

Nothing is more difficult than to estimate, by the eye, than the distance of objects seen in these plains. A small animal, as a wolf or a turkey, sometimes appears of the magnitude of a horse, on account of an

Figure 5

Emanuel Leutze (1816–1868)

Prairie Bluffs at Julesburg, South Platte, Storm at Sunset, ca. 1861

oil on canvas, 18 x 48"

Diplomatic Reception Rooms, United States Department of State, Washington, D.C. Photograph by Will Brown

RIGHT: **Figure 6**

John Gast (active 1870s)

American Progress, 1872

oil on canvas 17¾ x 21½"

Autry Museum of Western Heritage, Los Angeles

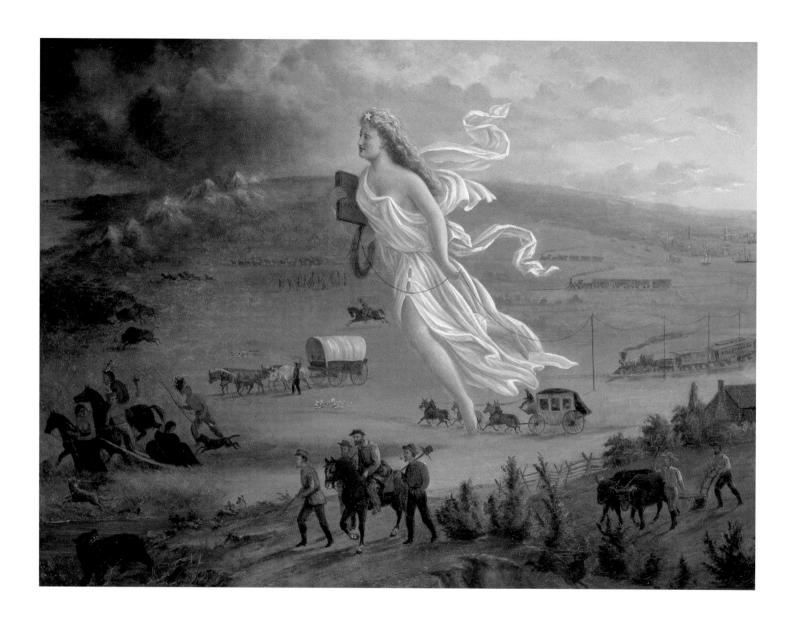

erroneous impression of distance. Three elk, which were the first we had seen, crossed our path at some distance before us. The effect of the *mirage,* together with our indefinite idea of the distance, magnified these animals to a most prodigious size. For a moment we thought we saw the mastodon of America, moving in those vast plains.[38]

Mirages, fantastic as well as mundane, were a frequent occurrence in the prairies and received the attention of many writers.[39] On occasion they provided artistic subject matter (see fig. 22), but such illusions did not readily commend themselves to portrayal; the aspiration of most visual documenters of the prairies, at least until the region had become familiar to their audiences, was to convey the land's characteristics without suggestions of fancifulness that might endanger the credibility of their work. They could construct acceptable views using the animals, wagons, and natural formations at hand, but except for compositions that were overtly and undeniably metaphorical, they tended to adhere to as naturalistic a portrayal as possible.

THE METAPHORICAL PRAIRIE

Although few early prairie artists took advantage of the tendency, the open landscape lent itself to a variety of symbolic interpretations and continues to as its appearance and character are reinterpreted from contemporary perspectives. In keeping with the enduring characterizations as desert, garden, and sea, prairies have accommodated everything from grandiloquent enthusiasm to abject negativity and have done so through allusions not limited to the three dominant metaphors. Explicit in literature—where authors can explain, for example, that the prairies' openness suggests freedom—such ideas are difficult to convey artistically. When placed in historical context, as in the subsequent chapters, however, the significance of allegorical prairie images is expanded; but even when viewed singly and briefly they demonstrate the metaphorical power and variety that comprise one of the prairies' most important contributions to American art.

One of the earliest examples of this type of representation may be *Prairie Bluffs at Julesburg, South Platte, Storm at Sunset* (ca. 1861, fig. 5), by Emanuel Leutze, whose *Washington Crossing the Delaware* (1851, Metropolitan Museum of Art) thrilled audiences and became the archetypal representation of that subject. In the hands of this nineteenth-century master of historical drama, the prairie was a land of fantasy and wonder. In *Prairie Bluffs* wild horses romp amid the open, rolling landscape, troubled only by the equally free Native Americans who ride among them. Through dark storm clouds that pass above, the sky opens to reveal a brilliant rainbow, the time-honored symbol of God's beneficence. Conceived during a single trip west and painted in a distant eastern studio, this depiction by a German American artist combines nostalgia with romanticism to render the prairies a place of freedom and independence.

In a different sense, John Gast's *American Progress* (1872, fig. 6) stands among the most explicit representations of the prairies' symbolic evocativeness. In this small yet monumental embodi-

TOP: **Figure 7**

W. D. Johnson (active 1890s)

Man Sitting by a Sink Hole, Kansas, 1897

silver gelatin print, 4¾ x 6⅝"

Openlands Project, Chicago, from a negative at the
United States Geological Survey

BOTTOM: **Figure 8**

Terry Evans (b. 1944)

Fairy Ring, Fent's Prairie, 1979

Ektacolor photograph, 15 x 15"

Collection of the artist, Chicago

ment of manifest destiny, America's nineteenth-century rationale for its imperialistic conquest of the continent, the heady hegemony of a growing culture finds its most promising opportunity in the prairies' epic expanse. Here the powerful industrial East is relegated to the margins, as is the dim and distant specter of the far West. The prairies are the locus of the scene, as the allegorical figure of Progress and her minions in the form of miners, settlers, and railroads bring enlightenment and civilization to the central continent. In an archetypal expression of the forward-looking American prospect, the prairies are where this dream will be realized and from there transported to the future in the westward flow of progress.

In reality, of course, the prairies would not yield so readily, nor would the conquest of the continent be as triumphant, and in keeping with the dual nature of the grassland region, despair alternated with hope and delight. Although separated by nearly a century, *Man Sitting by a Sink Hole, Kansas* (1897, fig. 7), by W. D. Johnson, and *Fairy Ring, Fent's Prairie* (1979, fig. 8), by Terry Evans, graphically depict two very different aspects of the prairies' nature. In the former, presumably photographed simply to document a geographical feature, the circularity of the formation offers a dramatic contrast to the surroundings, but its literal negativity, combined with the agricultural dilemma such sites presented to farmers, provokes a more foreboding interpretation. By contrast, the colorful and whimsical fairy ring in Evans's view suggests quite the opposite; its delicate circle of flowers appears as if by magic amid the waving grasses. When compared, notwithstanding their ahistorical relationship, the formal similarities of the two views intensify the metaphorical suggestiveness of their subject. Together they implicitly embody the hopes of a promised land and the failures of many in fulfilling that dream.

Such contradictory prospects were no more poignantly demonstrated than in the 1930s. In both life and art the optimism that had characterized so much of the prairies' identity since the 1860s was dramatically called into question. Thus we have contrasts like Grant Wood's *Breaking the Prairie* [*When Tillage Begins*] (ca. 1935–1937, fig. 9) and Dorothea Lange's dismal *Tractored Out*

BELOW: **Figure 9**

Grant Wood (1882–1942)

Breaking the Prairie [*When Tillage Begins*], ca. 1935–1937

colored pencil, chalk, and graphite on paper, 22¼ x 80¼"

Whitney Museum of American Art, New York, gift of Mr. and Mrs. George D. Stoddard

RIGHT, TOP: **Figure 10**

Dorothea Lange (1895–1965)

Tractored Out, 1938

silver gelatin print, 11 x 14"

Library of Congress

RIGHT, BOTTOM: **Figure 11**

Alexandre Hogue (1898–1994)

Crucified Land, 1939

oil on canvas, 42 x 60"

Thomas Gilcrease Institute of American History and Art, Tulsa, Oklahoma

 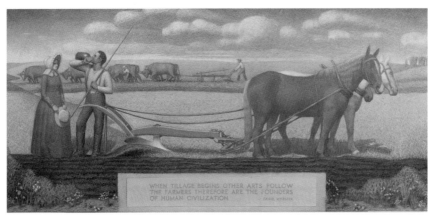

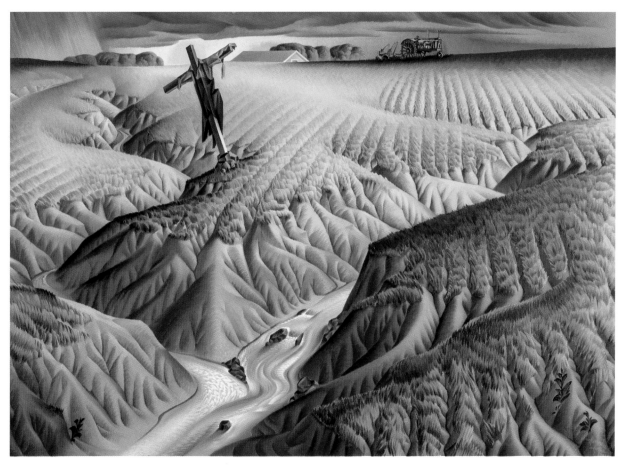

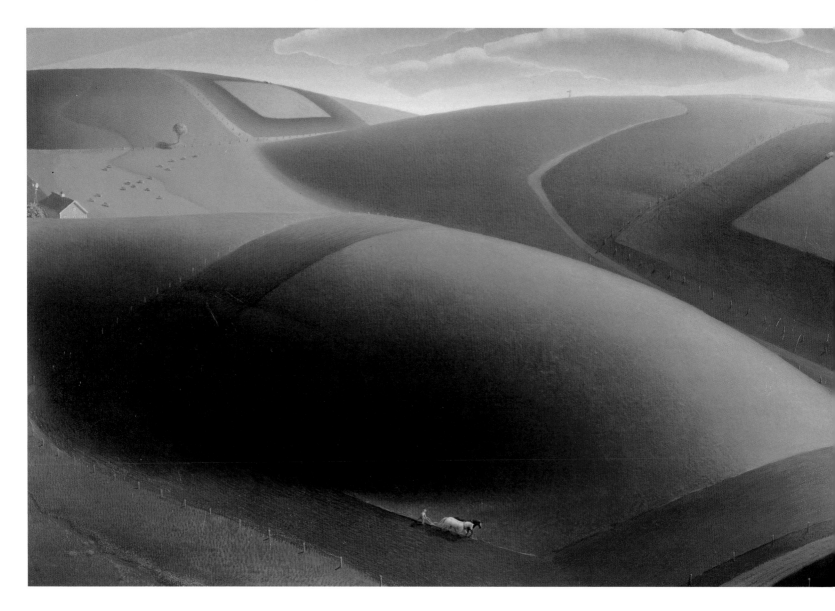

Figure 12

Grant Wood

Spring Turning, 1936

oil on Masonite panel, 18⅛ x 40"

Reynolda House Museum of American Art,
Winston-Salem, North Carolina, © 1996, Estate of
Grant Wood/Licensed by Vaga, New York

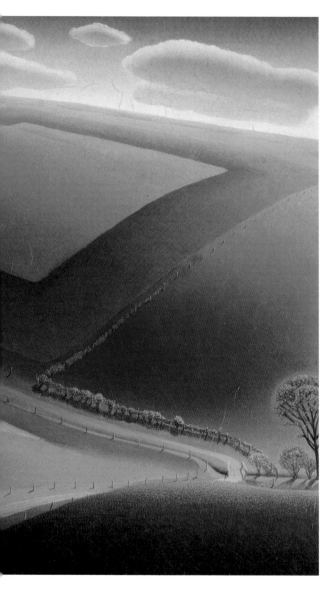

(1938, fig. 10). Wood's image, a preparatory study for a mural in the Iowa State University library, celebrates the farmers and the tools that transformed the landscape. Presented as a triptych, the three-part form of an altarpiece, Wood's message is underscored with a carefully inscribed plaque that poetically declares civilization's dominion over the land. By contrast, in Lange's photograph (one of her most famous and most redolent images), that triumphant view is revealed as folly; the weatherbeaten house, now abandoned and with furrows plowed to its doorstep, stands in mute testimony to the overconfident past and the dismal future. This duality is echoed in the even more condemnatory *Crucified Land,* by Alexandre Hogue (1939, fig. 11), in which the eroded red earth runs like blood, overseen by a scarecrow turned crucifix. Compared with its contemporary, the bucolic *Spring Turning* by Grant Wood (1936, fig. 12), the metaphorical ability of the prairie landscape to represent simultaneously the worst and best natures of its inhabitants is confirmed.

In a different way, Thomas Hart Benton's *Wheat* (1967, National Museum of American Art) and John Steuart Curry's *Kansas Cornfield* (1933, fig. 13) immortalize and even anthropomorphize contemporary prairie life in their monumental depiction of the plants that had become, by the mid-twentieth century, primary to the region's economic survival. Suggestive of emblematic portraits more than of landscapes per se, these iconic representations force the viewer to consider the plants as important individuals, not only to the farmers for whom they are a livelihood but also to all who live in the region and who depend on them for sustenance.

Although prairies might appear to some as godforsaken, they have long fostered spirituality among their inhabitants and sometimes even seem to embody a connection with the divine. More often, however, this is tempered with earthbound reality, as in John Vachon's *Grazing Land* [*Spiritualist Grounds near Minneapolis, Kansas*] (1938, fig. 14). The sign's arrow pointing off the frame, the break in the fence, the headless windmill, the looming telephone pole, and even the declaration of the closing date of the spiritualist camp, all conspire to lend irony to the scene and a wry humor to a subject of great seriousness in a place so full of pietistic sentiment and conflicted ambitions.

As these few examples demonstrate, the metaphorical possibilities of the prairie were and remain for the observant viewer as compelling as the economic prospects it eventually achieved. Indeed, manipulation of the prairie to suit cultural desires or represent fears has been a continuing response to the land's malleable character. Over the course of the nineteenth and twentieth centuries aesthetic and conceptual accommodations to the grasslands' challenges have, in fact, paralleled the Euro-American development of the landscape itself. Just as Americans have transformed the actual land according to their needs, preconceptions, and ideals—first with small inroads of survey parties and scattered settlements and then with trees, section lines, large-scale agriculture, and superhighways—so too have artists constructed their views of prairies. The results have varied tremendously, from the prosaic to the exalted, from optimism to despair, but

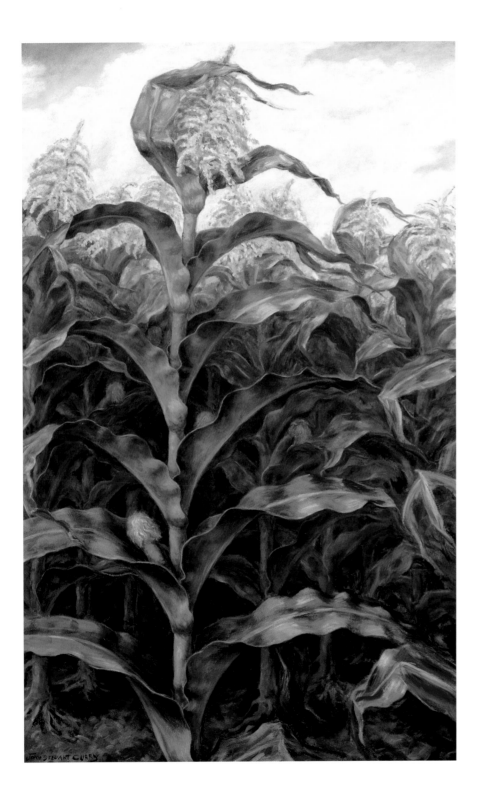

LEFT: **Figure 13**

John Steuart Curry (1897–1946)

Kansas Cornfield, 1933

oil on canvas, 60 x 38¼"

Wichita Art Museum, Wichita, Kansas

RIGHT: **Figure 14**

John Vachon (1914–1975)

Grazing Land [*Spiritualist Grounds near Minneapolis, Kansas*], 1938

silver gelatin print, 11 x 14"

Library of Congress

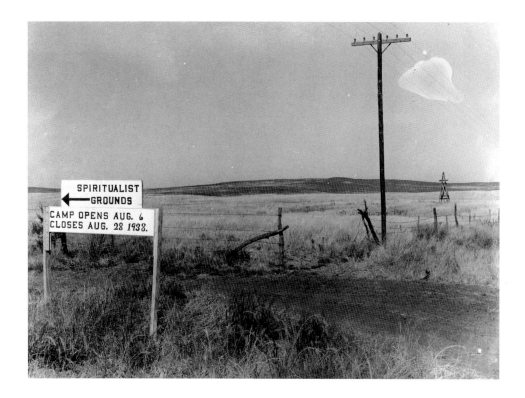

the relationship between depiction and utilization of the land has remained constant. Today the prairie is one of many ecosystems that are becoming better understood and more appreciated even as our awareness of the perceptual processes required to explore landscape's meanings is refined, but the subtlety of the open grasslands still challenges even the most sophisticated viewer.[40]

Artistic additions to and manipulations of the prairie landscape form a metaphorical taxonomy of the land's conceptual and physical transformation, but being more than mere reflectors of cultural change, the images embody the cultural reconciliations that made those changes possible. In other words, the images document the psychological adjustments to the terrain that were necessary not only for artists but also for all who would confront the prairie landscape and attempt to mold its prospects to their purposes.

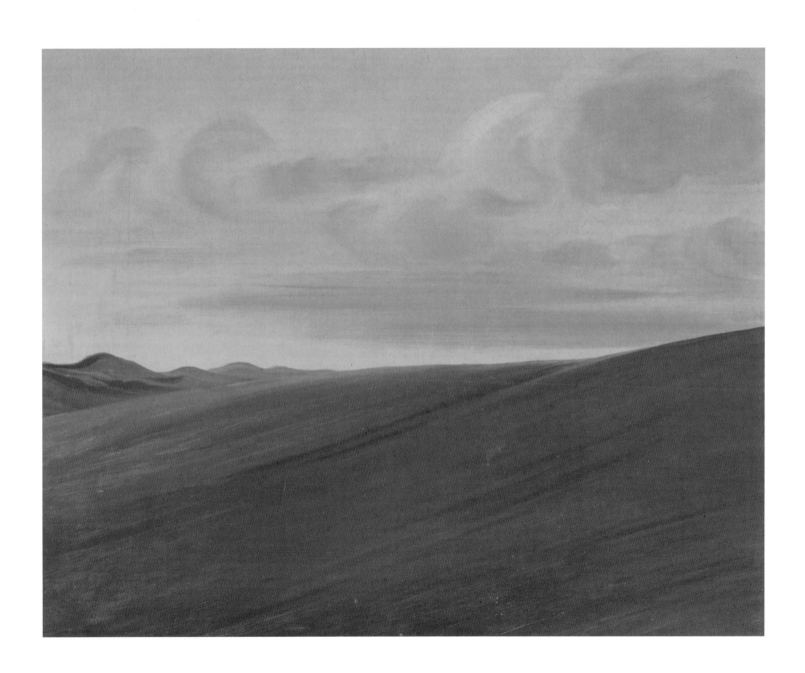

2 · PROSPECTING THE PRAIRIES
EXPLORATIONS, ENCOUNTERS, AND ENTERPRISING SOLUTIONS

The blue heavens of Italy have tasked the inspiration of a hundred bards, and the warm brush of her own Lorraine has swept the canvas with their gorgeous transcript! But what pencil has wandered over the grander scenes of the North American prairie? What bard has struck his lyre to the wild melody of loveliness of the prairie sunset?

Edmund Flagg, *The Far West*, 1838

Even though early artists of the prairies were often dismayed by the grasslands' lack of prospects, many persevered in confronting the landscape's aesthetic challenges. Their techniques of accommodation were often based on the principles of landscape theory and its compositional requirements, but to reconcile the two issues—form and desired content— that were so often at odds in a treeless landscape, they employed a variety of strategies that usually entailed manipulating what they found or inventing alternatives to the emptiness they encountered. In either case they were effectively adapting to the terrain's meager formal offerings and providing it with visual interest, with narrative expressiveness, and ultimately with meaning, based on their own experiences and on the developing mythologies about the landscape and its inhabitants. As a result, the art of the American prairies reflects the particular circumstances of the images' creation and embodies attitudes that provided the land with identity and significance over the course of its development.

Most Euro-American artists who visited and portrayed the prairies before the 1870s traveled to the region as members of expeditions, both private- and government-sponsored.[1] A number of others, however, never visited the grasslands at all but produced paintings and illustrations based on documentary reports, fictional narratives, and other artists' images. Even though their work had a different origin and often a different purpose from that of contemporaries who personally encountered the grasslands (illustrations in a popular periodical, for example, would have been more for entertainment than the informational images in a government report), it too contributed significantly to their audience's awareness and understanding of prairies in the nineteenth century. Whether produced in the field or in the studio, by artists who knew the region

Figure 15

George Catlin (1796–1872)

Nishnabottana Bluffs, Upper Missouri, **1832**

oil on canvas, 11 x 14⅜"

National Museum of American Art, Smithsonian Institution, gift of Mrs. Joseph Harrison Jr.

well or only secondhand, the images demonstrate the preconceptions and tastes of both their creators and the audiences for whom they were made.

Beginning with Meriwether Lewis and William Clark's 1804–1806 crossing of the Louisiana Purchase, dozens of expeditions over the course of the nineteenth century conducted official government explorations of the West, including the prairie region. The missions of the groups varied, but whether they were military or scientific, the parties were charged with collecting information about the land and its inhabitants that might provide insight into prospects for settlement and commercial development. Although the value of visual images to this process was not immediately realized, they would become vital, and by the 1820s it was typical to include artists as key members of expeditionary teams.[2]

In 1804 President Thomas Jefferson carefully directed Lewis and Clark to bring back physical specimens as well as answers to an exhaustive list of inquiries about the unfamiliar territory, but he did not, unfortunately, provide for the services of an artist who would create pictures of the landscape.[3] This oversight is somewhat surprising given that the president was himself a sensitive natural observer and a competent draftsman. It was an error sorely regretted by the explorers, who more than once wished for a means to document more thoroughly the sights they encountered.[4] Even without a method of conveying the landscape visually, however, Lewis and Clark vividly expressed their reaction to the prairies in their journals. In seeing and describing the grasslands, they were as influenced by theories of landscape construction as most artists, consistently perceiving the terrain according to their preconceptions.

At the same time, both explorers were often more admiring of the prairies than many who followed them. This may be attributed to their understanding of their mission and to their particular circumstances. Responsible only for written descriptions, they were not required to transform the landscape into artistically acceptable compositions, and thus they were not forced to confront the prairies' formal deficiencies in the same ways that artists would. Their route, furthermore, was for the most part restricted to rivers; their trip through the American grasslands was mainly via the Missouri River, which winds its way across the present state of Missouri, up the western border of Iowa, and then through central South and North Dakota before heading west into Montana. The party did not traverse the interior ranges of the treeless terrain for any great length of time. Even in the true plains that lie along this route, the river is frequently bordered by timber that would have framed their view of the prairies. As a result, Lewis and Clark did not experience the seemingly endless grasslands that prompted later travelers to disparage the landscape so vehemently, and this surely affected their rather positive view of the terrain.

The explorers did, as well, make the special efforts required by their surveying to find elevat-

ed vantage points from which surrounding views could more easily be composed. This allowed them to bring the landscape into conformity with their notion of a pleasing scene. A typical encounter is notable for the use of the term "prospect" and for its similarity to traditional methods for constructing a landscape picture:

After going to Several Small Mounds in a leavel plain, I assended a hill on the Lower Side, on this hill Several artificial Mounds were raised, from the top of the highest of those Mounds I had an extensive view of the Serounding Plains, which afforded one of the Most pleasing prospect I ever beheld, under me a Butifull River of Clear Water of about 80 yards wide Meandering thro: a leavel and extensive meadow, as far as I could See, the prospect much enlivened by the fiew Trees & Srubs which is bordering the bank of the river.[5]

In this incident the explorer consciously sought the highest ground to gain a perspective on the land, and the resulting scene was rendered beautiful to him for its expanse and because it was framed by trees and shrubs, which relieved the monotony of the grassy plain.

Lewis and Clark's reliance on descriptive conventions and their search for pleasing prospects are not surprising, since those techniques had been thoroughly integrated into the perceptual processes of most educated Europeans and Euro-Americans by 1800, but it is remarkable that they often proclaimed the prairies "butifull" or "handsome," even when the view was wholly lacking in the elements of a traditional prospect. "The country," one typical passage commented, "consists of beatifull, level and fertile plains, destitute of timber."[6] The complexity of the prairie landscape and descriptions of it is also evident in their use of the word "prairie." They apply it to completely treeless areas and to meadows that contained scattered trees. The large expanses that were totally without trees they usually referred to as plains, but these too were sometimes called prairies.[7] Already by 1805, such inconsistencies demonstrate, the American grasslands were a subtle and challenging terrain that required careful negotiation in a variety of ways.

THE LONG EXPEDITION

The lack of an artist on the Lewis and Clark expedition and the recognition of how valuable his work would have been to understanding the continent led government planners to provide for visual documentation on many subsequent explorations. The first to include artists was a tour across the prairies to the Rocky Mountains in 1819–1820 under Major Stephen Long.[8] Best known as the survey that gave the prairie region the name "Great Desert" on official maps, this expedition included not one but two artists: Samuel Seymour (ca. 1775–after 1823), whose only artistic training seems to have been as an engraver, and Titian Ramsay Peale (1799–1885), the youngest son of Philadelphia artist Charles Willson Peale.[9] At the age of twenty Titian Peale was already an accomplished draftsman and traveler; he had worked since a young age in his father's

natural history museum in Philadelphia and had made an expedition to Florida with entomologist Thomas Say. Hired as an assistant naturalist for the Long expedition, he produced many pictures from his experience and went on to participate in several important later expeditions.[10]

As the principal artist on the Long expedition, Seymour was to "furnish sketches of landscapes, whenever we meet with any distinguished for their beauty and grandeur. He will also paint miniature likenesses, or portraits, if required, of distinguished Indians, and exhibit groups of savages engaged in celebrating their festivals or sitting in council, or in general illustrate any subject that may be deemed appropriate in his art."[11] The requirement that the scenery have "beauty and grandeur" would be the most limiting factor for Seymour, since much of the prairie landscape was, according to Long and his colleagues, wholly bereft of those qualities.

For all their significance as the first Euro-American artists of the American West, Seymour and Peale remain less well known than their followers. In part this is because both artists' work from their early journeys is modest in scale and ambition, consisting of drawings and watercolors rather than finished paintings, and many of Seymour's sketches have been lost. Just as important for their subsequent reputations, neither Seymour nor Peale seems to have devoted much artistic energy to the landscape in which they spent the most time, the prairies.[12] Peale produced a sizable number of images from the journey, but since his official position was naturalist rather than artist, his principal responsibility was to document the fauna the expedition encountered rather than the landscape. He usually focused narrowly on animals, with the setting demoted to the role of mere backdrop.[13] Seymour seems to have waited until the party glimpsed the Rocky Mountains to do most of his work, and even then trees, animals, and individuals figure prominently, acting to enliven the scenes and alleviate any possibility of an empty scene.

Peale and Seymour's relative lack of attention to the prairies certainly did not reflect a lack of interest. In Peale's journal, one of the few surviving manuscripts from the expedition, the young artist-naturalist expressed his eagerness to see the grasslands and began commenting on their sporadic appearance as early in his journey as Saint Louis.[14] At nearby Saint Charles some of the expeditionary party, including the two artists, left the main group to venture on a short inland loop "that they might have the better opportunities for investigating the natural history of the country." After rejoining the main party, which had continued up the Missouri by steamship, they proceeded to spend weeks in the plains, traveling along the Platte River until they reached the foothills of the Rocky Mountains.[15]

Like Lewis and Clark before him, the expedition's official chronicler Edwin James used the term "prairie" quite broadly, and only when meadows were framed by trees and other picturesque elements could he find the grasslands beautiful. "The unaccustomed eye, in roving over those extensive undulating prairies, is beguiled by the alteration of forests and meadows, arranged with an appearance of order, as if by the labour of men, and seeks in vain to repose upon some cot-

tage or mansion embosomed in the little copses of trees, or in the edge of the forest, which margins the small streams and ravines in the distance."[16] The conventions of the picturesque were paramount, and even though human order was only imagined, it was sought no less ardently.

Even under the best conditions, however, James and his companions deemed the prairies "tedious," befitting the ubiquitous oceanic metaphor:

> The surface [of the land] is uniformly of the description, not inaptly called rolling, and will certainly bear a comparison to the waves of an agitated sea. The distant shores and promontories of woodland, with here and there an insular grove of trees, rendered the illusion more complete. The great extent of country contemplated at a single view, and the unvaried sameness of the surface, made our prospect seem tedious.[17]

The prairie's nonconformity to their expectations and its daunting expanse rendered it, at the very least, uninspiring. For Seymour and Peale, this effect, along with the terrain's lack of elements to contribute to a traditional prospect picture, eliminated it as an artistic subject.

Even more crucial to their choice of subjects would have been Long's opinion that the grasslands were little more than barren wastes. The judgment of their leader would not only affect the artistic production of his expedition but would also influence Americans' understanding of the region for several decades. Just as James wrote that he had "little apprehension of giving too unfavorable an account of this portion of the country," citing the lack of "timber, of navigable streams, and of water for the necessities of life" and labeling it an "unfit residence for any but a nomade population," his colleagues echoed his attitude, essentially finding nothing of interest in the grassland. It was, the expedition's zoologist Thomas Say wrote, "a situation from which the eye could not rest upon a tree, or even a humble shrub, throughout the entire range of its vision, to interrupt the uniformity of a far outspreading, gently undulated surface"; the whole range seemed a "vast desert" that "like the ocean, presented an equal horizon in every direction."[18] Statements like those, along with the expedition's map designating the region the Great Desert and Long's own recommendation to John C. Calhoun that the land was "uninhabitable by a people depending upon agriculture for their subsistence," solidified the notion of the prairie as a great wasteland.[19] Not until the 1860s and 1870s, when the land was made available for widespread Euro-American settlement, would that misconception be dispelled.

James's account of the Long expedition was widely read and became indispensable to subsequent travelers, including the artists who would follow Seymour and Peale into the prairies, but its opinion of the landscape was popularized as well through other publications, which became standard reading for anyone planning to cross the plains.[20] Most notable of these were James Fenimore Cooper's novel *The Prairie* (1827) and Washington Irving's autobiographical travel book *A Tour on the Prairies* (1835), written after an excursion through present-day Oklahoma with

Indian commissioner Henry L. Ellsworth.[21] Cooper's book, the third in his Leatherstocking series, relied heavily on James for its landscape description, since the author had not actually traveled west, and perhaps more than any other published source of the period underscored the notion of the prairie landscape as a barren plain that could serve the United States only as a barrier against overexpansion and invasion. Irving's tale, although written from direct experience, was quite clichéd in its treatment of the grasslands, usually relying on associationism and architectural metaphor to provide the land with the narrative content he required. Of the meadows along waterways he was especially admiring, saying, "The prairies bordering on the rivers are always varied in this way with woodland, so beautifully interspersed as to appear to have been laid out by the hand of taste; and they only want here and there a village spire, the battlements of a castle, or the turrets of an old family mansion rising from among the trees to rival the most ornamented scenery of Europe."[22] But Irving was often ambiguous in his characterization of the prairies, calling them at once "beautiful" and "boundless and fertile wastes," which even to modern readers seems an oxymoron or, at the least, an exceptionally inexact description.[23]

In subsequent decades a profusion of prairie literature followed, mostly in the form of dramatized travel accounts such as Francis Parkman's *Oregon Trail* (1849) and Josiah Gregg's *Commerce of the Prairies* (1844), although expeditionary reports remained important reading for anyone undertaking the journey overland, and romantic treatments recurred.[24] Many of the authors would devise their own means for contradicting the prevailing view of the landscape and its generally disparaging attitude. Others, and artists like Seymour and Peale, would be similarly unimpressed by what they found, or didn't find, in the grasslands. As Parkman wrote of the landscape around the south fork of the Platte, "for league upon league the desert uniformity of the prospect was almost unbroken."[25]

ROMANCE AND THE PRIVATE EXCURSION

While many other nineteenth-century artists followed Seymour and Peale into the prairies on government-sponsored expeditions, some of the most important early portrayers of the region traveled with private funding. Without the official responsibilities of documenting the land and its inhabitants for the government, these individuals could focus on their own interests or those of their employers. They could more easily indulge romantic notions about endless plains and noble savages and marvel at the mirages and unusual animals, without the constraints of interpreting what they saw for more practical purposes. Since their subjects were so little known, they were still bound to a great degree by the need for accuracy, but they could transform their reactions to the sights they encountered into images that would be both pleasurable and instructive to their viewers. Their work was motivated by a passion for adventure, knowledge, and some-

times altruism or entrepreneurship; regardless, through the art of these visionary individuals the prairies made their first real appearance in the art of the United States.

In 1830, only a decade after the Long expedition, another man who had spent his formative period in Philadelphia, George Catlin, traveled west. Over the next six years this lawyer-turned-painter would traverse more of the prairie country than probably any other artist before or since, ranging north and south from North Dakota to Oklahoma, east and west from the Mississippi River to the Rocky Mountains. He was most interested in documenting the Native Americans since he realized that their culture was vanishing, but he was just as interested in the country in which they lived, and his writings contain both social criticism and romantic philosophy offered in opinions about the land and peoples Catlin encountered. This often quoted statement remains an exemplar of the romantic artist's vision:

Man in the simplicity and loftiness of his nature, unrestrained and unfettered by the disguises of art, is surely the most beautiful model for the painter,—and the country from which he hails is unquestionably the best study or school of the arts in the world: such I am sure, from the models I have seen, is the wilderness of North America. And the history and customs of such a people, preserved by pictorial illustrations, are themes worthy of a life-time of one man, and nothing short of the loss of my life, shall prevent me from visiting their country and becoming their historian.[26]

True to his mission, and in addition to the hundreds of portraits he created from his travels, Catlin produced a sizable body of landscape images and wrote extensively about the scenery and its effects in his book *Letters and Notes on the Manners, Customs, and Conditions of the North American Indians* (1841). When he exhibited (and eventually tried to sell) his collection, which he called his "Indian Gallery," he advertised the inclusion of one hundred landscape views "descriptive of the picturesque *Prairie Scenes* of the Upper Missouri and other parts of the Western regions."[27]

Although primarily thought of as a portraitist and miniaturist in his early career in the East, Catlin had also painted landscapes, including several of Niagara Falls, and he was understandably familiar with the fundamentals of aesthetic theory, since he had exhibited at the Pennsylvania Academy of the Fine Arts and had associated with prominent Philadelphia painters Thomas Sully and John Neagle.[28] His response to the prairies was in many ways similar to that of his predecessors, based largely on convention, but because he was more visually perceptive than James, he was often more descriptive in his writings, and in his paintings he was more inventive and appreciative of the prairies' unique characteristics than Seymour and Peale were. He was more willing, for example, to depict "empty" scenes, and he produced one of the few pure prairie images of the nineteenth century, *Nishnabottana Bluffs, Upper Missouri* (1832, fig. 15), a view lacking in any compositional definition other than its green grassy horizon and a blue sky.

Catlin was also more innovative in his ideas about the prairies' prospects as an artistic subject. The artist was ambitiously entrepreneurial, for example, with his Indian Gallery and may have been no less so with his landscape views. Art historian William Truettner has speculated that Catlin painted his western scenes as a series, to be exhibited or published as a continuous narrative portrait of the Missouri River, and he certainly expected they would be novel and popular with a wide audience. The potential profitability of such a documentary transcription gave the landscape a value that others did not perceive and may have led Catlin to appreciate its special qualities in ways others did not.[29]

For all his admiration of the prairies, Catlin was inconsistent in his written characterization of them. He could be dryly lucid and scientific: "From St. Louis to the falls of the Missouri, a distance of 2600 miles, is one continued prairie; with the exception of a few of the bottoms formed along the bank of the river." At other times he was whimsically fanciful, calling the prairie a "fairy land," a "*shorn* country" whose "allurements have spun over the soul."[30] He most often succumbed to such romantic musings when at elevated viewpoints, as when he wrote of the countryside between Forts Pierre and Leavenworth:

I often landed my skiff and mounted the green carpeted bluffs, whose soft grassy tops, invited me to recline, where I was at once lost in contemplation. Soul melting scenery that was about me! A place where the mind could think volumes; but the tongue must be silent that would *speak* and the hand palsied that would *write*. A place where a Divine would confess that he never had fancied Paradise—where the painter's palette would lose its beautiful tints—the blood-stirring notes of eloquence would die in their utterance—and even the soft tones of sweet music would scarcely preserve a spark to light the soul again that had passed this sweet delirium. I mean the prairie, whose enamelled plains that lie beneath me, in distance soften into sweetness, like an essence; whose thousand thousand velvet-covered hills, (surely never formed by chance, but grouped in one of Nature's sportive moods)—tossing and leaping down with steep or graceful declivities to the river's edge, as if to grace its pictured shores, and make it 'a thing to look upon.'[31]

Unlike almost anyone else in the nineteenth century, Catlin could exult in the treeless terrain and, as he did here, remark on its picturesqueness—"a thing to look upon." As described in the previous chapter, however, in direct contrast to this effusive passage, when Catlin was forced to experience the prairie for any length of time without the benefit of an elevated position, he found its monotony "painful" and "at length felt like giving up the journey, and throwing myself upon the ground in hopeless despair."[32]

Of all the early prairie artists, only Catlin summoned the artistic courage to portray the landscape as it often appears in nature, as a simple band of blue surmounting a barely modulated band of green. Most striking in this regard is his *Nishnabottana Bluffs,* a dramatically simple composition that appears abstractly modern to twentieth-century eyes and, in the nineteenth century, must

Figure 16

George Catlin

Prairie Meadows Burning, 1832

oil on canvas, 11 x 14⅛"

National Museum of American Art, Smithsonian Institution, gift of Mrs. Joseph Harrison, Jr.

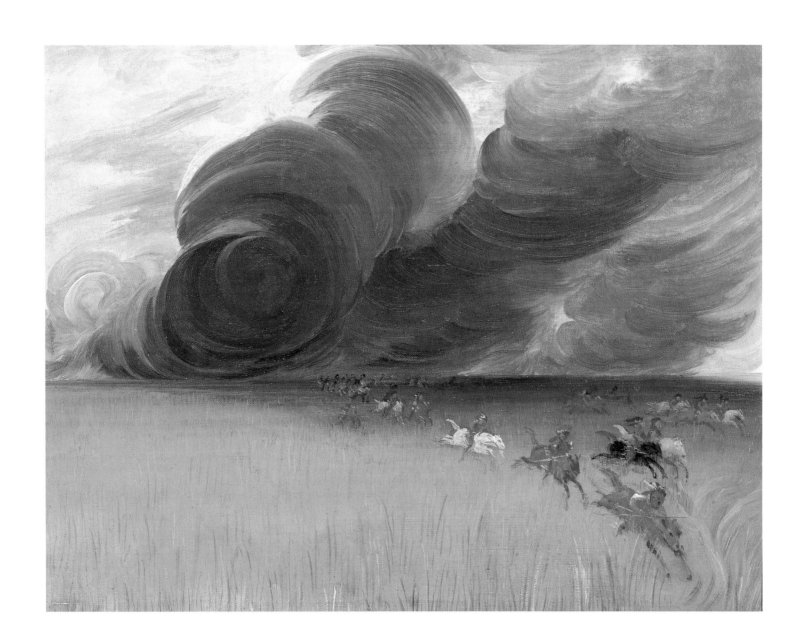

have looked so starkly alien as to be unintelligible. In James's *Account of the Long Expedition* the location is spelled "Nishnebottona" and described as

a beautiful river about sixty yards wide, [that] approaches within one hundred and fifty yards of the Missouri, being separated from it by a sandy prairie, rising scarcely twenty feet above the surface of the water. After pursuing for a short distance a parallel course, the two rivers diverge, and the Nishnebottona meanders along the side of the Missouri valley, about sixty miles, to its confluence with the latter river. From this point is a pleasing view of the hills called the Bald Pated prairie, stretching along the north-eastern side of the Nishnebottona, and diminished to the size of ant-hills in the distant perspective.[33]

Suitably named "the Bald Pated prairie," the landscape is denuded of anything but grass, and in Catlin's understated view it is allowed to revel in its directness, unapologetic for its simplicity and beguilingly subtle in its coloration.

But even Catlin, like most artists who would follow him, usually included Native Americans, bison, or events such as fire to carry a dramatic narrative. Prairie fires were especially compelling sights, set either by lightning strikes or by the native inhabitants, who burned off old growth to encourage new grass that provided forage for their horses and enticed buffalo. For artists these were, and remain today, among the most exciting events in the grasslands, and they were appreciated (at least by those out of harm's way) for the associations they conjured with Edmund Burke's sublime and the romantic effusions of other artists in the 1820s and 1830s. As Catlin wrote, "The prairies burning form some of the most beautiful scenes that are to be witnessed in the country, and also some of the most sublime. Every acre of these vast prairies (being covered for hundreds and hundreds of miles with a crop of grass, which dies and dries in the fall) burns over during the fall or early spring, leaving the ground of black and doleful colour."[34]

Catlin painted prairie fires several times, but among the most intriguing of his views is a small canvas, *Prairie Meadows Burning* (1832, fig. 16), which depicts a large looming cloud of smoke and flame as a backdrop to a group of fleeing horsemen riding diagonally toward the viewer and to the right. In his more scientific mode Catlin explained the scene, saying,

There are many of these meadows on the Missouri, the Platte, and the Arkansas, of many miles in breadth, which are perfectly level, with a waving grass, so high, that we are obliged to stand erect in our stirrups, in order to look over its waving tops, as we are riding through it. The fire in these before such a wind, travels at an immense and frightful rate, and often destroys, on their fleetest horses, parties of Indians, who are so unlucky as to be overtaken by it.[35]

Catlin's early observations were apt and repeated by many artists, such as his Canadian contemporary Paul Kane, who in *Prairie on Fire* (ca. 1849, fig. 17) also focuses on the sublimity of the scene.[36] Even late in the century prairie fires were embodied in nostalgic views such as Meyer Straus's *Herd of Buffalo Fleeing from a Prairie Fire* (1888, fig. 18), which recalls Catlin's depictions although it

TOP: **Figure 17**
Paul Kane (1810–1871)
Prairie on Fire, ca. 1849
oil on canvas, 23½ x 34"
Royal Ontario Museum, Toronto

BOTTOM: **Figure 18**
Meyer Straus (active 1880s)
Herd of Buffalo Fleeing from a Prairie Fire, 1888
oil on canvas, 17⅞ x 29⅞"
Amon Carter Museum, Fort Worth, Texas (1964.93)

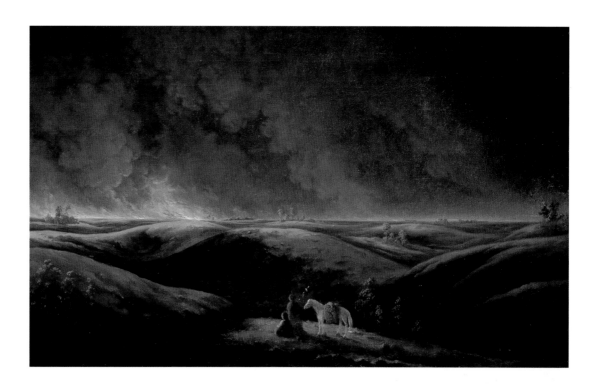

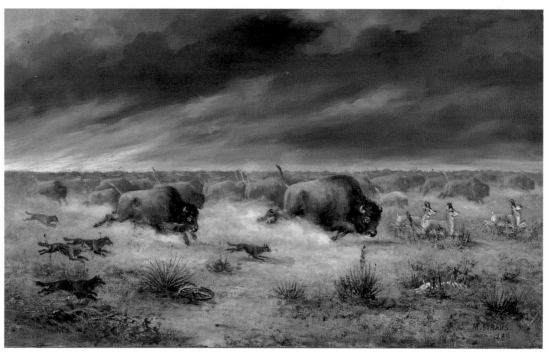

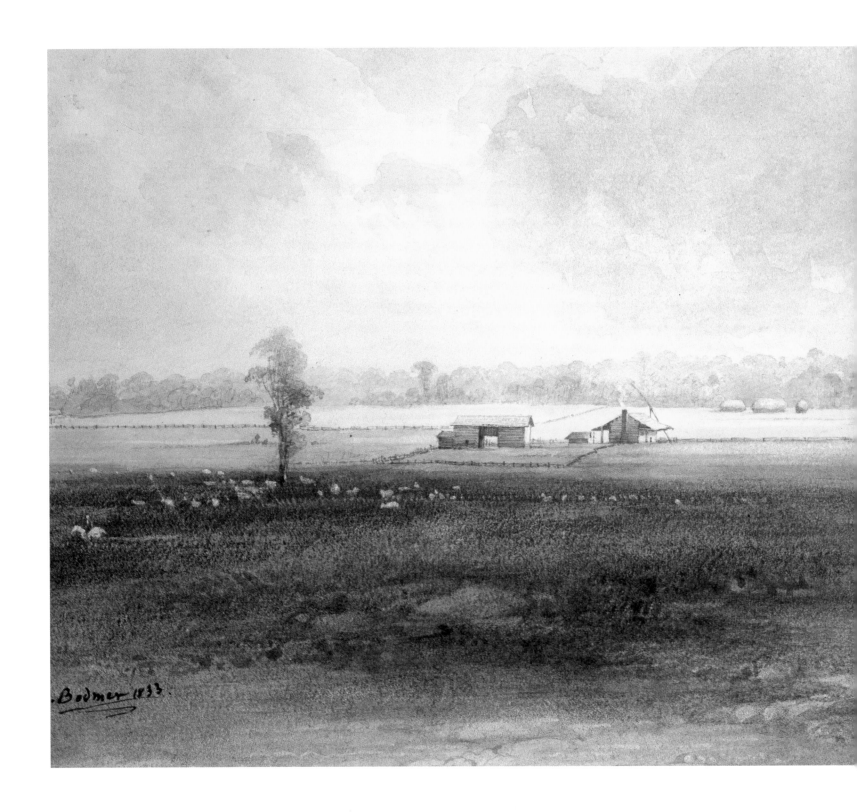

substitutes bison and antelope for the horsemen. By 1888 the animals too would have been a distant memory, but their presence in such portrayals added drama to an already dynamic subject.

Just as Catlin responded to the psychological and artistic attributes of prairie scenes in innovative ways that eluded others, he also envisioned a surprising prospect for the prairies themselves. As an alternative to the annihilation he foresaw for the native people and animals of the plains as whites encroached on their territory, he proposed "a nation's Park" that would preserve their way of life. His work as a whole was a testament to this dream:

What a splendid contemplation too, when one (who has traveled these realms, and can duly appreciate them) imagines them [the prairies] as they *might* in future be seen (by some great protecting policy of government) preserved in their pristine beauty and wildness, in a *magnificent park,* where the world could see for ages to come, the native Indian in his classic attire, galloping his wild horse, with sinewy bow, and shield and lance, amid the fleeting herds of elks and buffaloes. What a beautiful and thrilling specimen for America to preserve and hold up to the view of her refined citizens and the world, in future ages! A *nation's Park,* containing man and beast, in all the wild and freshness of their nature's beauty!

I would ask for no other monument to my memory, nor any other enrollment of my name amongst the famous dead, than the reputation of having been the founder of such an institution.

Such scenes might easily have been preserved, and still could be cherished on the great plains of the West, without detriment to the country or its borders; for the tracts of country on which the buffaloes have assembled, are uniformly sterile, and of no available use to cultivating man.[37]

The first to conceive the national park idea, Catlin was ahead of his time by nearly forty years (Yellowstone was designated the first national park in 1872), and even though he regarded the plains as "uniformly sterile," he would surely be today among the forefront of the prairie preservation movement that is still working to institute his idea, albeit without the same emphasis on the human inhabitants and with a different understanding of the landscape itself.[38]

BODMER AND THE EUROPEAN'S VIEW

Close on Catlin's heels, the Swiss painter Karl Bodmer (1809–1893) could not have been more thoroughly predisposed to avoid the flat and featureless horizon of the prairie landscape in his art. Traveling as far as the Dakotas in 1833–1834 as the employee of Prince Maximilian of Wied-Neuwied, who was compiling ethnographic images, specimens, and descriptions for a major pub-

Figure 19

Karl Bodmer (1809–1893)

View of a Farm on the Illinois Prairie, **1833**

watercolor on paper, 5¼ x 8⅜"

Joslyn Art Museum, Omaha, Nebraska, gift of the
Enron Art Foundation

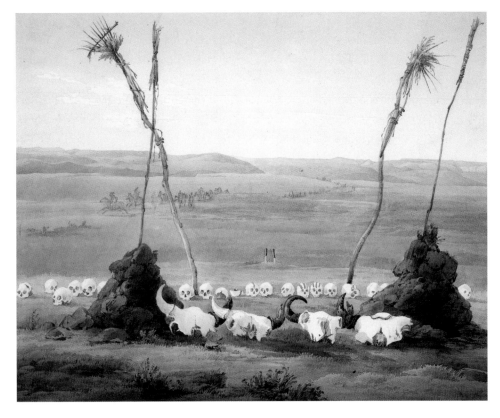

Figure 20

Karl Bodmer

Mandan Shrine, 1833

watercolor on paper, 8 x 10⅛"

Joslyn Art Museum, Omaha, Nebraska, gift of the
Enron Art Foundation

lication on the natural history and people of North America, Bodmer was a traditionally trained European artist whose previous landscapes had been in the manner of Claude Lorrain and the seventeenth-century classicists. Just before being hired by Prince Maximilian he had illustrated a publication on the scenery of the Moselle River, which, although different in appearance from the Mississippi and Missouri rivers, would have provided important training for his American experience.[39] It is highly unlikely that he had ever encountered anything like the prairie landscapes he witnessed daily in the American West. Perhaps that was the reason he never painted a pure prairie, even though he spent considerable time inland during his travels and saw firsthand some of the most dramatic areas of the American grasslands. Instead, he concentrated on eastern cultivations such as his *View of a Farm on the Illinois Prairie* (1833, fig. 19), as well as river views, rocky outcroppings, buffalo, and other objects that would enliven the scenes, and of course he painted many portraits of the Native Americans who were Maximilian's primary interest.

While he was not attracted by the prairies' artistic qualities, Bodmer did create some of the most eloquent expressions of the North American interior before it was substantially altered. His work has a delicacy of effect, a virtuosity of color, and a subtle nuance of line that are unrivaled

in American western art, in his own century or since. Although he avoided the stark prairies, his views along the Missouri and Platte rivers do provide a highly naturalistic and evocative glimpse into the experiences of the early explorers and artists who traversed these waterways before the coming of the railroad.

Prince Maximilian, Bodmer, and their companions arrived in Boston in July 1832 and spent time in Philadelphia before heading west. There they visited Charles Willson Peale's museum and undoubtedly sought information about Titian Peale's and Edwin James's experiences with the Long expedition. Traveling on, the prince wintered in New Harmony, Indiana, while Bodmer took a trip down the Ohio and Mississippi to New Orleans, rejoining his party in February. In both New Harmony and Saint Louis the explorers were able to consult veterans of western travel, notably Thomas Say in Indiana, the zoologist who had been with the Long expedition, and William Clark in Saint Louis. In that city, Indian agent Benjamin O'Fallon provided the prince with copies of Lewis and Clark's maps and showed him and Bodmer a large selection of Catlin's paintings that he had stored for the artist.[40] Bodmer's painting style was quite different from Catlin's, but the pictures would have been important prototypes for the Swiss artist, even though he and Maximilian later expressed contempt for Catlin's work.[41]

The closest Bodmer would come to a true prairie composition may be *Mandan Shrine* (1833, fig. 20), a striking image of a circle of skulls that fills the foreground within a sweeping grassland setting. It is clear that the ritual objects were for him the subject of the work, but they are visually striking for their contrast to the open landscape. Catlin's observations of the Mandans explain that these groupings were part of cemeteries:

When the scaffolds on which the bodies rest, decay and fall to the ground, the nearest relations having buried the rest of the bones, take the skulls, which are perfectly bleached and purified, and place them in circles of an hundred or more on the prairie—placed at equal distances apart (some eight or nine inches from each other), with the faces of all looking to the centre; where they are religiously protected and preserved in their precise positions from year to year, as objects of religious and affectionate veneration.

There are several of these "Golgothas" or circles of twenty or thirty feet in diameter, and in the centre of each ring or circle is a little mound of three feet high, on which uniformly rest two buffalo skulls (a male and a female); and in the centre of the little mound is erected a "medicine pole," about twenty feet high, supporting many curious articles of mystery and superstition, which they supposed have the power of guarding and protecting this sacred arrangement. . . . Here then to this strange place do these people again resort, . . . fond affections and endearments are here renewed, and conversations are held and cherished with the dead.[42]

Although Bodmer's painting gives prominence to the ritualistic configuration, the unadorned prairie is undeniably the setting that gives this grouping its visual power. The broad view to the horizon is softly rolling, subtly variegated in tonality, and wholly convincing in its display of light and scale. Bodmer outlined in pencil a long line of approaching horsemen and figures but,

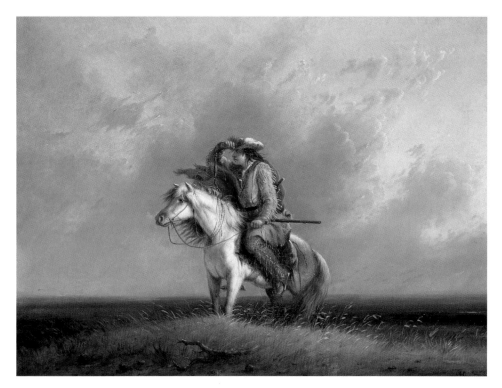

Figure 21

Alfred Jacob Miller (1810–1874)

The Lost Greenhorn, n.d.

oil on canvas, 17⅞ x 23⅞"

Buffalo Bill Historical Center, Cody, Wyoming, gift of the Coe Foundation

in the final watercolor and its succeeding lithographs, chose not to emphasize this meandering group that draws our attention to the farthest reaches of the scene.

Bodmer's lack of attention to the empty prairie not only indicates his awareness of traditional requirements of landscape composition but also reflects the interests and priorities of his patron, Prince Maximilian. The prince was intent on documenting the peoples of the interior of North America before they were substantially influenced by Euro-American intrusions, and it was he who directed Bodmer's vision.[43] An artist in his own right, the prince had made his own sketches on his 1815–1817 travels through Brazil, but on the advice of his friend the eminent German naturalist Alexander von Humboldt, who had preceded him to both North and South America, he acknowledged that a project as significant as his northern journey required a more talented artist, one competent to produce accurate and compelling images that would be translated into illustrative prints for his book.[44] In his research Maximilian was typical of the educated dilettante, a combined scientist and romantic who sought the exotic unknown and analyzed and transcribed his discoveries with exacting detail. Bodmer's work (for which the prince had contracted outright ownership) was designed to enhance the prince's studies more than it was envisioned as independent objects of art, but even so, because of the artist's innate talent, his work stands among the most beautiful of the American West.[45]

Only a few years after Catlin and Bodmer toured the prairies and its rivers, a Baltimore painter, Alfred Jacob Miller (1810–1874), took an alternate route overland through the grasslands, following the Overland Trail and the Platte River to Oregon to attend what would be among the last rendezvous of trappers and traders. He too accompanied the private expedition of a European nobleman, but unlike Maximilian, his patron was interested more in adventure than in science, and that difference in motivation seems to have influenced Miller's art, directing it toward the inherent romance of the undeveloped country and the exoticism of its inhabitants and their way of life.

Unlike the largely self-taught Catlin, Miller had studied art in Europe, taking the Grand Tour in 1833, auditing courses at the Ecole des Beaux Arts in Paris and later at the English Life School in Rome. He had copied the masters in the Louvre, including seventeenth-century landscape painters, and become acquainted with the work of his contemporaries Eugène Delacroix and Joseph Mallord William Turner, which he much admired. He was thoroughly familiar with the traditional prospect picture and produced several, in Europe and in his native Baltimore.[46] On his return to the United States Miller established a studio in Baltimore, but by 1836, unsettled by the death of his father and the responsibilities of his estate, he had departed for New Orleans in search of new horizons.

He had been in Louisiana only a few months when he met Sir William Drummond Stewart, a Scottish nobleman who was escaping his own problems at home by seeking adventure in the American West. Stewart had already been touring the states and territories since 1832 and in 1833 had met Prince Maximilian in Saint Louis. They contemplated combining their parties but in the end agreed that their interests were too different. It is intriguing to speculate that Stewart may have been inspired by the Prussian's example of visually documenting his travels and prompted to employ an artist to produce images for himself.[47] In any event, four years later, planning another foray into the West, he hired Miller to accompany him and produce pictorial souvenirs for his castle back in Perthshire.

Heading out by steamboat in April 1837 for Saint Louis, the party eventually made their way along the Missouri River to Westport (in present-day Kansas City), where they outfitted for the trip. Whereas Catlin and Bodmer had proceeded north up the river, Stewart and Miller turned west and then north into Nebraska, essentially following the path of the Long expedition but taking the north fork of the Platte to Wyoming rather than its south fork into Colorado.[48] Traveling through the heart of the American grasslands, Miller had the opportunity to portray them extensively, and because of his patron's less restrictive requirements, he may have been more open to their aesthetic possibilities than his predecessors had been.

It is difficult to estimate the number of paintings and sketches Miller produced from his west-

ern trip since in later years he painted numerous copies and adaptations of his originals.[49] Like most travelers through the region, he was especially impressed with the more dramatic landscapes—the rock formations along the way and the mountains they finally reached. But whereas Bodmer delineated his views with a crystalline clarity, providing their evocative effects through a delicacy of line, Miller's art is more painterly and corresponds to the mysterious effect of prairies, their ability to delight, confuse, and startle travelers in unexpected ways. He turned the hardy Indian ponies into delicate Arabian steeds and the chaos of hunts and rendezvous into romantic conflicts and glorified festivals. While his art offers an effusive glimpse into the heady days of the fur trade, however, its stylized presentation is often so fanciful that it diminishes the result to that of wholesale invention.

Many of Miller's major paintings, executed long after the expedition, are highly composed in the manner of traditional classical landscapes or prospect pictures, with all the requisite framing devices and compositional elements. He clearly preferred the mountainous views and more variegated landscapes that could be easily manipulated into these formats, but Miller did create several works that are undeniably prairie scenes. Many of them, including *The Lost Greenhorn* (n.d., fig. 21), eschew the predictable format and ingeniously convey an important aspect of life in the grasslands. The greenhorn subject proved so popular that Miller reproduced it in a number of versions.

In *The Lost Greenhorn,* Miller represents one of the early prairie traveler's continual fears. The forlorn figure has become separated from his party and searches desperately and vainly for landmarks that might locate him amid the waving grass. It was an all too common event, as Washington Irving described only a few years before.

I now found myself in the midst of a lonely waste in which the prospect was bounded by undulating swells of land, naked and uniform, where from the deficiency of land marks and distinct features an inexperienced man may become bewildered and lose his way as readily as in the wastes of the ocean. The day too was overcast so I could not guide myself by the sun; my only mode was to retrace the track my horse had made in coming, though this I would often lose sight of, where the ground was covered with parched herbage.[50]

Miller's *Lost Greenhorn* was based on a similar event; John, the English cook for the Stewart expedition, had left the group to search for buffalo, boasting of his prowess as a hunter. He was lost for two days, and a search party had to go out after him. He was brought back half-starved and thoroughly chastened by his experience. In Miller's portrayal, one of the more compelling of all prairie images, the lone mounted figure has ascended a small rise to look vainly across the surrounding country. We sense his desperation as we glimpse behind him the featureless landscape that extends miles to the horizon.[51]

Miller's *Prairie Scene: Mirage* (1858–1860, fig. 22), a more modest watercolor view, portrays another of the unsettling qualities of the shimmering grassland, the frequent optical illusions that many

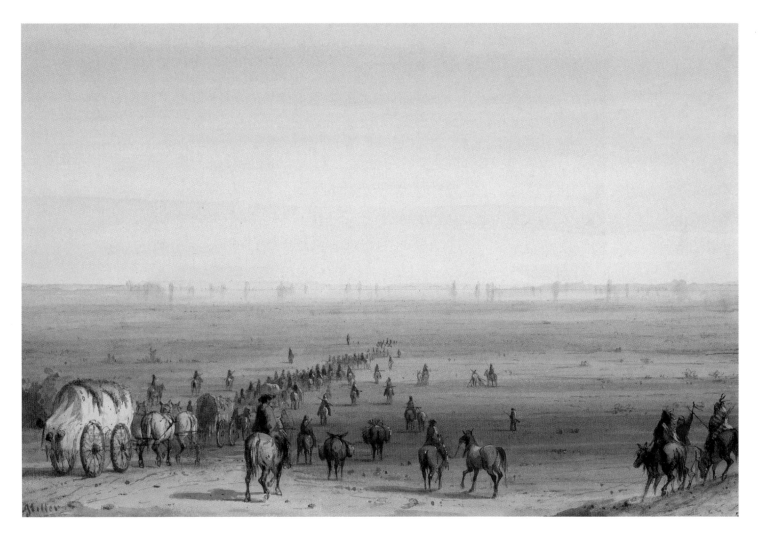

Figure 22

Alfred Jacob Miller

Prairie Scene: Mirage, 1858–1860

watercolor on paper, 8¹³⁄₁₆ x 13³⁄₁₆"

The Walters Art Gallery, Baltimore, Maryland

travelers experienced and wondered about. Miller's image is reminiscent of Catlin's description:

One commences on peregrinations like these, with a light heart, and a nimble foot, and spirits as buoyant as the very air that floats along by the side of him; but his spirit soon tires, and he lags on the way that is rendered more tedious and intolerable by the tantalizing *mirage* that opens before him beautiful lakes, and lawns and copses; or by the *looming* of the prairie ahead of him, that seems to rise like a parapet, and decked with its varied flowers, phantom-like, flies and moves along before him.[52]

Miller himself wrote about the prairie mirages in a passage that could well be a caption for this watercolor:

The caravan is proceeding at its usual steady pace, both men and horses suffering for want of water,— the day is hot and oppressive. Suddenly in the distance, an extensive Lake looms up,—delightful to the

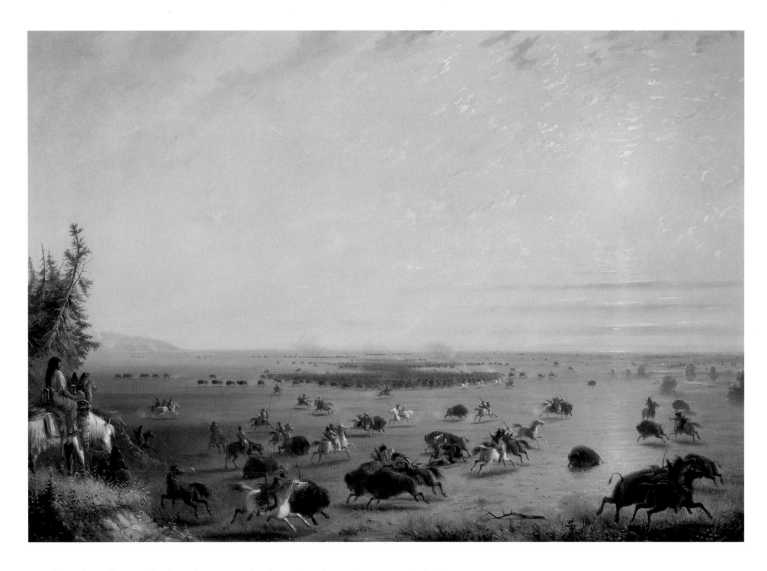

eye, the surface reflecting islands, and trees on its borders;—but what is the matter with the horses?—they neither raise their ears, quicken their motion, or snort, as is their wont on such occasions.

Poor brutes!—well do they know there is no water for them. It is the mirage, an optical delusion;—the deception is so perfect that you can scarcely credit your senses.[53]

In Miller's *Prairie Scene* the figures of the caravan flank the lower corners and meander toward the horizon like the streams and paths of traditional prospect pictures, but their object is the illusory image on the horizon that hovers like a vision, beckoning them forward.

Another important aspect of life on the plains before the 1870s was, of course, bison hunting. Before the mass slaughter of the animals by hunters with repeating rifles, the hunt was a

PLAIN PICTURES

complex communal activity, which became an enormously popular subject for artists.[54] Miller was no exception, and he completed numerous paintings of the theme. One of his more striking, *A Surround of Buffalo by Indians* (ca. 1848–1858, fig. 23), represents the dynamism of the event set against a sweeping prairie landscape. Catlin explained the method of the hunt:

> The plan of this attack, which in this country is familiarly called a "*surround*," was explicity agreed upon, and the hunters who were all mounted on their "buffalo horse" and armed with bows and arrows or long lances, divided themselves into two columns, taking opposite directions, and drew themselves gradually around the herd at a mile or more distance from them; thus forming a circle of horsemen at equal distances apart, who gradually closed in upon them with a moderate pace, at a signal given.[55]

The actions of the figures and animals and Miller's elevated perspective in *Surround* comprise an ingenious solution to the compositional problem of the prairies' missing prospects, imbuing the land with a mythic quality at the same time that it improvises an alternative to the terrain's visual simplicity. In this it is quite different from *Buffalo Hunt on the Prairies* (1847, fig. 24), by Henry George Hine (1811–1895). Hine, Miller's Canadian contemporary, had less hesitation in celebrating the rolling scenery, and in his view the land is marked only by a minuscule herd and a lone hunter at the head of the stampede who attempts to fell the leader. In this small painting the prairie landscape takes a more prominent role, lending its own dynamism to the image but also defining our perception of the hunt. Hine's bird's-eye perspective relegates the figures to a simple focal point that lends scale and emphasizes the dominance of the land.

Such scenes were more than mere curiosities of exotic animals and terrain. They became in many ways the defining images of the prairie landscape, icons that could, even when transport-

LEFT: **Figure 23**

Alfred Jacob Miller

A Surround of Buffalo by Indians, ca. 1848–1858

oil on canvas, 30⅛ x 44⅛"

Buffalo Bill Historical Center, Cody, Wyoming, gift of William R. Weiss

BELOW: **Figure 24**

Henry George Hine (1811–1895)

Buffalo Hunt on the Prairies, 1847

watercolor with gouache, 8¼ x 22⅜"

Royal Ontario Museum, Toronto, Sigmund Samuel Collection

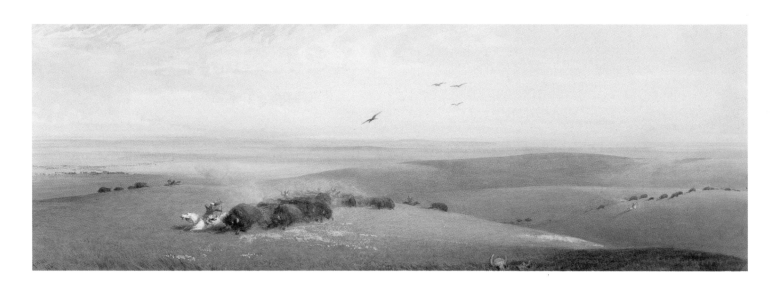

ed to other continents, conjure the essence of the region. Miller's work for William Drummond Stewart was intended to function precisely in this way. After their trip Miller proceeded to transform his preliminary work into finished paintings that would remind the Scottish aristocrat of his western adventures.[56] In 1840 the artist traveled to Scotland to supervise the decoration of Murthy Castle's hunting lodge, filling it with a fanciful mélange of western memorabilia. In addition to the many paintings he produced there, Miller designed a pair of carved "buffalo chairs," using the hooves and horns of two bison that Stewart had exported to his estate, hoping to start his own highland herd.[57] The couple had died before they could reproduce, but Miller's inventive response to their demise provided his patron with some exceptionally original souvenirs of his experiences in the American prairies.[58]

Alfred Jacob Miller's prolific devotion to the romantic scenes of the American West continued for many years after his association with Stewart. He spent the rest of his life in Baltimore but repainted many of his original works, elaborated and refined others, and supervised the reproduction of several into prints. Many of his later versions of his classic subjects are more successful than his early ones, presumably because he had more time to devote to them and because he developed technically throughout the 1850s. Although he spent much of his later years painting portraits, his reputation rested on his western scenes, and through them he provided one of the most important evocations of his time, the romantic view of an unspoiled wilderness.

FILLING THE VOID

The Oregon Trail was opened in 1841, leading settlers through Nebraska, and the Santa Fe Trail through Kansas was well marked by 1842. The fur trade was in decline, and many of the mountain men that had supplied it became guides for the steadily increasing numbers of settlers bound for the newly opened territories of the far Northwest. Finally, with passable routes, the era of mass migration began. At the same time, the government intensified its interest in the West, and with the reorganization of the Army Corps of Topographical Engineers into an independent division of the military in 1838, federal expeditions became focused agents of national expansion. The progress of the American people toward the Pacific and their domination of the continent, their manifest destiny, was well under way.[59]

The central prairies remained, however, something to be gotten through, rather than a destination, and their reputation as a worthless desert persisted in countless reports and guidebooks and in the minds of those who traveled through them.[60] Francis Parkman wrote in his famous *Oregon Trail,* as he and his party embarked from Westport, Missouri, "I was half inclined to regret leaving behind the land of gardens for the rude and stern scenes of the prairies and mountains."[61] The influx of travelers, however, focused attention on the central grassland in new ways. No longer were its characteristics of interest solely to the government and the few intrepid individ-

uals who ventured into the region; rather they became the vital concern of countless pioneers who saw the territory as an obstacle to their future in the land beyond. As more people experienced the place and as the westward journey was advertised and popularized in travel literature and other publications, the public's fascination with the prairies' curious topography increased. Artists, of course, made important contributions to this phenomenon as more of them ventured into the region and published and exhibited their work in the East, and still others produced images from their eastern studios to appeal to the public's desire for information and for dramatic narratives of western life.[62]

As landscape painting grew steadily in popularity in the 1840s and 1850s, genre paintings too became a major art form during the period. Many of the prairie pictures from these decades fall somewhere between the two categories, focusing the viewer's attention as much on figures in action as they do on the landscape itself. In many cases, however, the action derives its meaning and metaphorical significance from the grassland setting in which it takes place. These depictions should, therefore, be considered within the context of prairie landscape imagery.

A little-known figure at the vanguard of this category was another Philadelphia painter,

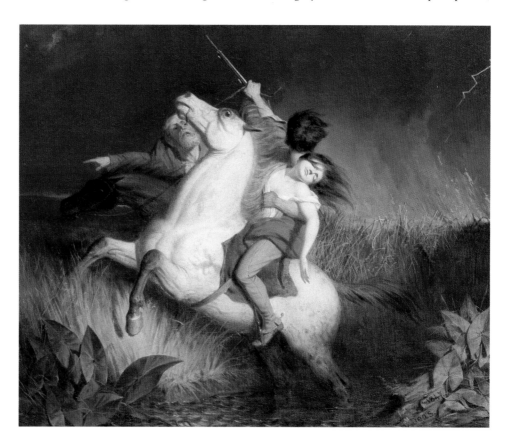

Figure 25

Charles Deas (1818–1867)

Prairie Fire, **1847**

oil on canvas, 28⅞ x 36 1/16"

The Brooklyn Museum, gift of Mr. and Mrs. Alastair Bradley Martin

Charles Deas (1818–1867). Grandson of the Revolutionary-era patriot Ralph Izard, whose portrait was painted by John Singleton Copley, Deas had grown up with the privileges of a prominent family, including an early exposure to art.[63] Unsuited to the military career that his family had chosen for him, he instead became a painter and already by the age of twenty-two had made a reputation as an artist. Elected an associate National Academician in 1839, Deas exhibited at least twelve paintings at the National Academy between 1838 and 1840. According to the nineteenth-century biographer Henry T. Tuckerman, Deas was intrigued with Catlin's Indian Gallery, which he apparently visited in New York in 1837 or 1838, and had also made paintings from *The Prairie* by Cooper and from Washington Irving's writings.[64] In 1840 he traveled to Fort Crawford in Prairie du Chien, Wisconsin, where his brother was stationed, and he spent much of the next year traveling in Wisconsin and Minnesota before moving to Saint Louis to establish a studio. In spring 1844 he accompanied Major Wharton's military expedition from Fort Leavenworth, Kansas, to the upper Platte River, taking him through the heart of prairie country.[65]

Deas's *Prairie Fire* (1847, fig. 25) was undoubtedly inspired by those western travels, although it was entirely constructed to appeal to popular tastes. More of a genre painting than a landscape, this work is highly romantic—the swooning woman carried on horseback—and suspenseful with its encroaching flames. Although it is not known whether Deas ever traveled abroad, he might have modeled his composition on European precedents, known from his early exposure to contemporary art in Philadelphia. While it clearly focuses on the drama of the human action, Deas's *Prairie Fire,* like Catlin's earlier images, capitalizes on the ever-popular sublimity of prairie fires, which were among the most frequently discussed events in the grassland landscape.

From his base in Saint Louis Deas sent his work east for exhibition, and many of his western scenes, including *Prairie Fire,* were in the American Art-Union exhibitions in New York during the 1840s.[66] The American Art-Union served as a gallery for American artists and as a distribution house for reproductions of their work; it was extremely important in the mid-nineteenth century for the promotion of art in the United States. Even so, little of Deas's work survives, and his career was cut short when he was committed to an asylum in 1848, the same year that he conceived ambitious plans to exhibit his western work in an Indian gallery of his own. Had he completed it, he might have surpassed the similar efforts of his predecessor, George Catlin, and perhaps even those of his contemporary John Mix Stanley.[67]

A BOOK WITH BLANK PAGES

As greater numbers of painters turned their attention to the prairies' possibilities, others were investigating the land's potential as a photographic subject. Among the first photographers of

the American prairies was Solomon J. Carvalho (1815–1894), who traveled with John C. Frémont, "The Pathfinder," on his last expedition in 1853, making sketches and paintings as well as daguerreotypes. One of the most romantic figures of the era of manifest destiny, Frémont had been exploring the West for the U.S. Topographical Corps for eleven years and apparently loved the prairie landscape. As his topographer Charles Preuss dryly remarked, "Eternal prairie and grass, with occasional groups of trees. Frémont prefers this to every other landscape. To me it is as if someone would prefer a book with blank pages to a good story."[68] Frémont's fondness for the grasslands may have been one of the reasons he employed Carvalho; through photography, he hoped, its character would be portrayed without the intervening veil of invention that characterized painted views.

Frémont had apparently attempted daguerreotypy himself on his first expedition in 1842, without success. The photographic process, invented only in 1839, was still exceptionally limited, and it is not surprising he achieved disappointing results. The report of that journey, however, was illustrated by the topographer Preuss and was tremendously popular, going through several printings and catapulting the survey leader into the national spotlight.[69] Encouraged, Frémont took other artists on subsequent expeditions, and by 1853, supposedly inspired by Humboldt's advice in *Cosmos* (American edition 1850), he had hired Carvalho to give photography another try.[70]

The expedition, following the thirty-eighth parallel from Saint Louis, was intended to determine the practicality of a centrally located transcontinental railroad line. To emphasize the feasibility of such a route, Frémont, with the enthusiastic backing of his father-in-law, Missouri senator Thomas Hart Benton, pursued his mission in winter. Unfortunately, none of Carvalho's photographs from the grueling trip has survived, but his efforts, which undoubtedly included prairie scenes, are worthy of recognition since they demonstrate the early awareness of photography's ability to convey the appearance of landscape to distant viewers. Moreover, on his return, Carvalho published a vivid account of his experiences, providing insight into the trials of artist-explorers and into his own perception of the American prairies.[71] He became lost in the prairies at least twice, encountered numerous bison, and marveled at the effects of grass fires. In describing them he revealed his awareness of European art and his predilection to conform the prairies to that model. "The scene that presented itself," he recounted, "was sublime. . . . the full moon was shining brightly, and the piles of clouds which surrounded her, presented magnificent studies of 'light and shadow,' which 'Claude Lorrain' so loved to paint. . . . The whole horizon now seemed bounded by fire."[72] Carvalho briefly mentioned photographing prairies, but his lack of commentary about the scenery, in contrast to his reactions to this nocturnal spectacle, indicates that the treeless landscape did not inspire him, perhaps because it usually lacked such a suggestive atmosphere.

Frémont's last expedition was an unofficial part of one of the most ambitious western undertakings in the 1850s, the federally sponsored Pacific Railroad Surveys, which sought the most practicable route for a transcontinental line. This comprehensive program, which consisted of four major surveys through different regions (north, south, and two central routes), employed at least eleven artists in 1853 to accompany the expeditions, document their findings, and illustrate the official reports to Congress. As Senator Benton declared, "We must have surveys, examinations, and explorations made, and not go blindfolded, haphazard into such a scheme."[73] All but the southernmost survey spent a great deal of time in prairie country, and although the artists' work from the project varied in quality, the railroad survey resulted in a wealth of visual material that contributed to Americans' awareness of the national landscape.

A few of the railroad survey artists went on to establish significant careers, and the others are known primarily from their work published in the final twelve-volume report.[74] Although a number of their images depict the plains and prairies, they are far exceeded by more attenuated scenery such as mountains and unusual rock formations. Thus the survey artists continued the trend of avoiding featureless grasslands in visual images. Besides, as historian Robert Taft noted, by the 1850s this area was already so familiar that apparently it did not merit a great deal of attention.[75] Even so, the reports emphatically reiterated the assumption that the prairies were barren. As one review of the final publication concluded, "We may as well admit that Kansas and Nebraska, with the exception of the small strip of land upon their eastern border, are perfect deserts with a soil whose constituents are of such nature as for ever to unfit them for the purposes of agriculture. . . . whatever route is selected for a railroad to the Pacific, it must wind the great part of its length through a country destined to remain for ever an uninhabited and dreary waste."[76]

Not all of the images in the reports confirmed this opinion. One notable example, John Mix Stanley's *Herd of Bison, near Lake Jesse* (1853–1855, fig. 26), stands out for its beautiful portrayal of the prairie landscape. In most of his other work Stanley seems to have been more interested in spectacular scenery or dramatic action than in grassland scenes, but *Herd of Bison* presents a striking contrast. Its emphasis on the epic nature of the treeless expanse and its bounty may reflect the desires of Stanley's survey leader, Isaac Stevens. As the new governor of Washington Territory, Stevens had a vested interest in securing the northern route they explored for the transcontinental line, but Stanley's scene was, as well, based on actual sightings. Sketched near present-day Jesse, North Dakota, and completed later for publication, it portrays the gently rolling terrain dotted with countless bison that many described before the great herds were decimated. Frémont had reported in 1842, "From hill to hill, the prairie bottom was certainly not less than two miles wide; and allowing the animals to be ten feet apart, and only ten in a line, there were already eleven thousand in view. Some idea may thus be formed of their number when they

Figure 26

John Mix Stanley (1814–1872)

Herd of Bison, near Lake Jesse, 1853–1855

color lithograph, from Stevens, *Explorations and Surveys,* facing p. 59, 6¹⁄₁₆ x 9¹⁄₁₆"

University of Iowa Libraries, Government Publications Department

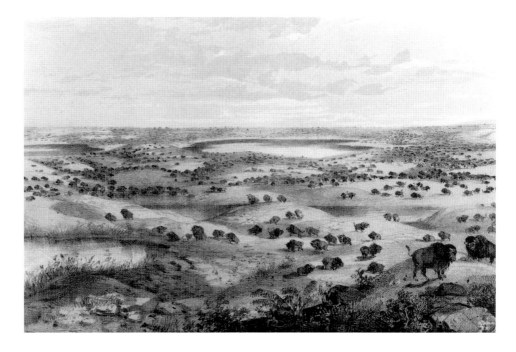

had occupied the whole plain. In a short time they surrounded us on every side; extending for several miles in the rear, and forward as far as the eye could reach."[77] Stanley corroborated this description but attested to his view being more in the range of fifteen miles, and Stevens estimated the number in the herd they saw in the range of two hundred thousand bison.[78]

Heading west from Saint Paul through North Dakota and Montana, the Stevens survey mapped the route that, although not selected for the first transcontinental line, essentially became the course of the Northern Pacific Railroad, completed in 1883. Much of this terrain is prairie, and Stanley's *Herd of Bison* strikingly evokes the appearance of the vast northern grasslands and their massive herds, creating a prospect that is artistically compelling at the same time that it envisions the land's economic future as a transcontinental route.

Stanley's trip with the Stevens survey was the culmination of a long western career. By far the most important of the railroad survey artists, Stanley had first traveled west privately in 1842. Throughout the 1840s, accompanying several expeditions, he met and witnessed some of the most important people and events of the period, including Colonel Stephen W. Kearny, with whom he served in the Mexican-American War, and Josiah Gregg, who had just published *Commerce of the Prairies* in 1844. Stanley was also in Oregon when Marcus and Narcissa Whitman were murdered in 1847 and only by chance missed being in danger himself. In 1848 he traveled even farther west, to Hawaii, where he painted portraits of King Kamehameha III. Few other artists of his time had such an interesting and eventful career.[79]

As well as making sketches during the Stevens survey, Stanley apparently also made daguerreotypes that have not survived. He promoted his work by publishing a few of his western pictures in guidebooks and some in the railroad reports, and he exhibited others in finished form in Cincinnati and Washington, including a vast panorama of the survey route, which undoubtedly contained prairie scenes.[80] He was most interested in his Indian paintings, which he had worked on throughout his travels. Inspired by Catlin's example, he also envisioned his collection as an Indian gallery, a corpus that would convey more about the native peoples than had previously been understood. He deposited the works with Joseph Henry at the Smithsonian in 1852 on extended loan and, also like Catlin, hoped that Congress would purchase his collection. Although Catlin's work eventually became the property of the national museum after the artist's death, Stanley's disappointment was even more cruel; not only did Congress not approve the offer but also most of his entire oeuvre—more than two hundred paintings—burned at the Smithsonian in 1865. While Stanley's achievements are still evident through his few surviving works and he is acknowledged as one of the more accomplished artists to have been in the West, his significant reputation would have been even greater if not for this unfortunate loss.[81]

A LANDSCAPE OF SUBLIMITY

Despite the continuing characterization of the prairies as a desert region lacking in prospects, other aspects of the landscape's identity began to emerge in art and literature in the 1850s. The openness of the grasslands, their profusion of flowers, their apparent availability, and even their native inhabitants, besides being seen as wild or savage, could be interpreted as metaphors for all manner of ideals—health, independence, freedom, and, increasingly, fertility and abundance. Diarist Susan Shelby Magoffin wrote, as she accompanied her husband on the same Santa Fe wagon train that John Mix Stanley joined in 1846, "Oh, this is a life I would not exchange for a good deal! There is such independence, so much free uncontaminated air, which impregnates the mind, the feelings, nay every thought, with purity. I breathe free without that oppression and uneasiness felt in the gossiping circles of a settled home."[82] The prairies could convey a sublimity that suggested even more than a conventional landscape, especially about American ideals and values.

Furthermore, by the 1860s the challenge of the landscape's emptiness remained, but because of a variety of cultural and technological developments that were beginning to open the region to white settlement and commercial development, the prairies' prospects were beginning to improve, literally and figuratively. The transcontinental railroad would be the most important of these, but despite the best efforts of the 1853 surveys, the line was not completed until 1869, delayed by political wrangling, the Civil War, and the slow construction of the track. Even so, the number of Euro-Americans moving through and settling in the prairie region was steadily

increasing, encouraged to a great degree by the Homestead Act of 1862 and the Timber Culture Act of 1873.

Perhaps influenced by these developments and a growing appreciation of the prairies' potential to represent important national and aesthetic ideas, artists became more adept at utilizing indigenous features in creative ways. Although their motivations are hard to document, it seems as if artistic conventions were hampering them less, making it easier to accommodate the treeless grasslands into their work. They may have been affected by the popularity of other types of landscape paintings that eschewed traditional formats; exotic or unusual compositions that emphasized a scene's sublimity, for example, were becoming more acceptable.[83]

Among the artists who recognized the prairies as a monumental subject was Emanuel Leutze (1816–1868), the famed creator of the enormously popular canvas *Washington Crossing the Delaware* (1851, Metropolitan Museum of Art) and a major influence on American art through his tutelage of many important artists at the Düsseldorf Academy. Leutze traveled west in 1861; afterward, in addition to his panoramic mural in the United States Capitol, *Westward the Course of Empire Takes Its Way* [*Westward Ho*] (1862), which is a figure-filled history painting, he painted at least one prairie landscape.[84] Typical of Leutze, who often bordered on aggrandizement in his work, in *Prairie Bluffs at Julesburg, South Platte, Storm at Sunset* (ca. 1861, fig. 5) the land is rendered sublime through the apparition of a rainbow, and the drama of the surrounding storm further heightens the breathtaking quality of the thundering wild horses and their Native American pursuers occupying the middle ground.[85]

Ever one to ennoble his subjects, Leutze was strongly influenced by the nineteenth-century tendency to romanticize the West and its inhabitants, both human and animal. Of these none was more compelling than the wild horses, as Josiah Gregg had written in 1844: "By far the most noble of these [animals of the grasslands], and therefore the best entitled to precedence . . . is the *mustang* or wild horse of the Prairies. As he is descended from the stock introduced into America by the first Spanish colonists, he has no doubt a partial mixture of Arabian blood. . . . The beauty of the mustang is proverbial."[86] The pedigree of the American mustangs gave them a mysterious allure, as if they were somehow both more civilized and more free than any of the other creatures in the West. Such a duality would have been generally intriguing, and it must have had special appeal for the German American artist, himself a foreigner who had adapted to life in the New World.

Another artist who captured the majesty and sublimity of the prairie animals was William Jacob Hays (1830–1875). Like Leutze, Hays made only one trip west, traveling up the Missouri River in 1860, but he had invested much of his career in prairie subjects. His views of bison, antelope, prairie dogs, and other animals recall John Mix Stanley's, but with an even more expansive vision that in many ways corresponds to the prodigiousness of the landscape itself.[87]

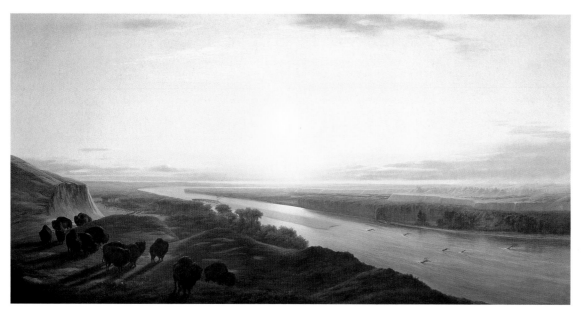

On his return east in late 1860 Hays proceeded to compose a series of such images, most notably a triptych of three bison scenes, *A Herd of Bison Crossing the Missouri River* (1863, fig. 27), *A Herd of Buffalo on the Bed of the River Missouri* [*Herd on the Move*] (1860–1862, fig. 28), and *The Stampede* (1862, fig. 29).[88] Historically reserved for highly significant subjects, the triptych form gives the paintings a cumulative power not available to each alone, even though in this case all three works are strongly dramatic and monumental. United, as they have not been since their completion, the canvases embody the prodigiousness of prairies and place the subject among the pantheon of artistic hierarchy.

In *Herd on the Move,* the central scene of the triptych, the animals pour down from the ridges, becoming the rivers and monumental features that the land lacked. In their enormity and unusual immediacy they seem almost to embody the stampeding herds that were so often marveled at by early explorers in the prairies. Auguste Niçaise, a Frenchman who visited the prairies about the same time as Hays, described such a scene:

We climbed up in a hurry to the little hillock at the foot of which we were camping. It commanded a view of the plain and the Nebraska River. Here is what we saw: About eight hundred meters from us, amid rising clouds of dust, a herd of buffalo, the *American Auroch,* composed of a million animals, runs tumultuously and rolls its living waves toward the river. The earth trembles under their feet, the ground also shakes under our feet. Soon the first ranks reach the Nebraska and they rushed into it like an avalanche. Under this furious tide, the river swells and overflows its banks. Forced to remain inactive spectators we hail them loudly as they pass by. During at least three quarters of an hour the Nebraska receives this black torrent which colors its waters with a large wake.[89]

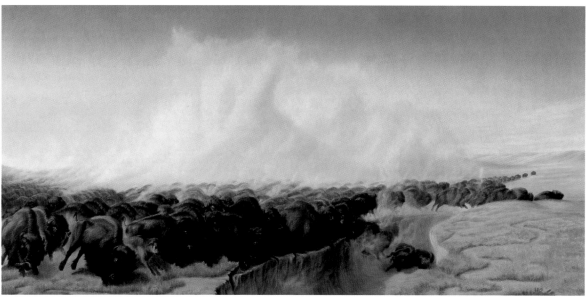

Hays saw buffalo throughout his trip, but *Herd on the Move* may have been inspired by a sight between Forts Stewart and Union; he wrote his mother, "On my way downriver I saw thousands of buffalo[;] they covered the bluff and prairie as far as we could see." Recognizing that Hays's paintings were based on firsthand experience, biographer Henry Tuckerman was careful to remind readers that the extraordinary depictions were not exaggerated: "Those who have visited our prairies of the far West can vouch for its [*Herd on the Move*'s] truthfulness." At the same time, he admitted, "nor can canvas adequately convey the width and breadth of these innumerable hordes of bison."[90]

Hays's sighting of the animals in 1860 would have been among the last such views of the great herds spanning the horizons. As early as the 1840s the buffalo were already being killed in large numbers, and some of the most observant travelers, among them Josiah Gregg, already anticipated their complete demise.

The continual and wanton slaughter of them by travellers and hunters, and the still greater havoc made among them by the Indians, not only for meat, but often for the skins and tongues alone (for which they find a ready market among their traders), are fast reducing their numbers, and must ultimately effect their total annihilation from the continent. . . . The vast extent of the prairies upon which they now pasture is no argument against the prospect of their total extinction.[91]

He would, of course, be proved nearly correct; in the 1870s auctions in Fort Worth sold more than two hundred thousand hides per day. Thousands of carcasses were left to rot on the prairies,

shot entirely for sport. From the countless millions that had awed early explorers, by 1900 the bison population had been reduced to only a few hundred, relegated mostly to private ranches and eastern zoos.[92]

THE HUMAN PROSPECT

With the development of regular outposts and reliable steamboat service throughout the upper prairies, many artists, like Hays and Leutze, traveled through the region on their own. Others, however, followed the examples of their predecessors and accompanied official surveys that continued to explore and document the West. Many of the more prominent did so on their own initiative, joining the parties as guests rather than employees. This group included some of the most famous artists of the era, such as Albert Bierstadt (1830–1902), who first glimpsed his preeminent subject on the Frederick Lander expedition in 1859. Exercising his artistic prerogative and following his European tastes, Bierstadt essentially ignored the prairies in favor of more dramatic mountain scenery farther west, especially Yosemite and the Sierra Nevada, which he elevated to a histrionic extreme in enormous paintings that commanded astounding prices of up to $35,000. During the Lander trip, however, he did make stereoscopic photographs and painted a variety of oil sketches of the prairies. He also produced one small, quite finished canvas, inaptly titled *Surveyor's Wagon in the Rockies* (ca. 1859, fig. 30), which focuses on a low-lying foreground with the mountains as a backdrop. He clearly preferred the elevations, since he wrote, "The mountains are very fine; as seen from the plains, they resemble very much the Bernese Alps, one of the finest

BELOW: **Figure 30**
Albert Bierstadt (1830–1902)
Surveyor's Wagon in the Rockies, ca. 1859
oil on paper on canvas, 7¼ x 12⅞"
Saint Louis Art Museum, gift of J. Lionberger Davis

RIGHT: **Figure 31**
Albert Bierstadt
Sunset on the Plains, ca. 1859
oil on canvas, 19 x 26"
Spencer Museum of Art, University of Kansas, Lawrence, gift of the Honorable Charles V. Kincaid

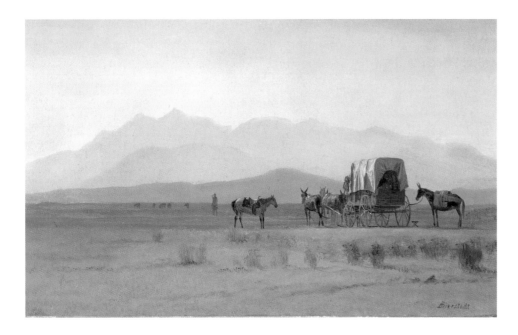

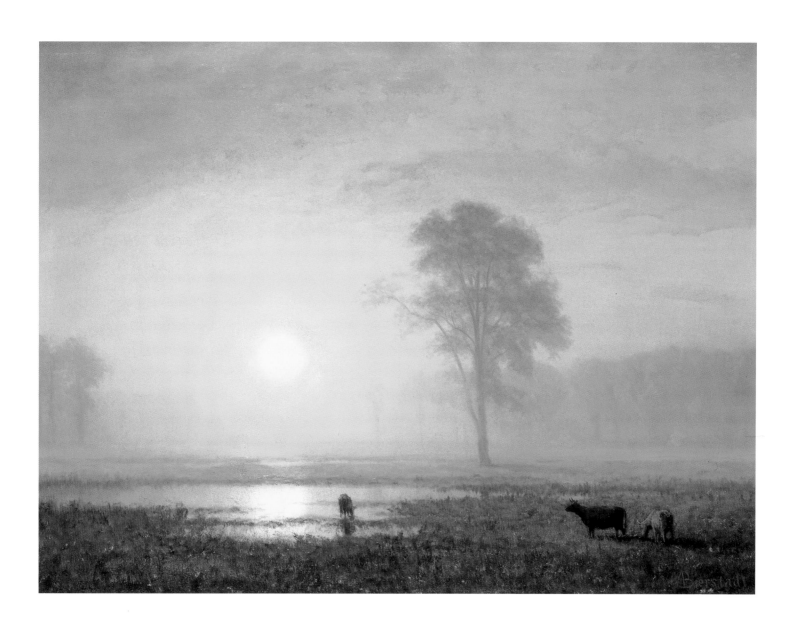

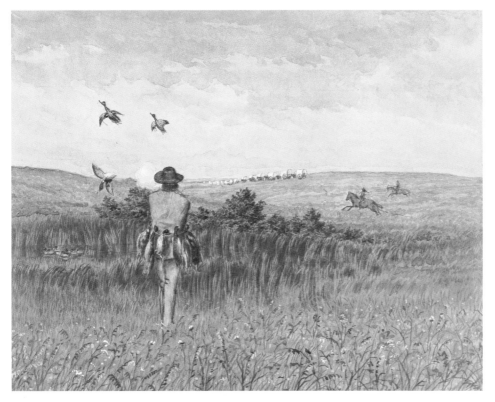

LEFT: **Figure 32**

William George Richardson Hind (1833–1889)

Duck Hunting on the Prairies, 1862

watercolor on paper, 9 x 11⅜"

National Archives of Canada, Ottawa (c-13969)

RIGHT: **Figure 33**

William Henry Jackson (1843–1942)

California Crossing, South Platte, 1867

oil on canvas, 22 x 34"

Thomas Gilcrease Institute of American History and Art, Tulsa, Oklahoma

ranges of mountains in Europe if not the world."[93] Like so many of his colleagues, Bierstadt was uninspired by the treeless landscape and waited until the Rockies were in sight to portray the flatness. Moreover, he required the human element of the wagon, with its attendant mules and a saddle horse, to offer a defining proportional dimension and a modicum of cultivation to the otherwise vast space. When he did claim to paint the prairies, as in *Sunset on the Plains* (ca. 1859, fig. 31), he usually molded them to his preconceived notions of beauty, adding the elements he required and generally inventing them anew rather than portraying them as they appeared.

After being interrupted by the Civil War, federal surveys began again in earnest in 1866, only this time, instead of being supervised by the military, the later expeditions were dominated by civilian engineers and scientists under the auspices of various federal departments.[94] Almost all of them included artists, many of whom, such as Thomas Moran and Sanford Gifford, were prominent painters of eastern landscapes. Although they all passed through the prairies, few produced significant portrayals of that terrain.

At the same time, during the 1860s, the prairies' prospects, both artistic and economic, began to change. As settlers moved into the region in ever-increasing numbers, and especially as the transcontinental railroad and its tributaries began to make their way through the territories, the

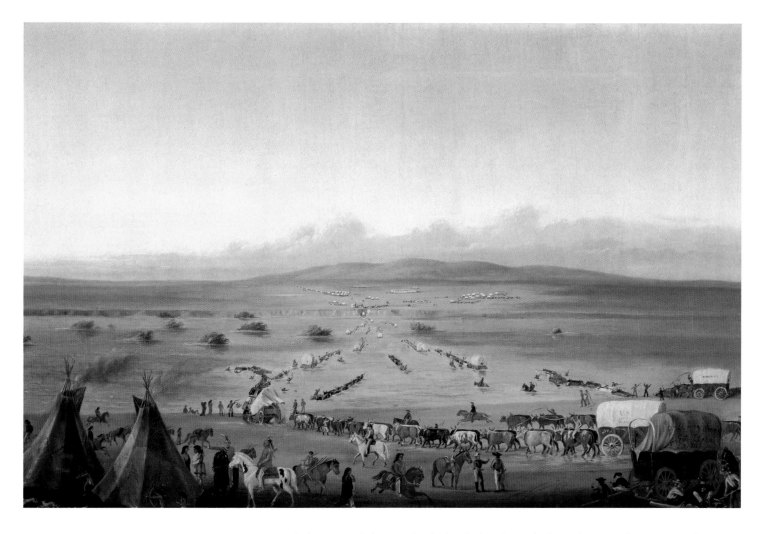

visual character of the grasslands that had so long challenged viewers began to conform to a different aesthetic. Just as people began to see the opportunities in the open landscape, their winding wagon trains and pack animals offered new subject matter for artists, substitutes for the native creatures that roamed the plains. Increasingly, as the next chapter will explore, these too would be replaced, by settlers' homes, fields, towns, and plantings that substantially altered the visual horizon.

Although portrayed within a natural prairie setting, Canadian painter William George Richardson Hind's watercolor *Duck Hunting on the Prairies* (1862, fig. 32) already reveals the human transformation. The animals are more appreciated for their food value than for the wildness that William Hays celebrated; the hunter in this scene, dangling nearly a dozen mallards from his belt, is presumably securing sustenance for the distant wagon train that heads over the horizon.[95] Only

a few years later, William Henry Jackson's *California Crossing, South Platte* (1867, fig. 33) conveyed the Euro-American infiltration of the prairies even more dramatically. Painted after the artist's first western trip as a drover for a wagon train in 1866, the scene recalls the party's fording of the South Platte River at the Nebraska village called California Crossing. In his autobiography Jackson remembered this as "a settlement of no more than a dozen buildings, half of them saloons and dance halls." He recounted that "the fording place [was] three or four miles past town. It was a great picture. The South Platte was about a half a mile wide at this point, and on both sides were wagon trains preparing to cross, while the river itself was the scene of the heaviest traffic we had yet witnessed. Oxen bellowed, men shouted and the air resounded with an incessant cracking of whips."[96]

Although the mass migration to settle the American continent may rightly be interpreted as the imperialistic wresting of a continent from its rightful inhabitants and the imposition of a cul-

BELOW: **Figure 34**

William Henry Jackson

[Omaha Indian] Village, Near View, Showing Lodges, 1868

photograph, 11 x 14"

National Anthropological Archives, Smithsonian Institution

RIGHT: **Figure 35**

Worthington Whittredge (1820–1910)

A Wagon Train on the Plains, Platte River, Colorado, 1866

oil on canvas, 10½ x 21½"

The Regis Collection, Minneapolis, Minnesota

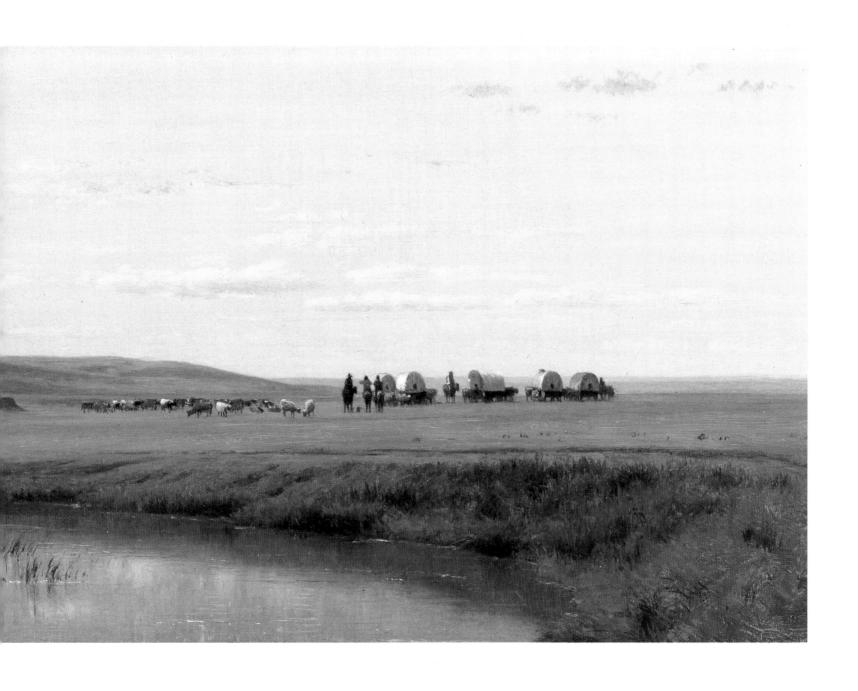

turally predetermined conception onto a land that had its own indigenous identity, the visual and physical result was undeniably the same as in a more triumphal reading. The prairies were given new prospects by those who remade them, and Jackson's view, as much as any other image of this period, exemplifies this complex and profound event. In an archetypal prospect composition, the elevated perspective of *California Crossing* places the viewer's gaze high above the action, the foreground is framed with tepees and wagons, and the procession of figures toward the horizon provides movement, a sense of scale, and a dramatic narrative. Their mission is to traverse and settle the land, and this, coupled with the view to the horizon, underscores the work's implicit message of futurity. The land itself is nearly featureless, but the actions of the figures provide it with meaning, with prospects both literally and figuratively.

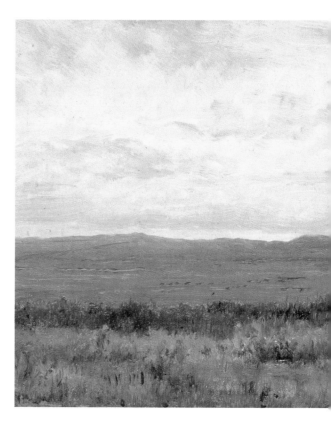

Better known as a photographer, Jackson started his career as a painter, and *California Crossing* is one of his earliest major works.[97] After his adventure on the Overland Trail, he settled in Omaha and began making photographic portraits of local residents and travelers, as well as documenting the lives of Native Americans who lived nearby. It was shortly afterward, in 1869, that he met geologist Ferdinand Hayden, who invited him to join his expedition, one of the four Great Surveys, which ultimately led Jackson to his most famous subjects in Yellowstone, the Colorado Rockies, and a career as one of the most important photographers of the American West.[98] Among his most significant achievements were his photographs of Yellowstone, the first ever taken, which persuaded Congress to designate it the first national park in 1872.

Of all his photographic works, Jackson's early Omaha series most directly portrays the prairie landscape and its emerging aesthetic after the Civil War. Although he had had little training, Jackson seems to have understood implicitly the basic elements of a photographic composition and carefully choreographed both the animate and inanimate elements in his views, as in *[Omaha Indian] Village, Near View, Showing Lodges* (1868, fig. 34). As biographer Peter Hales has written, Jackson "was, it seems, reflecting back the preconceptions, myths, and desires of the Eastern audience that projected, onto the vast *tabula rasa* of the West, a set of completed landscapes—populated or awaiting population, ordered, or awaiting order." He points out that the two figures in the scene have adopted the traditional poses of the "middle class witnesses of landscape" and that "these touches served to modify the West by imposing on it the conventions of an Eastern vision."[99]

The human element in the prairies was not always so reassuring; even the prospect of death provided subject matter that would, ironically, enliven prairie pictures. On his 1866 journey through the West with General John Pope, artist Worthington Whittredge (1820–1910), for example, often made the expedition itself the subject of his work, as in the beautiful painting *A Wagon Train on the Plains, Platte River, Colorado* (1866, fig. 35), but he also found graves near Kearney, Nebraska, a suitable object for contemplation (1866, fig. 36).[100] Throughout the nineteenth century and even today, similarly stark memento mori poignantly evoke the desolation of

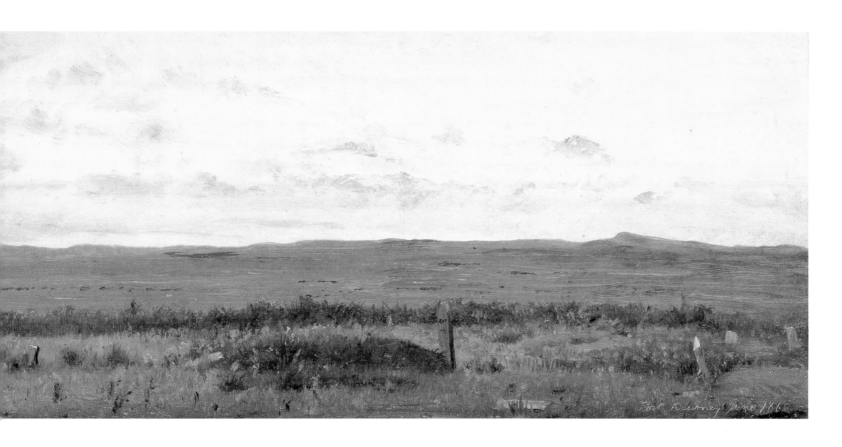

Figure 36

Worthington Whittredge

Graves of Travellers, Fort Kearney, Nebraska, **1866**

oil on paper mounted on board, 7¹⁵⁄₁₆ x 22¹³⁄₁₆"

© 1995, The Cleveland Museum of Art, Andrew R.
and Martha Holden Jennings Fund

the prairie and prompt musings about those who experienced it before us. As white settlers became established, such burial markers would become more monumental, as if to counteract the unrelenting flatness around them and secure a sense of permanence in a land that seemed to offer so little.

Whittredge traveled west again in 1870 in the company of fellow artists John Kensett and Sanford Gifford, who were also accomplished landscapists. Of the group only Whittredge, who is better known for his scenes of dense forests and mountains and as a second-generation Hudson River School painter, produced many images of the prairie region.[101] In contrast to others who found the grasslands oppressive, he wrote later in his autobiography of his awe of the limitless horizons:

I had never seen the plains or anything like them. They impressed me deeply. I cared more for them than for the mountains, and very few of my western pictures have been produced from sketches made in the mountains, but rather from those made on the plains and with the mountains in the distance. Whoever crossed the plains at that period, notwithstanding its herds of buffalo and flocks of antelope, its wild horses, deer and fleet rabbits, could hardly fail to be impressed with its vastness and silence and the appearance everywhere of an innocent, primitive existence.[102]

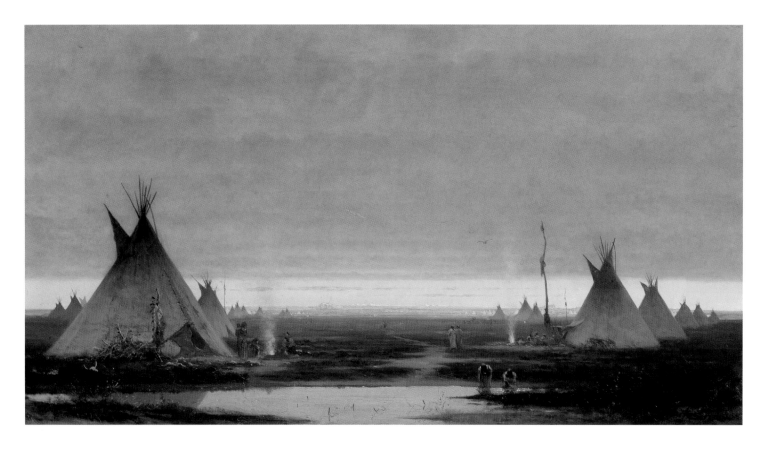

Even as he expressed his admiration for the prairies, as Whittredge admitted, most of his paintings of the terrain included the mountains in the background to provide scale and identifying elements. As a painter thoroughly imbued with the notion of the picturesque, Whittredge was rarely inclined to portray the prairies without definable elements of a traditional prospect.

Another artist reluctant to relinquish the conventional format, if not the subject matter, was Jules Tavernier (1844–1889). A native Frenchman and recognized painter of landscape and genre from his exhibitions at the Paris Salon, Tavernier signed on as an illustrator for *Harper's Weekly* immediately after his arrival in the United States in 1871. Two years later the magazine sent him, along with artist Paul Frenzeny, also a Frenchman, on an overland journey to California to provide a series of pictures for the publication. They traveled much of the way by rail and spent most of their time in prairie country, ranging throughout Nebraska, Kansas, Indian Territory (present-day Oklahoma), into Texas and eastern Colorado, before catching the Union Pacific to San Francisco.[103]

Often sketching together on the same woodblock, which would be sent east for engraving, Tavernier and Frenzeny drew a number of views that would have been familiar to their prede-

cessors in the West, but they also documented a variety of newer developments, including piles of buffalo bones, dugout homes of homesteaders, cattle drives, irrigation and mining operations, and the Indian reservations that were part of the prairies' new life and character. Returning to his original talent, oil painting (either in Denver where he and Frenzeny wintered or later in San Francisco), Tavernier painted a strikingly beautiful scene more in keeping with traditional prairie life. *Indian Village* (n.d., fig. 37) depicts a tranquil tepee village suffused with light and an almost tangible atmosphere. Composed as a traditional, classic landscape, it is quite symmetrical, with the right and left sides balanced on a central opening that extends to the horizon. The dark sky is heavy, but the air has cleared just at the horizon, lifting the clouds as if a blanket and echoing the flat terrain. The tepees are orderly, and the villagers move about serenely. The result is a pastoral portrayal of Native American life that by the 1870s was more often overshadowed by representations of savagery and despair.

PRAIRIES FROM THE PARLOR: THE ILLUSTRATORS

Although the artist-explorers produced the most credible images of the American prairies, picturing the prairies in art was not limited to adventurous individuals who actually traveled through the grasslands. Many others knew a good story when they heard one and recognized that it was even better when accompanied by dramatic images. Although most illustrated books on the subject would come later, *Davy Crockett's Almanack of Wild Sports in the West* used the persona of that colorful frontiersman, publishing witticisms, wisdom, and woodcut illustrations as early as the 1830s, including a prairie fire scene dominated by buffalo (1838, fig. 38). Such scenes, although

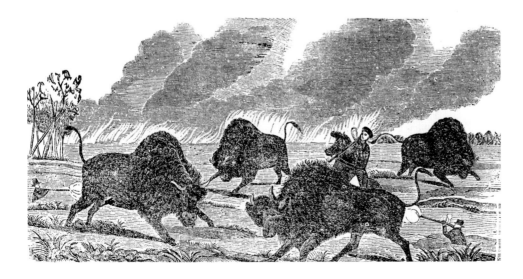

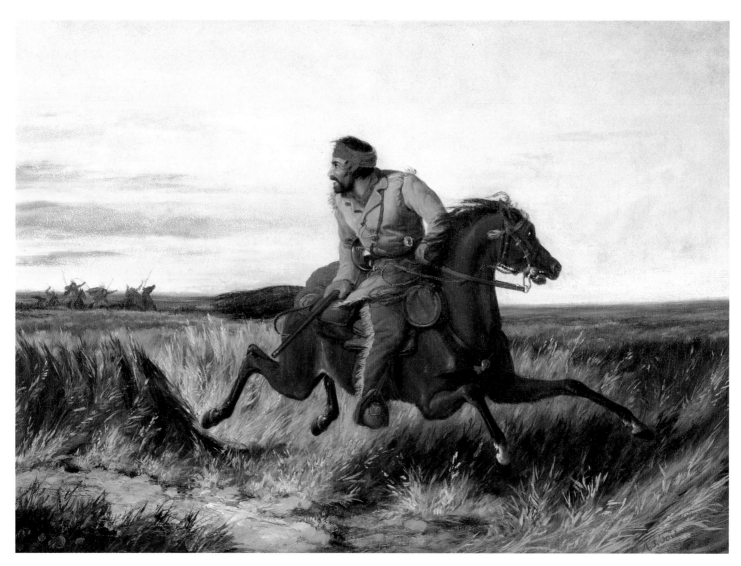

Figure 39

Arthur Fitzwilliam Tait (1819–1905)

The Prairie Hunter: One Rubbed Out, 1852

oil on canvas, 14 x 20"

Autry Museum of Western Heritage, Los Angeles

primitive in form, were extremely exotic at the time and surely whetted the interest of eastern readers fascinated with the frontier.[104]

With the rise of technology that aided printing in the 1850s and an increasingly literate and affluent population eager for information about their country's most exotic regions, publishing houses began to employ or commission artists, such as Tavernier and Frenzeny at *Harper's Weekly*, to illustrate themes of national interest, including the landscape of the American West and the prairies. The best known of these was Currier and Ives, but countless others produced images, as single prints available for purchase or as illustrations for magazines and illustrated books.[105] A comprehensive investigation of such illustrations would constitute a study in itself, so numerous and varied are they, but a few general characteristics were consistent.

Just as James Fenimore Cooper wrote his 1827 novel, *The Prairie,* in a study in Paris with expeditionary accounts as his primary references, many of these artists never traveled to the site of their subjects but contrived their fanciful depictions from other artists' images, from literary accounts, both fictional and nonfictional, and from their vivid imaginations. Their work obviously did not offer even the pretense of an eyewitness document, but their dramatic portrayals of life on the prairies added an important dimension to the emerging perception of America's grasslands in the popular imagination. For the most part their views emphasized human or animal action rather than landscape; still, in many examples the prairie is a strong element, not only giving the pictures a vivid setting but also contributing the defining characteristic of the work.

Sometimes illustrators drew directly on woodblocks or lithographic stones, which would be printed by technicians. In other cases they would provide drawings or monochromatic paintings, or for the most elaborate productions they would sell finished oil paintings to publishers who would then transform the image into prints. One artist who worked this way and specialized in frontier subjects, including prairies, was Arthur Fitzwilliam Tait. *The Prairie Hunter: One Rubbed Out* (1852, fig. 39) is one of his examples of such an original oil, and *The Trapper's Defence: Fire Fight Fire* (1862, fig. 40) is a print typical of those produced from such paintings. After publishers finished with the paintings, they would sell them at auction and the prints by subscription. Both these views are characteristic of the type of imagery that became popular, along with travel accounts and novels about life in the prairies during the 1850s, scenes that focused on the human drama in the grasslands rather than the landscape itself. In *The Prairie Hunter* Tait was capitalizing on the market for exciting Indian battle scenes; the fleeing hunter has just landed a shot and "rubbed out" one of his pursuers. In *The Trapper's Defence,* part of a series called "Life on the Prairie," the figures again dominate the composition, but the dramatic tension derives from the approaching fire, which can be repelled only by a backfire that the trappers desperately attempt to control.

Tait's success as a prairie artist may be surprising since he never saw the West and, indeed,

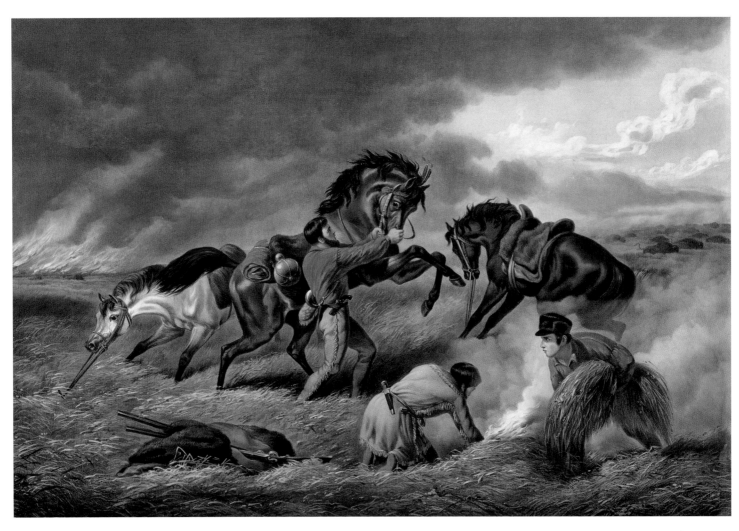

Figure 40

Arthur Fitzwilliam Tait

The Trapper's Defence: Fire Fight Fire, 1862

hand-colored lithograph, 19⅞ x 27³⁄₁₆"

Amon Carter Museum, Fort Worth, Texas (1971.58)

had only arrived in the United States in 1850. He had grown up in England but may have been inspired to immigrate by his acquaintance with George Catlin, who in the 1840s spent significant time in Tait's hometown of Liverpool. Tait's son later reported that the artist had joined Catlin's troupe that accompanied the Indian Gallery on its English tour.[106] Even though he never traveled west, Tait would have learned much from the experiences he did have, as well as from his friendship with fellow artist and illustrator William Ranney, who had spent time in the West and who provided him with accoutrements to fill his scenes. The work of the two men is similar in a number of ways. Each is known for dramatic action, even violence, and their numerous prairie subjects appeal to a romantic fascination with a mythic West of trappers, military parties, and pitched battles between whites and Indians. Both sold paintings to the popular lithographic firm of Currier and Ives, and through their wide distribution greatly influenced Easterners' understanding of the West.[107]

IDENTITY AND LOCATION

The first artists of the American prairies faced a difficult task, composing a landscape that to many appeared to contain nothing and seemed to *be* everything. They were further encumbered by backgrounds and training that limited their taste to more conventional landscapes and constrained by popular opinion that predisposed them to see a desert, a land with no prospects, if the land lacked trees. At the same time, they managed in a variety of ways not only to confront these problems but also to overcome them, and their resolutions in turn helped provide identity to a landscape that seemed so devoid of definition.

For those with more imagination, however, that which at first seemed so lacking in opportunity and interest became a prospect with no limits. It was available for almost any sort of interpretation, imposition, or characterization and could inspire a greater range of emotions than even the most heroic classic scene or the most refined pastoral one. This recognition was eloquently expressed by writer Theodore Winthrop in a letter to the most famous landscape painter of nineteenth-century America, Frederic Church, who, although he never painted prairies, contributed greatly to Americans' ability to appreciate their own scenery in all its variety. "Breadth of thought they claim," Winthrop wrote his friend from Saint Louis, "these dwellers on the sweeping prairies, a wide worldly range and terrestrial stride seven leagues, but their landscape is all horizon limitless, oceanlike, with no pyramid, mountain monuments of deathless aspiration. Earth is all; there is nothing to guide the look upward to the heavens that are above the earth. In prairieland thought may go galloping onward unchecked, saying this will I locate."[108]

Location, it seems, is what the art of the early prairies was really about. By searching for or inventing a prospect for a landscape that seemed to contain none, artists were finding themselves within that place, marking a land that in turn defined them and their viewers.

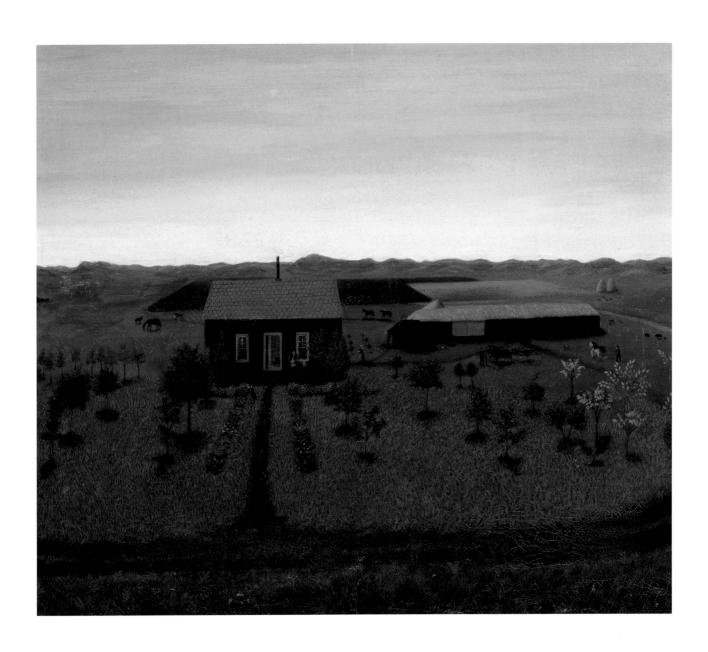

3 · PROMISES OF PROSPERITY
CULTIVATING THE GARDEN

The vast tract of prairie extending through all these regions is an important object of consideration. Amongst intelligent Americans, the question of—whether it can or cannot be peopled by civilized man? has often been agitated. Accustomed, as they are, to a profusion of timber, for buildings, fuel, and fences, they are not aware of the small quantity of that article which may be dispensed with, in a country abounding in another substance for fuel; nor can they conceive that fences, and even buildings, may be constructed with the application of a very small portion of timber. . . . the belief in America is, that the prairie cannot be inhabited by the whites. . . . My own opinion is, that it will not only be peopled and cultivated, but that it will be one of the most beautiful countries in the world.

John Bradbury, *Travels in the Interior of America,* 1817

Figure 41

Sallie Cover (active 1880s–1890s)

The Homestead of Ellsworth Ball, **1880s**

oil on canvas, 19½ x 23"

Nebraska State Historical Society, Lincoln

Sometime during the 1880s an artist named Sallie Cover, inspired by the springtime beauty of a Nebraska homestead, painted a charming view of a simple sod house and its blooming garden, *The Homestead of Ellsworth Ball* (1880s, fig. 41). Cover's painting is among the most evocative painted depictions of the prairies' new prospects after the Civil War. Here the land is young but luxuriously verdant; the humble home is an inviting extension of the prairies' fertility. The bustle of family activity, from the man plowing in the far right to the child picking flowers along the carefully tended row in front of the house, suggests cycles of growth and industriousness. The land, apart from the dark, newly cultivated field behind the house, is brilliantly green and sprinkled with prairie flowers, and the shingled roof on the "soddy" suggests a recently achieved prosperity.[1] Most indicative of the view's optimism are the saplings around the dwelling. They outline a carefully planned orchard that will shade the farm in future years and provide it with fruit of many varieties. Probably a homesteader herself, Cover would have known firsthand the challenges of transforming an empty claim into a productive farm, but instead of presenting a scene of dreary travail and squalid living, her view is one of hope and celebration. The joys of spring in a new land, no matter how modestly under way, she seems to

be saying, foretell of a bright future when the land is bountiful and visually variegated and progress is assured.[2]

By the 1870s and 1880s, as Cover's painting demonstrates, Euro-Americans had pushed not only across but also into the prairies and plains, bringing with them their preconceptions about what constituted a productive landscape. Through a series of events that included the Kansas-Nebraska Act of 1854, the arrival of the transcontinental railroad and its connecting lines, the issuance of land grants under the Homestead (1862) and Timber Culture (1873) acts, and the gradual removal of the "Indian problem," thousands of farmers, workers, and industrialists moved into the region and confronted the Great American Desert.[3] Partly to attract these settlers and partly through their efforts after they arrived, the long-standing notion that the grasslands were an uninhabitable waste was revised to conform to an old dream and a new reality.

The conceptual adaptation of the prairie landscape to a preconceived ideal and the work that accomplished that goal, transforming an enormous region from a supposedly barren desert to a blooming garden, constitute one of the epic events in American history. First envisioned in the imagination of boosters, politicians, and settlers who dreamed of their own piece of paradise, and then applied to the land itself by countless individuals who worked the soil, this process gave new definition to the prairies and substantially altered the way Americans understood their continent and themselves. Application and achievement went hand in hand with aesthetic adjustment, and with these accommodations the prairies' prospects improved dramatically, both economically and artistically.

IMAGE AND REALITY

By 1870, although settlers in many areas of the prairies were just arriving or were struggling simply to survive, some artists were already beginning to portray the region as a settled, arcadian landscape. Most focused on the eastern sections of the region, those that were more arable and were most readily settled and cultivated. Nonetheless, works such as Thomas Pritchard Rossiter's *Minnesota Prairie* (ca. 1858–1859, fig. 42) and Junius R. Sloan's *Cool Morning on the Prairie* (1866, fig. 43) contributed to Americans' ability to envision the entire grassland region as a pastoral garden. Apart from the humble log cabin in the right middle ground of Rossiter's view and the rude lean-to for the cattle in the lower left, the landscape looks more like a twentieth-century midwestern scene, or an eighteenth-century English one, than a fledgling prairie farm. With its carefully patterned fields that extend to the horizon, the neatly ordered haystacks, the fences and the bridge, this composition has all the elements of a classical prospect. From a different point of view, although a no less pastoral one, Sloan (an Indiana artist who was almost certainly painting his own locale in *Cool Morning on the Prairie*) depicted a small girl herding cows in a dewy pasture, replete with a split-rail fence that would have been entirely unavailable to prairie farmers

TOP: **Figure 42**

Thomas Pritchard Rossiter (1818–1871)

Minnesota Prairie, ca. 1858–1859

oil on canvas, 15⅜ x 25½"

Collection Frederick R. Weisman Art Museum, University of Minnesota, Minneapolis, gift of Daniel S. Feidt

BOTTOM: **Figure 43**

Junius R. Sloan (1827–1900)

Cool Morning on the Prairie, 1866

oil on canvas, 16⅜ x 34"

Percy H. Sloan Trust, Valparaiso University Museum of Art, Indiana

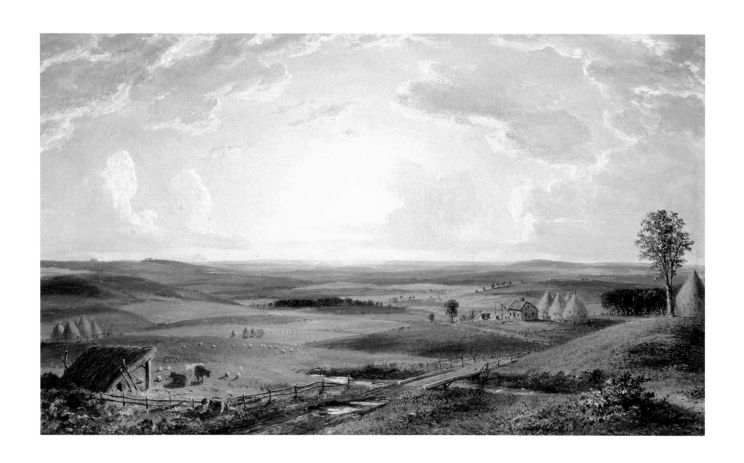

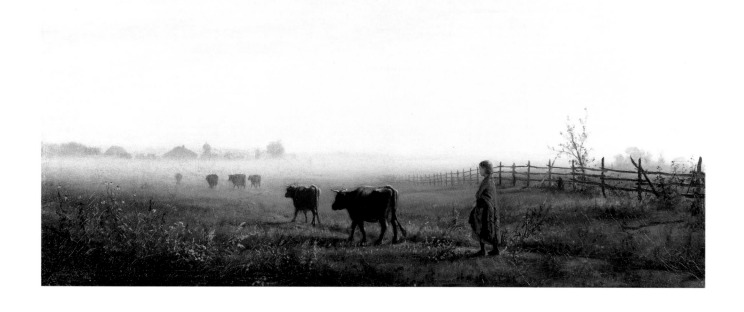

farther west.[4] Even though his and Rossiter's environments were substantially different from those in the western grasslands, their titles contain the term "prairie." Their bucolic images would have suggested to viewers, especially those unfamiliar with the extent and diversity of the grasslands, that tranquility and abundance were typical of all prairies, regardless of location. This promotional suggestiveness, conveyed in pictures and in late nineteenth-century rhetoric about the grasslands, was a powerful contributor to the actual transformation of the region.

The autobiography of painter Worthington Whittredge, who traveled through the western prairies about the same time that Rossiter and Sloan were creating these images, says of the "vastness and impressiveness of the plains" that "nothing could be more like an Arcadian landscape."[5] Tellingly, the artist rarely depicted the prairies without including elements such as mountains and rivers to provide definition to the expanse, but he seems to have admired the grasslands precisely for their lack of traditional characteristics. In their apparent emptiness they were open to associations, which for Whittredge included even the settled and historically significant (i.e., eastern and European) landscapes with which he was familiar. The uncertain prospects of the prairie were for him as malleable as his own pigments, and he reconfigured them in his imagination and on his canvases to fit his preconceptions of the beautiful.

The pastoralism of Sloan's and Rossiter's scenes and of Whittredge's ideal was hardly indicative of most people's lives in the prairies that lay west of the Mississippi, especially in the early years of settlement. The landscape's unique characteristics presented practical problems that far outweighed its aesthetic challenges, and they were not nearly as easy to dispel in reality as they

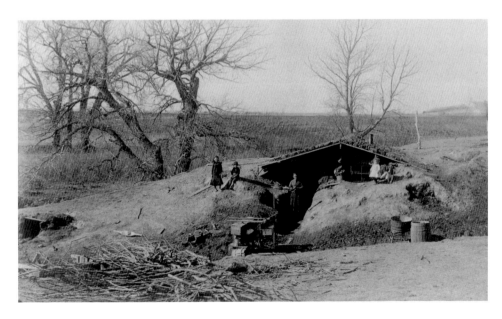

Figure 44
Anonymous
Family and Their Dugout, ca. 1870s
photograph, 11 x 14"
Nebraska State Historical Society, Lincoln

were on canvas or in a writer's imagination.[6] Many settlers arrived with high hopes to find that their vision of cultivated farms could be achieved only after years of hard labor, sacrifice, and repeated disappointments, if at all. The art of the period did, however, represent their story and their circumstances as well, providing an important balance to the more idyllic views of cultivated prairies.

As the photograph *Family and Their Dugout* (fig. 44), by an anonymous Nebraskan from the 1870s, demonstrates, constructing a dwelling without benefit of lumber or logs was one of the first concerns upon arrival on a prairie claim. The answer lay in the land itself; the thickly rooted sod made a passable building material, whether it was for the face of a dugout carved from the side of a rise or for the walls of a freestanding sod house. Although the biggest disadvantages of either type of structure were its dirtiness, resident insects, the lack of light, and a roof susceptible to leaks, dugouts and soddies with their three-foot-thick earthen walls were warm in the winter, cool in the summer, and inexpensive as well as relatively easy to construct.[7] As photographs of these humble abodes and their inhabitants suggest, the lives they contained, at least in retrospect, were both squalid and heroic. Burrowing underground because of the land's lack of building materials might seem an indignity, but like their neighbors—the prairie dogs, burrowing owls, and other subterranean creatures—hardy human settlers found their sustenance by becoming part of the land.

By the late 1860s and early 1870s, technological developments were encouraging settlement in the grassland region as never before. John Deere's invention and the mass production of a plow with a polished steel share facilitated the breaking of the otherwise impenetrable prairie sod.[8] Windmills and improved drilling methods were beginning to tap wells in areas with little or no reliable surface water. Railroads provided access to necessary supplies and the markets that prairie farming required to be financially viable. The invention of barbed wire enabled the fencing of the open, treeless landscape.[9] The soil, as it turned out, was exceptionally fertile in most places as long as it got sufficient rain and the right combination of other weather conditions.

Of inestimable importance in understanding life in and the art of the developing prairies, especially of the sod-house period of the 1870s and 1880s, are the photographs of Solomon Butcher (1856–1927), an erstwhile Nebraska homesteader and contemporary to Sallie Cover who devoted himself throughout the 1880s and beyond to making a pictorial history of Custer County in the central portion of his state. Trading portraits for food and lodging and financing his project through sales of the pictures and subscriptions to the eventual publication, Butcher traveled extensively, making images and collecting stories from his subjects. Although frustrated by a series of financial setbacks, he did finally publish this history and left a legacy of more than fifteen hundred photographs that chronicle the struggle to transform the prairies into the sought-after garden.[10]

As historian John Carter has noted, Butcher's photographs are not portraits in the traditional sense but rather portraits of states of existence, in which a family's house and possessions are as important as the homesteaders themselves. In many of the views the surrounding prairie landscape figures just as prominently, a characteristic that may be interpreted as a point of pride for the subjects as they pose in front of their property.[11] What is not visible, of course, is the interior of the home. Although some houses were hovels, others were as aesthetically pleasing as their owners could make them. Flowers were planted outside, either in pots or on the roof, and interiors could be relatively finished, complete with carpeting. Sarah Smith, a Nebraska homesteader, wrote in 1875 that her sod house was "very comfortable" and that "ours has a good fine floor in it and in the west is one whole window and in the sides are half windows, it is plastered and [with the] *pictures* hanging on the wall in a small quantity it would be hard to make you believe if you did not see the outside that you were in a house made of dirt."[12] From her description and Smith's emphasis on pictures in her home, it is clear that many homesteaders, despite their relatively primitive circumstances, were concerned with their aesthetic environment.

The pride and ambition with which many settlers regarded their land are dramatically embodied in Solomon Butcher's view entitled *East Custer County: Using All the Farm for Crops* (1886, fig. 45). The couple, their team, and their plow stand amid a corn crop that covers most of the ter-

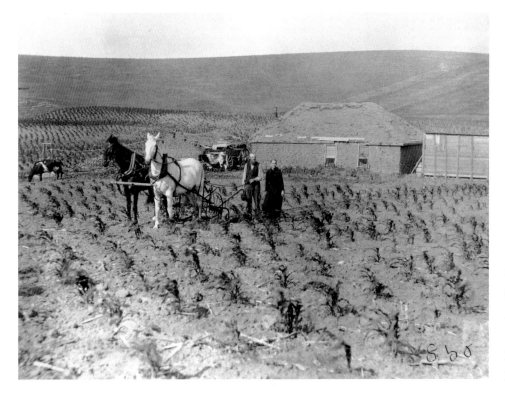

Figure 45

Solomon Butcher (1856–1927)

East Custer County: Using All the Farm for Crops,
1886

photograph, 11 x 14"

Nebraska State Historical Society, Lincoln

PLAIN PICTURES

rain, extending to within feet of the house itself. In a visible demonstration of their belief in the land's prospects, this family has maximized the potential of their acreage by planting as much ground as possible. After the first year of "sod corn," which was not expected to be a great harvest, the soil would gradually become sufficiently tilled, the prairie grass's roots decayed enough, to enable a bumper crop. This farmer's neatly planted, knee-high stalks hold such promise.[13]

The tremendous hope invested in spring planting all too often resulted in bitter disappointment, and in addition to what might be expected from too much or too little rain and from disease, the prairie region threatened farmers with at least two other crop disasters that were frequent enough to be of serious concern: grasshoppers and hail. Hailstorms were swift, scattered, and sporadic, but grasshopper infestations could be even more devastating, since they stripped hundreds of miles of vegetation and left eggs that would hatch the next year in a repetition of the catastrophe. The worst of these calamities came in 1874, when farmers throughout the prairie region were wiped out by a plague of locusts of biblical proportions, extending from Nebraska and the Dakotas into Minnesota. Many were forced to abandon their claims, and the misfortunes continued on a lesser scale until the mid-twentieth century, when reliable pesticides were developed.[14] Even so, as Butcher's photographs so clearly demonstrate, faith in the prairie-as-garden persisted. The homesteaders' diligence in pursuing their goal and the transformation that they achieved were undeniable evidence of the power of the dream and the resilience of the settlers' faith in its fulfillment.

A PRAIRIE EDEN

Even as the prairies were being dismissed as deserts by early explorers, they inspired visions of gardens. As early as the 1670s, Louis Jolliet had recognized that the lack of trees would enable a farmer to begin plowing "the very day of his arrival." More important even than such testimonials, however, was the need to make this enormous region conform to a preconceived vision of an idyllic America. Garden of Eden associations, for example, had been central to a mythic New World since Columbus's arrival and continued unabated through the nineteenth century. Agrarian republicanism of the sort Thomas Jefferson espoused had envisioned a United States populated with yeoman farmers, an ideal elaborated throughout the nineteenth century with the idea of progress that symbolized the movement of the American people toward their glorious future. Ideals powerful enough to motivate an entire country could not allow the central grasslands, nearly a third of the continent, to be relegated to the category of waste.

Contradicting the pervasive, persistent, and authoritative characterizations of the prairies as desert and altering them to their opposite required, in retrospect, a breathtaking presumption. In reality, of course, the substantive transformation of the land was a difficult and lengthy endeavor by thousands of individuals, but metaphorically the process seems to have been swift and rel-

atively effortless, as simple as shifting one's point of view to see opportunity in the openness and rationalizing the disparity between the vision and the envisioned as reasonably as possible. For prairie boosters, the landscape could be perceived as a paradise just as easily as it could be a desert wasteland. Some even argued, as Jolliet had two centuries before, that emptiness was a virtue in that it posed no obstacle to cultivation.

Boosterism notwithstanding, Edenic metaphors were unusually problematic in the context of the prairies and required creative interpretation to accommodate the land's special characteristics.[15] Landscapes of a more conventional sort better served the Adamic myth. By the late 1840s and early 1850s, however, it had been recognized that even the most desolate grasslands could, with effort, be transformed, especially if the progress of the country was at stake. Among the earliest and most prominent of the believers were Missouri senator Thomas Hart Benton and his son-in-law John C. Frémont, who infused their expansionist rhetoric with glowing reports of fertility beyond the Missouri. Backed by the authority of such respected men who knew the region, and fueled with desire, before long anyone who stood to gain was chiming in. State immigrant's associations and railroad land departments played exceptionally important roles, and many journalists of the region, such as Samuel Bowles of the *Springfield [Mass.] Republican,* were underwritten by interested investors.[16] As historian Henry Nash Smith explained, because of such investments, to prompt general interest in westward expansion and to encourage people to claim and cultivate the land, "it was therefore necessary that the settler's battle with drought and dust and wind and grasshoppers should be supported by the westward extension of the myth of the garden."[17] That the myth sometimes bordered on tall tale seemed irrelevant, and nearly everyone from prominent leaders to optimistic homesteaders succumbed to the promise.

The result, as we see in Butcher's photographs, was the heroizing of the settler, the glorification of the conventional cultivated landscape, and, most important, the provision of the prairies with prospects, artistic as well as economic. The carefully tilled furrows that followed rectilinear section lines, the newly planted trees, the emerging vertical structures, and the time-honored activities of farmers finally gave artists something to fill their frames, subjects that satisfyingly recalled narrative themes with long and respectable artistic pedigrees. With these physical and metaphorical endowments, the land at last had a promising future, reassuring the country of its mission and its progress toward that goal.

THE GOOD ORCHARD

The aesthetic manipulation of the prairies was nowhere more evident than in the widespread planting of trees, which by the mid-1870s bordered on public obsession. The Timber Culture Act of 1873 (initiated by a Nebraska senator) encouraged the practice, providing homesteaders an additional quarter section (160 acres, or a quarter of a square mile) if they would plant 40 of those acres in trees and maintain them for ten years. Known as a tree claim, this could add sub-

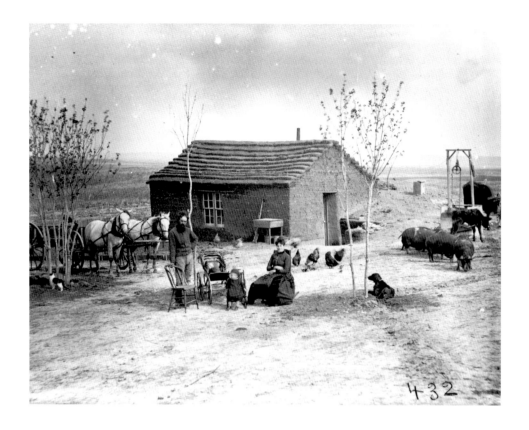

stantially to a family's landholdings and, over time, profoundly alter the appearance of the land-scape. Trees could have tax benefits too. In 1861 the Nebraska territorial legislature, for example, provided a $50 deduction on property tax assessments if a homesteader planted one acre with one hundred fruit trees or four hundred forest trees; the law was amended in subsequent years to the additional benefit of landowners. The plan became so popular in Nebraska that the state legislature made "The Tree Planters State" the official nickname in 1895.[18] The trees themselves were so prolific there that in 1902 President Theodore Roosevelt designated a large area in the sandhills, which had formerly been entirely prairie but was now wholly wooded, as a national forest. Forestry programs have continued in the prairie states down to the present.[19]

Solomon Butcher's photograph simply titled *East Custer County, Nebraska* (1887, fig. 46) is one of the most evocative portrayals of the efforts to transform the prairies into a timbered ideal. This family proudly appears in front of their sod house amid their livestock, with their child *and* their trees. In an existence that was at best tenuous, trees were an overtly positive and tangible addition to the horizontal landscape, but in this view, positioned amid the cat, the team, the dog, the chickens, the child, and the couple, the saplings seem almost cherished members of the family. That was, in fact, the opinion of some women, such as Illinois settler Eliza Farnham, who

wrote *Life in Prairie Land* in 1846. In her book she referred to individual trees and shrubs that she and her family planted as her "companion" during the early years when she had little company. She compared the land to "a strong and generous parent, whose arms are spread to extend protection, happiness, and life," and said of the trees that her "heart turns fondly to these tall tenants of the plain as to elder brothers."[20]

This familial notion persisted and was popularized on a broad scale in the 1870s, most especially by J. Sterling Morton, one of Nebraska's most prominent early citizens. Like good mothers or fathers who hover over their children, the leafy boughs of trees, he asserted, made those who lived in their shadow "better in mind and in heart." As the founder of Arbor Day and later secretary of agriculture for President Grover Cleveland, Morton viewed tree planting as more than an aesthetic indulgence or even a practical need: it was a moral cause. In his Fruit Address of 1872, Morton proclaimed,

There is beauty in a well ordered orchard which is a joy forever. It is a blessing to him who plants it, and it perpetuates his name and memory, keeping it fresh as the fruit it bears long after he has ceased to live. There is comfort in a good orchard, in that it makes the new home more like the old home in the east.... Orchards are the missionaries of culture and refinement. They make the people among whom they grow a better and more thoughtful people. If every farmer in Nebraska will plant out and cultivate an orchard and a flower garden, together with a few forest trees, this will become mentally and morally the best agricultural state.[21]

From Morton's perspective, the treeless grasslands had to be altered to make them conducive to the moral growth of their inhabitants. An empty landscape, he implied, is a potentially hazardous place, at least culturally and socially, and only through its transformation can it be made supportive of positive human development. How widely held this position was is unclear, but undeniably the tree planting campaign was enormously popular, as the ubiquitous appearance of trees on the contemporary prairie indicates. A solution to the uncomfortable prairie aesthetic had at last been found, and it answered the empty prospect's deficiencies in all its forms—visual, moral, and economic.

RAIN FOLLOWS THE PLOW

It was the lack of trees, as much as any other single factor, that led to the early and persistent belief that the grasslands were sterile. As late as 1858, Lieutenant Gouverneur K. Warren of the U.S. Corps of Topographical Engineers was reporting, "There is no disguising the fact that a great portion of it [the prairie] is irreclaimable desert, with only a little wood and cultivable land along the streams."[22] If the region could only become more timbered, it was hoped, the overall fertility, temperateness, and productivity of the region might be improved. Wind velocity could

be slowed, widespread shade would reduce the summer heat, and because the trees would store moisture in their roots and transfuse it to the air through their leaves, the water would return to the soil, in the form of rain. The role of fires in keeping woody growth down was also recognized, and if they could be controlled, perhaps more trees would grow.

The tree issue was part of a larger belief that cultivation itself could change climate. Known as the "rain follows the plow" theory, this idea as much as any other promoted the agricultural development of the prairie landscape, especially because, by providing a method for transforming land from a desert into a garden, it rationalized and validated settlement in areas once declared barren. More than simply an idealistic and naive desire of land-hungry settlers for arable land, the concept was promoted by some of the most reputable authorities of the time, employed at the country's most prestigious institutions. Eagerly accepted at first, the theory today seems so bizarre as to have been a conspiracy concocted solely for capitalist gain, with little regard for the land itself or for those who would make it their home.[23]

The notion that the prairie region's climate could be altered by settlement and cultivation gained momentum after the Civil War, but it had been expressed at least as early as 1844. In his influential book *Commerce of the Prairies,* Josiah Gregg, for example, speculated that planting trees and other foliage in the western grasslands might affect rainfall:

The high plains seem too dry and lifeless to produce timber; yet might not the vicissitudes of nature operate a change likewise upon the seasons? Why may we not suppose that the genial influences of civilization—that extensive cultivation of the earth—might contribute to the multiplication of showers, as it certain does of fountains? Or that the shady groves, as they advance upon the prairies, may have some effect upon the seasons? At least many old settlers maintain that the droughts are becoming less oppressive in the West.[24]

In 1888 the popular *Harper's New Monthly Magazine* reiterated the by then common idea in vivid terms, outlining the basic assumption: "It is certain that the buffalo-grass sod which has covered these plains for centuries has become as impervious to water as a cow-boy's slicker. Hence the rain never penetrates it, but rushes off the 'divides' in a fury to reach the rivers. . . . But when the prairie sod has once been ploughed, the soil absorbs water like a sponge."[25] This absorption over a broad area, it continued, would be cyclically evaporated into the atmosphere, which in turn would discharge the moisture again in the form of rain. Ultimately the very nature of the weather would change to the advantage of farmers, as Charles Dana Wilber, professor and superintendent of the Department of Geology and Mineralogy at the University of Nebraska, explained:

Suppose [farmers over] 50 miles, in width, from Manitoba to Texas, could, acting in concert, turn over the prairie sod, and after deep plowing and receiving the rain and moisture, present a new surface of green,

growing crops instead of dry, hard baked earth covered with sparse buffalo grass. No one can question or doubt the inevitable effect of this cool condensing surface upon the moisture in the atmosphere. . . . The chief agency in this transformation is agriculture. To be more concise, *rain follows the plow.*[26]

These ideas made some men and their respective causes famous. Eastern journalist Horace Greeley, for example, became a household name, in part for espousing such encouraging news. Federal geologist Ferdinand Hayden, who completed a survey of Nebraska Territory in 1867–1868 and made similar prophecies, received additional congressional appropriations from 1869 to 1872 to explore Wyoming, leading to national prominence for Hayden and to the designation of the first national park, Yellowstone, which Hayden surveyed. Most famous of all, at least at the time, was William Gilpin, who had been with Frémont in 1843, subsequently wrote several books devoted to his enthusiasm for the American prairies and their prospects, and became governor of Colorado Territory. Gilpin proclaimed, "These PLAINS are not *deserts,* but the opposite and are the cardinal basis of the future empire of commerce and industry now erecting itself on the North American Continent. They are calcareous, and form the PASTORAL GARDEN OF THE WORLD. . . . The prospect is everywhere gently undulating and graceful, being bounded as on the ocean, by the horizon. . . . Upon them PASTORAL AGRICULTURE will become a separate grand department of national industry."[27] For Gilpin the prairies were at the heart of manifest destiny, and it was through them that the greatness of America would be achieved. Through his and others' consistent and authoritarian reiteration of the theme, it was not long until such concepts became the norm in everything from land policy to art.

GUIDEBOOKS, RAILROADS, AND THE PRINTED IMAGE

One of the most pointed representations of the prairies and their role in manifest destiny as Gilpin understood them was a small but influential image, *American Progress* (1872, fig. 6), by John Gast. America's national spirit is represented in the painting as a floating female figure who glides over the country, from Manhattan on the far right to a murky West on the far left, stringing telegraph wire as she proceeds. As we see her she is high above the prairies, and the grasslands below rise like a large greenish mound, distinguished here and there by a wagon train, a stagecoach, a railroad, and miners pushing Native Americans and bison alike to the margins of the scene. At the lower right, just behind the leading edge of these early inhabitants, is the farmer with his plow, carefully tending a fenced field already bordered with small trees. Implied, of course, is that although the farmer is not on the first wave of expansion, he will be the one who transforms the landscape and provides it with its ultimate cultivation and value.

Gast, a chromolithographic printer not known for any other paintings, produced this striking image at the request of one of the most prolific guidebook writers of the time, George Crofutt,

who, by his own account, designed the picture.[28] An engraved version of the work appeared in at least one edition of Crofutt's popular guide to the transcontinental railroad line, *Crofutt's New Overland Tourist and Pacific Coast Guide,* which he had first published in 1869, and Gast's painting also appeared in chromolithograph form.[29] Regardless of authorship, the image allegorizes not only manifest destiny, as many have recognized, but as well the expansion of this nationalism into the prairie and plains region. The pictorial embodiment of Gilpin's proclamation, Gast and Crofutt's *American Progress* positions the prairies as the center of the continent, literally and figuratively, and emphasizes their fundamental importance to the national prospect.

George Crofutt's enterprising use of images was not unique. After the Civil War, illustrated guidebooks, periodicals, and publications of all sorts proliferated, in part because improved technology facilitated plate and paper production and because it was becoming clear that illustrating a text greatly strengthened readers' interest. Guidebooks to the West became exceptionally popular, especially after the transcontinental line was completed in 1869. Often funded by the railroads themselves, these publications were not only directed to the tourist passenger but also to the prospective settler, who would contribute greatly to commerce and traffic on the route. The head of the Burlington and Missouri River Railroad's land department wrote in 1859, "We are beginning to find that he who buildeth a railroad west of the Mississippi must also find a population and build up business. We wish to blow as loud a trumpet as the merits of our position warrant." Railroad company tactics were often outlandish, extending to intensive promotions for prospective immigrants in foreign countries. They almost always promised far more than could be reasonably expected, and even the most modest reiterated the glowing prospects for the region and its new agricultural identity. "Stop Paying Rent," the *Dairy and Farm Journal* of West Liberty, Iowa, beckoned in 1883 in a typical advertisement by the Burlington Railroad, "and buy a home of your own in Nebraska, the garden state of the West."[30]

The Union Pacific Railroad, the principal partner in the transcontinental railway, put out two promotional publications almost immediately upon completion of its line: *Guide to the Union Pacific Railroad Lands* (1870) and a newsletter, *The Pioneer* (1874). Furthermore, George Crofutt, who published privately for the company, was joined by many other entrepreneurs who capitalized on the vogue for western travel. All, of course, painted a rosy picture of the prairies through which the trains ran.[31] For example, Albert D. Richardson's *Beyond the Mississippi* (1867), which anticipated the completion of the line, included several prairie scenes, including *Building the Union Pacific Railroad in Nebraska* (fig. 47), by Alfred R. Waud (1828–1891). In this view the actual construction of the line takes place against the setting of the open grasslands, although the flat Nebraska landscape has been accentuated with low mountains in the background.[32] Crofutt's later commentary put the achievement into perspective: "For five hundred miles west of Omaha the country was bare of lumber save a limited supply of cottonwood on the islands in and along

the Platte River, wholly unfit for railroad purposes. East of the river the same aspect was presented, so that the company were compelled to purchase ties cut in Michigan, Pennsylvania, and New York, which cost, delivered at Omaha, $2.50 per tie."[33] The marvel of the railroad was rendered even more impressive through such statistics, and although this daunting lack of resources should have been a warning to prospective settlers who rode the trains or purchased land from the railroad, it seems instead to have fueled their determination to provide the land with the timber it lacked.

Other popular images presented the railroad as a solitary cultural force braving the odds in prairieland. In *Prairie Fires of the Great West* (1872, fig. 48), by an anonymous illustrator, a prairie fire along the horizon threatens to overcome the train that bravely steams ahead to the left with its precious cargo of passenger cars. Instead of being menacing, however, the scene is oddly reassuring; the defiant presence of the locomotive in the formerly trackless waste seems to belie the danger. The dominance of the machine over any natural predator, as conveyed by its determination to continue in the face of such challenges, suggests a happy outcome and presumes to assure viewers and potential travelers of their safety. The view may even have been chosen to emphasize the speed of the trains, contradicting the common perception of many who worried about prairie fires, "a flame wall a thousand feet high in the middle and roaring straight down . . . with a gale behind which drove it faster than any train could travel."[34]

In addition to such illustrations, textual characterizations of the prairies in guidebooks and travel accounts presented an optimistic view of the land's new prospects. The grasslands were no

LEFT: **Figure 47**

Alfred R. Waud (1828–1891)

Building the Union Pacific Railroad in Nebraska, *1867*

engraving, from Albert D. Richardson, *Beyond the Mississippi,* **facing p. 567, 4 x 6½"**

University of Iowa Libraries

RIGHT: **Figure 48**

Anonymous

Prairie Fires of the Great West, **1872**

hand-colored lithograph, 9¼ x 12⅛"

Library of Congress

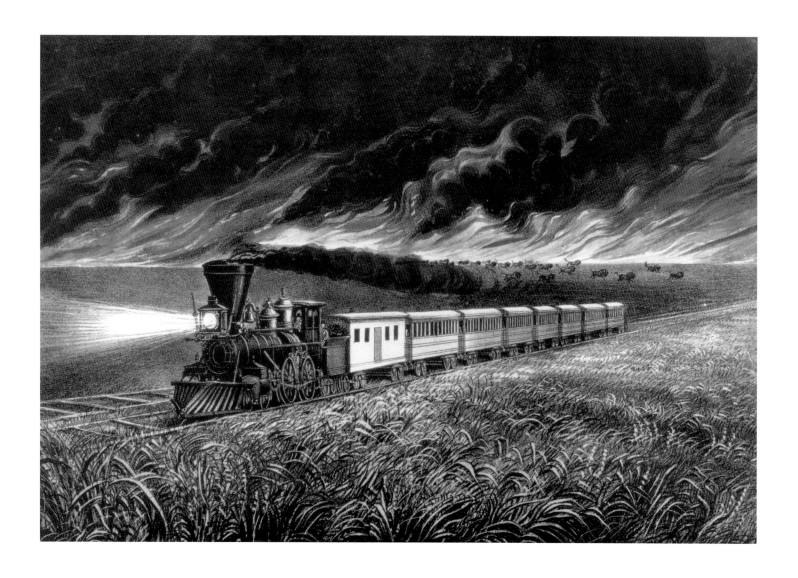

longer overwhelmingly desolate, they insisted, but rather beautiful, rich, and promising. As journalist Samuel Bowles wrote in his popular *Across the Continent* in 1866, "The country . . . presents the characteristics of the finest prairie scenery of the West—illimitable stretches of exquisite green surface . . . spreading out as far as the eye can reach, with the distant fringe of thin forest by the water-course, and sending forth and receiving the sun at morning and evening, as the ocean seems to discharge and accept it when we travel the trackless space. No land could be richer, no sight more deeply impress you with the measureless extent of our country and its unimproved capacities."[35] Illustrators also presented their subjects in the most appealing ways; Alfred Waud, for example, in *A Prairie Home* (1869, fig. 49), a wood engraving in Frederick Goddard's

Where to Emigrate, and Why (1869), depicted a large house and barn, surrounded by trees, split-rail fence, good-size stream, and bounteous wheat field. The nearest neighbors are only a short distance away, in the middle ground of the scene, and there is productive work to do, harvesting the sheaves, as well as time for leisure, represented by the boys fishing in the foreground.

As Bowles extolled the untapped bounty of the land, noting with special appreciation the prairie atmosphere "so pure, so rare, so ethereal, as pictures every object with a pre-Raphaelite distinctness," he also approved of the steady stream of "long trains of wagons and carts . . . going in empty, coming out laden with corn for man and beast." The prairies were so luxuriant, he insisted, that working draft animals actually gained weight on their trek west. "They depend entirely upon the prairies for food as they go along; and indeed the animals grow stronger and fatter as they move on in their summer campaign of work, coming out of their winter rest poor and scrawny, and going back into it in the fall, fat and hearty."[36]

Even beyond the hundredth meridian, where the grass was undeniably sparser, boosters found a positive spin. Although Bowles, whose travel and writing were underwritten by railroad interests, admitted that they "found the soil growing thinner and thinner" the farther west they went, he adamantly refused to dismiss the land as a waste. "Yet [it is] not a desert, as such is commonly interpreted—not worthless, by any means. The soil is fat, indeed, compared with your New England pine plains. It yields a coarse and thin grass that, green or dry, makes the best food for cattle that the Continent offers. It is indeed the great Pasture of the nation. This is its present use and its future profit. . . . Let us then, not despise the Plains; but turn their capacities to best

account."[37] Earlier travelers had reported very different conditions, but Bowles, always one to extol the attributes of the West, spared no enthusiasm on the lowly prairies. For him, as for Gilpin and the visual promoters such as Gast, Crofutt, and Waud, the grasslands were among America's most promising prospects.[38]

ORDER AND THE NEW AESTHETIC

In response to such claims and in search of cheap land, settlers arrived in the prairies and plains in increasing numbers throughout the 1870s. The open spaces and the widespread 160-acre claims, compounded by the lack of roads in the early years, made transportation difficult and community a precious commodity. Towns became all the more important for the disbursement of goods and services but also as centers of social interaction. Correspondingly, prairie towns became a significant artistic subject as statements of pride in community achievement and their forward-looking visions of the future.[39]

Until the mid-twentieth century, prairie towns appear in photographs and in bird's-eye lithographic prints more often than in paintings. Sometimes the view is up a main street, but more often, when possible, it is from a high prospect, as in the photograph by Alexander Gardner (1821–1882) entitled *Overlooking Lawrence and the Kansas River* (1867, fig. 50). In this view, taken during the Kansas Pacific Railroad Survey, the isolation of the single monumental building starkly emphasizes the determination of early town planners to endow their surroundings with a sense of permanence.[40] Sited on one of the highest points in town, on an elevated overlook with a view of the meandering river flanked by numerous dwellings and businesses, the structure is clearly positioned to take advantage of the vista's picturesqueness, and Gardner focuses on that aspect of the scene. The unusually hilly location amid the Kansas prairies was chosen as the first establishment of the abolitionist Emigrant Aid Society, which sought to fill the territory with antislavery sentiment, and was (and continues to be) frequently admired for its beauty. A founding resident, Clarinda Nichols, wrote of the town, presumably before the building in Gardner's view was constructed, "I wish I could convey to your readers a bird's eye view. . . . let me linger on '*Capitol Hill,*' a noble, but gradually reached elevation in the center of the most beautiful and magnificent scene my eye ever rested upon. In the south-west I see the Wakarusa [River] approach the southern banks of the Kanzas, as if it would lovingly pour its limpid treasures into her broad deep bosom."[41] A native Vermonter, she naturally would have responded to the rolling terrain and shimmering river, but any prospects that allowed viewers to rise above and see across the flat land were widely appreciated, as the proliferation of aerial town views demonstrates.

Bird's-eye-view town portraits, such as A. Ruger's *Bird's-Eye View of Iowa City* (1868, fig. 51), number among the most obvious expressions of community pride and local boosterism in the developing prairie region. As John W. Reps has found in his exhaustive research on the subject, thousands of towns, many of which were in the central portion of the United States, were depicted in this way. Artists would usually produce the prints on speculation and then, through newspaper advertising, sell them directly to the public, usually charging $2 to $5 each. Sometimes they sought bulk commissions from local businesses or from railroads interested in promoting a town. The detail in these images, which are often colored by hand or machine, is exceptionally fine, appealing to the desire of residents to see their own houses and businesses. The sweeping perspective allowed everything to be included, along with a sense of the city's physical setting, which added monumentality and prestige to the representation. In their form and their emphasis on the town's growing prospects, the prints encouraged a visual claiming by the community, a "magisterial gaze" that appropriates all that is surveyed. As such they are similar to the English estate prospect pictures of the eighteenth century, not to mention European town views that date back as far as the fifteenth century.[42]

One of the striking characteristics of the town views, an effect that is even more apparent from today's airplane windows, is the emphasis on the grid plan, which exerts itself so defiant-

Figure 51

A. Ruger (active 1860s)

Bird's-Eye View of Iowa City, Johnson County, Iowa, 1868

hand-colored lithograph, 20½ x 26"

State Historical Society of Iowa, Iowa City

ly on the contemporary landscape. Unlike most early eastern cities (New York and Washington are major exceptions), which grew almost organically as population increased, resulting in winding streets that are named rather than numbered (and thus rendered so confusing to all but local residents), most prairie towns were surveyed and planned on paper before they were ever constituted or inhabited. The surrounding landscape was gridded by surveyors into square-mile sections before it was parceled out through the Preemption and Homestead acts, and roads tended to follow those lines, reinforcing the patterns. The imposed, regularized plan, whether rural or urban, shaped the developing land, making by the twentieth century what had been the most featureless region in America into the most ordered.[43]

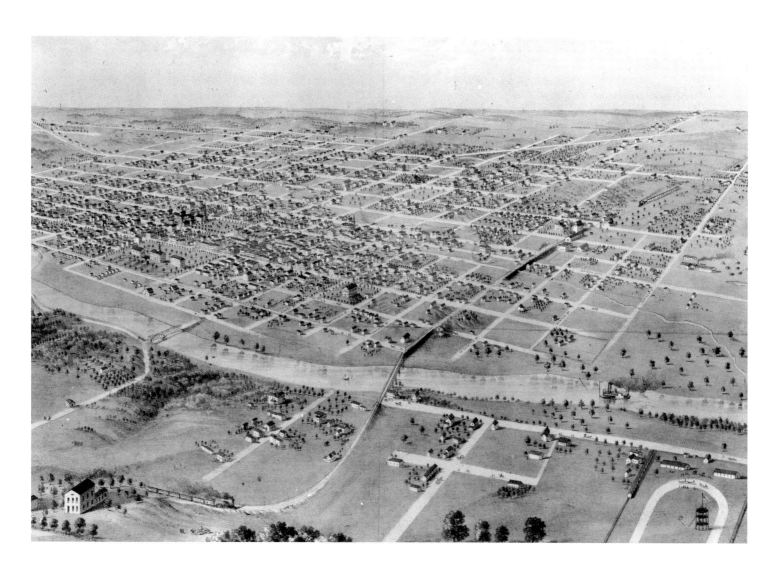

Akin to the aerial town views, which usually position the city amid a larger landscape, are photographs such as Solomon Butcher's view of Comstock, in Custer County, Nebraska (1904, fig. 52), founded in 1899 on a trunk line of the B&M Railroad.[44] From eye level, however, the town's vulnerability within the surrounding prairie is emphasized; it lacks the domination over the landscape that is key to the lithographs' appeal. A simple cluster of frame buildings, given scale by the figures and their wagon and buggy in front but nevertheless overwhelmed within the larger context, poignantly evokes the isolation of these communities amid the expansive grasslands. In this way Butcher's view corresponds to a similar oasis Owen Wister described in his contemporaneous novel *The Virginian* (1902):

Town, as they called it, pleased me the less, the longer I saw it. . . . I have seen and slept in many like it since. Scattered wide, they littered the frontier from the Columbia to the Rio Grande, from the Missouri to the Sierras. They lay stark, dotted over a planet of treeless dust, like soiled packs of cards. Each was similar to the next, as one old five-spot of clubs resembles another. Houses, empty bottles, and garbage, they were forever of the same shapeless pattern. More forlorn they were than stale bones. They seemed to have been strewn there by the wind and to be waiting until the wind should come again and blow them away.[45]

Regardless of their lack of real permanence, towns provided an important demarcation on the prairies between the civilized and the uncultivated. It must be noted that in the early days, such demarcation was not quite the same as the difference between city and country. In a land so boundless, so without delineation as the prairies were before the twentieth century, "country" as defined in the East would have been welcomed, with its patterned vistas of cultivated fields, commodious barns, and neatly fenced perimeters.

PERMANENT PRAIRIESIANS

In a region where anything rising above the horizon became a locating device, even the humblest of markers could become a focal point of enormous significance. Psychologically as well as visually, vertical elements provided relief from the oppression of the horizontal, alleviating what Robert Louis Stevenson called "a sickness of the vision peculiar to these empty plains."[46] The explorers' concern about being physically lost, the homesteaders' anguish about losing touch with family and their earlier identities, the often repeated horror at the oblivion of the featureless expanse, and the immensity of the peculiar silence were all compounded by the lack of landmarks and were likened by many to death. As a young Dakota boy wrote in the 1880s, the treeless prairie reminded him "of an enormous thing long dead."[47]

Death on the prairie was, of course, made even more poignant by this apparently lifeless landscape. A common sight on the major trails by the 1860s, graves had formed the focus of Worthington Whittredge's *Graves of Travellers, Fort Kearney, Nebraska* (1866, fig. 36). Writers too

Figure 52

Solomon Butcher (1856–1927)

Comstock, Custer County, Nebraska, 1904

photograph, 11 x 14"

Nebraska State Historical Society, Lincoln

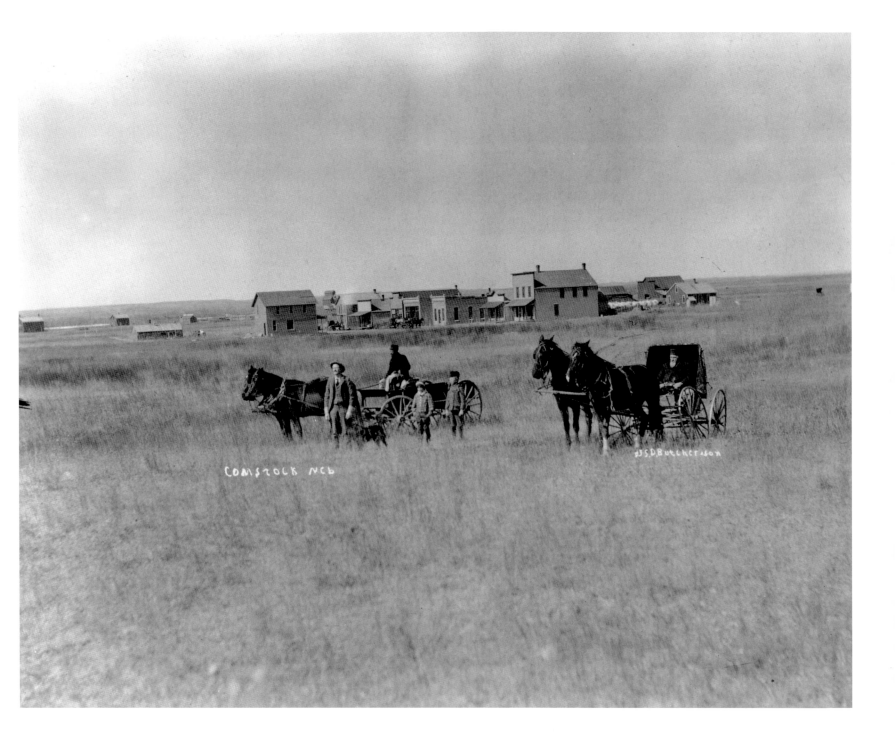

COMSTOCK NEB

S.D.Butcher&Son

remarked frequently on the tangible evidence of life's fragility in the prairies. Samuel Bowles noted that "occasionally the pathos of a human grave gave a deeper touch to our thoughts of death on the Plains, deepened too, by the knowledge that the wolf would soon violate its sanctity, and scatter the sacred bones of father, mother, or child over the waste prairie."[48] Especially vivid were women's observations; Cecelia McMillen Adams and Maria Parsons Belshaw both kept track of their days along the trail to Oregon in 1852–1853 by the number of graves they passed. Another noted that "it is common to see beds and clothing discarded by the road not to be used again. It indicates a death."[49]

Poignantly evident in Butcher's and others' photographs of families clustered around the grave of a departed relative, usually a child, or holding a portrait of the deceased, death was inescapable and became an important landmark, quite literally, in the lives of prairie dwellers and a significant motif in prairie art. Such vulnerability within a landscape that had so few visible reminders of time helped motivate the construction, when it was possible, of more permanent cemeteries, marked by massive stone monuments. Increasingly evident in the prairies as the settlers became established and more prosperous, gravestones such as that pictured by Joseph Judd Pennell (1857–1926) in his photograph *Tom Flanagan's Monument* (1898, fig. 53) testified to the desire for permanence among the living and the cultivating influence of the prairies' dead.[50] Carefully tended and usually set on a rise surrounded by trees, these islands of civilization, these bold markers to permanent prairiesians, even today demand contemplation within the open horizon for their simultaneous audacity and humility in the face of such enormity.

LEFT: **Figure 53**
Joseph Judd Pennell (1857–1926)
Tom Flanagan's Monument, 1898
silver gelatin print, 7¼ x 8⅞"
Spencer Museum of Art, University of Kansas, Lawrence

RIGHT: **Figure 54**
Olof Krans (1838–1916)
Corn Planting, 1896
oil on canvas, 24 x 39"
Bishop Hill State Historic Site, Illinois Historic Preservation Agency

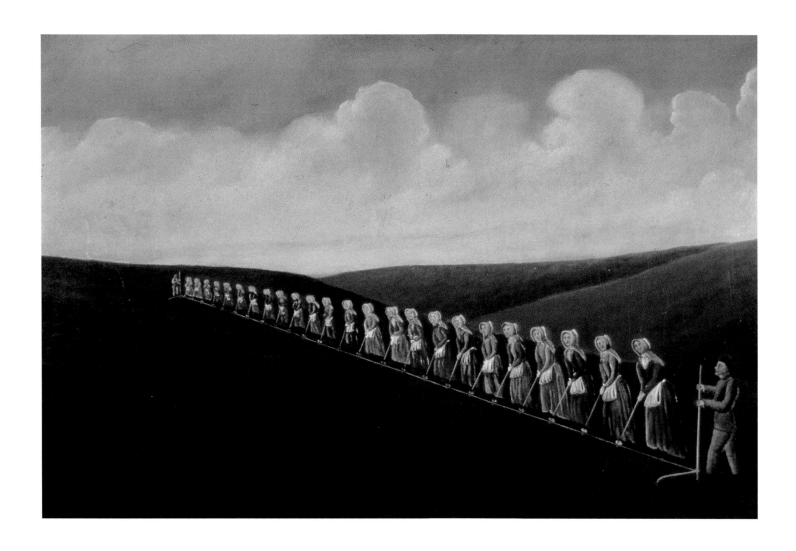

Among those who peopled the prairies, in contrast to the stereotypical image of the Midwesterner as white and part of a conventional family, a wide variety of individuals moved to the region after 1870. Although traditional nuclear families and patterns of racial segregation accompanied the new settlers, on the prairies as in no previous American settlement a wider range of ethnic groups as well as single women were able to lay claim to their own place and future.[51] Few of these individuals—whether minorities, immigrants, or white women—were themselves artists, but they formed a significant if small subject group within the visual characterization of the prairie landscape.[52]

One of the few immigrant artists in the early prairies was Olof Krans (1838–1916), a naive

painter and member of the Swedish Jansonist community of Bishop Hill, Illinois.[53] Like many other utopian groups, Bishop Hill members lived and worked in common, and as Krans later depicted in his *Corn Planting* (1896, fig. 54), both men and women took on the farm chores in teams. One visitor wrote,

We had never before seen so large a farm, nor one so well cultivated. One of the trustees took us to an adjacent hill, from which we had a view of the Colony's cultivated fields, stretching away for miles. In one place we noticed fifty young men cultivating a cornfield where every furrow was two miles in length. . . . One morning I was brought to an enclosure on the prairies where the cows were being milked. There must have been at least two hundred of them, and the milkmaids numbered forty or fifty.[54]

The planting chores were also often done by women, and Krans's view reveals that straight rows of corn were obtained by stretching a regularly knotted rope down the furrow. Seeds were dropped at each knot, and the rope was moved to the next furrow by the men at each end.

Krans's charming documentation of his society's life was unusual; more often the pictorial recording of prairie life was done by an outsider or a visitor. Solomon Butcher's photograph *The Shores Family near Westerville, Custer County, Nebraska* (1887, fig. 55), for example, is a graphic demonstration of the human diversity in the prairies. Jerry Shores, as historian John Carter notes, was a former slave who cultivated claims near those of his brothers. The brothers, Moses Speese and Henry Webb (they took their former owners' names), are also in the picture with a woman who appears to be one of their wives, a child, and a dog who, held upright on a chair, is included as a treasured member of the family.[55] They lived near Westerville, Nebraska, a community established during Reconstruction that had attracted a sizable number of black settlers from the South. By 1870 nearly 45,000 freed slaves had moved to the West, and after 1879 their migration increased dramatically, focused strongly on Kansas and its neighboring territories.[56] Butcher's representation of this family is no different from his views of whites, suggesting that the leveling aspect of the prairie ideal was, at least in those early years, partially realized for some fortunate individuals.[57]

The openness of the landscape, it seemed to many, was a tangible counterpart to the freedom, opportunity, and optimistic prospects available in the prairies, its emptiness a perfect setting for new beginnings. Not all agreed; one newly arrived black woman complained, for example, that had she known Kansas had no trees she never would have listened to all the talk and would have stayed home.[58] Just as often, however, the land's lack of boundaries was considered symbolic of a democratic future. Clarinda Nichols, an outspoken opponent of slavery and advocate of women's rights who settled in Lawrence, Kansas (a free-soil community established after the 1854 Kansas-Nebraska Act), wrote in 1855 to the *Springfield [Mass.] Daily Republican,* "But what of Kanzas? . . . an instinctive indignation enters the soul with the first glance against licensing

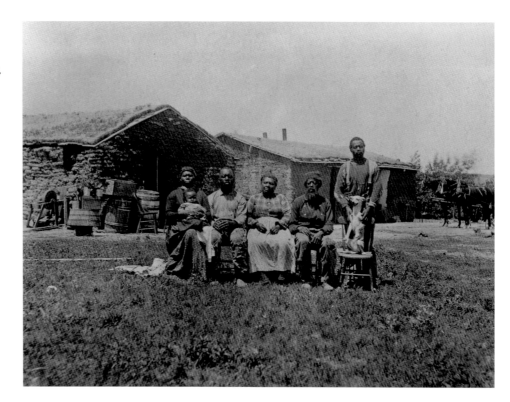

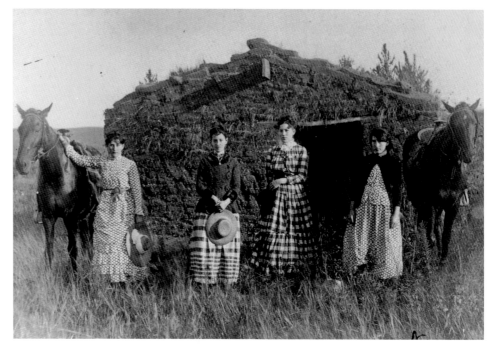

human bondage on this glorious race course for the free! It is as if the Almighty had spread wide the heritage of humanity to indicate its inherent right to freedom."[59] Not all were so welcoming, however, and the tremendous migration of African Americans, most without the capital to begin homesteading, caused serious concern for their prospects and the effect they would have on the established communities where they sought assistance.[60] By comparison with the destitution of many of those new arrivals, the Shores family in Butcher's photograph, with their land, their home, and their united family, are among the elite of their time and place.

As the free-thinking Nichols, who traveled widely for her causes, demonstrated, in many ways women could be more independent in the prairie region than elsewhere. They were able to claim their own land, but whether married or single their lives were frequently filled with dirt, drudgery, and loneliness.[61] Diaries and letters reflect the oppressiveness of the empty landscape and bemoan the lack of social interaction on isolated farms. Still, it was a life where creativity, out of necessity as much as for pleasure, made the difference between success or failure. The most resourceful and inventive women found satisfaction and sometimes inspiration in dealing with the landscape, physically and psychologically.

One of the most common ways women coped with the loneliness of the prairie landscape was by writing. Journals, diaries, and letters were a convenient and perhaps comforting substitute for the conversation of relatives and friends, and many women wrote long descriptive passages of their surroundings and their reactions to them. Sometimes the inscriptions were purely personal, but they could be written as well for publication. Nichols, for example, wrote a series of important articles for the *Lawrence Free Herald* and eastern papers that included opinions about politics and observations about her visual environment. At times she found the openness intimidating, echoing the vocabulary of George Catlin. "In going to Ossawatamie," she wrote, "we cross a twelve and eight mile prairie. I would not be willing to live so *far from land* as in one of these, where no tree nor spring greets the eye. I can think of nothing more solitary, more desolate. It is not being 'alone in nature,' for it seems as though nature had gone on a long journey, 'emigrated,' and taken all her treasures with her, and left her hearth-stone dark." Just as often she exulted in her new home: "It is the most beautiful country my eyes have seen; a country outromancing the descriptions of the novelist and just as God made it."[62]

Women's independence in the prairies is perhaps most charmingly demonstrated in Solomon Butcher's portrait of four homesteaders, *The Chrisman Sisters near Goheen Settlement on Lieban Creek* (1886, fig. 56). Their achievement as landholders is particularly striking because of their youth and their obvious self-possession. Neatly, even fashionably dressed, they stand alongside two of their horses. Their soddy is modest, and their land appears unimproved, lacking visible outbuildings, and grass has grown up around the house, indicating a disuse uncommon to most claims Butcher photographed. *The Chrisman Sisters* was one of Butcher's first images from Custer

County. He reported in his published history that the young women's father, Joseph Chrisman, was a major rancher in the area. Undoubtedly following his example, they took full advantage of the land opportunities of the time. Each claimed a homestead, a timber claim, and a preemption claim (which was purchased for a nominal amount per acre) and took turns living together on each other's land to meet the residence requirements of the Homestead Act.[63] Although it was obviously not the case in this example, often women and children lived on claims to satisfy the law while their husbands sought paying work elsewhere. The money the men sent would support the family until they returned at harvest, and the lonely times contributed significantly to the difficulties of women on the early farms. It was common for bachelor homesteaders such as the Chrisman sisters to join forces and build houses near each other (on their own land to meet the law) or, stretching the legal limits, to build adjoining houses on property boundaries or to "visit" each other on an extended basis.[64]

The effect of the prairie landscape on women is difficult to generalize, but it seems clear that for them the new arcadian view of the grasslands did not completely displace the more pessimistic one that had preceded it in the popular understanding. Rather, the perceptions alternated according to the viewer's predisposition and her circumstances, which likewise fluctuated according to growing conditions, personal health, the general economy, and politics. This duality was no more apparent than in the art of the few early women who sought visual expression for their experiences. As we have seen, Sallie Cover's *Homestead of Ellsworth Ball, Nebraska* (1880s, fig. 41) epitomizes the ideal of the prairie as garden. Her contemporary Imogene See, however, presents a more desolate view, *Nebraska Farmstead* (1880s, Joslyn Art Museum, Omaha), a far more discouraging depiction of life in the prairies, in part because it is almost monochromatic and lacks human presence. Neither of these women artists is known other than from these single pictures, and it is presumed that they were themselves homesteaders who, like Abby in Bess Streeter Aldrich's Nebraska novel *A Lantern in Her Hand* (1928), sought cultivation of their own sort by taking brush in hand and painting the world around them.[65]

A DISMAL PROSPECT

The great influx of settlers into the prairies was possible, of course, only because the original inhabitants, the Native Americans, had been moved out or consolidated onto reservations to make room for the newcomers who wanted their land. This process, under way in various parts of the United States throughout the nineteenth century, first moved eastern Indians into the plains in the 1830s—to a region called Indian Territory and later named Oklahoma. The story is now generally known, but in this study of prospects it is significant that the ceded land, dominated by prairie and more arid plains, was thought by the government to have no alternative use; it was in every way expendable.

Even as more tribes were moved to Indian Territory, the once useless prairies were becoming more attractive, and the reservation system was devised as a means to move Native Americans off newly desired land and into smaller and even less promising areas. There, it was supposed, they would pose no threat, physically or otherwise, to the white settlers, who by the 1850s and 1860s were moving into the region in ever larger numbers. The situation was endlessly discussed from various points of view in the white press, but a typical response is that of the journalist Bowles, who included his thoughts in his columns in the *Springfield Republican* as well as in his several books from the 1860s. "Whoever shall discover and cause to be put in practice," Bowles wrote in *Across the Continent,*

a policy towards our Indian tribes, that shall secure protection alike to them and the whites, and stop indiscriminate massacre on both sides, will prove the greatest of national benefactors. But the almost uni-

Figure 57
Theodore Kaufmann (1814–ca. 1887)
Westward the Star of Empire, **1867**
oil on canvas, 35½ x 55½"
Saint Louis Mercantile Library Association

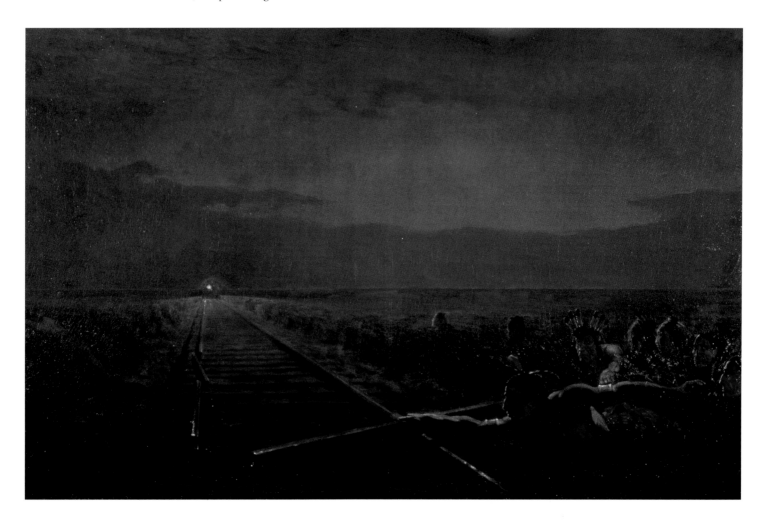

versal testimony of the border men is that there can be no terms made with the Indians—the only wise policy, they aver, is extermination. This is dreadful if true; and I cannot believe it. . . . But if the policy of extermination is the only possible one, the sooner it is adopted and carried out the better. It is cruelty to all parties, it is loss to people and nation, to let affairs drift along in the present way, exposing settlers and travelers to unexpected assaults and robbery, and interrupting the course of the subjugation and civilization of the continent.[66]

In a Machiavellian rationalization all too common in the nineteenth-century view of Native Americans, Bowles relinquished a massive population to extinction as the only way to achieve American civilization. Reiterated in everything from political speeches to images such as Theodore Kaufmann's dark *Westward the Star of Empire* (1867, fig. 57), which demonized the Native Americans who sought retribution for incursions into their land, by the 1870s the extermination of the problem was a national priority. Kaufmann renders his native figures evil through various techniques: by portraying their dismemberment of the track to derail the oncoming train (and so the forces of civilization), by a crepuscular handling of color that gives the Indians a sinister glow, and by depicting them slunk low in the grass, suggesting a snakelike viciousness, a sinister malignancy. In this he echoed Cooper, who in *The Prairie* says of his elusive Native American antagonist, "The passage of the savage . . . could be likened only to the sinuous and noiseless winding of the reptiles which he imitated."[67]

The art that deals with the themes of Indian-white relations, before and during the widespread settlement of the prairies by Euro-Americans, is primarily figurative in its form, that is, devoted to the human story. Images by both Euro-American and Native American artists are dominated by dramatic battle scenes, for example, and unlike Kaufmann, rarely do they present the grassland landscape as the primary component of compositions. Exceptions are found in photographs, which frequently depict figures within the context of the land. One example is *Woman Quilling Moccasin Tops, Rosebud Reservation* (ca. 1893, fig. 58), by an anonymous photographer, a quiet scene that would seem, were it not for the woman's location, the most tranquil of portrayals. She proceeds with the age-old work of decorating footwear with porcupine quills, the traditional material for such purposes, especially before the availability of mass-produced glass beads, a favorite trading item of whites. But here, relegated to a reservation and removed from the vast range her people once roamed, she poignantly exemplifies the containment and spiritual destruction of her people. Ambiguous in its implication, the photograph portrays her amid the wide grassland in what may have been a nostalgic effort to capture this disappearance, or perhaps the artist wished to suggest that she is content with her new circumstances.

A NEW PRAIRIE AESTHETIC

To celebrate the conquest of the continent and the triumphal transformation of the prairies into the garden of America, toward the end of the nineteenth century midwestern communities began

building great agricultural palaces that used vegetables and grains instead of paint or sculpture as a medium for decoration. Surviving today in the Corn Palace of Mitchell, South Dakota, originally built in 1892 and every year redecorated with a variety of grains, these monuments displayed plain pictures of a sort different from traditional art, made from the stuff of their builders' success. In addition to elaborate exteriors, replete with all manner of colorful and textural crops, the interiors were sculptural and pictorial vegetative marvels.[68] The *Grand Island [Nebr.] Daily Independent* described its local Sugar Palace in 1890:

The interior is fantastically fixed up. The different rooms represent the different kinds of grain and produce raised in Hall and adjoining counties. The designs are pretty and in keeping with all that is pleasing to the eye. Full size figures have been made of grass, wheat, oats, barley, etc. and two large maps—one of Nebraska and one of the United States have been made from corn, wheat, and oats, showing Grand Island in the centre of the state with her immense railroad facilities, while in the United States map Nebraska is shown as the central attraction. . . . There is a field of sugar beets and another of wheat. In the center of the latter appears a huge beet loaded upon a wagon making its way through the field. The exposition building is about 200 feet square and built in artistic design.[69]

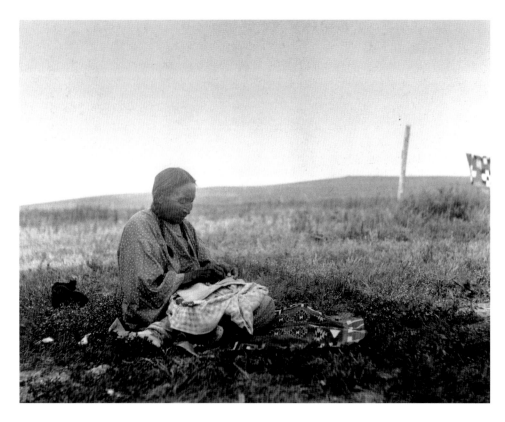

Figure 58

Anonymous

Woman Quilling Moccasin Tops, Rosebud Reservation, ca. 1893

photograph, 11 x 14"

Nebraska State Historical Society, Lincoln, John Anderson Collection

In these great grain palaces, as well as in the more modest, albeit equally celebratory displays at county and state fairs and in railroad promotional tours, the bounty of the prairie triumphed, and settlers who only a generation before had struggled with the great waste congratulated themselves on their remarkable success in turning a desert into a cornucopia.[70]

At the same time, even as the pastoral garden image dominated the transformation of the prairies and its art, aesthetic appreciation of natural prairie scenery was also quietly developing. In 1888, for example, in *Harper's Monthly,* Frank Spearman described some of the appealing characteristics of the original landscape and gently admonished those who might not appreciate them. The title of his essay was "The Great American Desert," and although he used the term "desert" relatively uncritically in his commentary, the phrase really served as a foil to his tribute. He noted that the term had been "expunged from the maps," but, he chided, "it still remains obstinately fixed in the minds of thousands of otherwise intelligent people who have not kept pace with the developments of the past quarter century." That, he explained, was due largely to misguided aesthetics:

The idea is prevalent in the East that a location anywhere on the plains means living in a flat and featureless country, where the horizon presents in every direction a monotonous stretch of prairie, devoid of any objects of interest or nature beauty, and impressing upon one feelings of dreary loneliness. This is a mistake. Certainly the most enthusiastic resident of the desert would not deny that the lovely groves of the East would be a great addition to our landscapes; but we are by no means in the poverty-stricken state in which our Eastern cousins have pictured us in respect to the beauties of nature. . . . The valley of the Republican River affords any number of beautiful landscape effects. The pure clear air and the great expanse of sky in every part of our country afford the loveliest cloud effects and the most magnificent sunsets to be found east of the mountains. Dakota is favored with the mirage which lifts into photographic clearness towns thirty miles away. The fact is, there is no known limit to the richness and depth of this desert soil.[71]

Although his concern is "the beauties of nature" and the appreciation of landscape for its own sake, Spearman consistently underscores his observations with the usual references to the soil's fertility. His main discursive technique, however, is visual. Furthermore, in an unusual departure from the norm, he focuses more on what prairies offer than on what they lack. In contrast to how they have been "pictured," the "photographic clearness," the "great expanse of sky," and the "magnificent sunsets" all evoke an aesthetic that any artist should find intriguing.

In similar fashion, as the domination of cultivation increased, after the turn of the century the wild prairies that had so recently been plowed under began to be eulogized. In this mode the ideal that had dominated the nineteenth century was inverted; the virgin prairies became the garden and the cultivated landscape a destructive force that had ravaged or, at the very least, had

sectionalized the pristine landscape. As writer Conrad Richter dryly put it in 1937, the land was "dead and quartered today like a steer on the meat block."[72] A more expansive elegy was that of Hamlin Garland:

I confess that as I saw the tender plants and shining flowers bow beneath the remorseless beam [of the plow], civilization seemed a sad business, and yet there was something epic, something large-gestured and splendid in the "breaking" season. . . . At last the wide "quarter-section" lay upturned, black to the sun and the garden that had bloomed and fruited for millions of years, waiting for man, lay torn and ravaged. The tender plants, the sweet flowers, the fragrant fruits, the busy insects, all the swarming lives which had been native here for untold centuries were utterly destroyed. It was sad and yet it was not all loss, even to my thinking, for I realized that over this desolation the green wheat would wave and the corn silks shed their pollen.[73]

Often written by the children of the settlers, who recalled their youth in the new land from the perspective of adulthood in a dramatically different one, such reminiscences look with new appreciation to the original prairie landscape and its beauties, and to the faults of cultivating inhabitants. Quite different from the earlier prairie literature—which, with a few exceptions such as the writings of Cooper and Irving, had taken the form of travel narratives—these treatments, most of which were written after the turn of the twentieth century, were overwhelmingly novelistic and literary. So numerous as to constitute a genre unto themselves, the midwestern writings by such authors as Willa Cather, Hamlin Garland, Ole E. Rölvaag, Sinclair Lewis, and Sherwood Anderson, to name but a few, became known for their eloquent and often poignant depictions of the prairies and the lives the land had fostered.[74] As literary historian Robert Thacker has explained, for many of them who wrote from the vantage of urban maturity, their nostalgia for the original landscape was perhaps more sentimental than they cared to admit. In an observation written just as the prairies were beginning to be transformed, George William Curtis's thoughts on the dynamics of perception and appreciation seem fitting to the later, retrospective celebration of the native prairie. "The *idea,*" Curtis wrote in *Lotus-Eating* (1852), "of the great western rivers and of lakes as shoreless to the eye as the sea, or of magnificent monotony of grass or forest, is as impressive and much less wearisome than the actual sight of them."[75]

In the same vein, some artists in the early years of the twentieth century (perhaps encouraged by the freedom modernism offered, with its emphasis on form, light, and color, and inspired by their liberation from traditional conceptual and formal restrictions) began to celebrate the land for its own sake, without the encumbering elements of figurative narration. Elizabeth Holsman's *Still Waters* (1914, fig. 59) is one such example, although it retains a reliance on the verticality of trees and a semblance of conventional composition. More of an American Claude Monet than a

Figure 59
Elizabeth Holsman (1873–1956)
Still Waters, **1914**
oil on canvas, 27 x 32"
Joslyn Art Museum, Omaha, Nebraska

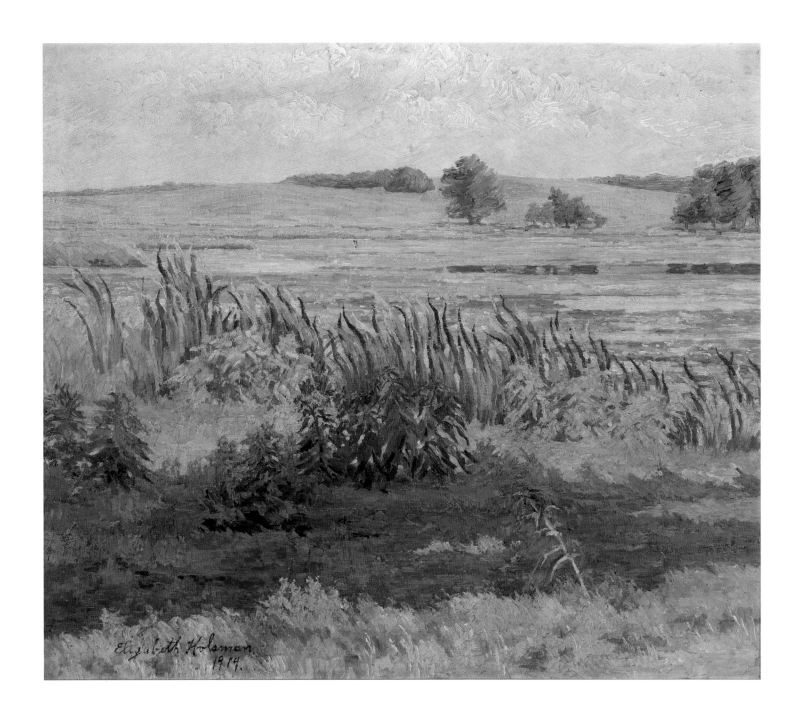

Elizabeth Holsman
1914.

LEFT: **Figure 60**
Georgia O'Keeffe (1887–1986)
Light Coming on the Plains II, 1917
watercolor on paper, 11⅞ x 8⅞"

Amon Carter Museum, Fort Worth, Texas (1966.32)

RIGHT: **Figure 61**
Laura Gilpin (1891–1979)
The Spirit of the Prairie, 1921
platinum print, 7⁵⁄₁₆ x 9⅛"

© 1981, Laura Gilpin Collection, Amon Carter
Museum, Fort Worth, Texas (P1977.64.2)

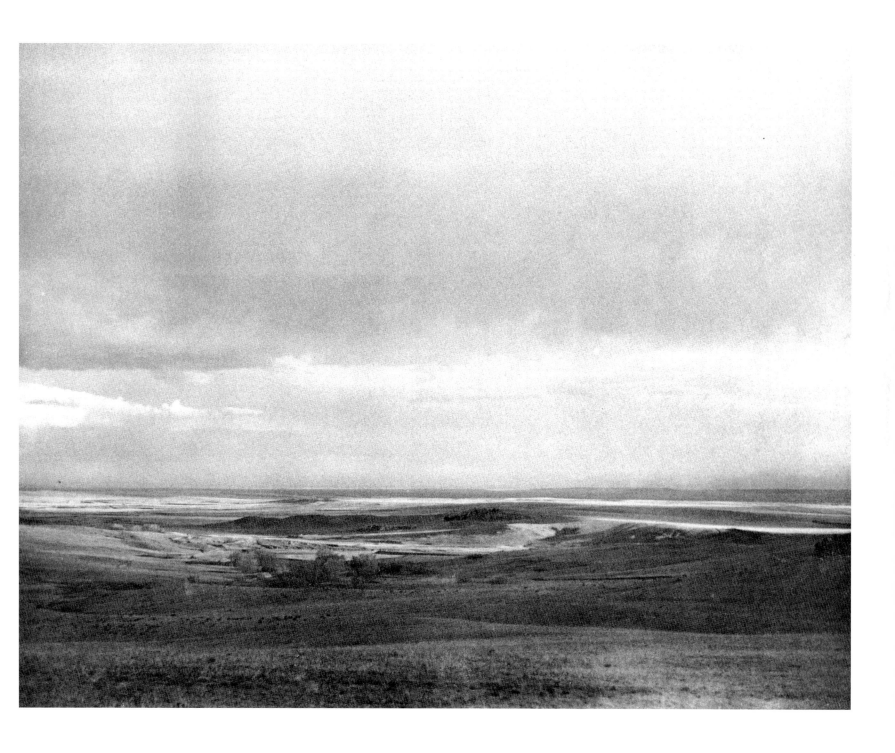

true prairie celebrant, Nebraska native Holsman (1873–1956) in this view does, however, provide a glimpse of the subtle joys of a prairie pothole and its surroundings, albeit through the lens of Giverny.[76] Much more avant-garde was the modernism of Georgia O'Keeffe (1887–1986), whose earliest work included a series of watercolors such as *Light Coming on the Plains II* (1917, fig. 60), inspired by the minimalism of the plains and the light that suffused it (see ch. 5). Similarly, in the beautiful *Spirit of the Prairie* (1921, fig. 61) by Laura Gilpin (1891–1979), grandniece of the early prairie booster William Gilpin, the landscape is allowed to speak for itself, and through the title it takes on a metaphorical quality, endowing it with a significance not usually ascribed to the land in earlier representations. One of Gilpin's favorite poems, by Eliza Swift, reads, "Across the broad spaces, the limitless places, / Unfettered, unhindered, my spirit goes free."[77] Instead of portraying the attributes of the prairies, the elements added to it, or the work done in it, Gilpin and O'Keeffe recognized, as no artist since Catlin had, the visual power of the land unadorned.

The nostalgic celebration of the prairies was even more often conveyed figuratively. Sometimes these portrayals are quaint in their recollections of the picturesque aspects of settlement days, as in *Early Start* (1913, fig. 62) by South Dakotan Charles Greener (1870–1935), but just as often they are visually adventurous in their homage.[78] Unlike the crowded scenes of earlier artists uncomfortable with empty space, these views more often than not silhouette a single figure or just a couple against a wide horizon. In their emphasis on the openness of the landscape and on the spectacle of the sky, they prefigure the paintings and photographs of the 1980s, which focus almost wholly on those characteristic prairie features. Striking in its balance between modernity and traditionalism, *The Prairie* (1917, fig. 4) by Laura Gilpin, for example, presents a solitary woman in a diaphanous white dress, arms outstretched, surrendering to the prairie around her. Portrayals such as this gain their power by presenting the figure *in* the landscape, instead of before it or in some other dominating posture, and allowing the two to enter more fully into a visual dialogue. Through such integration the woman becomes striking by contrast to her surroundings, but the epic quality of the land is also heightened by her presence; her outstretched arms echo the line of the horizon. United by their common elemental passions, the two define each other without intrusion on either's identity.

It is only a small step to presenting women as symbols of strength, fertility, and abundance, echoing that of the land itself, and after the turn of the century the depiction of women in prairie landscape images turned noticeably toward such heroizing or elegiac portrayals. Not always restricted to adult subjects, this message is just as clear in Frank Cundill's photograph *South Dakota (Girl in Hay Stack [Wheat Shock])* (1915, fig. 63). The elegantly dressed little girl is immersed in the shock of wheat, and her height—the same as the bundles'—makes it appear almost as if *she* is the harvest. A diminutive Ceres offering her bounty, she demonstrates her family's pride in their finest crop.[79] In a more austere version, but nonetheless heroic, South Dakotan Harvey Dunn

Figure 62

Charles Greener (1870–1935)

Early Start, 1913

oil on canvas, 20 x 28"

South Dakota Art Museum, Brookings

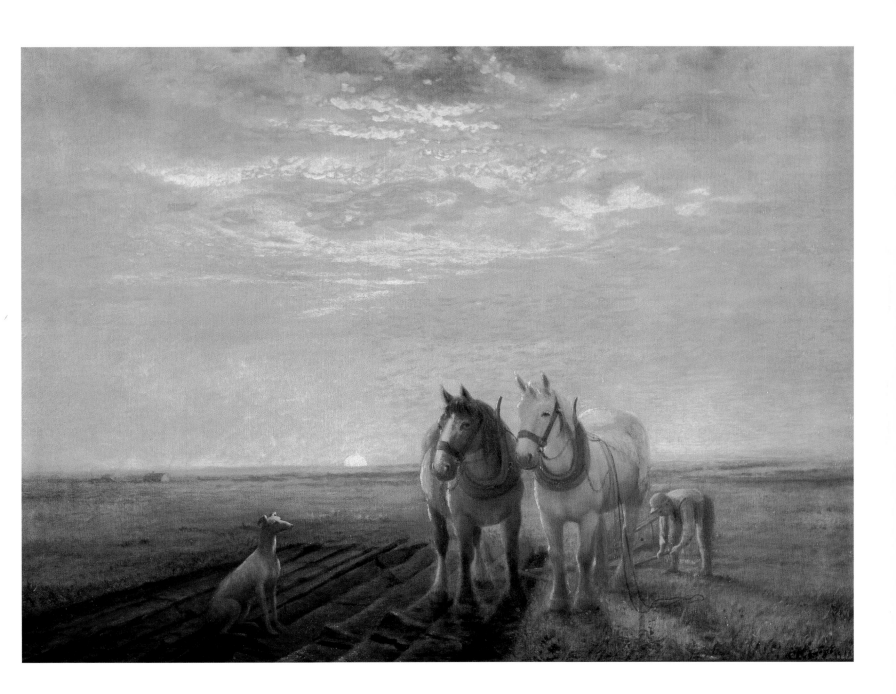

(1884–1952), better known for his monumental *The Prairie Is My Garden* (ca. 1925–1950, South Dakota Art Museum, Brookings), depicted in *The Homesteader's Wife* (1916, fig. 64) a woman vigorously leading a cow, presumably in from the pasture to be milked. Her effort and fatigue are undeniable as she pulls the animal, bending at the waist against its resistance. Whether an attempt to immortalize her as the pioneer woman who made life for her family tolerable with, among other things, her contribution of butter and egg money, or a representation of the pain of existence on the plains, Dunn's portrayal celebrates the women who withstood such trials with grace and forbearance. Like those characters in Willa Cather's novels from the same period, who are successful at farming and only grow stronger while the men fail, Dunn's heroines seem eternally wedded to the land, deriving sustenance from it as they endow it with their own.[80]

Like his literary contemporaries who, from the distance of urban maturity, memorialized the prairie of their childhood, Dunn had grown up on a homestead, but on the advice of an early mentor, painter Ada Caldwell (who taught art at South Dakota Agricultural College in Brookings, now South Dakota State University), he left the region to pursue an artistic career. After studying at the Art Institute of Chicago just after the turn of the century, he joined N. C. Wyeth and others at Howard Pyle's studio school in Wilmington, Delaware, and became a successful illustrator, contributing work to many popular periodicals, including *Harper's* and the *Saturday Evening Post.* Although he returned to his home state on occasion, he, like many of his contemporaries and successors (including his student John Steuart Curry, who became well known in the 1930s for his Kansas paintings), remained in the East and painted his most eloquent prairie pictures from his New York and New Jersey studios.[81] Not surprising then is the nostalgic, sentimental tone of these works, as romanticized as those of the nineteenth-century painters and illustrators (such as Arthur Fitzwilliam Tait) who focused on adventure scenes in regions they had never seen. Significantly, they anticipate the ambiguous idealizations of Grant Wood, Curry, and others who, in the 1930s, would seek confirmation of their own pastoral identity and that of their homeland by choosing to ignore the realities of a changing world.

The promoters of prairie settlement had inflated their mission with lofty claims of providential design and national purpose, served by homemakers who would redeem the Great American Desert; now the children and grandchildren of the pioneering generation faced the consequences of that presumption.[82] The legacy they inherited was a landscape that was not only cultivated but also profoundly transformed. In its new incarnation the prairie was increasingly industrialized and mechanized, its people more and more dependent on manufactured goods and external social and economic forces. Those factors changed the appearance and ecological balance of the grasslands and also resulted, at times critically, in a new and uneasy relationship with the people who lived within them.

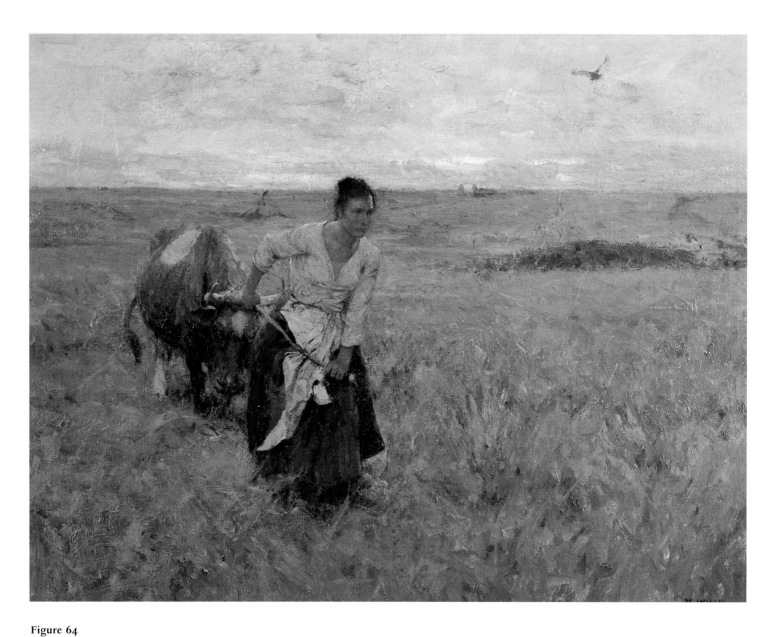

Figure 64

Harvey Dunn (1884–1952)

The Homesteader's Wife, 1916

oil on canvas, ca. 40 x 50"

South Dakota Art Museum, Brookings

The Great American Desert, in the end, could be tamed but not conquered. It succumbed to its new role as a blooming garden in many ways but continued, as it would reveal in subsequent decades, to resist those who would claim it fully. The early twentieth-century art of the prairies only hints at this; it would wait to be realized in the paradoxical images of the next generation. The old dream had been largely fulfilled, but it came with a price. The new realities in the grasslands brought unprecedented challenges and fundamental realignments, not all of which were redeeming and many of which haunt us even today.

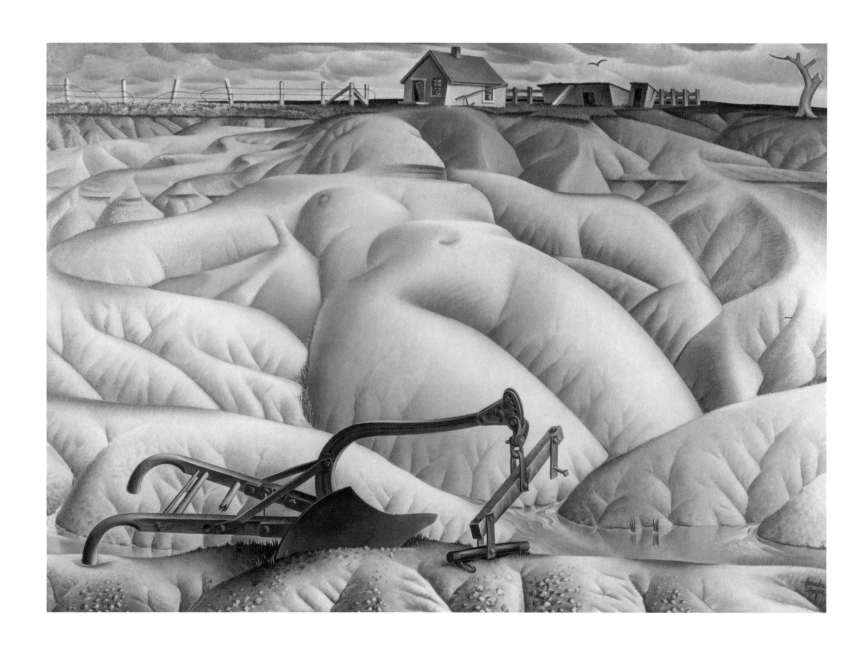

The long harangues of the grass in the wind are our histories

We tell our freedom backward by the land

We tell our past by the gravestones and the apple trees

We wonder whether the great American dream

Was the singing of locusts out of the grass to the west and the

West is behind us now.

The west wind's away from us

We wonder if the liberty is done:

The dreaming is finished

We can't say

We aren't sure

Archibald MacLeish, "Land of the Free" (1938)

Figure 65

Alexandre Hogue (1898–1994)

Erosion Number 2: Mother Earth Laid Bare, 1938

oil on canvas, 44 x 56"

The Philbrook Museum of Art, Tulsa, Oklahoma

The optimistic visions that seemed to transform the prairies into a garden paradise after the Civil War were seriously challenged by events in the 1920s and 1930s that threatened to make much of the region into the desert wasteland it was once thought to be. Farm crises, the Great Depression, widespread drought, and withering heat forced a reconsideration of the prairie's character and a tempering of the enthusiasm that had so wholeheartedly embraced its improving prospects. At the same time, the nationalist politics of the period after World War I, a desire for alternatives to an increasingly industrialized society, and other developments focused attention on the land even as they prompted a new awareness of its essential identity and its enduring contribution to American life.

Art did not just reflect these trends; it actively influenced them and by the 1930s became a focal point for national concerns, hopes, and energies. Not since the heyday of landscape painting in the 1850s and 1860s had there been so much attention to and appreciation of the American scene's symbolic value. This was especially true for what became known as Regionalist

art, a movement that did not begin with but was encouraged and supported by New Deal art programs that promoted localized subject matter. Although different areas in the United States fostered their own subjects and styles (not all of which were rural), Regionalism became closely associated with the prairie states and the Midwest, where the preeminent subject was the landscape and its inhabitants.[1] Far from the outmoded pastoralism some art historians have dismissively taken it to be, this movement, despite its emphasis on figuration and narrative content, was not simply an antimodern or isolationist phenomenon. To the contrary, Regionalism directly embodied the issues of its time, especially in its tension between the real and the ideal. As notions of a mythic garden in the grasslands, which had dominated the childhood of these artists and entered the national psyche, were profoundly contradicted by ideological and economic disasters, the uneasy art of the era struggled to confront this unsettling challenge to the prairies' prospects.

Comparisons of images from the period provide dramatic evidence of those tensions. Practically contemporaneous paintings of similar subjects and styles are often strangely dichotomous, so polarized in mood and message that they seem antagonistic. *Spring Turning* (1936, fig. 12) by Iowan Grant Wood (1882–1942), for example, when compared with *Crucified Land* (1939, fig. 11) by Texan Alexandre Hogue (1898–1994), is striking in its passionate contrast.[2] Wood's idyllic aerial prospect of the cultivation of a verdant Iowa field is overwhelmingly optimistic in its dewy freshness and bountiful rolling swells. Nostalgic in both form and implication, Wood's view includes a tiny farmer plowing with horses over a field that looks more like a perfect patchwork quilt than a farm. Hogue's scene on the other hand, although just as consciously constructed, harshly confronts the viewer with a ravaged landscape, an eroded specter of desolation where the land runs away like rivulets of blood in the wake of the receding storm, and a tattered scarecrow forms an emblematic cross that stands as witness to the natural sacrifice. In the distance lurks the perpetrator, the tractor with its cultivator that has opened the soil and left it vulnerable to its fate.[3]

The geographical differences in the prairie regions Wood and Hogue chose to portray do not entirely account for the remarkable differences in their paintings. Of course the undulating, lush landscape of eastern central Iowa is hardly comparable with the flat, red earth around Denton, Texas, but neither Hogue's nor Wood's pictures are factual renditions. Instead, they both struggle, though differently, with the disparities between the real and the ideal. One continues to heroize the rosy prospects of an earlier generation, even as its portrayal is at odds with the current conditions, and the other responds to the landscape's dismal present, discomfiting those who would prefer its ideal. Each resolves the potential conflicts without pretense of reportage; rather, they elevate the subject into the realm of mythic representation, an almost surreal commentary on the land and those who work it. By recasting the traditional relationship of the real and the

ideal in a manner not unlike that of the so-called magic realists in literature, emphasizing at once a superrealism and its unreal quality, Wood and Hogue attempted to reconcile the symbolic issues of life and land during a period when the relationship between them seemed perilously tenuous.[4]

Similarly, the art of the 1930s vacillates between documentary narrative, usually depressing, and heroic optimism, often overwrought. The extreme circumstances of the time seemed to encourage or even require such disparity, but even so, the imbalance was disquieting for artists. They were often compelled to be and do things, in their art and in their lives, that they were not completely comfortable with, and in many cases they seem to have balanced precariously between two worlds, that of their subjects and that of modern, urban (and often eastern) America. The result was an art that is neither modern nor regressive, neither wholly of the prairies (in this case) nor entirely distant from them, and never completely free of a foreboding uncertainty about prospects—the artists', those of their subjects, and those of the country as a whole. As Archibald MacLeish wrote in "Land of the Free" (1938), "We aren't sure." Sometimes the response to this ambivalence and insecurity was a bold assertion of a desired ideal, sometimes it was an unflinching expression of experiences or reactions to the dire realities of the world. But for the artists of the American prairies during their most challenging era, the inherent conflicts and paradoxes of the land were never far from view.

THE DIRTY THIRTIES

The pressing financial and agricultural difficulties that confronted Wood and Hogue and other artists who focused on landscape subjects during the Great Depression were not entirely unprecedented in the prairie states, but they were infinitely more serious and widespread than ever before. After the grasshopper disasters of the 1870s, which had caused many to doubt the region's prospects, the 1890s brought a bleak period when prairie farmers became so desperate from drought and general economic panic that large groups marched on Washington in a populist revolt. Some blamed the boosters who had enticed settlers into a land that could not support them: "Everything was depicted [in those promises] in the most attractive colors," one magazine complained in 1891, in an indictment that seemed focused on artists as much as on writers, "luring thousands to settle in the wilderness in which many of them are now starving."[5] The theory of "rain follows the plow" had been a delusion, and even the widespread cultivation and tree planting campaigns that had been undertaken so enthusiastically seemed a feeble if not cruel joke. Those efforts had wrought a dramatic visual change in the landscape but did little to fulfill the promise of bringing rain and bountiful harvests.

By the turn of the century, however, improving farm technology, adequate rainfall, better crops, and rising food prices had brought stability, a golden age of agriculture, that seemed at last to confirm that the intermittent difficulties had been isolated incidents and that the transformation

of the region was complete, an aesthetic as well as economic triumph. During the period, moreover, the final prairie states had been admitted to the Union, symbolically verifying that the Great American Desert, the great Other, which less than a century before had been perceived as a barrier to overexpansion, was a thing of the past. The farm boom was especially pronounced during World War I, when demand for food and other products soared; productivity and profits increased dramatically.[6]

Agriculture, however, is a cyclical business, and in 1920 prices and farmers' fortunes took a drastic downturn. As most of the nation enjoyed its most prosperous decade ever, the prairie states suffered, in part because of their own success. The increase in the amount of land farmers had brought into production during the good years and the decrease in demand after the war resulted in an oversaturated market and correspondingly lower prices. It was a crisis most farm families were ill prepared to wait out. They had borrowed heavily to purchase land and the machinery to work it, taking on debt and more taxation. Those factors, coupled with the new elevated standard of living they had developed during prosperity (with such amenities as automobiles and gas-powered tractors that were more expensive to maintain than livestock), put farmers in difficult straits after World War I.[7] With few federal restrictions to control their output, they responded by producing even more and thus compounded their problem. Sociologists who analyzed the conditions in Iowa observed, "Every effort was made to keep the farms. Every acre had to be cropped intensively. . . . More and more was taken out of the soil, less and less put back. Many farmers believed they were ruining their farms, but thought only about making them produce in order to save them. They argued that it was better to have a rundown farm than none at all."[8]

By the 1930s things were, of course, even worse. The stock market crash of 1929 had precipitated the Great Depression nationwide, and by 1932 nearly thirty million people were unemployed. Recurrent drought and unusual heat compounded the disaster, bringing a series of poor harvests, and many farms were foreclosed, sold by banks desperate for cash. The damage and the difficulty varied—the worst conditions were west of the ninety-eighth meridian, where the prairie technically becomes the plains and where rainfall in good years is only adequate—but even in the most fertile and well-watered areas the prairie region endured extreme hardships in the "dirty thirties."

As historian Robert Athearn has written in *The Mythic West in Twentieth-Century America,* the changes in perceptions and treatments of the western land that occurred during this difficult period were partly practical; as the nation's food supply was threatened and its farmers could not afford to harvest their crops, for example, precious financial resources were allocated to the vast territory. This profoundly altered the relationship the agricultural region had with the federal government, a situation that continues to the present. Part of the change was, however, ideological, based on the demise of century-old dreams that had vitalized the settlement of the prairies and the West generally. What had seemed a national asset of infinite limit and promise now

threatened to become a liability, a colony that could not pay its own way and might well take the rest down with it.[9] Correspondingly, in the art of the period land becomes a prominent character in an ongoing drama; it is not merely a setting for human action, a tabula rasa yielding readily to manipulation, but rather a living entity to be contended with and, for some, to be consumed by. In the most idealized portrayals this representation is benevolent, and the land swells with bounty, bestowing honor on those who till it. Just as often, though, it is an adversary, a malevolent victim that demands retribution for the sins that have been committed against it. O. E. Rölvaag described just such a prairie in *Giants in the Earth* (1927), "Monsterlike the Plain lay there—sucked in her breath one week, and in the next week blew it out again. Man she scorned. . . . She would know, when the time came, how to guard herself and her own against him."[10]

GIANTS IN THE EARTH

In the paintings and photographs of the 1930s the land's anthropomorphic character emerged in a manner unknown in earlier works, ranging from power and voluptuousness to exultation and despair. One of the most vivid visual examples is Alexandre Hogue's *Erosion Number 2: Mother Earth Laid Bare* (1938, fig. 65), part of the series the artist entitled "Erosion, by wind and by water." The painting is among Hogue's most mythical and compelling and has become an icon of the Dust Bowl era, one of the most remarkable images of the decade. A prairie farm lies in ruin, its fields eroded, as abandoned and ravaged as a strip mine. The house and outbuildings stand dejectedly in the background, and the yawning field occupies most of the scene. Swathed in light sandy tones, it at first appears to be a hilly pasture simply denuded of vegetation, but a ghostly apparition of a female form emerges, lying not in the earth but *of* the earth, her body revealed in a quiltlike terrain, her face masked. Looming menacingly on a foreground rise, as if her guardian, is a dark abandoned plow, its share rusted and its wooden crossbeam broken, its tongue crossing over the figure's leg.[11]

The painting's overt symbolism conjures many associations, the most obvious of which is the feminization of the landscape, ubiquitous in everything from ancient mythology to agricultural terminology (e.g., husbandry).[12] Hogue drew on his personal fantasies in the analogy, recalling that his mother had told him about Mother Earth as she worked in her garden. "To my youthful imagination this thought conjured up visions of a great female figure under the ground everywhere—so I would tread easy."[13] He began conceiving the composition in the 1920s, in charcoal and pencil studies that explore the feminine contours of the land as a voluptuous and nurturing force; the prairie is a virgin goddess, and evidence of man is entirely absent.[14] By 1932, however, with the advent of the clouds of dust and widespread erosion through much of west Texas, Mother Earth in Hogue's drawings had become a victim of and a threat to the progress of those who stripped her, violating her natural glory. Hogue said of the theme, "I consider this subject

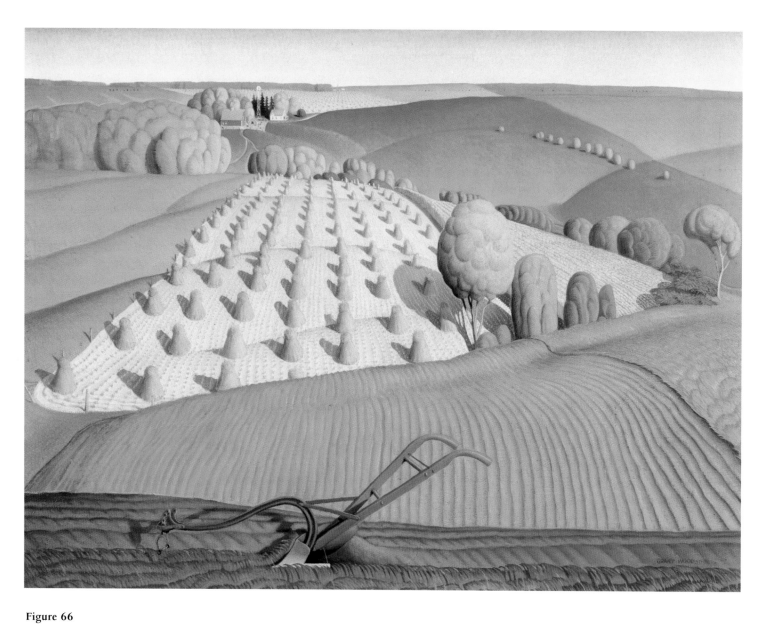

Figure 66

Grant Wood (1882–1942)

Fall Plowing, 1931

oil on canvas, 30 x 40¾"

The John Deere Collection, Deere and Company,
Moline, Illinois

beautiful in a terrifying way. I've always been interested in that kind of beauty—things that scare you to death but still you've got to look at them."[15]

The harrowing scene is even more compelling when compared with Grant Wood's earlier Iowa counterpart, *Fall Plowing* (1931, fig. 66). Like Annette Kolodny's book, *The Lay of the Land* (1975), which played off Henry Nash Smith's earlier title, *Virgin Land* (1950), Hogue's symbolic depiction of the eroded landscape relies not only on our recognition of the Depression-era drought that turned the western plains into the Dust Bowl but also on our understanding of the implications of a raped Mother Earth, exposed and violated by man.[16] That the man (at least if we see the painting through the foil of Wood's picture) is John Deere, whose sod-breaking plow enabled the plains to be settled, is highly ironic, since Wood's painting is now owned by the Deere Corporation.[17] In *Fall Plowing* a shining new Deere-style plow rests in the extreme foreground, but here the land is bountiful and graceful, a voluptuous cornucopia with perfect furrows and corn shocks, billowy trees and pastures, and a picturesque farmstead in the distance. Its opulence might have had much to do with the hopeful idealism of Iowa, a state that led the nation in agricultural productivity and took pride in its native sons President of the United States Herbert Hoover and Secretary of Agriculture Henry Wallace, but surely by 1931 Wood would have recognized that the state's triumphs were already compromised.[18] Alexandre Hogue's devastated scene from only a few years later reveals the inherent vanity of culture's presumptions; instead of bringing rain and redemption, the plow and its harvest have reaped only hardship and humiliation, hunger and heartache. The early prophecy that the prairies were unfit for cultivation now seemed all too true. Or more accurately, since it was cultivation itself that had rendered them so, perhaps it was the cultivators that were unfit for the prairies.[19]

Quite apart from its coupling with gendered symbolism, the plow became an emblem of 1930s art, both as the hero of the prairies and as its ravager. Immortalized in Pare Lorentz's film *The Plow That Broke the Plains* (1936) and Herman Clarence Nixon's book *Forty Acres and Steel Mules* (1938), it also appeared in numerous paintings and photographs of the period, such as *Plow Covered by Sand, Cimarron County, Oklahoma* (1936, fig. 67) by Arthur Rothstein (1915–1985), even though by the mid-1930s the horse-drawn plow was rapidly being replaced by tractors.[20] As early as the 1870s and 1880s, riding plows, gang plows, and then disk plows were available in lieu of walking plows, and by the 1930s tractor power was doing the job of human and animal labor on a massive scale. Tractors dominated farming in the richest agricultural areas, such as Grant Wood's Iowa, but they were common elsewhere as well, including Texas and Oklahoma, where Hogue and Rothstein worked.[21] It was not unusual, however, to find two farmers in the same district plowing with very different methods, as Texan Merritt Mauzey (1898–1973) demonstrated in his amusing *Neighbors* (1938, fig. 68).[22] On one side a farmer plows his cotton field with a tractor, while on the other side of the fence his neighbor uses a horse-drawn plow. In a subtle touch

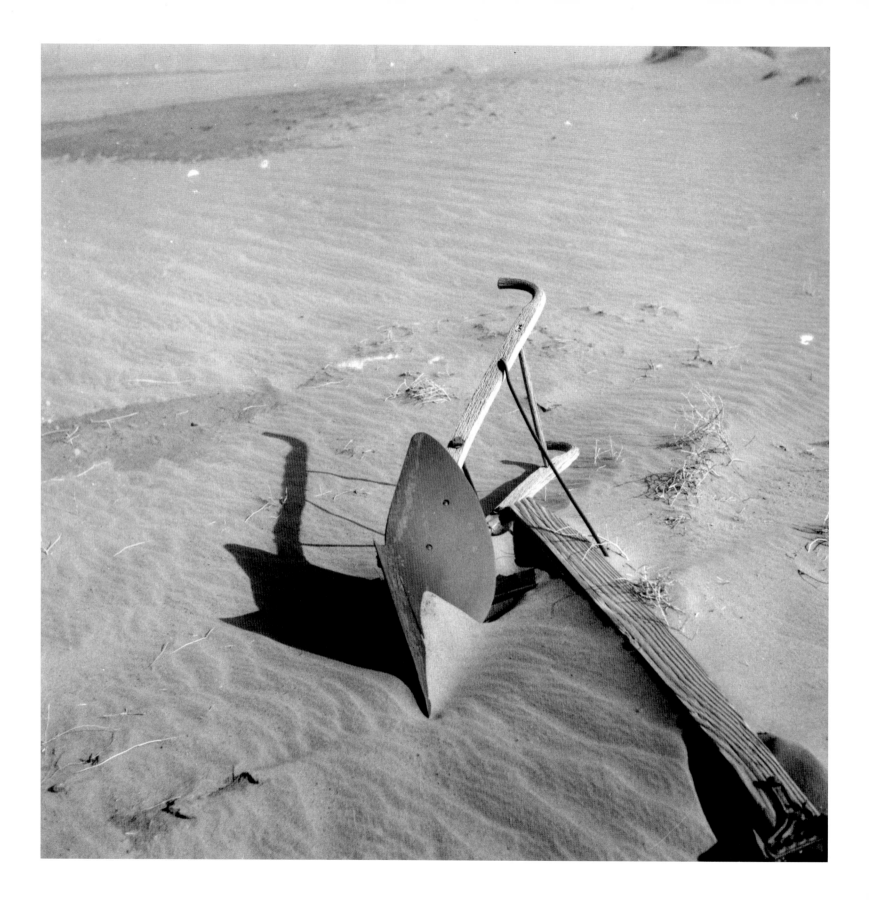

emphasizing the dichotomy, the houses on both sides are noticeably different in scale, and Mauzey tellingly placed the church on the side of the more progressive and substantial farm. The implication is clear in this view: mechanization contributes to (and is fostered by) prosperity on the farm, if it is not the outright cause of the farmer's success. The focus on the old-fashioned plow in the art of the 1930s, as the protagonist in a heroic story or the antagonist in a tragic one, demonstrates the tool's significance not only as a farm implement but also as a symbolic artistic motif. The single most important accessory to the development of the prairies, the plow had begun the process of transformation in the landscape. For good or for evil it had achieved that goal, and in the paintings and photographs of the period it was recognized for its contribution.

A HARVEST OF WIND

The dual consequences of the plow and its mechanization were no place more evident than in the western prairies, where the ravages of overcultivation were worst during the drought-plagued 1930s. The problem was unprecedented, partly because of the sheer amount of land in production. In the early years of settlement homesteads were limited to 160 acres, plus a timber claim and a preemption claim if one was lucky, and crop sizes were controlled by the power of horses or oxen. After the turn of the century, however, more and more land was considered arable, especially beyond the ninety-eighth meridian. Recognizing that low moisture levels farther west required more acreage to create a sustainable farm, the Kinkaid Act of 1904 enlarged the homestead allotment in some counties to 640 acres, a full square-mile section.

New technology facilitated irrigation on some of this land, although the National Reclamation Act of 1902 provided water for only 160 acres per family.[23] Tractors, combines, and other machines helped by enlarging cultivated fields, and where water and the power to move it were not available, experimental dryland farming techniques were intensified. These practices resulted in bountiful harvests in the short run, but they also contributed to the collapse of the grain-belt economy in the 1930s by overextending the land's capacity. In opening vast tracts to the wind and stripping the surface of its age-old grassy anchor and sustenance, farmers too late discovered, the innovations that were to be their salvation in the end brought about their downfall, as the land over a vast territory was depleted to a dangerous degree.[24]

Although many aspects of dryland farming compounded the problem, one of the worst was growing a crop on a field only every other year. This was not the same as letting it lie fallow, covered with grass that might be cut for hay, nor was it the more recent practice of sowing an alternative crop such as legumes (e.g., soybeans) that would enrich the soil after the harvest of a nitrogen-depleting crop such as corn. Instead, the technique was based on the theory that more moisture was lost through vegetation than through exposed ground. Advocated by the influential Hardy W. Campbell, it was known as summer tillage or, incorrectly, summer fallowing, and was

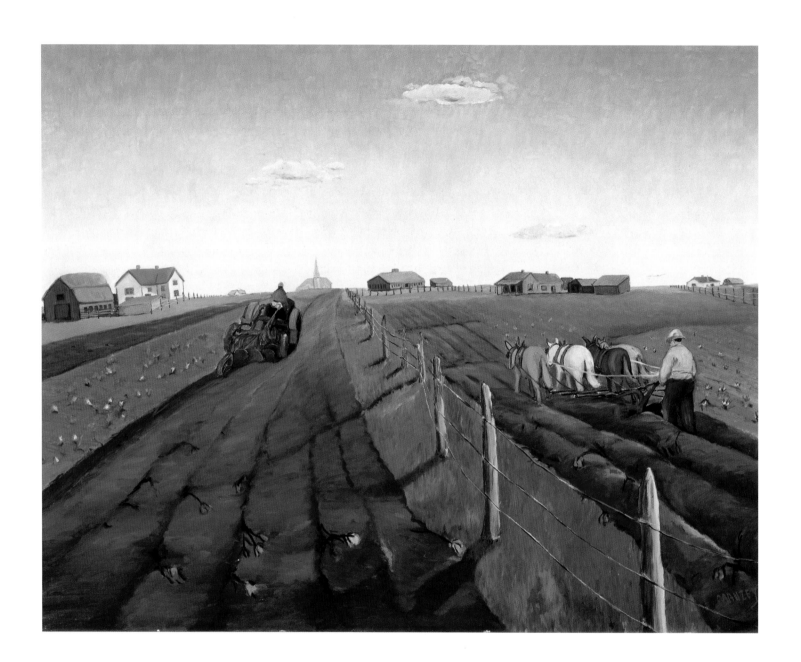

summed up by the aphorism "one plowing, frequent harrowing, two years' moisture—one big crop." The farmer who practiced summer tillage kept fields scrupulously free of vegetation and harrowed or cultivated after every shower to capture the new moisture and store it in the soil.[25] This method, which produced a surface of "dust mulch" that was highly prized as a repellent to evaporation, reportedly brought big yields in the early years after the turn of the century and was lauded with optimistic forecasts: "It now seems as the history of the prairie lands further east are about to be paralleled. . . . Just as these lands yielded in time to the plow and harvester, so will the inexhaustible soil of the Great Plains richly reward the toil of those who adapt farming methods to natural conditions."[26] In reality, these enormous expanses of dry ground were exceptionally vulnerable in times of extended drought, such as those that came in the 1930s. High winds lifted the soil and stirred it into vast dust storms in the flatlands beyond the hundredth meridian, creating the notorious Dust Bowl that plagued the plains, especially in the panhandles of Texas and Oklahoma and the territory adjacent to the border of Colorado and Kansas. Despairing newspaper headlines pronounced "Wheat Prospects Blown by Winds," and the prairies' future was once again in doubt.[27]

Artists, especially photographers, documented this phenomenon thoroughly, and in many cases a riveting vision elevated a composition into national prominence. The unforgettable images of a young farmer and his son running to their half-buried house, a migrant mother staring despondently out of her tent, and abandoned farms and bread lines were diligently produced under the auspices of the Farm Security Administration (FSA) photographic section, a New Deal program designed to address the needs of American farmers, especially the poorest. Under the leadership of social economist Roy Stryker, FSA photography was conceived broadly, for current purposes and for posterity. As a section photoeditor wrote, the file included "the most gay and the most tragic. . . . they are all here, photographed in their context, in relation to their environment. In rows of filing cabinets, they wait for today's planner and tomorrow's historian."[28]

Stryker had studied under Rexford Tugwell, the original head of the Resettlement Administration (as the FSA was originally called), and in the 1920s they had worked together compiling illustrations for Tugwell's book *American Economic Life.* It initiated Stryker into the great American documentary photographic tradition of progressive reformists Lewis Hine and others and was the inspiration for his work with the FSA. Over the course of the section's life, and although it was transferred several times to various government divisions, the program resulted in some 77,000 images of many aspects of the national condition. They were used in a variety of news releases, publications, and exhibitions, and during the Depression these views of America's most unfortunate citizens had an important influence on legislation and more generally on people's awareness of the widespread agricultural problems.[29]

Since their primary purpose was documentary, the FSA photographers' emphasis was naturally

more on the real than was the case for their painter contemporaries. Stryker also advocated a strongly socialist, or at least humanist, perspective, which conditioned if not directed the photographic results. Although he was scrupulous in allowing his photographers artistic freedom, he insisted that they read *North America: Its People and the Resources, Development, and Prospects of the Continent as an Agricultural, Industrial, and Commerical Area,* written by his friend, the economic geographer J. Russell Smith, before they began their fieldwork.[30] Even with their preconceived agenda, the FSA photographers, many of whom have become some of the century's best-known artists, often presented their subjects no less mythically than painters, transforming them from the mundane into the epic, in what Joanne Jacobsen has called a "hesitation between a timeless ideology and a timely realism."[31] Dorothea Lange (1895–1965) in the famous *Tractored Out* (1938, fig. 10), for example, vividly portrays the human consequences of mechanization by focusing on a lone farmhouse, the former home of a sharecropper family that has been forced off the land.[32] The cause, the title suggests through an idiom of the time, is the tractor; with the mechanized plow and cultivator the owner no longer needs people to work his land. As one Kansas farmer wrote in 1938 to his U.S. senator, "The tractor and its machines is nice and I am for them. Used in its place its betters farm life, but it makes people greedy and they can not get enough. . . . They run the renter off, tear down the buildings so tax will be cheaper, and no upkeep. . . . In other words, the rich are getting richer and the poor, poorer."[33] In Lange's photograph, the owner, with no need for the house, has plowed the ground up to its porch, leaving the dwelling as a decaying island. Lange's husband (economics professor Paul Schuster Taylor) wrote of the phenomenon in a caption to the image: "Tractors replace not only mules, but people. They cultivate to the very door of the houses of the men they replace."[34] At the same time, nearly everyone recognized that mechanization was inevitable, even if they did not always foresee the results. According to Herman Nixon, "The tractor . . . suggest[s] important readjustments in the agricultural economy of this region. The mule in the flesh must be adjusted to the steel mule."[35] As if in response to this dilemma, the formal starkness and implied narrative of Lange's image work together to create its power; it at once speaks of hardships and consequences and stands in mute testimony to the land's perseverance in the face of change.

One of the major subjects of the FSA photographers, as Lange's photograph indicates, was the depopulation of American farms during the 1930s, especially in the western and southern prairies. Written about in everything from John Steinbeck's *Grapes of Wrath* (1939) to the book published by Lange and Taylor, *An American Exodus: A Record of Human Erosion* (1939), this mass migration represented a major shift in the demographics of the United States and in the American relationship to the land, one that threatened to reverse the settlement patterns that had originally peopled the prairies. As Taylor wrote laconically of Oklahoma in 1938, "The treeless landscape is strewn with empty houses."[36]

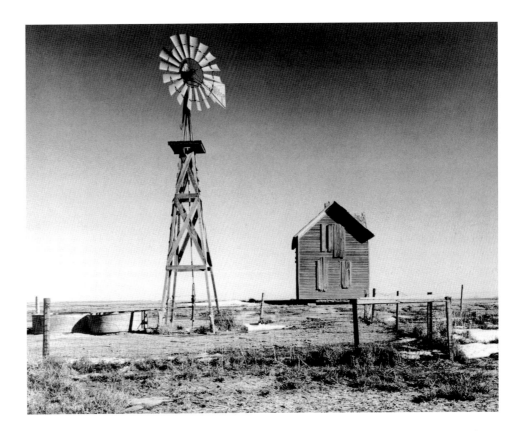

Another who was struck by these vacant edifices was Wright Morris, who before becoming a well-known writer made photographs briefly for the FSA. His *Abandoned Farm* (1941, fig. 69) recalls Lange's bleak views but is an even more striking photographic counterpart to Alexandre Hogue's documentary works such as *Drouth Stricken Area* (1934, Dallas Museum of Art). Morris later wrote about the poignancy of such sights, saying, "What is it that strikes you about a vacant house? I suppose it has something to do with the fact that any house that's been lived in, any room that's been slept in, is not vacant any more. From that point on it's forever occupied. With the people in the house you tend to forget that . . . but with the people gone, you know the place is inhabited."[37] Morris would use *Abandoned Farm* in several of his "photo-texts" and novels, including *The Home Place* (1948). Strangely, perhaps to emphasize their fictional quality, he also appeared to dismiss the veracity of his vision: "What if I should tell you that my barren plains, the inhabitants included, are largely a product of my imagination? They arise out of my *need* rather than my experience."[38] But as his own photographs, those of his contemporaries, and the lives of countless migrants reveal, the phenomenon he captured in *Abandoned Farm,* quite apart from his literary constructions, was all too real.

Not all the images of the era were agricultural, of course, and in addition to the urban scenes that constituted a large portion of the paintings and photographs, rural communities also formed an important subject for artists in the Depression-era prairies. John Vachon's *Oil Company Production Camp, Moore County, Texas* (1942, fig. 70) stands out for its alternative view of the landscape and its formal emphasis on the horizontal. This FSA photograph depicts the modest dwellings typical of a company town, lined up in efficient rows, shining brightly against a looming backdrop of black smoke. The stretch of houses not only echoes the prairie setting but also reminds us that the southern prairies were transformed by oil during the 1910s, 1920s, and 1930s almost as dramatically as the northern grasslands had been by agriculture. During the Depression, although slowed substantially by the national economic disasters, the petroleum industry helped maintain local economies throughout parts of Texas and Oklahoma and even added to the growth of some prairie towns and cities. Just as significant, oil contributed its own visual elements to the prairie landscape, dotting those treeless expanses with derricks, tank batteries, pump jacks, and oil camps such as those Vachon portrayed.[39]

THE LAND'S REVENGE

In Rölvaag's epic saga *Giants in the Earth,* when the earth rises to defend herself from human onslaught she is never alone; she is joined in her retribution by her Red Son, which burns down on people and crops, and the Great Cloud that looms menacingly along the northwest horizon before deluging those below with torrents of rain, hail, grasshoppers, and blizzards. As if revisiting the devastating plague of 1874, compounding the misery of the Depression and drought, the grasshoppers returned again to the western prairies throughout the 1930s.[40] Undocumented in the nineteenth century by visual artists, the power of these creatures was captured in a series of FSA photographs by Arthur Rothstein.[41] Even more compelling is Richard W. Hufnagle's *Tripp County, South Dakota, August 8, 1940* (1940, fig. 71), taken not for the federal FSA but rather for a Nebraska conservation program headed by state geologist George E. Condra.[42] In Hufnagle's view, one of the few that actually depict the grasshoppers themselves, the encrusted fence post testifies to the voraciousness of the locust swarms. Although many wrote about the infestations in the nineteenth century and after, Rölvaag's description perhaps most dramatically suggests their horror:

The brown bodies whizzed by on every hand, alighting wherever they pleased, chirping wherever they went; as many as half a dozen of them would perch on a single head of grain, while the stem would be covered with them all the way to the ground. . . . That night the Great Prairie stretched herself voluptuously; giantlike and full of cunning, she laughed softly into the reddish moon. "Now we will see what human might may avail against us!"[43]

Figure 70

John Vachon (1914–1975)

Oil Company Production Camp, Moore County, Texas, **1942**

photograph, 11 x 14"

Library of Congress

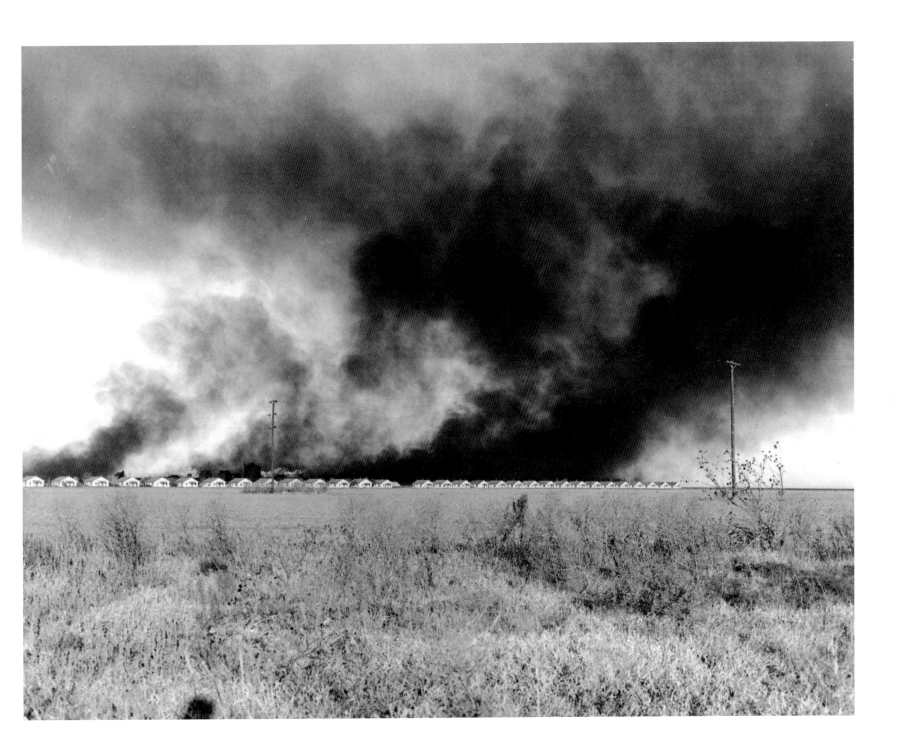

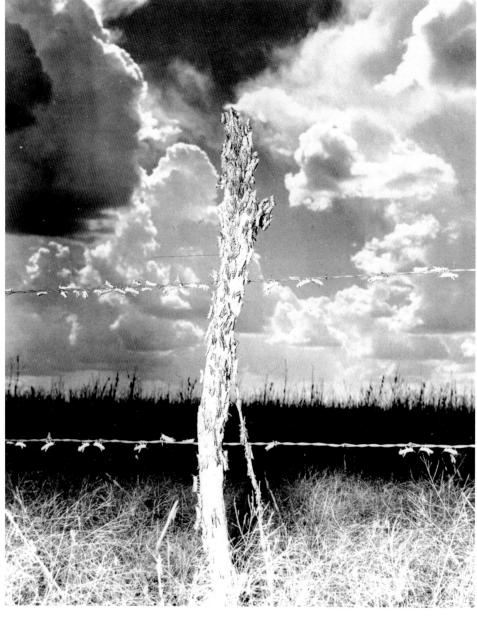

As prairie farmers had recounted miserably for decades, the grasshoppers usually left little in their wake. One Boone County, Nebraska, woman recalled that her five-year-old daughter left her doll outdoors one day in 1936, and "when we found it the next day the hordes of grasshoppers had eaten all of its clothes off."[44]

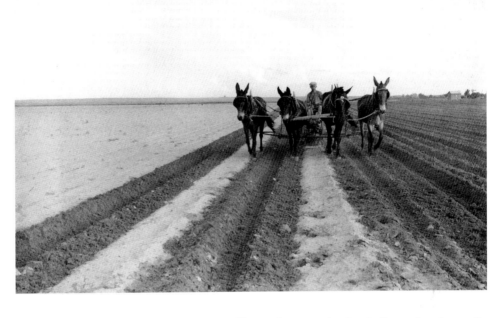

As if clouds of insects and dust were insufficient, the 1930s also, ironically, produced sporadic flooding.[45] Although drought was the major problem during this period, erosion was just as serious. If rain came at the wrong time or in too great a quantity, it could strip a field of its topsoil or flush out newly planted seeds, forcing farmers to plant the same field again and, sometimes, again. Such was the case for the man in Dorothea Lange's striking photograph *West Texas Farmer Replanting Cotton; Three Inches of Rain Washed Out First Crop* (1937, fig. 72), which presents the farmer less as a defeated victim and more as a figure of resignation continuing on despite nature's whimsical and punishing behavior. In this picture he reworks his field with a mule-drawn cultivator, but because of the way Lange composed her view, the drudgery of his task is minimized. By positioning herself and the viewer directly in front of the team and slightly below, she framed the farmer in a light halo of dust, providing a heroic aura to him and his work. It glorifies his labor, as if to reassert his primacy over nature, but when the image is placed in the context of the title, his efforts are revealed as either exceedingly determined or futile.

In some areas, as Hogue emphasized in *Mother Earth Laid Bare,* erosion was so severe that it seemed as if there was no soil left. The FSA photographs often depicted wasted farms, but none were so striking as the monumental painted testimonials of Hogue and such contemporaries as

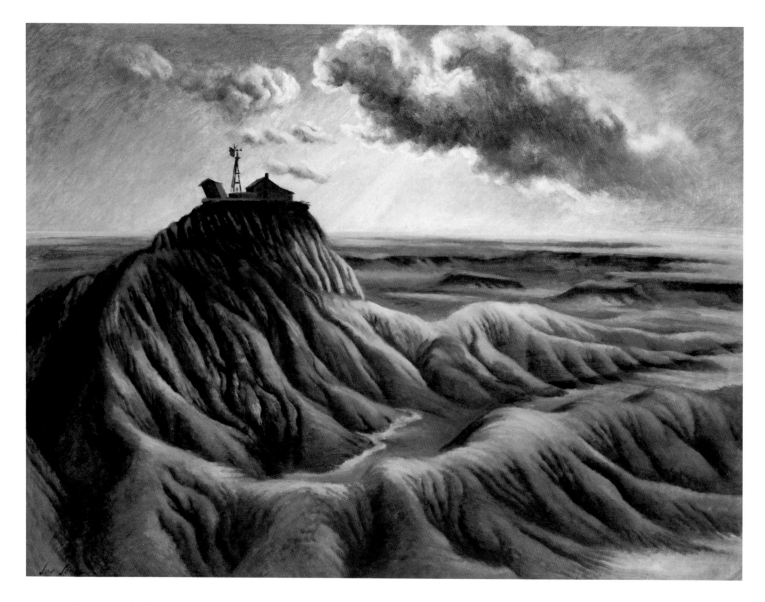

Joe Jones (1909–1963) of Saint Louis. In Jones's *American Farm* (1936, fig. 73), a starker version of Hogue's *Mother Earth Laid Bare* without the gendered symbolism, a mythic farm has been so wholly eroded that only the house, the broken windmill, the outhouse, and the stock tank survive, perched like a lighthouse overlooking a vast badland desert. The billowing gray clouds threaten more rain, which will only further denude this "ocean of dirt" where once, we are to assume, there was a sea of grass or waving wheat. In this image, a dark and twisted version of the traditional prospect picture, the future of the land and its inhabitants is not just bleak but actually appears doomed.[46]

Figure 73

Joe Jones (1909–1963)

American Farm, 1936

oil and tempera on canvas, 30 x 40"

Whitney Museum of American Art, New York.
Photograph by Sandak Inc., New York

In the context of all these agricultural disasters, Grant Wood's *Breaking the Prairie* [*When Tillage Begins*] (ca. 1935–1937, fig. 9), which formed the basis for a mural in the Iowa State University Library in Ames, is either highly ironic or hopelessly naive. Since Wood spent much of the decade creating biting satires of American myths and tongue-in-cheek portrayals of midwestern life, it is likely that he was keenly aware of the complicated implications of this work. Intended as the first of a series of murals tracing the progress of civilization in Iowa, the triptych form is flanked by panels depicting two men energetically chopping trees, and in the center scene a farmer stands with his plow and team, pausing from turning the stubble of a newly harvested field to refresh himself from the jug his wife has brought him. Behind, another farmer breaks more ground with several ox teams and a sod-breaking plow. In Wood's study, although not in the monumental version completed by his students, the neat furrows are interrupted by a framed inscription, taken from an 1840 statement by Daniel Webster, "When tillage begins, other arts follow. The farmers, therefore, are the founders of human civilization."[47] Wood's use of the quotation and the historic subject echoed a sentiment popular in his youth and in the fond desires of his contemporary audience. National Grange director N. J. Bachelder had expressed it to his organization in 1908,

The prosperity of other industries is not the basis of prosperity in agriculture, but the prosperity of agriculture is the basis of prosperity in other industries. . . . Immense manufacturing plants and great transportation companies are dependent upon agriculture for business and prosperity. Great standing armies and formidable navies may protect the farmers in common with other people of a nation, but their support comes from the tillers of the soil.[48]

Heroizing the farmer in monumental representations was precisely in keeping with much of the rhetoric of the 1930s, both in the art world and in politics, but as might be inferred from the various problems that plagued agriculture, the notion was often seen from a different perspective during the Depression. One Kansan wrote to his congressman, "There has got to be something done to save the farmers of this country. You put the farmer on his feet and other industries will soon recover. The Farmers are the back bone of the whole works and the poor devils have had the least consideration of anybody. How long their faith in their country is going to last I don't know."[49] Even in a region as relatively unscathed as Wood's Iowa was at the time, such despair and frustration must have cast a shadow over Wood's mural. In its prominent position in the state's agricultural college library, the artist's pictorial homage to the glory of the farmer was a hollow heroism.[50]

In a similar though more convincing effort, John Steuart Curry painted a nearly life-size botanical portrait entitled *Kansas Cornfield* (1933, fig. 13). In this work, rather than celebrating the

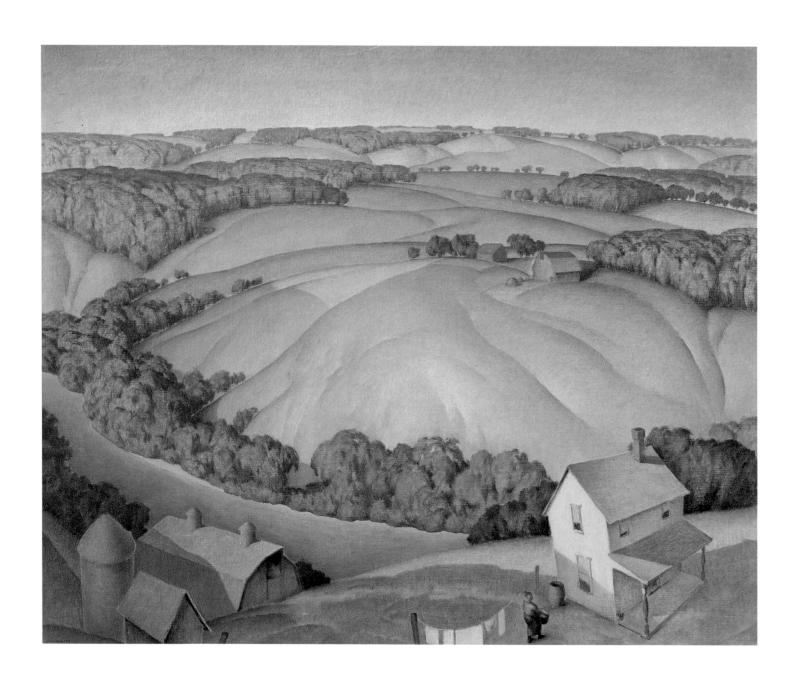

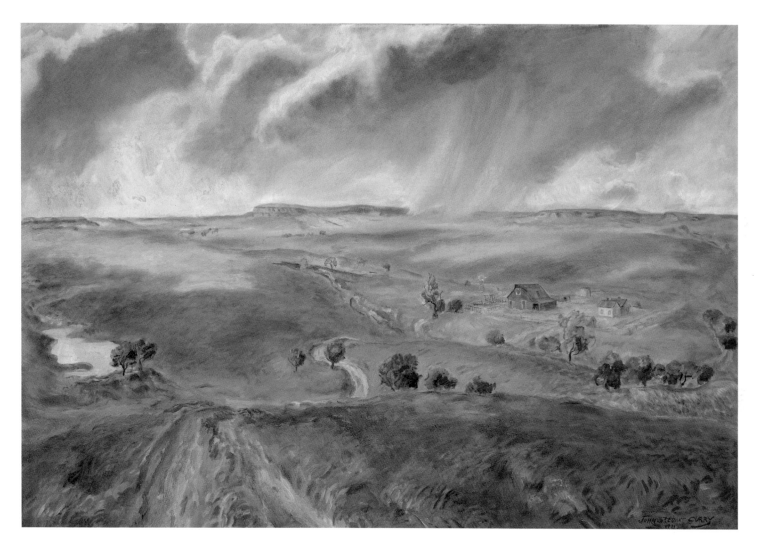

LEFT: **Figure 74**

Marvin D. Cone (1891–1965)

River Farm, 1925

oil on canvas, 24 x 30"

The Coe College Permanent Collection of Art,
Cedar Rapids, Iowa

ABOVE: **Figure 75**

John Steuart Curry (1897–1946)

Spring Shower, Western Kansas Landscape, 1931

oil on canvas, 29⅞ x 43⅞"

The Metropolitan Museum of Art, New York,
Arthur Hoppock Hearn Fund, copyright © 1996,
Metropolitan Museum of Art

farmer, Curry immortalizes one of the crops that had so dramatically transformed the prairie. As the stalk writhes and bends in the wind, it takes on an anthropomorphic quality that the focused treatment accentuates. Because the view is so thoroughly attentive to the individual plant, without any distracting evidence of human presence (although it is clear that this is not a native prairie species), Curry's image lacks the irony of Wood's *Breaking the Prairie,* with its strong cultural associations and contradictions. Not a landscape painting per se, Curry's work nevertheless manages to evoke the character of the emerging agricultural prairie without compromising it with human frailty. Three decades later his powerful portrait was echoed in Thomas Hart Benton's *Wheat* (1967), a smaller counterpart, albeit a no less sincere tribute to the new prairies' identity.[51]

Many other artists portrayed the prairies and life in them as it had been in better times, but most were hardly so literal in emphasizing the human triumph as Grant Wood had been. Wood's best friend and colleague Marvin Cone (1891–1965), for example, produced an ambitious series of views along the Cedar River near Cedar Rapids, Iowa, in which soil and water, grass and trees, humans and the landscape, coexist harmoniously. In one, *River Farm* (1925, fig. 74), quite the opposite of Jones's *American Farm,* the rounded Iowa landscape is viewed from an exaggerated elevation, emphasizing its bountiful swell as it curves around the river.[52] Never as famous as his friend, Cone nevertheless portrayed his local scenery in all its pastoral splendor throughout a career that deserves to be better known. Similarly, Texan Florence McClung (1896–1992) was apparently undaunted by the widespread drought around her in the southern prairies, and in works such as *Squaw Creek Valley* (1937, Dallas Museum of Art) she delighted in the patchwork effect of rolling fields at harvest time. Since McClung was a student of Alexandre Hogue's, it is perhaps surprising that she was not more influenced by her teacher's preference for scenes of devastation; instead she chose to present a view much more in keeping with Wood's and Cone's rolling, verdant Iowa scenes.

Like Hogue, John Steuart Curry (1897–1946), Kansas' premier Regionalist, also portrayed the trials and tribulations of his native region, in paintings of tornadoes and electric storms for example. In other works, such as *Spring Shower, Western Kansas Landscape* (1931, fig. 75), he chose instead to focus on the fecundity of the prairie in its most delightful season. In this painting, similar to works by Cone and McClung, Curry emphasized the optimism of the season by elevating the perspective, looking across the landscape from a small rise. One of his three most significant paintings of prairie landscapes, it depicts the Heart Ranch in Barber County, where Curry spent time in 1930 and which he used in a number of works. In his view, the western prairies are the beneficiaries of the blessing of rain and good fortune and not the region that would so soon afterward become a wasteland of dust.[53]

In all these depictions the land and its inhabitants are elevated to a mythic dimension, one even more pronounced than that which proclaimed the prairies to be a garden. Because this effort was

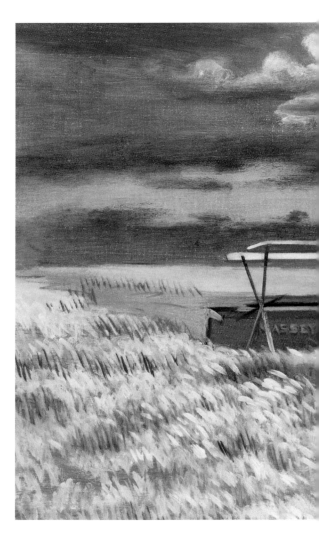

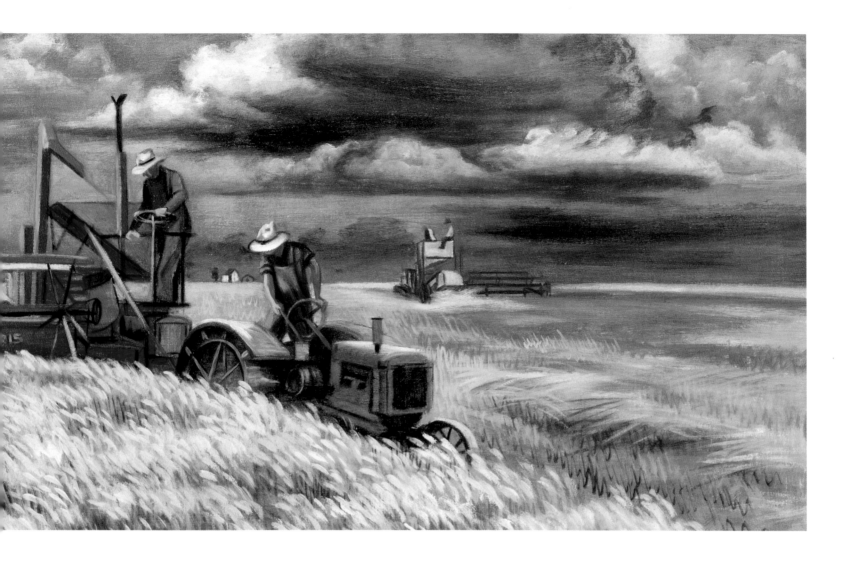

Figure 76

Joe Jones

Men and Wheat, ca. 1939 (mural study for
Seneca, Kansas, post office)

oil on canvas, 15½ x 35¼"

**National Museum of American Art, Smithsonian
Institution, transfer from the U.S. Department of
the Interior, National Park Service**

so strikingly challenged by contemporary circumstances, it formed one of the central tensions of
the Regionalist art of the period. To contend with the profound difficulties of the era and per-
haps to compensate for what was lacking—in hope, in finances, and in the land itself—the artists
monumentalized their subjects, as if their portrayals of an ideal would realize it for their audiences.

PRAIRIES FOR THE PUBLIC

The optimism that prevailed in many of these works, especially the public murals such as Wood's
Breaking the Prairie, was encouraged by their function and their origin in government commissions.
Between 1933 and 1943 four different federal relief programs helped artists cope with the

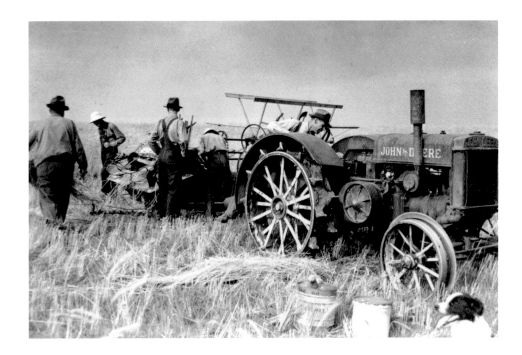

Depression and supported such works. One in particular, the Section of Painting and Sculpture administered under the Treasury Department, strongly advocated localized subject matter and celebratory tones for the works its artists produced. The most famous were the post office murals that adorned hundreds of federal buildings throughout the country, but other government structures were decorated as well. Although the section had the final say, the artists for these commissions were chosen and supervised by local juries, which had a vested interest in seeing themselves and their history represented positively.[54]

This community emphasis suited the Regionalists' interests well, and artists were often able to appeal directly to the desires of their prairie-state audiences through a strong focus on the landscape and its ideal prospects. One example was Joe Jones and his wheatfield murals, such as *Men and Wheat* (ca. 1939, fig. 76), for the Seneca, Kansas, post office. In contrast to his desolate *American Farm,* in this work Jones appealed directly to Kansans' most profound longings in those Depression years—for work and for good crops—and he represented their engagement with both. "Aside from the importance of wheat to Kansas," he said, "my interest was in portraying man at work—his job before him—and how he goes about it with his tools—man creating."[55]

Jones's interest in labor and his region's agricultural health was determined not solely by the difficulties of the Depression but as well by his working-class background and his own commitment to socialist ideals. He began his career as a housepainter with his father in Saint Louis and was self-taught as an artist. At age twenty-two he left the city for a time and worked as a

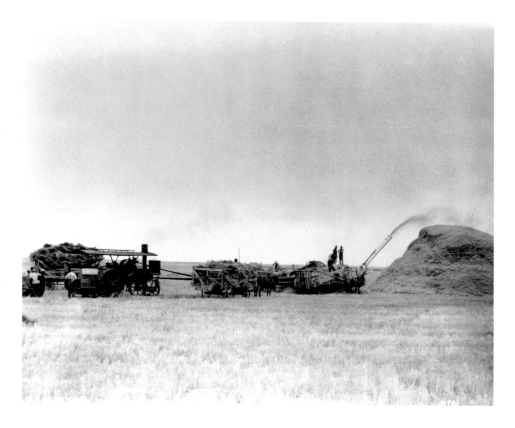

wheat harvester, gaining insight he would use later in some of his most distinctive images and
solidifying his identification with the working classes. On his return to Saint Louis in the early
1930s, while working for the Public Works of Art Project (PWAP), he fulfilled his commitments
to labor and earned a reputation as a radical by organizing art classes for unemployed artists at
Saint Louis's Old Courthouse. Most of those students happened to be African American, and as
if that wasn't enough to upset the conservative city's administrators, Jones displayed Soviet
posters in the rotunda as part of his lessons. He was evicted for distributing propaganda and later
narrowly avoided arrest for protesting the lack of relief for the poor, an incident that prompted
him to leave briefly for New York.[56]

Jones began addressing the subject of wheat farming as early as 1934, when he included one
work, *Wheat,* in the Whitney Museum of Art's biennial exhibition. Two years later he exhibited
an entire series at the Walker Gallery in New York and for years afterward was so well known
for the subject that he jokingly called himself the "Professor of Wheat." When the Treasury
Department began looking for artists in the wheat belt to fill local commissions, Jones was a log-
ical choice. From 1936 to 1941 he produced three murals of grain harvesting for post offices in

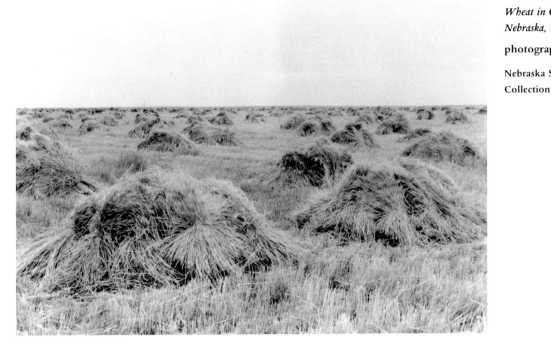

Figure 79

Anonymous

*Wheat in Cheyenne County, West of Gurley,
Nebraska,* 1940s

photograph, 11 x 14"

**Nebraska State Historical Society, Lincoln, Condra
Collection**

Seneca and Anthony, Kansas, and in Charleston, Missouri. The 905 liquor company in Saint Louis also commissioned him and another artist, James Barre Turnbull (1909–1976), to produce five murals entitled *The Story of the Grain* in a similar mode, for the company's stores.[57]

In their bountiful optimism and socialist underpinnings, Jones's murals do reflect an ideal relationship between humans and nature, but they also portray the harvesting practices of the time, as demonstrated by comparisons with photographs from George Condra's state conservation program that documented Nebraska's recovery from the Depression in the early 1940s. *Men in Wheat Field with John Deere Tractor* (early 1940s, fig. 77), *Harvest, Cheyenne County, Nebraska* (1940s, fig. 78), and *Wheat in Cheyenne County, West of Gurley, Nebraska* (1940s, fig. 79), for example, convey the same bountiful fertility and pastoral harmony. Like the social agenda of Condra's program, Jones's strong political beliefs melded well with his chosen subject, satisfying his public and preserving a strong sense of the landscape. In his views the prairies are cultivated, but they maintain their fertility and integrity, and his people continue to possess their inherent dignity even as they persist in their struggle with the land.[58]

As artists responded to the circumstances of their surroundings—the increasing industrialization of prairie agriculture, the difficulty of making a living on the land, and the farmer's vulnerability to outside political and economic forces—they also struggled with the problems these posed for their efforts to make Regionalism nationally significant. They constantly negotiated between the mundane and the transcendent, seeking reconciliations of the merely local and the universally significant. This exceptionally difficult task formed the heart of their work and their attitudes toward it and, as well, became the basis of prairie representations and the terrain's emerging identity in the modern era. The delicate balance the Regionalists desired—that within the particular rhythms of the Midwest an equivalence might be found for American ideals—was neither natural nor always comfortable, but it provided their work with a much more important foundation than has sometimes been ascribed to it. In the end the art was not wholly successful in its embodiment of the larger ideals; the particular will always ultimately fail in its representation of the whole. Still, in their struggle to find a middle ground that could contain such lofty ambitions, the prairie Regionalists did reveal a number of significant characteristics that persist in our relationship with the land.

The most important of these is paradox. As the Regionalists grappled with the contradictions of their aspirations, they themselves embodied the paradoxes of their subject. They were local and cosmopolitan, ordinary and remarkable, simple and complex. They concerned themselves with the conflicts that had long been a part of aesthetic controversies and that still affect the art world—the incompatibilities between high and low art and subject matter, the differences and affinities between regionalism and nationalism, and the disparities between modernism and conventionalism—but they also struggled with other considerations unique to their subject—the stigma of provinciality, the criticism of local audiences skeptical of any effort to portray them, and, perhaps most important, their own insecurities about being identified as regional.

Many of the Regionalists were raised on midwestern or prairie farms but left to study in eastern and European cities just when modernism was coming into its own. Even those who never fully embraced the new trends were thoroughly aware of them. Thomas Hart Benton, for example, became a prominent abstract painter in Europe and New York before he returned to Missouri and its local subjects in 1935; John Steuart Curry began his career as a commercial illustrator with Harvey Dunn in New Jersey before moving to the art colony in Westport, Connecticut; Grant Wood remained in Iowa but traveled widely in Europe and maintained relationships with individuals prominent in the national art scene; Alexandre Hogue lived in New York for four years before returning to Dallas, Texas, to teach and paint; and Marvin Cone lived out his life in Cedar Rapids, Iowa, but made extended tours to Paris. When they began, in the mid- to late 1920s, to concentrate on the landscapes and people with whom they had grown up, they were portraying

the same subjects they had deliberately left behind earlier in their careers. Their return to regional subject matter was a conscious response to popular taste and the political and economic circumstances of their time, but it required them to position themselves against the avant-garde that had dominated artistic development in the 1910s and 1920s, the avant-garde to which many of them had aspired as young artists.[59]

Even as they were making these difficult choices, it seemed that the artists were being called on to be both regional and national, particular and universal, modern and traditional. In 1935 Thomas Craven, the preeminent champion of Regionalism, wrote in an article entitled "Our Art Becomes American," "It is no accident that the leaders of the new school have come out of the Middle West: for in that region American particularism is at its highest and the frontier heritage of thought and conduct lives on in stark realities spreading distrust for all absolutes and preserving the hope and temper of democracy." With such expectations, to be both mundane and profound, it is not surprising that the Regionalists would have trouble coming to terms with their subject and that their statements, actions, and images would reflect those deep ambivalences.

From the beginning Regionalism, in its movement away from modernist abstraction toward narrative themes based in localized subjects, contained the desire to reconcile inherent polarities and contradictions. In a 1924 article entitled "Form and the Subject," for example, Benton explained the notions guiding him by contrasting the aesthetic with the social: "We must have in clear outlines the human imagination actually disposing and ordering relationships. . . . The connection between form and the subject is far more vital than is commonly supposed." Two years later, reviewing an exhibition of sculpture by Constantin Brancusi, he more pointedly admitted the dichotomy, saying, "It is interest in the world, its fact and plain poetry, and not in fine-spun notions of essential essences and strained perfections that gives the electric charge to form and sends it streaming and spluttering into the future."[60]

Grant Wood added his own comments in a series of lectures in Iowa City, in the brochure for his Stone City Art Colony in 1932, and in a more adversarial manifesto entitled "Revolt against the City" (1935). In the latter Wood admitted that it was because of the "magnetic drawing-power of the Eastern cities that the whole country, almost up to the present time, looked wistfully eastward for culture," but he emphasized that

the Great Depression has taught us many things, and not the least of them is self-reliance. It has thrown down the Tower of Babel erected in the years of a false prosperity; it has sent men and women back to the land; it has caused us to rediscover some of the old frontier virtues. In cutting us off from traditional but more artificial values, it has thrown us back upon certain true and fundamental things which are distinctively ours to use and to exploit.[61]

One of the most ardent promoters of the Regionalist movement, Wood was echoing many of the concerns and interests of a large sector of the American public that was disenchanted with

contemporary art and contemporary problems, but within his discussion was a fundamental opposition between urban and rural, local and national. Industrialism seemed to have diminished individuals' control over their own lives. The horrors of an international war, an ever more complicated political climate, and the emergence of art that seemed at once foreign and incomprehensible led many to look back nostalgically to earlier times and to places, such as the prairie region and the Midwest generally, where life was supposedly simpler and more American. This was, of course, an illusion. The economic realities of the Depression were forcing more and more people to look outside their own communities for financial support, and the prairie states were forced to recognize that they were indeed dependent on the rest of the nation for their prosperity. The notion of a regionalism separate from a larger America was a fiction.

The polarization of rural and urban manifested itself in many ways between the two world wars; one of the more ironic was the migration from the cities, which rivaled in scale the original wave of settlement after the Civil War. The numbers have been estimated in the millions. Initiated by the idealism of 1920s city dwellers disillusioned with urban life, the "back to the land" movement continued during the Depression with the support of the federal government. With hopes of reducing the need for relief programs in the cities, the government established more than one hundred resettlement colonies in rural locations, even as prairie farmers were being forced out in droves by their inability to survive on the land.[62] This country-life trend was only one aspect of a larger yearning for indigenous American values and lifestyles; Regionalist art, with its focus on rural patterns of national life, strongly responded to and fueled that desire.

One of the ironies of this migration, of course, was that Midwesterners, especially rural ones, had been striving for decades to achieve the sophistication of their eastern and urban counterparts. Only when they were suffering to an extent unknown since the pioneer period was their lifestyle appreciated. The same could be said for the artists as well; just as they were leaving their backgrounds behind, popular taste returned them to those subjects. As Wood revealed in his essay, however, their response was to exploit the trend, taking full advantage of the opportunity. They provided their audiences, especially those who were not midwestern, with exactly what they wanted. Even though this was something they personally advocated in their work and in their statements, their assertions almost always have a discomfiting edge that reveals their ambivalence toward the popular longing they were presumably satisfying.

This consciousness is revealed in many ways. One of the first was the staging of Regionalism's emergence as a movement. Art historian Henry Adams has pointed out that the event that joined Benton, Curry, and Wood into an artistic alliance was in fact a sophisticated promotional ploy by a New York dealer, Maynard Walker, who was intent on encouraging sales. He first featured Benton, Curry, and Wood in a Kansas City exhibition in 1933 and then orchestrated the following year's unprecedented *Time Magazine* cover story, which brought the three artists and their work to the national forefront. The coverage marked several firsts: it was the first

time a portrait of an American artist (Benton) was given pride of place on the magazine's cover, the first issue of the publication to reproduce color images on its inside pages, and the first time that the art of the central United States had received serious national attention in the popular media.[63] Most important, however, it initiated the construction of midwestern Regionalism into a unified concept. The movement was not a cohesive style or group at all, but rather an artificial association; the artists and their subject matter had to be cultivated into an idealized model, one that was belied in many ways by their circumstances at the time.

Far from unwitting rustics manipulated by a cagey city dealer, Benton, Curry, and Wood all recognized a good opportunity and played their parts with panache. To strengthen their personal affiliation with their subjects and to encourage public interest, the artists downplayed their sophistication and affected a down-home persona. When they met at Wood's Iowa City home for photographs, Curry and Wood donned overalls for the cameras and posed with pipes in hand.[64] Staying in character in subsequent photo opportunities and press events, they reinforced the notion that they were homespun interpreters of their surroundings.[65]

Even as the three artists willingly participated in the charade, they could not have helped being uneasy with their roles as country bumpkins. They were, each in his own way, exceptionally sophisticated individuals and had long ago left the simplicity of their origins, if indeed they had ever existed as such. Benton had worked almost exclusively in Europe and the East before 1935; Curry was a successful Connecticut painter and illustrator; and although Wood stayed close to his Iowa roots, by the time of his *Time* appearance he had achieved national standing and was active in intellectual circles at the University of Iowa that were far from provincial. Benton later commented on the portrayal of the triumvirate as unified and homespun. "How or why this first occurred is hard to say," he wrote. "A play was written and a stage erected for us. Grant Wood became the typical Iowa small towner, John Curry the typical Kansas farmer, and I just an Ozark hillbilly. We accepted our roles."[66]

Most buyers of their works, moreover, were from areas other than those the artists painted, and the local residents, who logically should have celebrated their achievements, often harshly criticized the paintings, condemning them as unflattering or stereotypical. The outcry was intense in some cases. Elsie J. Nuzman Allen, the wife of a former governor of Kansas, complained to her friend William Allen White, an influential Emporia journalist who had supported Curry's work, "Mr. Curry has a great force in delineating the subjects . . . but to say that he portrays the 'spirit' of Kansas is entirely wrong. . . . To be sure, we have cyclones, gospel trains, the medicine man, and the man hunt. . . . But why paint outstanding friekish subjects and call them the 'spirit' of Kansas?"[67] Grant Wood's signature work, *American Gothic* (1930, Chicago Art Institute), was even more controversial. Its depiction of two dour individuals raised an outcry from some insulted Iowans, even as it was purchased by one of the leading museums in the

country and hailed by other local residents as the embodiment of the "strength, dignity, fortitude, resoluteness, [and] integrity" of midwestern farmers.[68] Benton's *Indiana Mural* for the 1933 Chicago World's Fair and his *Social History of Missouri* (1936) in the Missouri State Capitol were roundly criticized by local residents for what they deemed a satirical portrayal of their history and citizenry.[69]

The conscious construction of a midwestern Regionalist identity, combined with the mixed local receptions and the artists' ambivalence about their home regions, suggests a more complicated relationship between subject and artist than has been previously described. More important than simply psychoanalyzing personal uncertainties, however, this recognition points instead to their understanding of the land in which they were raised and their perception of their place in it. Wood instructed his students at the Stone City Art Colony, in a description of their subject that could easily apply to prairies generally, that the artists were to struggle with "a subtle quality that extends over a large but quite homogenous area, and that manifests itself in a thousand elusive but significant ways."[70] He and his contemporaries were exceptionally aware of the nuances of their subject in all its contradictions and ironies.

Wood's satirical portrayals and his images that monumentalize the landscape and its inhabitants in aggrandized celebrations were all a response to this awareness. Like the overwrought historical epic murals of Thomas Hart Benton, which at once immortalize and critique their subjects, Wood's paintings (and those of other Regionalists such as Hogue or Curry) represent an important understanding of the place and time they depict. In either extreme, whether triumphal or ironic, these images most often address their subject through a mythic structure. By rendering the most ordinary farm as the site of cosmic forces, for example, they could elevate it to epic significance, at the same time recognizing its mundaneness. This mythologizing is evident as well in the details and the form of the paintings. Wood's farmers barely etch the surface of their land, leaving its underlying essence untrammeled; the forces that affect his subjects are largely subterranean, whereas in Benton's work the figures themselves writhe with the same energies, but these are wholly above ground. The contrast bears out Wood's observation of "a subtle quality that . . . manifests itself in a thousand elusive but significant ways" and testifies to the power of the land that shaped these visions.

Such dichotomies were also, of course, affected by a widespread disillusionment with the land. By the time midwestern Regionalism was finally hailed as the emerging national art, the land and the people that it celebrated were in the midst of the worst depression in history. Artists responded not only to the people's failure to realize the prospects that had seemed so promising only a few decades before but also to the land's failure to live up to expectations. The ambiguities of Regionalist images, their inherent contradictions, are as resonant as the paradoxes in the prairie landscape that was their inspiration.

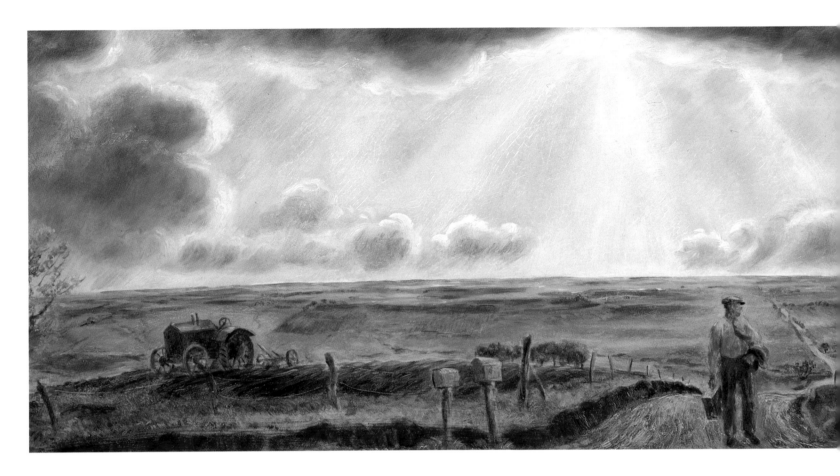

Figure 80

John Steuart Curry

Leaving the Farm for Army Training Camp, 1941

tempera on canvas, 15 × 42"

New Britain Museum of American Art, New
Britain, Connecticut

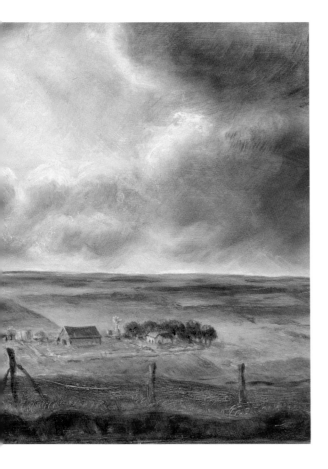

At the end of the Depression some of the fundamental problems of the prairie states that had burdened Regionalism with ambiguities began to be resolved, and a less conflicted outlook emerged, one that regarded the landscape through new prospects. John Steuart Curry's *Leaving the Farm for Army Training Camp* (1941, fig. 80), for example, depicts a lone young man looking back over his shoulder at the Kansas farm where he has grown up as he leaves to join the army. The landscape is green and rolling, expansive and beckoning, making him appear small and vulnerable as he waits for the bus that will begin his journey to the battlefields of Europe, but his hesitancy is more about his future than his past. Curry, who held ardent antiwar sentiments, had created a scathing painting, *Parade to War: Allegory,* in 1938–1939; when the Japanese bombed Pearl Harbor in late 1941, he had only recently finished painting an homage to a friend killed in World War I, *The Return of Private Davis from the Argonne* (1928–1940, Gulf States Paper Corporation, Tuscaloosa).[71] He had been painting the canvas, a sort of prairie *Burial at Ornans,* for twelve years. When linked with *Leaving the Farm,* it inverts the traditional going and coming dichotomy. In Curry's sequence, the outcome of the War to End All Wars is not only the return of the prairies' children to treeless cemeteries but also their return to the battles of the world in the form of their younger followers. In *Leaving the Farm* the landscape prospect is behind the figure; he turns his back to it and to his parents' future as he bravely faces his own, but at the same time his decision seems uncomplicated. There is none of the intense pathos or irony that characterized the leave-taking glimpsed in Lange's *Tractored Out* for example, and the figure departs with his relationship to the land intact. Later that familiarity would be challenged in images that portray modern alienations from the land—the industrialization of and encroachment on the prairies—but as the country emerged from the Depression, human harmony with the land seemed, at least for a time, to have been restored.

Indeed, one of the more positive effects of the Depression and its accompanying agricultural crisis was the recognition that the grasslands were not a limitless or infinitely malleable resource. They could not be taken for granted as they had been, and they were not all one great continuum that could be treated uniformly. Harry Hopkins, author of *Spending to Save: The Complete Story of Relief,* wrote in 1936, "If we can say anything good about the drought of the summer of 1934 it is that it . . . was instrumental in arousing the country to the need of a better land utilization program. Culminating several dry years of increasing severity, it did what years of writing and talking by the conservationists had never done—focussed public attention on what was happening to our greatest natural resource."[72] Many of the experimental New Deal conservation efforts were based on the premise that all the prairie lands are the same, and they were therefore unsuccessful, but they did begin a slow process of forging a new relationship with the land. Many of the earlier changes to the landscape had been made arrogantly—assuming that the land was there simply to be exploited—or in the vain hope of increasing rainfall, or simply

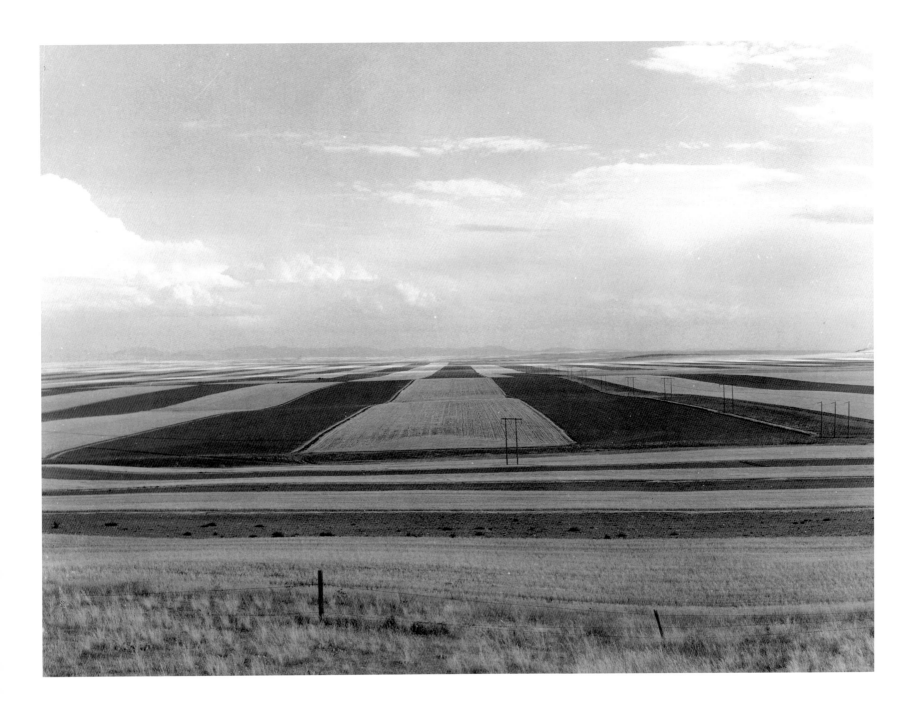

for aesthetic purposes; the Depression era forced farmers and the government to consider working with the land's basic qualities rather than trying to impose practices that had worked in other, different regions. Various programs did continue some of the efforts of the earliest settlers that added to the landscape and reshaped it to prevent wind and water erosion, but new strategies also reconsidered the value of prairie pasture. The Great Plains Committee concluded in its report to Congress, "Rehabilitation of a great region in which it has been discovered that economic activities are not properly adjusted to basic and controlling physical conditions, is not merely a problem of encouraging better farm practices and desirable engineering works, and revision of such institutions as ownership and tenure. It is also one of revision of some of the less obvious deep-seated attitudes of mind."[73] The new projects continued to promote agricultural productivity, but often they did that by taking land out of cultivation, thus discouraging farmers from working submarginal land and from producing too much of some crops. These programs affected the appearance of the landscape as much as the original cultivators had, but they were significant because they recognized that success could be achieved only if the land's intrinsic character and climate were respected.

To protect the soil and crops and to provide employment relief during the Depression, the Prairie States Forestry Project (also known as the shelterbelt program) resumed the arbor theories of the late nineteenth century, planting tree lines throughout one million acres of farmland in the western prairies.[74] Extending a hundred miles from east to west and from the Canadian border to the Texas panhandle, roughly along the line of the ninety-ninth meridian, this massive windbreak was intended to reduce wind erosion throughout the prairies and to alleviate crop damage from drought. In reality, most of the trees died, except for those that were carefully tended and watered, and their effect on the problems they were designed to solve was minimal.

Similarly, the Soil Conservation Service advocated strip cropping to alleviate erosion. This entailed planting different crops in alternating sections of the same field, one a nitrogen-fixing legume (such as alfalfa or soybeans), the other a nitrogen-depleting grain (such as corn or wheat). In theory each crop would protect the other, one by shielding against the wind, the other by fertilizing the soil. As suggested by one of Marion Post Wolcott's FSA photographs, the beautifully composed *Strip Cropping in Wheat Fields, near Great Falls, Montana* (1941, fig. 81), by the early 1940s this practice was widely utilized and to some extent successful, although its usefulness in the Dust Bowl region was limited because of the few crops that could be grown together under drought conditions. Nevertheless, just as the original grid survey and the initial efforts at cultivation had altered the prairies' appearance, and as irrigation had contributed its own patterns, now crop variegation and other conservation methods, such as contour plowing and terracing, added their signatures to the landscape's visual power.[75]

One of the most important of the soil conservation efforts was the reclamation of grassland

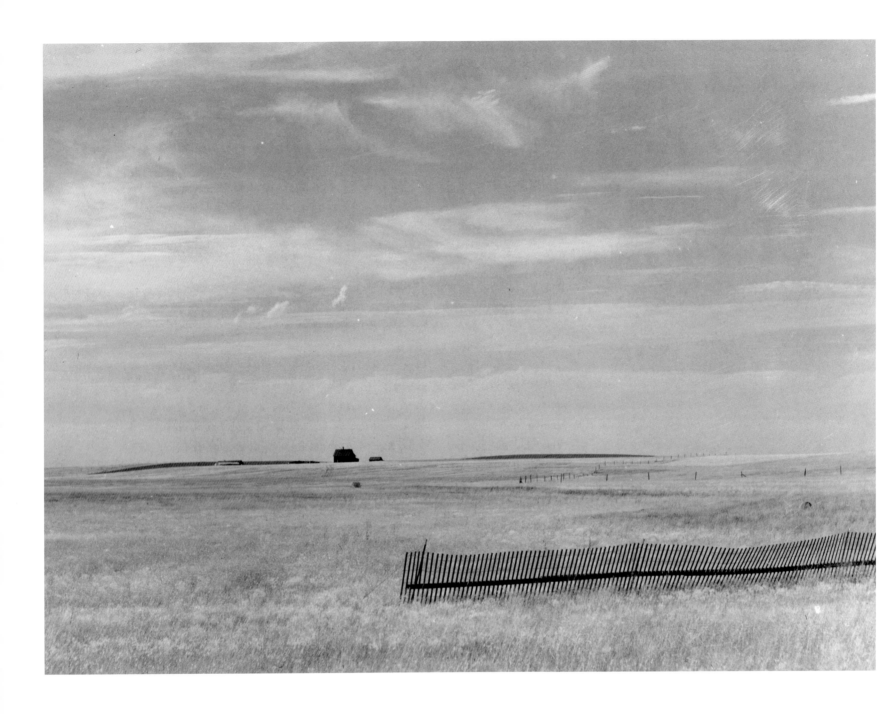

and its return to pasture. This was not as simple, however, as it might have seemed, since the native grasses were not a single species, nor did their protecting cover and underlying root system develop quickly. In a 1935 study, *Drought Survival of Native Grass Species in the Central and Southern Great Plains,* the estimates were sobering: "The time required for buffalo grass to renew its original virgin condition on abandoned farm land . . . ranges from 20 to 50 years." Furthermore, little was known of the complex makeup of prairie grasses or even how to acquire their seeds.[76] With this recognition, never-plowed prairie took on a new significance. It not only maintained its original integrity and subsurface root system but also harbored the species diversity that was suddenly so important. Another Wolcott view, *Prairie and Pasture Land with Snow Fence and Ranch House* (1941, fig. 82), reflects the reevaluation of grassland. With its long, waving vegetation extending unbroken to the front porch of the house, it makes simple grass seem as beautiful as cultivated landscapes had such a short time before. While grassland reclamation efforts were instituted for practical purposes—to put marginal and submarginal land out of production and to promote soil conservation—they resulted as well in a new appreciation of the native prairie grasses. They were the foundation of the health of the region and remarkable for their innate, subtle beauty. This developing awareness of the prairie as an ecosystem has been extremely important for more recent artists who focus on the landscape, not as a resource to be exploited but rather as a holistic system of which humans are a part.

REGIONAL FOCUS, NATIONAL VISION

The heightened tension so apparent in prairie images from the 1920s through 1940, and indeed in much Regionalist art generally (which includes the contradictions between a documentary or social realist subject matter and a highly stylized or idealized presentation), has prompted many to criticize the movement, even to the point of denying it the status of art. To do so, however, is to misunderstand its significance as both a national and localized phenomenon. This is especially true in the context of prairie landscapes. Neither garden nor desert, but sometimes resembling both, the prairies resist categorization and have over the centuries so fluctuated between the extremes as to seem wholly contradictory. Similarly, Regionalist prairie art contains elements of factual documentation and of whimsical fantasy, but in this tension lies its power. It expresses precisely the uncertainty that pervaded its time and its subject, and it embodies in its form the discomfort that accompanied that insecurity. Like all important art, it can be read and interpreted in a variety of ways, depending on the viewer's point of view and agenda, because, as Lawrence Levine has said of the era's photography, "it can freeze conflicting realities, ambiguities, paradoxes, so that we can see them, examine them, recognize the larger, more complex, and often less palatable truths they direct us to."[77] In the photographic and painted representations of the prairies from the Depression era, the grasslands were finally revealed for the complicated and paradoxical land that they have always been.

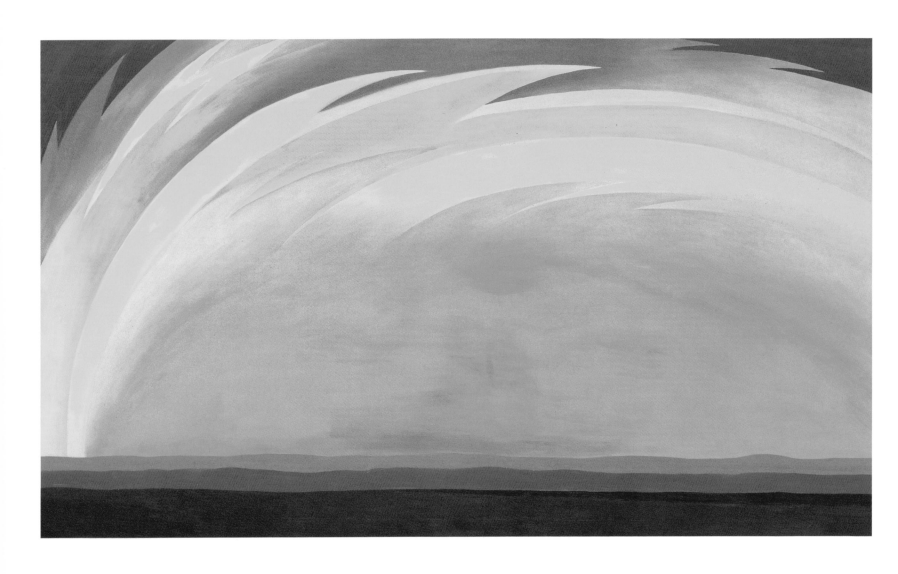

5 · COMPETING PROSPECTS
THE CONTEMPORARY PRAIRIE

Miles and miles of prairie, slowly rising and falling, sometimes give you a sense that something is in the process of becoming, or that the liberation of a great force is imminent, some power, like Michelangelo's slave only half released from the block of stone.

Saul Bellow, "Illinois Journey," 1957

The plain is a metaphysical landscape. . . . Where there is almost nothing to see, there man sees most.

Wright Morris, "Our Endless Plains," 1958

Following the New Deal era's attention to regional issues and images, the abstract trends of the 1940s through the 1960s relegated landscape to a minor subject. While some have argued that Abstract Expressionist painting is a form of sublime landscape, and although minimalism and earthworks functioned in an environmental context, the fundamentally nonrepresentational nature of this art precluded its addressing those features that had distinguished earlier prairie landscape imagery.[1] At the same time, modernist styles, techniques, and ideologies profoundly contributed to artists' ability to return to the grasslands for inspiration. Abstraction, minimalism, and earthworks validated the intrinsic form of the prairie, with its essentialist horizon and limited elements, and many artists began to recognize that grasslands offered a quintessentially modernist subject, as well as one that embodied important cultural developments and conditions of contemporary life.

One early visionary was Georgia O'Keeffe, who in her initial images drew on a strong awareness of the simplicity and power of the prairie landscape. Her watercolors of the 1910s, such as *Light Coming on the Plains II* (1917, fig. 60), capture the sublimity of the low horizon and its spectacular sky, offering abstract conceptions that broke new ground in the representation of that terrain. She had studied with traditional artists, such as John Vanderpoel at the Art Institute of

Figure 83

Georgia O'Keeffe (1887–1986)

From the Plains I, 1953

oil on canvas, 47¹¹⁄₁₆ x 83⅝"

McNay Art Museum, San Antonio, Texas, gift of the estate of Tom Slick

Chicago and William Merritt Chase at the Art Students League in New York, but her own style and ideas were most directly influenced by the avant-garde theories of Arthur Wesley Dow, who emphasized individuality and simplicity in design. Her ability to approach the prairie so directly may have been affected by Dow's assertion that "it is not the province of the landscape painter merely to represent trees, hills, and houses—so much topography—but to express an emotion, and this he must do by art."[2]

O'Keeffe painted her early prairie scenes during the two-year period she taught at West Texas State Normal College in Canyon, although she was already in close touch with the modern art scene in New York, her drawings having been exhibited in 1916 at 291, the gallery of Alfred Stieglitz, her mentor and future husband. She wrote her friend Anita Pollitzer in Manhattan, "It is absurd the way I love this country. . . . I am loving the plains more than ever it seems—and the SKY—Anita you have never see SKY—it is wonderful." She recalled that time later, saying, "I was alone and free—*so very free*."[3]

After creating those early depictions, O'Keeffe returned to the prairies only occasionally in her art. The monumental oil *From the Plains I* (1953, fig. 83), with its hard-edged brilliance, is one instance, but for the most part she preferred the starkly spectacular New Mexican scenery farther west. Nevertheless, the prairies of her youth prepared her for those rarefied and evocative landscapes that she identified with so closely in later years and that brought her fame. "What's important about painters is what part of the country they grow up in," she wrote. "I was born and grew up in the Middle West. . . . the normal, healthy part of America, had a great deal to do with my development as an artist."[4] The grassland's formal simplicity, its subtlety of color and light, and its open space encouraged an aesthetic that O'Keeffe nurtured throughout her long life, surpassed for her only by the harshly beautiful desert of the Southwest and its unusual offerings of bones and flowers.

While O'Keeffe anticipated the late twentieth-century awareness of the grasslands, most artists until quite recently continued to portray the subject in more conventional ways. In *Open Country* (1952, fig. 84), for example, Thomas Hart Benton continued his allegiance to narrative content and the American Scene style he developed in the 1930s, even as he conveyed a growing interest in the native landscape of his protégé, the Wyoming native and prominent Abstract Expressionist Jackson Pollock. *Wheat* (1967), on the other hand, although figurative in form, monumentalized the modern, cultivated identity of the landscape in a prairie portrait, much as his contemporary John Steuart Curry did in *Kansas Cornfield* (1933, fig. 13). In a tribute that recalls a medieval altarpiece, with the wheat stubble in the foreground forming a predella, Benton acknowledged the implicit relationship between beauty and use. His student and friend Earl Bennett said, "Well, of course beauty is in the eye of the beholder, but he painted beauty. It could be an old farmer. It could be hogs. It could be an old beat-up steamboat. But he saw the beauty

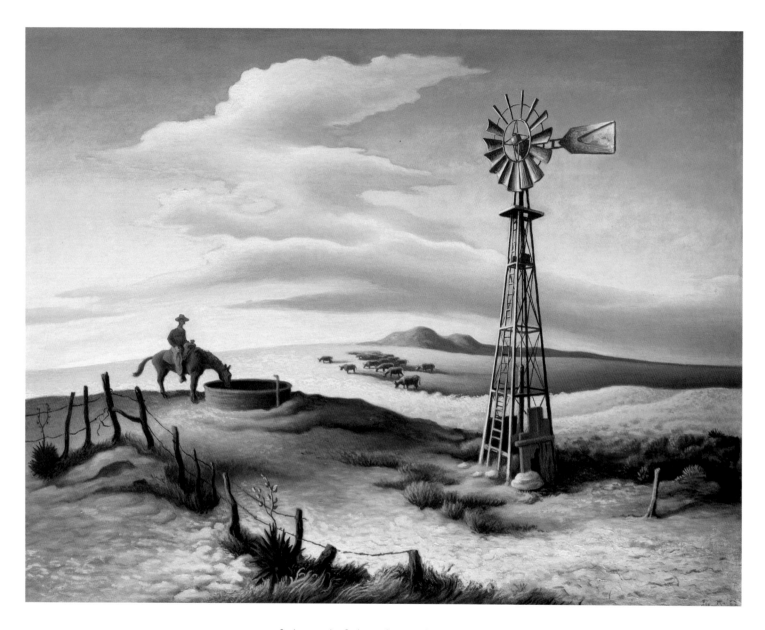

of, the need of these things. There isn't any beauty unless there are fulfilled needs."[5] Benton's focused treatment of the wheat rather than natural prairie grasses acknowledges the beauty of needs fulfilled and, with modern subtlety, points to human impact on the land. In this he touched on the major theme of contemporary prairie images—the tenuous, if now permanent, relationship of nature and culture. The prairie, now more than ever, fulfills American needs in all their contradictions, satisfying at once desires for simplicity and complexity, for openness and boundaries, and

for profit and idealism. Where wastes are relegated and purity persists, where pastoralism coexists with industrialism, amid the expanse where ancestors were lost, new identities can be located.

Even with the lessons of the Depression, the development of the American prairies during and after World War II continued many of the efforts of the earliest Euro-American settlers, who treated the grasslands as an empty terrain available for the taking and amenable to alteration of many sorts. But whereas the primary character of the prairies was rural through the 1930s (the landscape sprinkled with family farms and small towns, interspersed with undeveloped areas), since the war urban and suburban pressures on the region have increased, concentrating populations in cities and gradually depopulating the countryside.[6] At the same time, the area of land under cultivation or some form of production has not diminished, but rather more acreage is now worked by large corporate farmers or agribusinesses and by fewer individuals. Modern large-scale farming and ranching have reconfigured the terrain to their needs, replacing natural prairie biodiversity with a few hybridized species and introducing a wide array of chemicals into the ecosystem. Despite these trends the region has become sentimentalized as the Heartland, where Americans look for the purest archetypes of their national identity.

Like even more desolate regions farther west, the central grasslands have also become host to such things as military bases, complete with bombing ranges, missile silos, and ammunition bunkers, that exploit the isolation of the location while demonstrating by their presence the region's international connections. With the advent of interstate highways, rural electrification, communication networks, and air routes, the prairies have become solidly connected to the rest of the world. The expansive land has seemed to accommodate these changes relatively well; its openness and pastoral character have survived over a large portion of the region even as industry has spread, bringing with it tract housing, gravel mining, petroleum drilling and refining, salvage yards, and landfills. But amid what appears to be a predominantly rural and natural landscape, extremely few areas retain their integrity as natural, unbroken prairie. Those that have survived intact are almost wholly lands that are agriculturally unprofitable. Today's prized prairie is yesterday's wasteland, and today's visual wastelands are commercially viable resources, highly valued for their contributions to the local and national economies.

All these changes have had, of course, a visual, cultural, and psychological effect on the region's character and our perceptions of it. Whereas the early prairies seemed to offer no prospects, either cultural or artistic, the contemporary landscape includes such a diverse range of inhabitants, elements, and potential that it seems in some ways to have developed too many. It has become a contested landscape of multiple and often competing points of view, a land where fulfilled needs do not always equal beauty. Nevertheless, while industrialists, agriculturalists, and

Figure 85
Art Sinsabaugh (1924–1983)
Midwest Landscape Number 78, **1962**
silver gelatin print, 4⅛ x 19⁹⁄₁₆"

Art Sinsabaugh Archive, Indiana University Art Museum, Bloomington. Photograph by Michael Cavanagh and Kevin Montague

environmentalists vie for their own notions of the prairies' future, often seeing each other's ideals at odds with their own, artists and photographers have found new inspiration in the conjunction of these disparate visions. As they return to the land in growing numbers, their work embodies and is enriched by the conflicting features the prairies now incorporate.

Unlike the more obviously spectacular landscapes of the Rocky Mountain and far West that have been immortalized in their pristine form and idolized for their wildness, the prairie landscape has from the beginning been interpreted in terms of its societal usefulness. Contemporary artists of the grassland region, even more than their predecessors, engage their subjects with an acute consciousness of their role as participants and interpreters in an ongoing dialogue between the land and its inhabitants, and they respond to its inherent form rather than attempting to alter it significantly. In their work they confront their own relationships to their subjects and challenge viewers to do the same, often by making explicit the prospect from which they view the landscape. Automotive and especially air travel, for example, provide new vantage points onto the prairies from which the land's patterns appear endlessly varied, but from these perspectives human agency in shaping the land is undeniable; the terrain has been sectioned, tamed, irrigated, and traversed, appearing as a giant, multihued quilt. Our awareness of order in this tapestry simultaneously emphasizes our identification with and distance from the land; we recognize our participation in that patterning at the same time that we observe it.

Aesthetic distancing is also affected by modern transportation in that it is possible to venture into and exit the landscape quickly. Whereas early prairie travelers felt they could not escape the

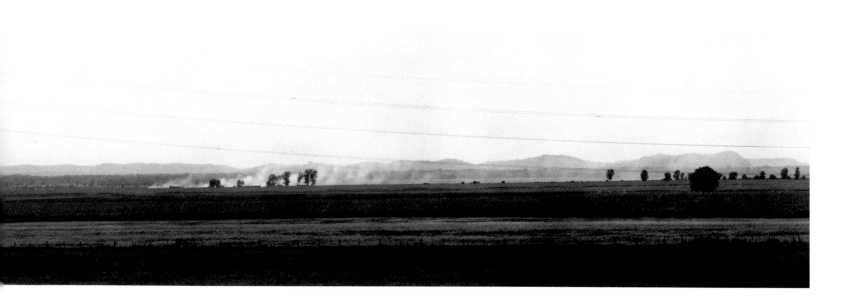

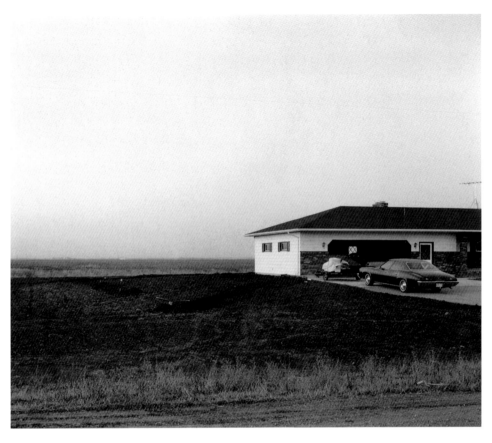

Figure 86

Frank Gohlke (b. 1942)

A House on the Outskirts of Moorhead, Minnesota,
1977

photograph, 16 x 20"

Collection of the artist, courtesy of Bonni Benrubi
Gallery, New York

sameness and found the scenery uninspiring partly for that reason, contemporary artists and
viewers often escape *to* the open spaces. These ventures are made more appealing because depar-
ture is just as available, and because the land's openness is viewed through the context of what
has been left behind. The landscape is rendered more valuable and thus more beautiful because
it is framed—in time, in distance, or through visual features—by urban incursions. Contemporary
prairie artists address these issues in a variety of ways, but each is engaged, no less than their
predecessors, in conceiving a new aesthetic for the region, one that incorporates the land's intrin-
sic forms and ancient rhythms with their awareness of its ongoing relationship with those who
live amid its grasses.

THE NEW TOPOGRAPHY

Among the first artists to recognize the prairies' modern cultural and visual value was Illinois
photographer Art Sinsabaugh (1924–1983). In the early 1960s Sinsabaugh devoted his work to
the midwestern landscape—an unusual choice of subject for the time—and began experiment-

ing with inclusions of cultural evidence; he provided a powerful alternative to the rarefied photographs of such artists as Edward Weston and Ansel Adams, who, although not prairie photographers, had been drawing attention to the western landscape in its most pristine form. Sinsabaugh's work, by contrast, more closely paralleled urban art, focusing on rows of grain elevators, railroad yards, and urban fringes abutting prairie land. He also produced images of less defiled midwestern landscapes, but his insistence on equal treatment to all available elements in a scene gave a new dimension to his pastoral subject. One critic described it as a "panicky sense of illimitable American distances," which "seems to express a conviction that terrifying emptiness lurks just beyond the domestic doorstep."[7]

To emphasize the land's dichotomies, Sinsabaugh experimented with format and framing, as in *Midwest Landscape Number 78* (1962, fig. 85), composing exceptionally wide images with a twelve-inch-by-twenty-inch view camera or trimming his negatives to emphasize the horizon and the low-lying land.[8] His innovations also incorporated features that continue to fascinate artists of the central United States—the panorama, the role of the frame in determining a view, the uneasy juxtaposition of pastoral settings and urban encroachment, and the strong sense of place in open spaces.[9]

In the 1970s several photographers began devoting themselves to these issues, frankly confronting the landscape in all its bleakness. Dubbed the New Topographics in a 1975 George Eastman House exhibition (referring to their desire to portray their subjects as objectively as surveyors), these artists disavowed personal involvement, taking, as the curator noted, "great pains to prevent the slightest trace of judgement or opinion from entering their work."[10] Typical perhaps of the formalist preoccupations of the time, these aspirations nevertheless ignored the highly selective nature of photography and were quite self-conscious in their abdication of conscious interaction. More to the point, the emotional distance implicit in these images seems instead to have underscored the intense and vulnerable relationship with the land that their creators felt. One of the photographers, Frank Gohlke (b. 1942), later admitted, "There must be an Other before there can be love; Eden becomes the object of our desire only after we are cast out. The best landscape images, whatever their medium and whatever other emotions they may evoke, are predicated on that loss. They propose the possibility of an intimate connection with a world to which we have access only through our eyes, a promise containing its own denial."[11]

In *A House on the Outskirts of Moorhead, Minnesota* (1977, fig. 86), as in his early pictures of grain elevators from the same decade, Gohlke graphically commingles his desire for direct encounter with the prairie landscape with his sense of loss at its transformation to a more settled space.[12] Focusing on a common sight, a new subdivision tract home next to a flat graded lot abutting an open field that extends to the horizon, Gohlke allocated exactly half of the image to each, emphasizing that such houses and the land now share the space of the prairies. He brutally

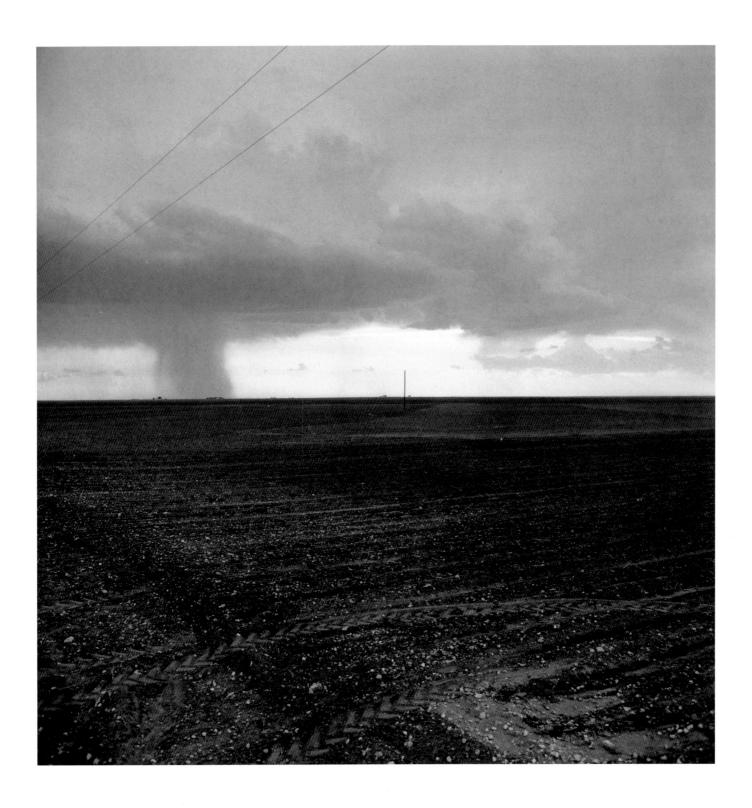

LEFT: **Figure 87**

Frank Gohlke

Fields and Thunderstorm, near La Mesa, Texas,
1975

photograph, 16 x 20"

Collection of the artist, courtesy of Bonni Benrubi
Gallery, New York

RIGHT: **Figure 88**

Robert Adams (b. 1937)

*From the Front Porch of an Abandoned One-Room
Schoolhouse, Looking into the Niobrara River
Valley,* **1978**

photograph, 11 x 14"

Courtesy Fraenkel Gallery, San Francisco

cropped the house with the right edge of the frame, forcing viewers to examine it in relationship to the terrain that surrounds it and suggesting that neither the land nor the dwelling is wholly comfortable in the other's presence.[13] In *Fields and Thunderstorm, near La Mesa, Texas* (1975, fig. 87), Gohlke is more subtle in his exploration of the human and the natural, but the implication is the same. The barren field is traversed with tire tracks, and the storm threatening overhead does little to enliven the desolate scene.[14]

While the blatantcy of such images may be unprecedented, the examination of the relationship of nature and culture in the history of prairie images was hardly new. Other American landscape types have been glorified in their virgin state and mourned as their purity has been compromised by human encroachment (as in the Carleton Watkins photographs of the pristine Pacific Northwest and Darius Kinsey's logging views), but as this study has demonstrated, the grasslands have, from the earliest Euro-American contact, been freely transformed with remarkably little concern for what was being lost. The New Topographers, except in their more critical attitude toward their subject and in the magnitude of the changes they present, largely continued the visual treatment that has dominated prairie representation for more than one hundred years.

For photographer Robert Adams (b. 1937), another of the New Topographers, the prairies' prospects are as unpromising as in Gohlke's art, but he steadfastly clings to hope for their improvement, saying, "On the prairie there is sometimes a quiet so absolute that it allows one to

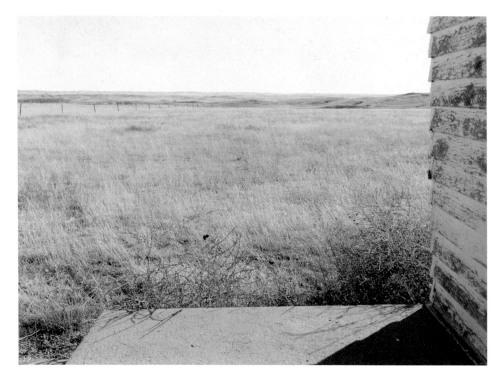

begin again, to love the future."[15] Admitting that he identified early with the land and has been increasingly distressed at what is happening to it, he openly mourns the loss of the West as he knew it and expresses his commitment to this concern in his work.[16] Although he photographs the landscape society has created, he also searches for that earlier vision, as in *From the Front Porch of an Abandoned One-Room Schoolhouse, Looking into the Niobrara River Valley* (1978, fig. 88), which looks across rolling grass in Nebraska, its melancholy tangible in the weather-beaten structure that frames the view. Always, however, Adams's images are about space. "The end of the

American Space is related . . . to the two principal threats to life on earth—overpopulation and nuclear war," he observes darkly, but as he advocates a strongly environmentalist future that would address these problems and their more subtle manifestations, he also places his faith in the power of art to reorient our relationship to the land.[17]

Adams's apocalyptic vision is explicit in David Plowden's *Nuclear Generating Station, Sillman Valley, Illinois* (1981, fig. 89), which depicts a massive cooling tower rising ominously from surrounding fields. Heavy clouds hover overhead, menacing in their formal echo of the configuration of the land below and in the funnel-shaped tails that descend and embrace the edges of the cylinder. Confronted with so powerful a force, nature itself seems to turn demonic, but Plowden's view implies that it cannot hold its own against such a giant. As Plowden wrote in a Sierra Club book on the Great Plains in 1972, "the strength of the land lies in its power of recovery—given time." Considering the half-life of nuclear waste, "the prospect is grim indeed."[18] While it may be true, as Stephen Jay Gould phrased it, that "we must move beyond the theme of squalid waste dumps versus beautiful countryside, for it is profoundly unhelpful in casting the two realms of nature and culture as intrinsically apart," it is equally true that those realms will never be fully reconciled.[19] Although the act of photographing cultural intrusions on the land aestheticizes them, the transformation does not resolve their differences. As Plowden and others have emphasized, these forces will forever remain antagonistic, or at least in competition, even within the context of art.[20]

When allowed and sometimes helped, prairies do reclaim cultural wastelands and are engaging artists in their redeeming work. Photographer Terry Evans (b. 1944), for example, in conjunction with the Openlands Project in Chicago, is currently documenting the Joliet Arsenal and its restoration from a Department of Defense compound to a State of Illinois Park System prairie preserve. Confronting the vestiges of a military complex enables her to explore her long-standing interest in attitudes toward the grassland landscape and the cycles of abandonment that have been a continual aspect of American culture's relationship with the land. Evans has traced the difference between this new work and her earlier images of pristine prairies: "When I first discovered the prairie ecosystem in its undisturbed perfection, I knew I was observing a profound mystery that was closer to heaven than to home, but that held the key that could unlock home as it was meant to be. . . . Twelve years later I find myself needing to photograph home as it is on the prairie in all its disturbed, cultivated, inhabited, ingratiated, militarized, raped, and beloved complexity."[21] In her most recent work Evans does not flinch from photographing gravel pits, bomb targets, salvage yards, garbage dumps, and suburbs in the prairies. They are, she says, part of the continuum of the prairies' identity as well as our own.[22]

Painters also confront the contemporary dichotomies of nature and culture, of course, but frequently without the uncomfortable edge of reality that is inescapable for photographers. Since the 1980s, with the profusion of subject matter, media, and renewal of figurative style in the art

world, coupled with increasing attention to environmental issues and other contemporary concerns (many with strong midwestern roots), the landscape has reemerged as a significant focus for painters.[23] Using an expressionist's palette and style, for example, Susan Puelz (b. 1959) celebrates the monumentality of the agricultural landscape's most visible symbol in *Prairie Laureate II* (1990, fig. 90). As Wright Morris wrote, these American pyramids of the prairies have long been cherished icons, and not only for their containment of the region's bounty:

There's a simple reason for grain elevators, as there is for everything, but the force behind the reason for the reason, is the land and the sky. There's too much sky out here, for one thing, too much horizontal,

LEFT: **Figure 90**

Susan Puelz (b. 1959)

Prairie Laureate II, 1990

watercolor on paper, 34¾ x 46¼"

Private collection

BELOW: **Figure 91**

Alexandre Hogue (1898–1994)

Aerial Irrigation, 1987

pastel, 19¼ x 37"

Cline Fine Art Gallery, Santa Fe, New Mexico

too many lines without stops, so that's the exclamation, the perpendicular had to come. Anyone who was born and raised on the plains knows that the high false front on the Feed Store and the white water tower, are not a question of vanity. It's a problem of being. Of knowing you are there. On a good day, with a slanting sun, a man can walk to the edge of his town and see the light on the next town, ten miles away. In the sea of corn that flash of light is like a sail. It reminds a man the place is still inhabited. I know what it is Ishmael felt, or Ahab, for that matter—these are the whales of the great sea of grass.[24]

Like medieval cathedrals that rise above their surroundings, centering the faithful physically and spiritually in their world, grain elevators function in a flat landscape as important locating devices, but in Puelz's view the vibration of line and intense colors creates a sense of disturbance rather than an order maintained. It is as if nature is in vital competition with the human presence for visual dominance.[25]

In a different sort of commentary on the human presence, Alexandre Hogue, who during the Depression so scathingly depicted the rape of Mother Earth, continued his visual critique of land use in *Aerial Irrigation* (1987, fig. 91), a whimsical if pointed observation on the extensive efforts to nurture the prairie garden at the expense of its most valuable resource, water. In this case, the water is being drained from subterranean aquifers at a dangerous rate. Whereas his early work

focused on drought conditions and the destructive action of uncontrolled water, this pastel from the last years of his life continued his insightful portrayal of efforts to maintain an unnatural landscape regardless of the price.[26]

In the same vein, Roger Brown (b. 1941) focuses on the human impact on the prairies in wry painted satires. A native of Alabama, Brown was for many years a constant traveler based in Chicago. He first emerged as a major painter in the mid-1960s with large visual analyses of art and life in America. Employing a flat, almost folk-art style, he engages urban and rural customs in contemporary society, from suburban sprawl and urban inanities to popular icons and political heroes. Astutely aware of the changes in the midwestern environment, in such works as *The Garden of Eden* (1990, private collection) and *Landscape with Dollar Sign* (1991, Phyllis Kind

Figure 92

Roger Brown (b. 1941)

Citizens Surveying the Flat Landscape, **1987**

oil on canvas, 48 x 72"

Jeffrey K. Mercer and Linda Glass

Gallery, Chicago), Brown confronts viewers with the inescapable realities of the prairie's economic value and the losses inherent in its modern form. In *Garden of Eden,* using what has been called "a war of words and images," he pays homage to the nineteenth-century paintings of bison in a posterlike depiction of a galloping bull, at the same time dryly reminding the viewer of changes wrought during the past century and a half with the inscription, "This Land Was a Garden of Eden . . . 100 Years Ago."[27] In *Citizens Surveying the Flat Landscape* (1987, fig. 92), Brown emphasizes the overwhelming dominance of the prairie sky through stylized cloud effects, at the same time observing the contemporary traveler's mode of encounter via the automobile, all the while presenting the scene from an unnaturally elevated and tilted perspective.[28] By interspersing throughout the scene small figures who gesture at their surroundings, he emphasizes at once the isolation of the modern traveler and the multitudes who now frequent the grasslands on their way to someplace else.

EARTH AND FIRE

The harsh realities of the contemporary prairie and its uneasy relationship with those who live on it vacillate in recent art with an unprecedented celebration of the pure landscape—that which remains apparently untouched by the ravages of civilization and, although diminished in scope, reminds us of the great expanse that once extended unbroken for hundreds of miles. Conservationists and artists have been devoted to the West's more spectacular sites for more than a century, but only in the last few decades have many of them begun to grasp the complexity of the prairie environment and appreciate the landscape in its purest form.[29] A growing number of photographers and painters cooperate with organizations such as the Land Institute in Salina, Kansas, the Openlands Project in Chicago, the Nature Conservancy, the U.S. Fish and Wildlife Service, the Center for Great Plains Studies, and various state agencies that are attempting to generate public interest and support for environmental causes. These mutually beneficial alliances have contributed to a new genre of prairie art that finally celebrates the natural grassland's intrinsic visual power.

A recent color photograph by Larry Schwarm (b. 1941), *Grass Fire near Cassoday, Kansas* (1990, fig. 93), recalls earlier depictions of prairie fires in its subject matter and even in its sublimity, but it is unprecedented in its intensity, a feature that derives in part from the medium. Schwarm's work, however, is more than a romantic response to a regional phenomenon in the manner of nineteenth-century representations of the subject. It is informed by the contemporary awareness of fire's role in the survival of the prairies. Early inhabitants of the grasslands realized that fires cleared old growth and prompted new, but only recently has it been recognized that regular burning is essential to the health of the ecosystem. Some species of grass will not germinate without such clearing, and prairies need burning every few years to keep out woody vegetation

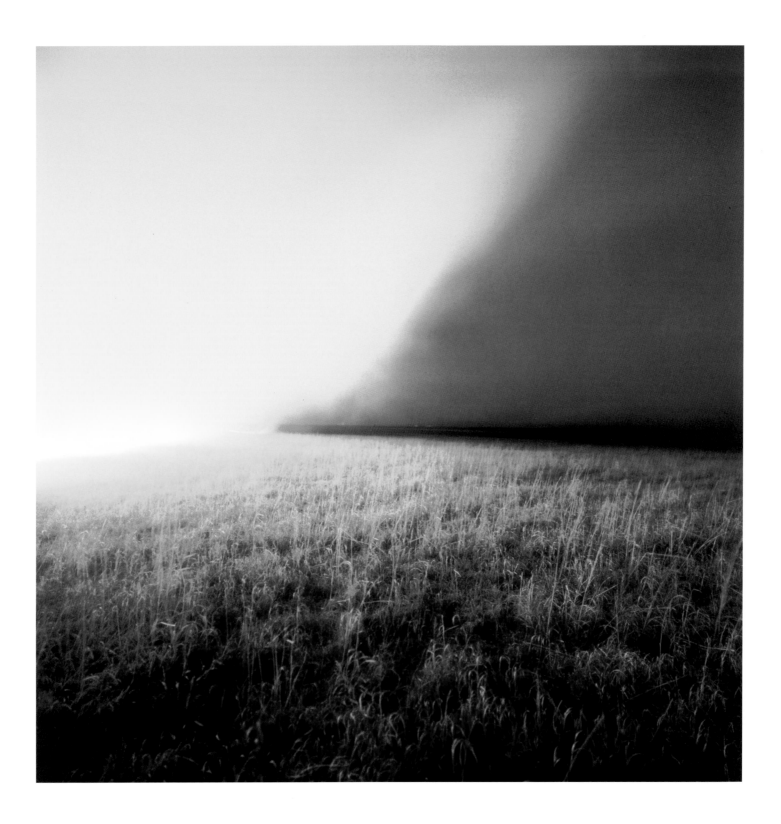

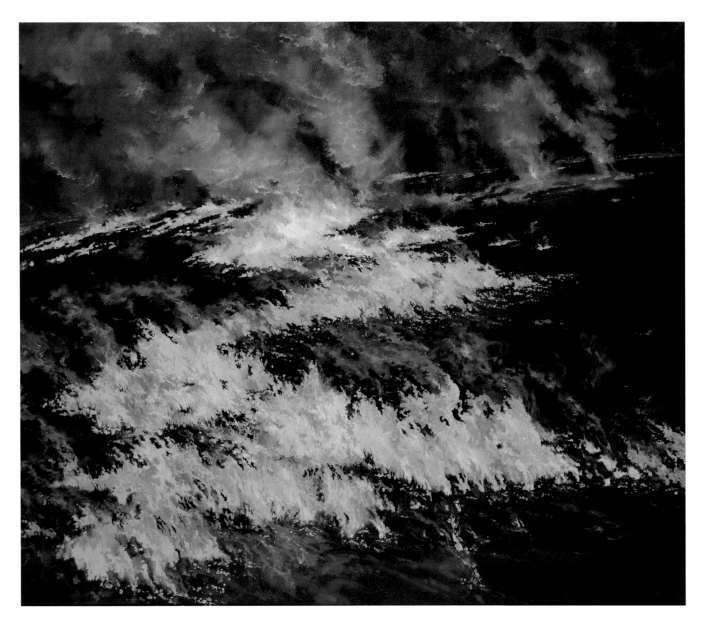

LEFT: **Figure 93**

Larry Schwarm (b. 1941)

Grass Fire near Cassoday, Kansas, 1990

Ektacolor photograph, 13¼ x 13¼"

National Museum of American Art, Smithsonian
Institution, gift of the artist, © 1990, Larry
Schwarm

ABOVE: **Figure 94**

James P. Cook (b. 1947)

Fire at Night, Kansas, 1982

oil on canvas, 60 x 70"

Wichita Art Museum, Kansas

and exotic invaders and to sustain the particular biodiversity that is at the core of their identity. In the area around Emporia, Kansas, where Schwarm lives and works, prairies are burned regularly by ranchers interested in managing their range and by botanists who are attempting to restore and maintain original vegetation.[30] In *Fire at Night, Kansas* (1982, fig. 94), James Cook (b. 1947) creates a nocturnal rendition of the subject on canvas as spectacular as Schwarm's photographs. His painterly technique applied to the glowing light of grassfire and its illumination of rising smoke demonstrates that fire, even without the implicit danger and drama favored in the last century, provides a compelling visual subject for contemporary artists that is both conceptually intriguing and visually expressive. This image embodies the notion of creation out of destruction that is so central to the bond between fire and life in the prairies.

Another Kansan, Terry Evans, conveyed her own understanding of the region's complexity in her early photographs, depicting sweeping vistas and close-up views of individual native grasses. The latter images lower the angle of vision to the heart of the prairie, the life force that is often overlooked in favor of the vista's more dramatic openness. In *Prairie Roots and Big Bluestem and Other Grasses, Konza Prairie* (1979, fig. 95), for example, she focused on the leaves of grass and their intricate root system below. "Gradually," Evans wrote of her work of this period, "I was learning about the form of the prairie, and . . . I was being initiated into the mysteries of form in art and life. I began to understand that sacred and symbolic knowledge, knowledge that goes beyond the world of appearances, is transmitted through form and structure."[31] Taking a subterranean perspective on a cut section of sod, Evans's view graphically demonstrates the source of the land's resistance to being broken and reveals the fundamental asset of prairie grass, the roots. While almost infinitely varied above the surface, the vegetation relies on the real complexity below, in tangled systems that can measure more than twenty-five feet in length. William Least Heat-Moon wrote in *Prairy Erth* (1991), "I came to understand that the prairies are nothing but grass as the sea is nothing but water, that most prairie life is within the place: under the stems, below the turf, beneath the stones. The prairie is not a topography that shows its all but rather a vastly exposed place of concealment, like the geodes so abundant on the country, where the splendid lies within the plain cover."[32] The immense underground network of the prairie grasses is, of course, the source of their survival in times of drought and fire, but once disrupted by plowing, their hold on the land is severely weakened if not altogether destroyed. Although some grass will certainly regrow, the age-old strength and diversity, like that of a virgin forest that has been clear-cut, is difficult if not nearly impossible to recapture, at least in humanly meaningful units of time.

More traditional in its view across a field, Drake Hokanson's photograph entitled *Big Bluestem, Peterson Township, July* (1990, fig. 96) also exemplifies one of the remarkable characteristics of the prairie grasses in its focus on a single clump of bluestem, one of the most prominent species in

RIGHT: **Figure 95**

Terry Evans (b. 1944)

Prairie Roots and Big Bluestem and Other Grasses, Konza Prairie, **1979**

Ektacolor photograph, 10 x 10"

Collection of the artist, Chicago

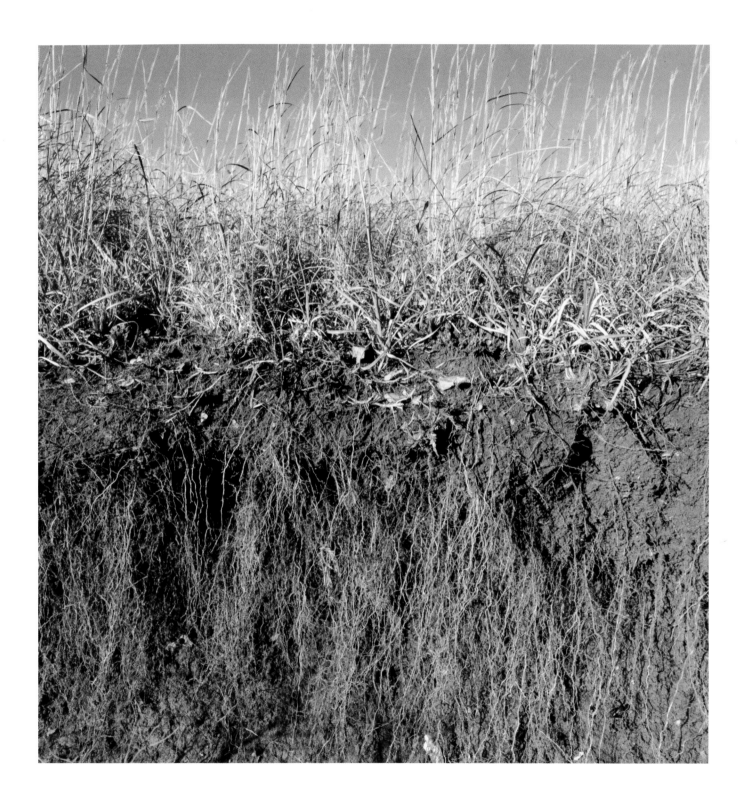

the tallgrass region. Isolated among shorter grasses along an unmowed roadside, its proud defiance is made even more poignant in Hokanson's photograph by the mowed field beyond. In its solitude it cannot begin to evoke the immense forests of grass that rose above the heads of early prairie travelers; nevertheless, it stands as a reminder of those remarkable expanses and of the diversity within the native grassland as well. As Wayne Fields has written, the names of the species read "like a Whitman poem, a prairie litany":

bluestem, needlegrass, Scribner's panic grass, Indian grass, switch grass, Canada wild rye, dropseed, American slough grass, fawn manna grass, hawk weed, compass plant, prairie button, button snakeroot, fringed loosestrife, stiff bluntleaf bedstraw, Jerusalem artichoke, buffalo grass, prairie cat's foot, beard tongue, lousewort, bastard toadflax, locoweed, rattlesnake master, will aster, blazing star, prairie rose, star grass, and oxeye daisy.[33]

These species and many more survive in small patches throughout the original tallgrass region; in a few areas, such as the Konza Prairie, more extensive areas are protected, primarily because their soil is too shallow to plow. Approximately 9,000 acres owned by the Nature Conservancy, the Konza Prairie that Evans photographed is part of the area known as the Flint Hills, an exceptionally beautiful terrain that covers a large portion of east-central Kansas and extends south into Osage County, Oklahoma, where a much more expansive tract (36,600 acres) called the Tallgrass Prairie Preserve has recently been established.[34] Appreciation of such refuges is growing in many states, but their acreage is minuscule in comparison with the original prairies and cannot begin to approach them in grandeur or significance.[35]

One of the ways artists convey their understanding of this piecemeal conservation and those areas' relationship to a larger context is through serial imagery and deliberate framing that calls attention to what is not seen. Photohistorian Merry Forresta has said of landscape photography in the 1980s, "A single view of anything came to seem insufficient."[36] That idea is critical in representing a prairie, which cannot be captured in isolation as, for example, a mountain or a canyon might be. Evans for one believes that neither her work nor her subject is ever complete, no matter how evocative it might be of its referent, but must be as much as possible connected and understood, even if imperfectly, in conjunction with a real past and a living and ongoing present. Her three-part image entitled *Chase County, South of Matfield Green, Kansas* (1993, fig. 97) strikingly conveys the autumnal spectacle of the prairies in a compelling, disjointed panoramic view that insists in its very form on a conceptual extension beyond the boundaries of each frame into a larger context. Part of a project with the Land Institute to document the people and the land around Matfield Green, the *Chase County* triptych uses simultaneous singularity and multiplicity to emphasize the limitation of lone images in representing such an extensive subject. A town of about fifty residents near Emporia in the heart of one of the last remaining areas of treeless

Figure 96

Drake Hokanson (b. 1951)

Big Bluestem, Peterson Township, July, 1990

silver print, 14 x 11"

Collection of the artist, Sheboygan, Wisconsin

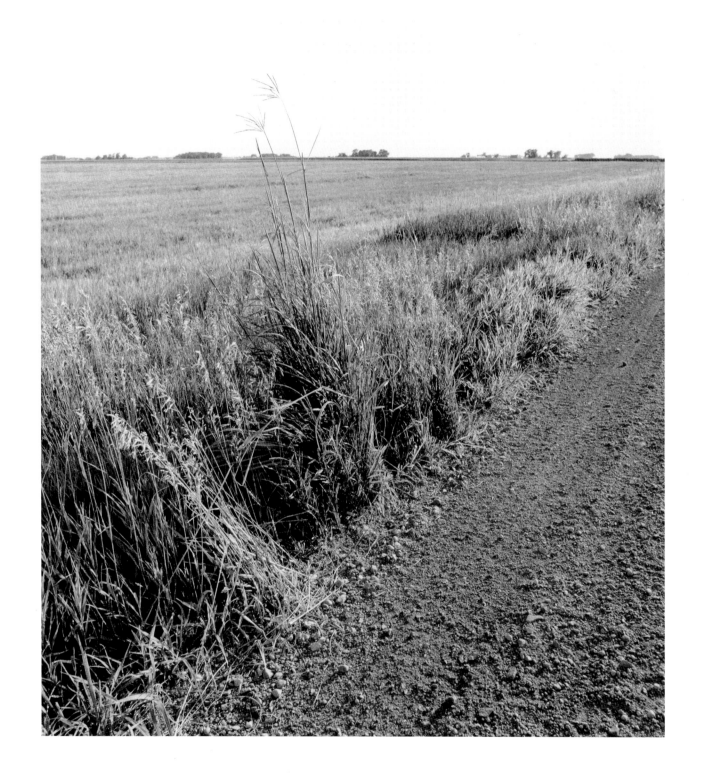

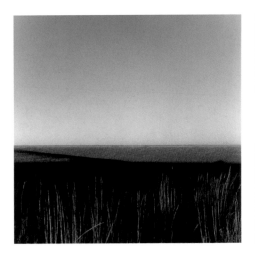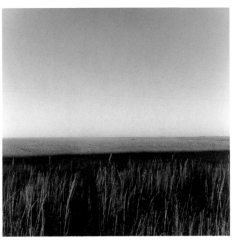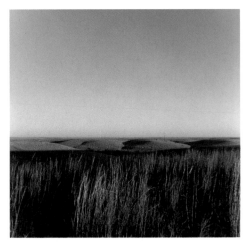

grasslands, Matfield Green is an example of the many small prairie communities threatened by declining population. The vacancy of the landscape in *Chase County* points compellingly to this most recent prospect as well as to the spectacle of the indigenous land forms.

In other works artists explore the prairies' interconnected structures and relationships through the visual elements of borderlines—intersections and conjunctions of features such as fields, rivers, treelines, old and new settlements, deer trails, and tractor tracks. Just as these connect adjacent areas, they also produce discontinuities, especially evocative from the air. Such physical evidences of geographical change and transition combine to create compelling abstract designs with special cultural significance. One example, Evans's *Rosehill Cemetery, Saline County, Kansas* (1991, fig. 98), isolates a rectangular and carefully ordered cemetery amid a harrowed field, the cemetery's neatly timbered perimeter sharpened by the lengthening shadows and its poignancy deepened, like the funerary monuments of a century ago, by isolation within the surrounding expanse.

AN OPEN PROSPECT

As the United States becomes more developed and populated, open space has become an increasingly valuable commodity. This dominant feature of the prairies, once considered oppressive, is newly appreciated as it becomes scarce, and it has even been endowed with spiritual significance precisely because of the qualities that once suggested it was godforsaken. As Kathleen Norris wrote in *Dakota* (1993), "the western Plains now seem bountiful in their emptiness, offering solitude and room to grow." The prairies' age-old paradoxes also have new relevance within the open spaces of an ever more crowded world, vacillating "between hospitality and insularity, change and inertia, stability and instability, possibility and limitation, between hope and despair, between open hearts and closed minds."[37] Photographers and artists express their awareness of those polarities in wider canvases and panoramic photographs; they consciously seek out uninterrupted

ABOVE: **Figure 97**

Terry Evans

Chase County, South of Matfield Green, Kansas, **1993**

chromogenic development print, triptych, each panel 20 x 16"

Great Plains Art Collection, University of Nebraska, Lincoln, gift of Friends of the Center for Great Plains Studies

RIGHT: **Figure 98**

Terry Evans

Rosehill Cemetery, Saline County, Kansas, **1991**

silver print, 14¾ x 14¾"

Collection of the artist, Chicago

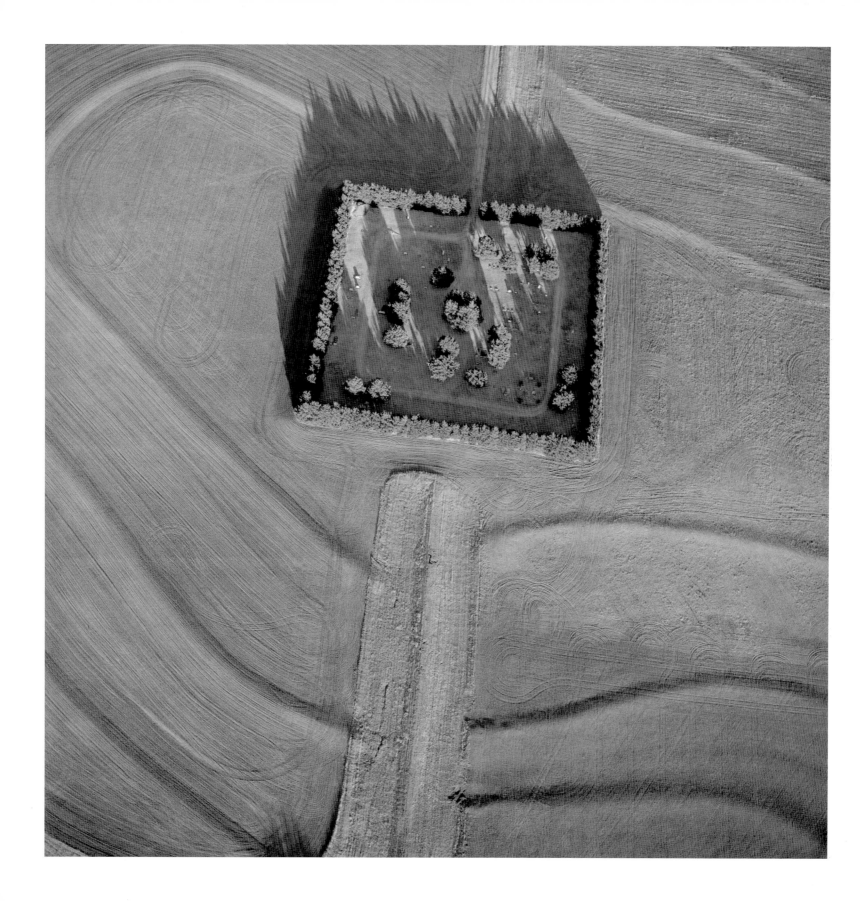

views that enable them to concentrate on the sky and its changing effects or the subtle nuances of color and light. In celebrating the prairies for the characteristics that nineteenth-century artists found insufficient, today's artists are discovering one of the few landforms that has not been overworked as a visual focus and that at the same time links their art to the epic landscapes of the past. In their images the old notion of prospect—that of the vantage point—has finally been successfully commingled with its other connotation—that of possibility—as the artist mediates the prairies' multivalent relevance to contemporary culture.

Most striking in the emerging interest in the open vistas of the American grasslands is the corresponding emphasis on expansive vision captured in ever wider canvases and photographic images. At the extreme is the 360-degree view, as in *Cut Wheat* (1988, fig. 99) by Gus Foster (b. 1940). The rotating circuit camera captures the encompassing extent of the horizon that awed so many early travelers in the prairies, even though in this case the endless circle does not encompass prairie grasses but rather the most important crop of the western grasslands, just after harvest. Dividing the horizontal scene equally between earth and sky, Foster emphasizes the epic, an effect enhanced by the visual bending of the straight furrows produced in the rotating exposure. The result is a dramatic illusion; we can see in all directions at once, but our own physical rotation is presented linearly. The furrows at both ends of the scene are in reality juxtaposed. In a modern version of the prairie mirages that confused Alfred Jacob Miller and other early travelers, the 360-degree photograph disorients our traditional notion of vision and underscores the prairie's most mysterious quality, its continual capacity to challenge our conception of space.

Gary Irving (b. 1953) and Stuart Klipper (b. 1941) also explore the openness of the prairie landscapes in compelling images that focus on light and color, but instead of a circuit camera they use wide-angle panoramic lenses that more accurately replicate the normal human range of sight, including peripheral vision. Klipper's views of common sights, such as *Cornfields, off Highway 169, North of Fort Dodge, Webster County, Iowa* (1992, fig. 100), intensify the mundane to a more conceptual realm by orienting the line of vision down the seemingly endless rows, emphasizing the perceptional dominion of both the photographer and the viewer. Conceived as part of an ongoing effort that the photographer calls "The World in a Few States," a global endeavor to consider space and its implications as homeland visually, such images add to the double entendre of the project's title, simultaneously suggesting location and psychological orientation.

Working closer to home, from Wheaton, Illinois, Irving by contrast traveled frequently as a child across Iowa to visit his grandparents' farm in Nebraska, and he concentrates his work in those three adjacent states. He admits to being an enthusiast of the region, so much so that although he says he quickly tires of the conventionally spectacular scenery of the far West, he is endlessly fascinated by grasslands, either agricultural or natural.[38] He recognizes that his subject is an acquired taste, but, he says, "the beauty of this place is the kind that grows on you, the

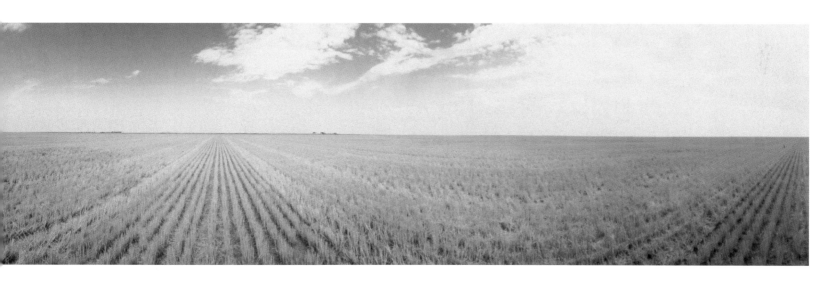

Figure 99

Gus Foster (b. 1940)

Cut Wheat, 1988

360-degree panoramic Ektacolor photograph,
18 x 86¼"

National Museum of American Art, Smithsonian
Institution, gift of the Consolidated Natural Gas
Company Foundation, © 1988, Gus Foster

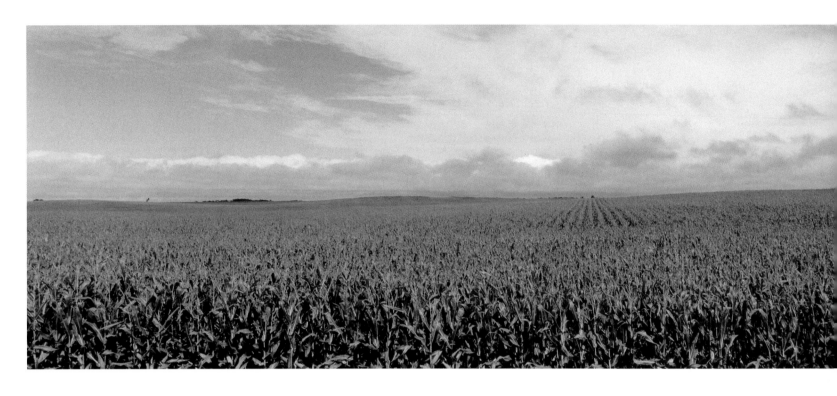

ABOVE: **Figure 100**

Stuart Klipper (b. 1941)

Cornfields, off Highway 169, North of Fort Dodge,
Webster County, Iowa, 1992

Cibachrome photograph, 12 x 38"

Collection of the artist, Minneapolis

RIGHT: **Figure 101**

Gary Irving (b. 1953)

Windmill, Western Nebraska, 1995

Cibachrome photograph, 13 x 39"

Collection of the artist, Wheaton, Illinois

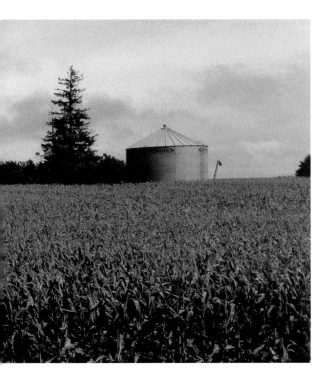

kind that holds rewards for those willing to look beyond the obvious and learn the vernacular of Midwestern light."[39] Appreciative of historically redolent rangeland, as in *Windmill, Western Nebraska* (1995, fig. 101), he nevertheless includes such elements as power lines and telephone poles that locate us in the present, acknowledging that nature and culture persist in an ongoing dialogue. *Cemetery in Winter, Livingston County, Illinois* (1987, fig. 102), by contrast, is typical of Irving's photographs of settled landscapes, with its long view into a cultivated field, in this case a winter view with snow drifts in place of crop rows. Along the horizon is a tiny rural cemetery, made minuscule by the extreme depth of the field, its monuments rising bravely above the expanse, locating us in another way within this space and time. Suffusing the whole, as in all of Irving's work, is a scintillating light that heightens the chromatic spectrum as it casts the plain into relief, giving it texture and palpability it would otherwise lack.

Painters manipulate their imagery differently from photographers, but they too are interested in and attentive to the shifting prospects of vision and conception that the contemporary grassland presents. Exploring their perceptions through a range of formats, perspectives, and styles, they are able, as photographers are not, to rearrange, exclude, enhance, and invent the landscape as they see and imagine it. One such artist has written, "I am more interested in the *character* of place than I am in the *specifics* of place. As a result, much editing is involved and quite often

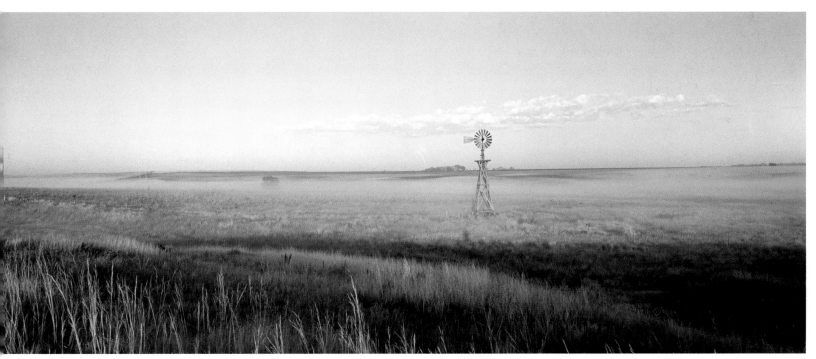

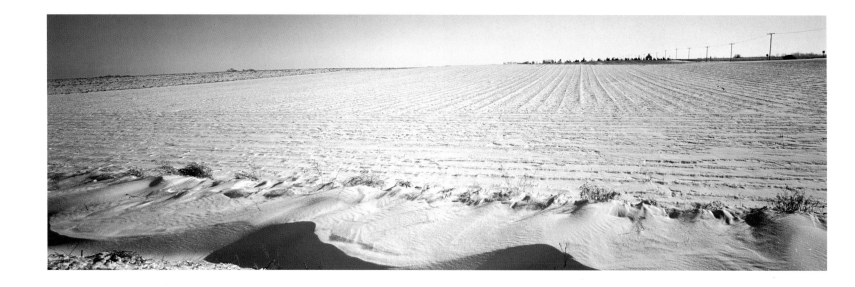

things are rearranged for the sake of the whole."[40] Painters do not ignore the changes society has brought to the landscape, but they often concentrate on and celebrate those enduring features of land and sky, of color and light, that are ever present in the American prairies. Even as they extol the natural spectacle, however, they exert a tight control over their compositions, as if in an attempt somehow to grasp and order that expansive and elusive space.

Although not a resident of the region and not a regular painter of prairies, April Gornik (b. 1953) has painted a number of canvases that focus on the flat landscape and its dramatic spatial qualities. In *Gyre* (1989, fig. 103) she powerfully conveys the fury of the flatlands and their weather in an epic portrayal of light, shadow, earth, and atmosphere. Silhouetted against a back-lit horizon, the dark foreground emphasizes the low-lying line of the plain, which is oppressively hemmed in by the burgeoning storm clouds above and the torrential downpour to the right. Finding immense drama in the prospect of such contrasts, Gornik suggests the epic relationship of earth and sky so prominent in nineteenth-century narrative.

The first contemporary midwestern painter to achieve national prominence for his landscapes of the region, Harold Gregor (b. 1929) has, through his paintings and his many years as a professor of art and art history at Illinois State University in Normal, become a major influence on the representation of the prairies. Gregor developed his sense of design and his interest in flatness as an abstract painter in the 1960s, but during the following decade he applied those same skills to the scenery of his immediate surroundings in photo-realist depictions of corn cribs, structures he found intriguing for their formal properties as well as for their marginalization within vernacular architecture. Highly conscious of constructing vision, both in nature and in

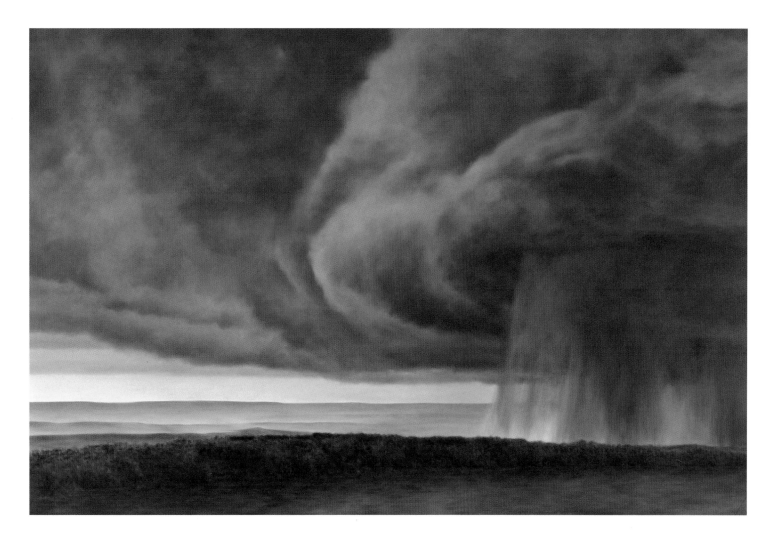

RIGHT: **Figure 102**

Gary Irving

Cemetery in Winter, Livingston County, Illinois,
1987

Cibachrome photograph, 13 x 39"

Collection of the artist, Wheaton, Illinois

ABOVE: **Figure 103**

April Gornik (b. 1953)

Gyre, 1989

oil on canvas, 72 x 112"

Private collection. Photograph courtesy Edward
Thorpe Gallery

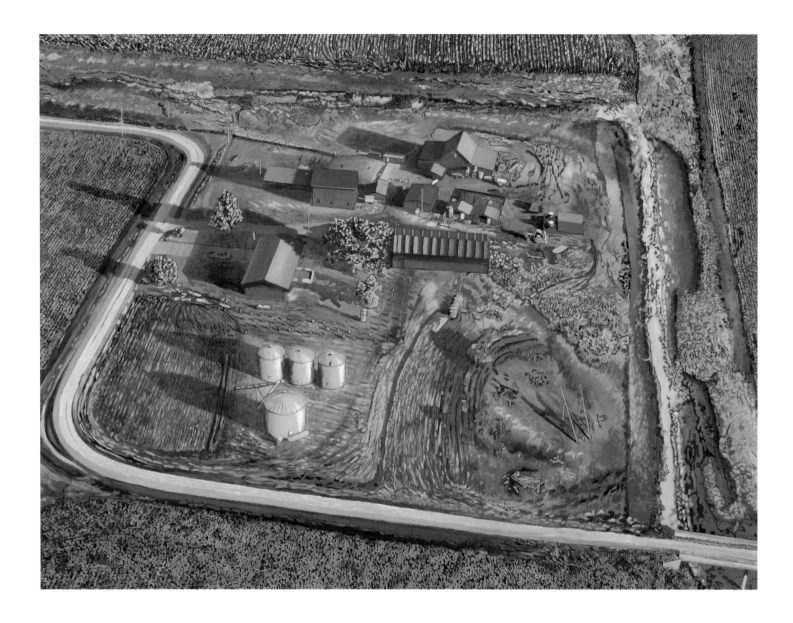

art, Gregor in his more recent work addresses the multiplicity of this process in three basic prospects from which he views and presents the landscape. From what he calls "window space landscapes," which take a relatively traditional point of view across a scene, he has expanded to "big sky" panoramas and finally to his most unusual viewpoint, his "flatscapes," which are aerial constructions, looking down on the earth, often from a tilted angle that throws the regular patterns into isometric perspective.[41]

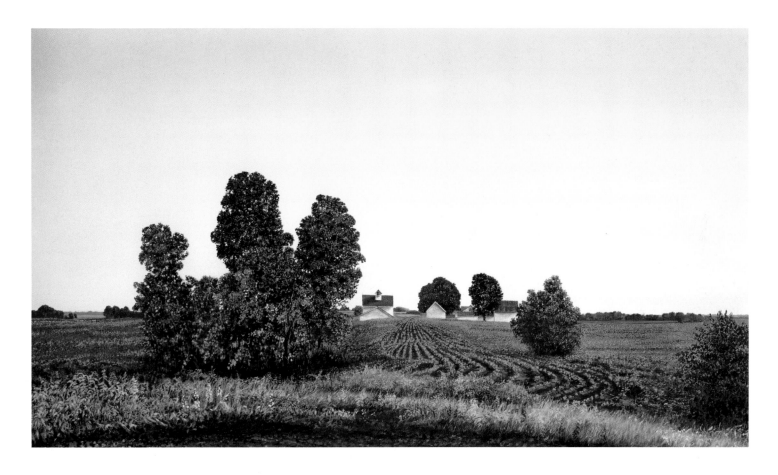

LEFT: **Figure 104**

Harold Gregor (b. 1929)

Illinois Flatscape Number 56, **1994**

oil and acrylic on canvas, 60 x 82"

Richard Gray Gallery, Chicago

ABOVE: **Figure 105**

Harold Gregor

Illinois Landscape Number 65, **1984**

oil and acrylic on canvas, 38 x 68"

Wellington Management Company, Boston. Photograph by Greg Heins, Boston

Especially in the flatscapes, as in *Illinois Flatscape Number 56* (1994, fig. 104), Gregor heightens the strange aerial effects through vibrant colors and often a pointillistic style. Even as these border on the decorative, recalling the vibrancy of Van Gogh, they nevertheless maintain a strong sense of formal structure and design, a characteristic common to most of the contemporary prairie painters, most of whom were trained as abstractionists. In his more traditional compositions, such as *Illinois Landscape Number 65* (1984, fig. 105), Gregor uses an almost photo-realist technique, but the apparent concern for superficial appearances masks the invention; these are often views he has fabricated in the studio.[42] *Illinois Landscape Number 120* (1992, fig. 106), by contrast, has both verisimilitude and a sense of unreality; its space seems simultaneously infinite and compressed as the foreground of shaggy autumn grass and the sweeping sky of pale pastels come together at the horizon. Most significant, the painting's celebration of the emptiness of the landscape as a sublime object of contemplation demonstrates how the visual prospects of the prairie have at last come into their own. In their satisfaction of modern longings for space

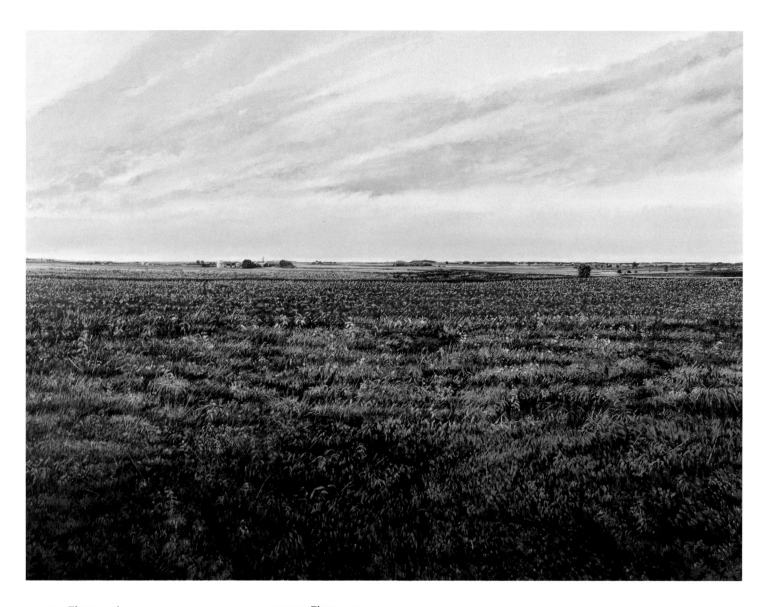

ABOVE: **Figure 106**

Harold Gregor

Illinois Landscape Number 120, 1992

oil and acrylic on canvas, 60 x 82"

Richard Gray Gallery, Chicago

RIGHT: **Figure 107**

Walter Hatke (b. 1948)

River Fields, 1983

oil on canvas 23½ x 38¾"

Collection of Chemical Bank, New York

and solitude, for wildness *and* domestication, the open lands offer, as few other regions do, a new form of beauty that is visually compelling and conceptually and spiritually rewarding.

The ability of contemporary prairie painters to negotiate the subtle boundaries between artifice and transcription, between the mundane and the transcendent, is their most significant and enduring contribution to the representation of their subject and to the larger development of American art. Indeed, as they work within this middle ground, they and their images embody the same paradoxes that have characterized their landscape throughout its history; within flatness they find space, amid the unremarkable they sense and convey the extraordinary.

This transformation is possible not only in the pristine prairies, untrammeled by human civilization, but is found as well in cultivated landscapes. In the work of Illinois painters James Winn

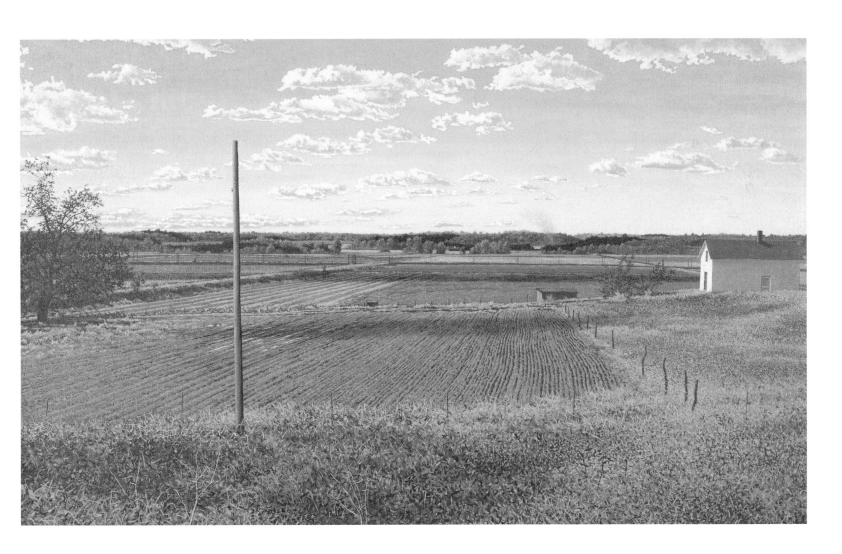

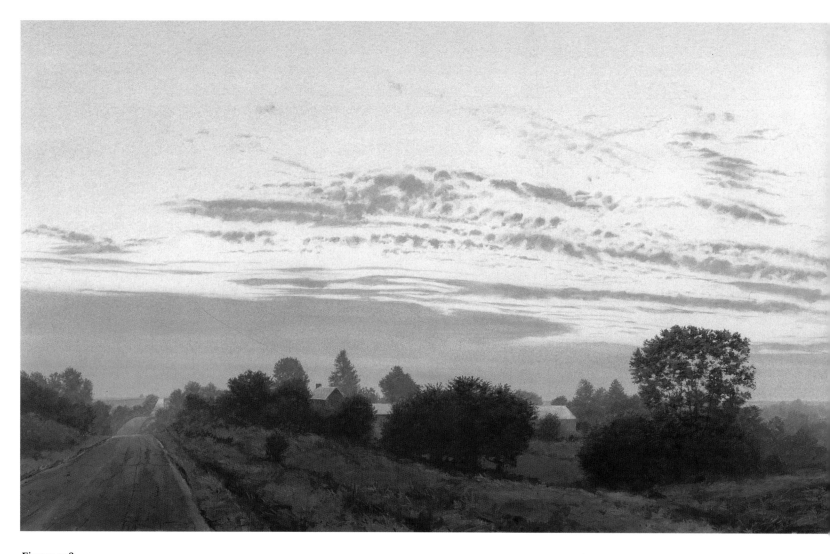

Figure 108

James Winn (b. 1949)

Dusk: Number 35, 1992

acrylic on paper, 16 x 38"

Collection of the artist, Sycamore, Illinois

(b. 1949), George Atkinson (b. 1949), and Walter Hatke (b. 1948), the everyday midwestern scenery that seems so monotonous to the automobile traveler is charged with significance. Commingling the effects of agriculture and decades of settlement with the natural spectacles of seasons, times of day, and climatic conditions, these painters transform planted, harrowed, and harvested fields and pleasingly timbered vistas into elegies and symphonies of land and sky. In Hatke's *River Fields* (1983, fig. 107) the banality of the site is belied by the subtle strength of the painting's formal construction and, as well, by its embodiment of the simple grace such scenes seem so often to impart. Winn's *Dusk: Number 35* (1992, fig. 108) displays the qualities of light and delicate tonal range that are so much a part of this artist's oeuvre, evoking a quietude that lies at the heart of prairie experience. Strongly influenced by the American tradition, Finnish and Russian landscape art, and the example of his teacher Harold Gregor, Winn's work recalls the remarkable luminosity of nineteenth-century painters Caspar David Friedrich, Martin Johnson Heade, and John Kensett. At the same time, however, it is uniquely his own, reflective of his spiritual beliefs and his long contemplation of his native land.[43]

George Atkinson's *West of Winona* (1992, fig. 109) more dramatically focuses on that great subject of the contemporary prairie painters, the sky and the deep recession of space it creates as it bows toward the horizon. The barely perceptible furrows direct the composition into the scene, gently at first from a rounded end and then forcefully back in an almost startling turn toward the horizon. Ordering the space through the framing of the taller crop, which angles gracefully into the center from the left, and measuring the distance with a single tree in the middle ground, Atkinson reconceives the nineteenth-century formula for landscape composition in a way that no less carefully directs the viewer's gaze, but at the same time does not restrict its free range through the infinitude of space. Most dramatic of all is the towering sky, raking a pastel glow through the roof of vision; in streaks of gray and pink it hints of the sun below the horizon, enlivening the view in its absence.

Often allied with his fellow Illinoisans, James Butler (b. 1945) has moved toward a somewhat different aesthetic, focusing more on sweeping prospects from elevations than on earthly vistas. In its emphasis on heightened effects, pushing the vast scale and clouds of the prairies to their ultimate extreme, Butler's work seems almost overwrought, in the manner of the operatic canvases of the nineteenth-century painter of the sublime, John Martin, but it is saved from bombast by the ordinariness of his subject and the control with which he constructs his scenes. In *Parker's Ridge* (1994, fig. 110), for example, the relative simplicity of the terrain balances the epic effect, and the result simultaneously monumentalizes the mundane and tempers the grandiose.[44]

Not surprisingly, Butler's works, like those of Atkinson and others, are also composites, conceived from photographs he combines to synthesize several angles of vision. Like the nineteenth-century practice of producing field sketches and compiling them in the studio into one

scene that incorporates a number of differing points of view, Butler's method constructs a vision that is banal in its familiarity and otherworldly in its effects. In technique, too, his images are refined to an exceptional degree. For *Parker's Ridge* he painted on panel, sanding it as he worked, to produce an exceptionally smooth surface. He labors over technique, producing layers of glazes and a highly refined finish that captures his vision of luminous prairie vistas. He is, as well, exceptionally conscious of contemporary transformations in the land, especially through pollution, flooding, and other ecological disruptions. In *Parker's Ridge,* as with many of his views, the roads and farmsteads are as evident as the natural features.[45]

Most of the contemporary prairie painters move between cultivated scenes and more natural horizons, seeing in each the promise of balance and tension between the formal and the conceptual. Iowa painter Fred Easker (b. 1944), like Winn, Hatke, and Atkinson in Illinois, expands his horizons amid the specter of cultivation. Borrowing the photographer's panoramic format for *Morning on Springville Road* (1995, fig. 111), Easker contemplates the tranquility of the moment and its intensification of the rich colors of early spring, at the same time incorporating such elements

ABOVE: **Figure 109**

George Atkinson (b. 1949)

West of Winona, **1992**

pastel on paper, 36 x 66"

Collection of Mr. and Mrs. William J. Kirby, Winnetka, Illinois

RIGHT: **Figure 110**

James D. Butler (b. 1945)

Parker's Ridge, **1994**

oil on panel, 30 x 54"

Collection of the artist, Bloomington, Illinois

as trees and roads that have so altered the original scene. In the views of Iowa by Genie Hudson Patrick (b. 1938), natural forces balance those of human presence. Moving readily in her work from settled scenes to more vacant ones, she often portrays the patterns of farmscapes that have transformed her home state, seeing in the swelling fields and meandering swales a natural beauty within a constructed environment. At her finest in her most minimal views, as in *A Season Turning* (1994, fig. 112), she eloquently conveys the power of simple masses that undulate and roll, recalling the omnipresent metaphor of the prairie as ocean. Viewed from an upland plateau in the Loess Hills, the land in this painting is devoid of timber and more suggestive of the Flint Hills region in Kansas and Oklahoma than of late twentieth-century Iowa with its frequent trees and cultivated fields, but as such it testifies to the persistence of prairie throughout the region, even if greatly diminished.[46]

Farther west, Hal Holoun (b. 1939) displays a similar interest in rolling grassland, although his is clearly a more rugged terrain. Looking out across his family's Nebraska farm in *Hill* (1981, fig.

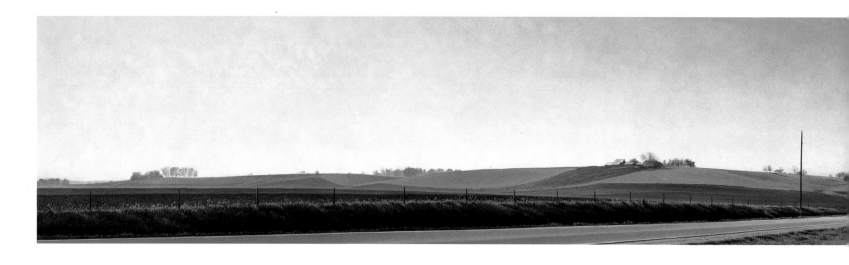

113), Holoun pays homage to a gentle bounty in the graceful curves of the sky and the land, recalling the form of Grant Wood's and Marvin Cone's fecund scenes from the 1930s. In Holoun's conception, however, the landscape is more pristine, more western, and somehow more real. In place of the pastoral gracefulness that characterized the idealistic views of his Iowa predecessors, he captures a wild rawness that has led many to describe the unplowed prairies as shaggy and unkempt.

In another Nebraskan's work, that of Keith Jacobshagen (b. 1941), the real and the ideal, the plain and the spectacular, are united. Sky usually dominates his scenes, as it so often does near his home in Lincoln, but the land as well is essential, in all the permutations of that word. Lowering the horizon line so that the foreground space of his paintings often occupies no more than one sixth of the entire composition, Jacobshagen emphasizes the sky through a great variety of luminous displays. In *Crow Call* [*Near the River*] (1990–1991, fig. 114), for example, the celestial sphere becomes the defining element of the work, leading the gaze through orthogonal cloud formations toward the tiny trees and structures that lie deep in the extended space below. More than a coy technique or even ironic device, Jacobshagen's stratospheric effects are the structural foundation of his images and, indeed, of the landscapes he turns to for inspiration. As they lift the gaze they simultaneously elevate the prospect, placing the viewer metaphorically somewhere between earth and sky, looking across the land from a floating perspective that ambiguously exposes the constructed identity of the view at the same time that it beguiles with its apparent veracity.

Like many of the contemporary prairie painters, Jacobshagen seeks out vistas in the land itself, doing small field sketches, making photographs, and, in his case, keeping sketchbook journals of his experiences, thoughts, and ideas, as well as noting climatic conditions in exacting detail. In

ABOVE: **Figure 111**
Fred Easker (b. 1944)
Morning on Springville Road, 1995
oil on canvas, 17 x 90"
Collection of Mid American Energies, Davenport, Iowa

RIGHT: **Figure 112**
Genie Hudson Patrick (b. 1938)
A Season Turning, 1994
oil on canvas, 47 x 80"
Collection of the artist, Iowa City. Photograph by David Trawick

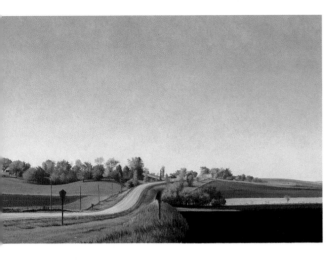

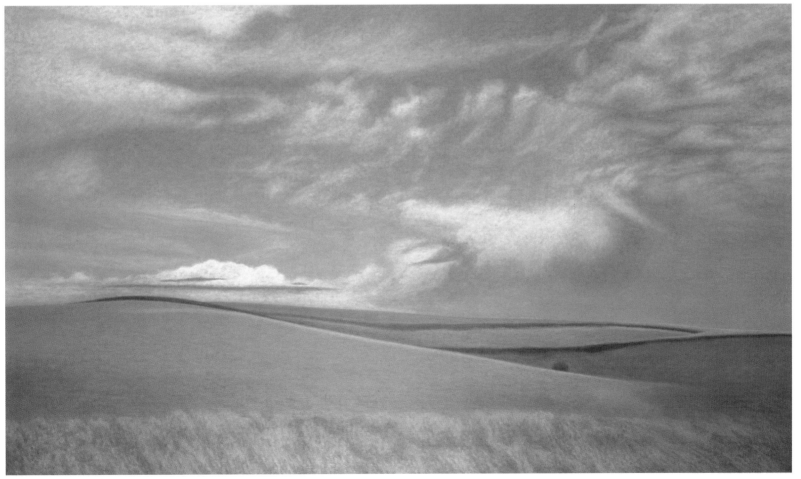

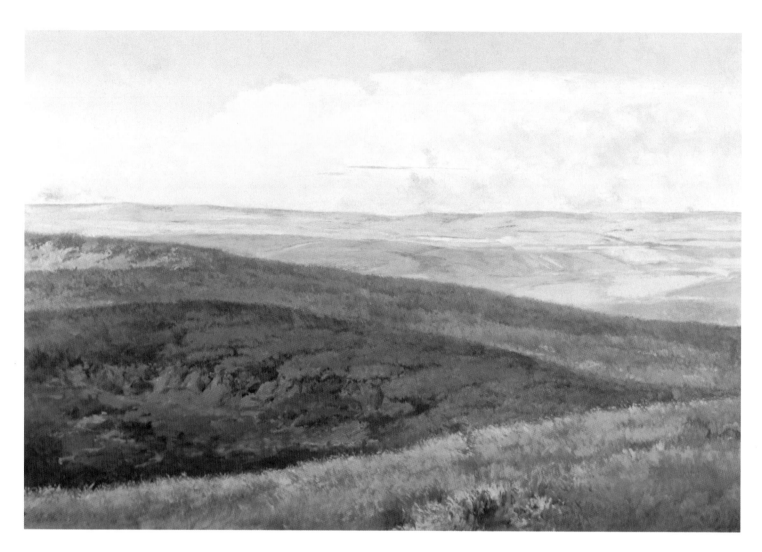

ABOVE: **Figure 113**

Hal Holoun (b. 1939)

Hill, 1981

oil on canvas, 43½ x 66"

Museum of Nebraska Art and the Nebraska Art
Collection, Kearney

RIGHT: **Figure 114**

Keith Jacobshagen (b. 1941)

Crow Call [*Near the River*], 1990–1991

oil on canvas, 46⅛ x 80¼"

Nelson-Atkins Museum of Art, Kansas City,
Missouri, purchase: acquired through the generosi-
ty of the National Endowment for the Arts and the
Nelson Gallery Foundation, © The Nelson Gallery
Foundation. All reproduction rights reserved

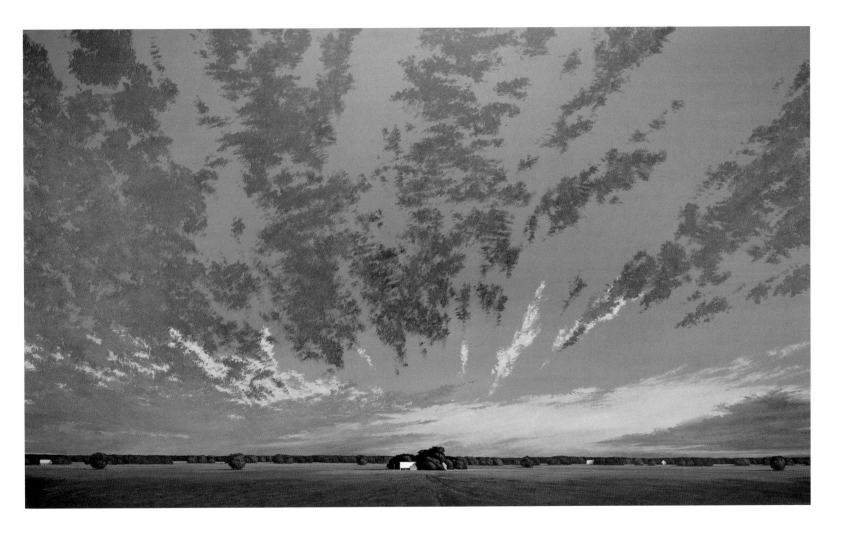

his oil and watercolor studies, the specific topographical information, seasonal conditions, and weather data are often included with the scene, usually written in a neat script below. More than simply a record of a particular place and time, these memoranda become an integral part of the work, formally and conceptually, an almost poetic inscription undergirding the contemplation of the prospect. Even in Jacobshagen's large canvases, which are more often conceived from memory and his own imagination than from field sketches, such personal musings are frequently represented in his titles, as in *In the Evening I Dreamed of Rain and Cicadas* (1995, fig. 115), a meditation on the impression of contrasting prairie sounds and atmosphere.[47]

While contemporary prairie landscape paintings are sometimes products of the imagination of the artist as much as of personal experiences, these canvases evoke the real in ways that the

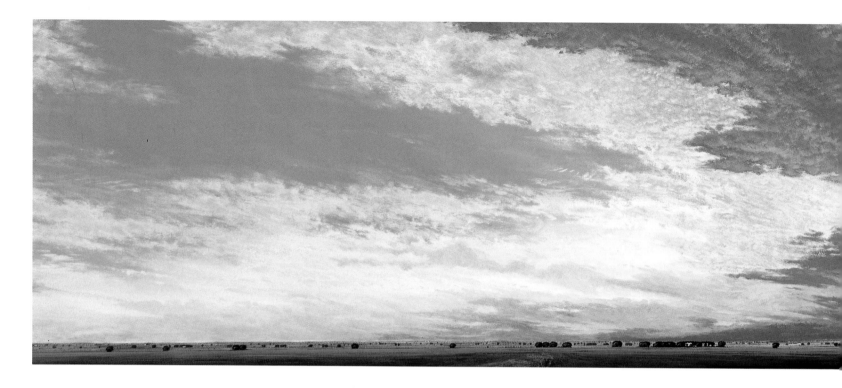

real often cannot. This can be a factor of physical distance, an actual removal from the place; as one urban collector expressed it, "It's enough for me to wake up in the morning, look at that painting, and know that somewhere out there, that landscape exists."[48] But our responsiveness to the painted image can also be the result of emotional distance. As we have been inured to or distracted from the subtle beauties of the actual landscape because of its banalities, its defilement, and its distance from places we deem more interesting, we often lose the ability to see it in all its wonder. The monumental canvases of contemporary grasslands reveal the land anew for us. They present it in all its pristine glory, but they reveal as well the quiet spectacle of its everyday form, a phenomenon that may be even more precious.

In these images the American concept of space that has so fundamentally shaped the country's history and culture finds its ultimate visual expression. Even within the transformed landscape of the late twentieth century, the old expansiveness persists and is all the more compelling for its rarity. Whereas earlier artists had difficulty seeing beauty in the void of an endless terrain, the new painters celebrate its vacancy for its ability to renew the soul and release the spirit; as a result, their visions are equally satisfying to the eye and to the mind. For Americans, in a world where such spaces are increasingly scarce, it is even more important to know that in some form or another the prairies will always exist. They encompass a realm that seems to suggest everything but at the same time contains nothing—but possibility.

Figure 115

Keith Jacobshagen

In the Evening I Dreamed of Rain and Cicadas, **1995**

oil on canvas, 20 x 72"

Collection of the artist, Lincoln, Nebraska

PLAIN PICTURES

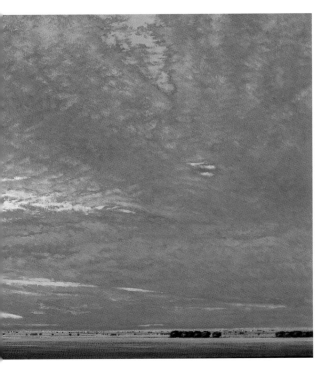

For artists the competing prospects and challenges of the modern prairie have become compelling not only as a subject but also as a canvas and a medium. Instead of relying solely on the traditional linear perspective that characterized earlier landscape views, they now present the region from a wide variety of angles—looking down from airplanes and from within the land itself as it becomes a sculptural form of its own. During the late 1970s and early 1980s Harold Gregor anticipated some of these interests, in his innovative flatscapes and in site-specific installations as well, where he used agricultural produce—grains and seeds of many sizes and colors—to produce floor sculpture. These constructions evoked his notion of the harmony in the contemporary cultivated prairie landscape, but they also recalled the ambitious and spectacular vegetative constructions that dominated agricultural fairs at the end of the nineteenth century.[49] Although this aspect of his work differs dramatically from other artists who explore the landscape's sculptural potential, he and others are nevertheless extending the boundaries of prairie art into new dimensions.

Identifying strongly with the land as a female force and a counterpart to the body, Cuban-born Ana Mendieta (1949–1985) created her most powerful evocations of the American prairies in the 1970s while a graduate student of Hans Breder's at the University of Iowa. Utilizing undulating terrain outside Iowa City, she created a powerful series of site-specific *siluetas,* which conjoined the earth and the figurative form. Planting, burning, and sculpturing body images from the grasses, mud, leaves, sand, and flowers and immersing her own body in the soil, she worked to express her loss of country as well as her discovery of self in a new land. "I work with the earth. I make sculptures in the landscape. Because I have no motherland, I feel a need to join with the earth, to return to her womb."[50] Mendieta came with her sister to the United States in 1961, escaping the Castro regime and leaving their parents and younger brother in Cuba. The girls were for a time placed in an Iowa orphanage by the Catholic church before being rejoined with their mother and brother in 1966 (their father remained a political prisoner in Cuba). These early disruptions and difficulties instilled in Mendieta an intense longing for home, and while she maintained connections with her Cuban heritage, she strongly identified with Iowa and its landscape as the nurturing ground of her youth. Even after she moved to New York, she continued to return to Iowa to work until her untimely death at the age of thirty-six.[51]

Recalling Alexandre Hogue's *Mother Earth Laid Bare* (1938, fig. 65), Mendieta's *Grass Flowers* (1978, fig. 116), a *silueta* in clover, evokes a simultaneous birth and burial and suggests a life force that permeates the earth and those who find sustenance in it. But whereas Hogue conceived of Mother Earth as an entity apart, something to be objectified and observed, Mendieta envisioned the terrestrial spirit as inseparable from herself.[52] In her work the prairie becomes less a canvas than a medium through which she could become one with her art and her environment.

In a different way, the Swiss photographer Georg Gerster (b. 1938) perceives and records the

Figure 116

Ana Mendieta (1949–1985)

Grass Flowers, 1978

silueta with clover

Photograph by the artist, from the collection of
the Mendieta family, Cedar Rapids, Iowa

art of the earth on a grand scale. Working from the air, he has discovered both the subtle and the dramatic throughout the agricultural lands of the United States; he credits the farmers as the true artists:

All over the world farmers draw with plow, harrow, and harvesting combine, and paint with the colors of their crops. As land artists they have no equal, and the palette and patterns of American agriculture in particular seem inexhaustible. While coaxing bounty from the earth to feed to the United States and other nations, farmers coincidentally offer up a visual feast for the eyes of an airborne viewer . . . an open-air museum, with hundreds of thousands of tableaux on display, most of them a square mile in area and framed by bordering roads. Some of these exhibits rival the mystery of prehistoric ground drawings; others conjure up the tumultuous abstractions of modern canvases.[53]

Gerster notes that farmers have been using their tractors as etching styluses for years, unintentionally and intentionally, and recounts instances of consciously created designs in fields dating to the 1930s. More recently, however, realizing that airliners were regularly passing overhead, farmers have sometimes resorted to using their fields as massive billboards for their own political and personal statements. In the 1980s for example, one farmer plowed the words "I am broke Mr. Reagan." In a plea to a higher authority during a drought, another simply wrote "water!", which Gerster captured in *North Dakota: Farmer Crying Out for Rains near Armenia* (ca. 1989, fig. 117). On the flat quilt of the plains, the grid pattern of the original surveyors' design is nowhere more evident, and the imposition of the letters only serves to highlight the regularity. At the same time, it humorously, if poignantly, evokes the ongoing struggle to contend with the prairies' unpredictability.

Always attentive to the practical, environmental, and economic consequences of such farming practices as strip cropping, contour plowing, and crop rotation, as well as their historical development, Gerster is even more aware of the visual effects of agricultural techniques. In *Field near Stafford, Kansas* (ca. 1989, fig. 118), for example, the subtle abstraction of the plowed field when viewed from the air could, as the photographer noted, hang in any exhibition of modern art. As he notes with most of his images, however, the delicacy of visual effect is always the result of working with or against natural forces. In this instance, "the fine pen lines from the air are rough ridges at ground level, turned up by a farmer in an effort to halt wind erosion. . . . The faint tracks at the left were made to combat an earlier wind; now the wind has shifted and so have the lines of defense. The broad brushstrokes at the bottom of the field are bands of dark soil turned up by a disk to prepare a seedbed."[54]

With a more conscious intent, Kansas artist Stan Herd (b. 1950) has been just as inventive in his creation of "crop art," giant earthworks plowed, planted, or mowed out of tracts of land that often encompass 160 acres—the original size of a prairie homestead. Paralleling the efforts of whimsical farmers, the mysterious crop-circle artists of Britain, and the unknown ancestors who

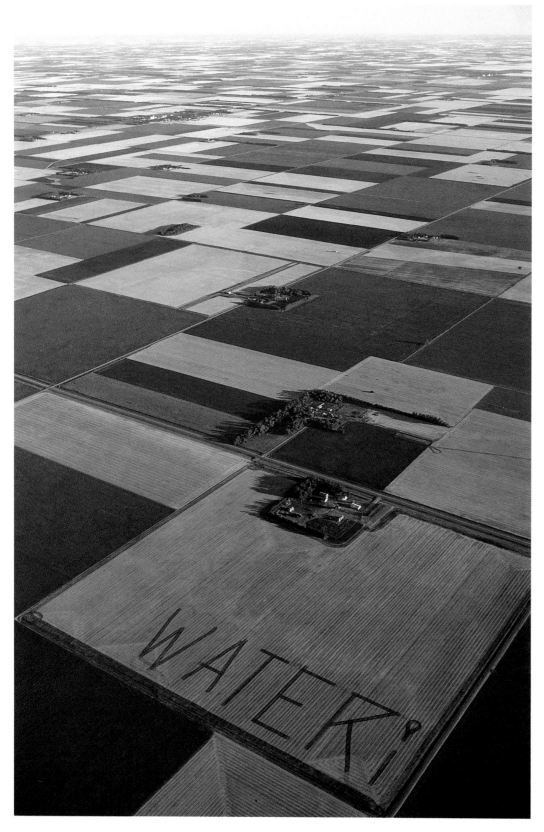

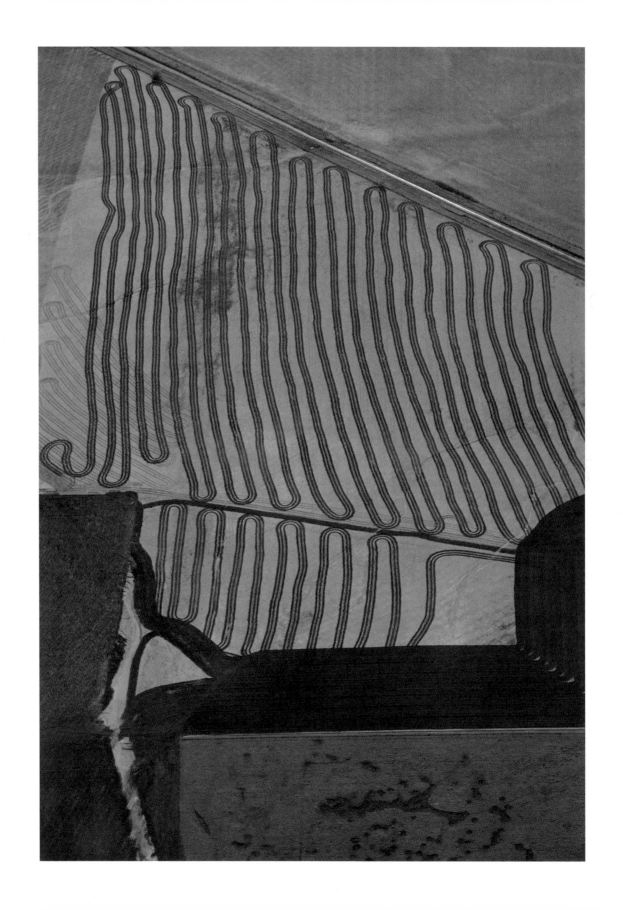

left such massive images in the land as the white horse of Salisbury and the serpentine mounds of Ohio, Herd has provided the prairies with an entirely new artistic prospect. Raised on a Kansas wheat farm just north of the Oklahoma panhandle, he attended Wichita State University and explored modernist art early in his career, but standing in front of Josef Albers's *Ascending Squares* in 1979, he "saw a logical evolution from the Post-Impressionists . . . ending with a simple, uncluttered square of color. To me that square represented my open field back in Kansas. I was free to go back and do anything I wanted." He had already conceived what would become his own art—making an image on and in the land, "using tools and methods that generations of my family had employed for their livelihood," relying especially on the tractor and the vagaries of prairie weather.[55] Also critical to the project's success were surveyor's instruments, a gridded drawing (often with one inch corresponding to one hundred feet on the ground), long tape measures, flags that marked the design on the ground, and a high-wing airplane to check the results. His first effort at a prairie earthwork was *Chief Santana* (1981), which embodied his devotion to the land and its compelling visual qualities and his long-standing interest in Native Americans. Chosen specifically to honor the Kiowa chief who had participated in the 1867 Medicine Lodge Peace Treaty signed only fifty miles from Herd's hometown, the image was plowed on a quarter section near Dodge City in the northernmost portion of the Kiowa hunting range. An etching more than a crop piece, since the land was not planted, this project proved to Herd the viability of his art form and led to more ambitious undertakings that in different ways evoke powerful aspects of the prairie landscape, its history, and its culture.

Another compelling regional tribute, *Will Rogers* (1983, fig. 119), a portrait half a mile square of the famous Oklahoma humorist of the 1920s and 1930s also planted near Dodge City, was a lesson in the trials that prairie farmers had endured for decades. Mechanical problems slowed Herd's first effort to incorporate crops into the image; once planted in maize, *Will Rogers* was beset by drought, which diminished its coloration. Furthermore, the government intervened, reminding the farmer who owned the land that he had agreed not to plant feed-grain crops on that quarter section and ordering the field plowed under. With the help of a congressman, however, the portrait was declared a wildlife refuge; apparently there was no existing loophole for prairie earth art.

Figure 119

Stan Herd (b. 1950)

Will Rogers, **1983**

earth portrait near Dodge City, Kansas, half a mile square

Photograph by Peter B. Kaplan, from the collection of the artist, Lawrence, Kansas, © 1978 Peter B. Kaplan/Peter B. Kaplan Images, Inc., New York. All rights reserved

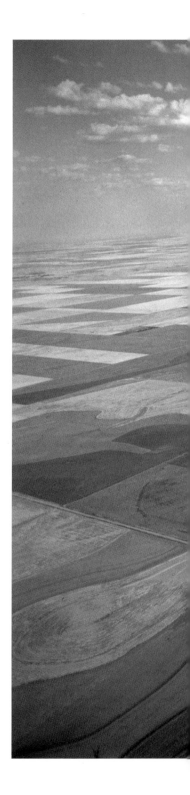

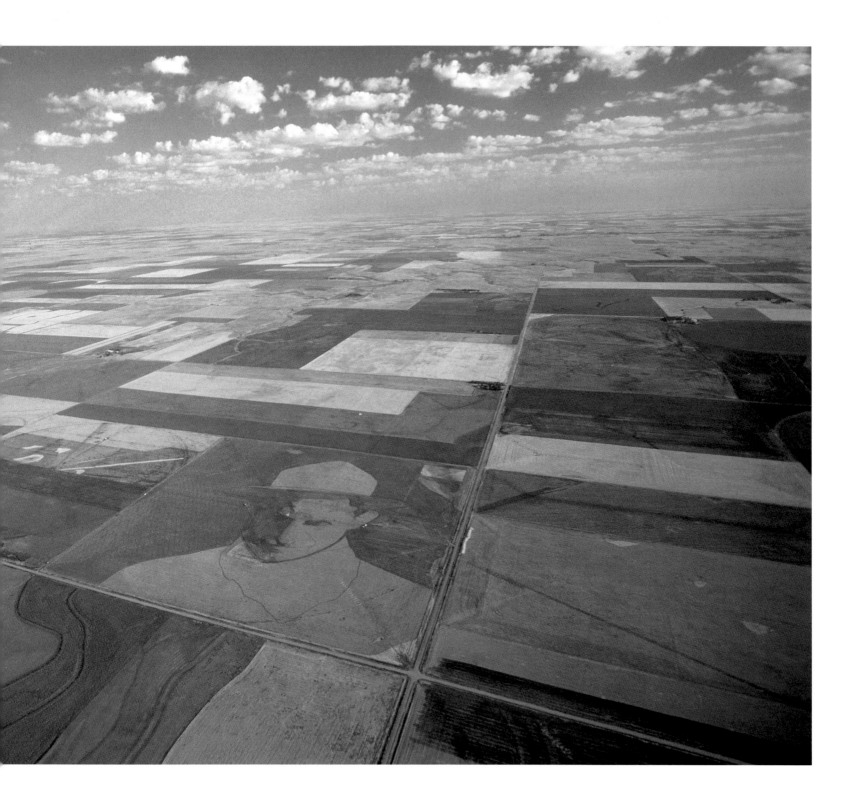

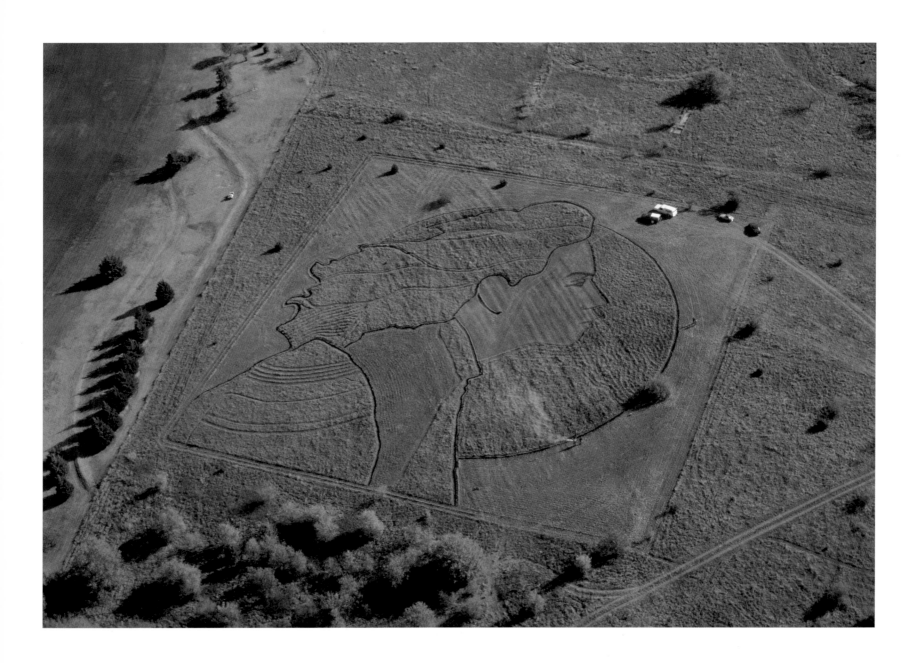

In subsequent projects Herd has explored themes other than portraits; he has become nationally famous for planting a version of Vincent Van Gogh's *Sunflowers* with actual sunflowers and for an Absolut vodka bottle that has appeared in countless advertisements. More interesting within the context of the American grasslands, however, is *Little Girl in the Wind (Carole Cadue)* (1990, fig. 120). Herd's first effort at making a plain picture without plowing, this image is a work of serious theoretical aspirations, socially as well as ecologically. With the counsel of the Land Institute in nearby Salina, Kansas, Herd used the prescribed techniques for maintaining a natural prairie: burning, mowing, and, in this case, the hand planting of natural species of grasses. Unlike Herd's former earthworks, which were all plowed under to restore valuable agricultural land to more practical use, *Little Girl in the Wind* is a perennial work that will evolve and persist until it is eventually subsumed by the natural forces of the Kansas prairie.

Intended as the initial image in a series Herd is titling *Nation's Portrait,* his first true prairie portrait was inspired by a growing awareness of pan-American multiculturalism.[56] To represent the United States, he chose a young girl named Carole Cadue, the daughter of the tribal chairman of the Kansas Kickapoo, suggesting a Native American legacy and its ties to the land and contemporary society. Perhaps in keeping with the theme of the work, literally and ideologically, a controlled burn intended to define the edges of the image leaped the boundaries of the design and scorched the top half of the portrait. Fittingly, however, the project was continued, and over the following years it was planted with hundreds of yellow coneflowers and penstemons, native wildflowers that will continue to wave in the wind for many years to come. With a profound sensitivity to the implications of his art, Stan Herd combines an awareness of the prairie soil in his native state with a global concern for humanity, and his imagery offers a new and dramatic prospect for the interrelationship of all three.

THE LOOKING-GLASS PRAIRIE

In the 1970s Wright Morris wrote, "It is emotion that generates image-making: it is emotion that processes memory. . . . First we make these images to see clearly: then we see clearly only what we have made."[57] Today's grasslands are "Looking-Glass Prairies," to borrow from the name of the southwestern Illinois landscape Charles Dickens visited in the 1840s.[58] The prairie is no longer alien or forbidding. Indeed, it is mostly as manicured, trimmed, combed, and accessorized as we are ourselves. Fulfilling the desires of the nineteenth-century artists and settlers, the actual landscape has been framed and endowed with all manner of cultivations, and we must look closely for its original characteristics, just as aging faces strain to see vestiges of youth when confronted with a mirror. At the same time, the prairies reflect our cultural uncertainties and disagreements as they form the locus for continual debates over land use and its meaning. Like figures in the tall grass of the virgin prairie, the grasslands within contemporary society throw the elemental and the human into high relief, each revealed by the character of the other.

The prairies have been so thoroughly transformed, have become so conflicted and paradoxical, visually and culturally, that they have become a postmodern subject. The land has been filled and altered to the point of losing its identity; instead of looking in vain for something to break the expanse as our predecessors did, we must search for the uninterrupted view and are constantly diverted by distractions. Competing forces of other sorts—from environmentalists to agribusiness, industrialists to suburban dwellers—vie for the prairies' future, and except in times of natural catastrophe, such as tornadoes, droughts, or floods, it seems as if humans have gained the upper hand.

More than just nostalgia for a simpler place by an increasingly urban public, attitudes and artistic responses toward the middle American landscape are incorporating new appreciation of these new aspects of the region's complexity. The prospects of the prairies have improved and multiplied, even as they compete for a claim on the land's identity. In some ways, the art world has finally grown into the subject; as contemporary Americans struggle ever more vainly to locate themselves within an increasingly complex society, prairies have become a focal point for cultural identification, embodying long cherished ideals of harmony with the land and, for those with more fortitude, pragmatism, or insight, the vainest follies and most tragic mistakes of culture and history.

Throughout it all, in the midst of competing visions and transforming innovations, the grass and the horizon retain their power, and as the contemporary prairie artists show us, we are made more significant by our relationship with them. They and the images of them, past and present, locate us however uneasily in a landscape of our own making. Their future is ours, no matter how we are able to manipulate the vantage points to that distant horizon.

As we approach a new century and millennium, the prairies offer an opportunity to locate ourselves anew. Just as they have always disoriented us, dislocating us from familiar references and reliable landmarks, they continue to offer a prospect that confronts us with our own nature.

N O T E S

INTRODUCTION

1. Alvar Núñez Cabeza de Vaca wandered through the southern plains after becoming lost in a Gulf storm in 1534. *Spanish Explorers in the Southern United States, 1528–1543* (edited by Hodge and Lewis) contains [Thomas] Buckingham Smith's 1851 translation of *The Narrative of Alvar Núñez Cabeza de Vaca.* Francisco Vásquez de Coronado was the first intentional European explorer of the region, in 1541. Hammond and Rey, *Narratives of the Coronado Expedition.*

2. For a thoughtful and well-documented discussion of these and other issues related to the central region of the United States, see Shortridge, *Middle West.*

3. Although many over the years have simplified the prairies into a monolithic region, the understanding of them as varied and complex is not a modern notion. See for example Gregg, *Commerce of the Prairies,* pp. 346–383.

4. Patricia D. Duncan, *Tallgrass Prairie,* p. 5.

5. In 1834 Bryant deleted his reference to the English language's lack of a term for prairies, but he reinserted it in 1836, and it remained in later editions. Steven Olson, *Prairie in Nineteenth-Century American Poetry.* The implications of this etymological interpretation lie outside the scope of this study, but it is intriguing to speculate on the source of Bryant's fascination with it. While it is true that "prairie" is a term of French origin (ultimately from Latin), and Bryant could have known this from a variety of sources, he may have focused on the issue through its emphasis in James Fenimore Cooper's introduction to *The Prairie* in the 1832 edition. Bryant was familiar with the book, having written a review of it upon its first release in 1827. Cooper, *Prairie,* pp. xxxi, 3–4; Bryant, "The Prairie," 306–7.

6. Thwaites, *Original Journals,* 1:51.

7. *The Oxford English Dictionary* defines "prairie" as "a tract of meadow land" and "a tract of level or undulating grass-land, without trees and usually of great extent; applied chiefly to the grassy plains of North America." For more on the term and its early application, see Madson, *Where the Sky Began,* p. 7.

8. For more on this see Shortridge, *Middle West.*

9. Studies of this issue are numerous. A brief overview from a philosophical perspective is Carlson, "On Appreciating Agricultural Landscapes." For a discussion of approaches to prairie ecology, see Tobey, *Saving the Prairies.*

10. Carlson, "On Appreciating Agricultural Landscapes"; and Joni L. Kinsey, Rebecca Roberts, and Robert Sayre, "Prairie Prospects: The Aesthetics of Plainness," *Prospects: An Annual of American Studies,* forthcoming 1996.

11. This point is made in a sweeping context by Leo Marx, "The American Ideology of Space," in Wrede and Adams, *Denatured Visions,* pp. 62–78.

12. Cather, *My Antonia,* p. 7.

13. On literary treatments of prairies, see Thacker, *Great Prairie Fact,* an excellent study that has greatly informed this book.

14. The implicit authority of the Renaissance-derived point of view has been discussed in various ways by many scholars. A succinct depiction is that of Carole Fabricant, who likened the view of the spectator in these traditional landscapes to "a lord overseeing his creation, [who] was able to 'command' a view of the country stretching out beneath him and thereby exert control over it in much the same way that the aristocratic class (at least through the seventeenth century) ruled over those on the lower rungs of the social hierarchy." Cohen, *Studies in Eighteenth-Century British Art and Aesthetics,* p. 56.

15. The Native American tradition of visual representation is usually considered a separate field of study from European and Euro-American art. For a recent consideration of Native American imagery see Maurer, *Visions of the People.* I am grateful to Louise Lincoln for her conversations with me about this issue.

16. Although not focused on midwestern landscapes, the classic text on this subject remains Marx, *Machine in the Garden.*

17. For the making of the myth, if not the garden itself, see Emmons, *Garden in the Grasslands.*

18. The most extended discussion of this interpretation is found in Rosenblum, *Modern Painting and the Northern Romantic Tradition.*

19. Landscape art of other American regions has received extensive attention in major exhibitions, books, and scholarly articles, but prairie painting has been discussed only within the context of western art more generally or in scattered articles. Some of these include Stein, "Packaging the Great Plains"; Lamar, "Seeing More Than Earth and Sky"; Howard Lamar, "Image and Counterimage: The Regional Artist and the Great Plains Landscape," in Engel, *Big Empty,* pp. 75–92.

1 · PRAIRIE PROSPECTS

1. Edward Roper, *By Track and Trail through Canada* (London: W. H. Allen, 1891), 51, cited by Ronald Rees, "Painting, Place, and Identity: A Prairie View," in Sadler and Carlson, *Environmental Aesthetics,* pp. 117–141.

2. Sir William Francis Butler, *The Wild North Land: The Story of a Winter Journey, with Dogs, across Northern North America* (1873), quoted in Thacker, *Great Prairie Fact,* p. 52. This was written regarding the Canadian prairie but is typical of (if somewhat more eloquent than) similar American descriptions.

3. This pedigree is debatable; some would place the origins of landscape theory in ancient times, but it is clear that modern landscape ideas are most directly related

in art to the developments and ideas that grew out of the seventeenth and eighteenth centuries.

4. The literature on this subject, both primary and secondary, is extensive. A few recent excellent studies that cite the most significant theoretical texts include Cohen, *Studies in Eighteenth-Century British Art and Aesthetics;* Daniels, *Fields of Vision;* Daniels and Cosgrove, *Iconography of Landscape;* Hefferman, *Re-Creation of Landscape.*

5. Gilpin, *Three Essays.* Gilpin was not the only one to describe the picturesque (in fact, the word *pittoresco* was used at least as early as the sixteenth century as an overt reference to the painter's art); another principal theorist on the subject was Uvedale Price, whose *Essays on the Picturesque* (1794) more firmly established the category as a companion to the sublime and the beautiful. For more on this see Hussey, *Picturesque.*

6. A good concise introduction to the three theoretical categories and their implications for American painting is Ketner and Tammenga, *The Beautiful, the Sublime, and the Picturesque.*

7. There were exceptions to the avoidance of "picturesque" when describing the prairies. George Catlin used the term more than once, but usually in areas that contained rivers and all the vegetation that accompanies them. Of one such place he reported, "It has been, heretofore, very erroneously represented to the world, that the scenery on this river was monotonous, and wanting in picturesque beauty. This intelligence is surely incorrect." Catlin, *Letters and Notes,* 1:18.

8. This plate is illustrated in Bermingham, *Landscape and Ideology,* p. 64.

9. Kane, *Wanderings of an Artist,* quoted in Thacker, *Great Prairie Fact,* p. 62.

10. These are described in many places, but see for example Clark, *Landscape into Art,* pp. 114–115, 128, 130.

11. One significant exception that was distinguished in part by its departure from formula was Frederic E. Church's *Niagara* (1857, Corcoran Gallery of Art), which was widely acclaimed for its compositional innovation.

12. This is an enormously significant aspect of the rise of American landscape painting and has been discussed widely and variously. One primary text, however, that exemplifies such ideas is Thomas Cole's "Essay on American Scenery," *American Monthly Magazine,* new series 1 (January 1835): 1–12 (reprinted in McCoubrey, *American Art, 1700–1960,* pp. 98–110).

13. This problem is noted throughout exploration literature and was a constant in Meriwether Lewis's journals. Lewis specifically wishes for artistic ability that would more effectively convey the impression of the Great Falls of the Missouri River. Thwaites, *Original Journals,* 2:149–150. I have more thoroughly discussed the deficiencies of conventional representational techniques in regard to western American landscapes in my book *Thomas Moran and the Surveying of the American West,* esp. pp. 2–3, 20–23. For more on Lewis and Clark's reactions to the prairies specifically see Thacker, *Great Prairie Fact,* pp. 24–26.

14. Whitman, *Specimen Days,* p. 94.

15. Ibid., p. 95.

16. Say, *American Entomology,* 1:3.

17. The reasons and ways that prairie ecosystems prevent trees from growing are complex geologically and botanically, but generally two essential factors are at work: the thick grassland root system that resists penetration by and nurturing of tree seeds, and fires that periodically kill off the woody growth that does get started. These fires do not kill the grasses (and in fact nurture them), because their principal life support is below ground. The real question, not sufficiently understood even now, is how grass got such an advantage in the first place. For more see Madson, *Where the Sky Began,* pp. 29–50. Zebulon Pike speculated on this as early as 1806, making reference to many hypotheses already in existence, and attributed the lack of trees to aridity. Pike's journal and the dissertation have been reissued several times since the original 1810 publication, most notably in an 1895 annotated version in three volumes, edited by Elliott Coues (recently reprinted in two volumes). Coues, *Expeditions of Zebulon Montgomery Pike,* 2:524–525.

18. In the same breath some compared it to the sea: "Like the ocean, [it] presented an equal horizon in every direction." Both from the same passage, Say, *American Entomology,* 1:3.

19. Although not given to musing on landscape, Pike frequently described the prairies in relatively positive terms, then referred to them as deserts. The reference to "internal deserts" is found in Pike's "Dissertation on Louisiana," his summary report. Coues, *Expeditions of Zebulon Montgomery Pike,* 2:524.

20. Coues, *Expeditions of Zebulon Montgomery Pike,* 2:234. Maj. Stephen Long, "General Description of the Country Traversed by the Exploring Expedition between the Meridian of Council Bluffs and the Rocky Mountains," in James, *Account of an Expedition,* 14:147–148.

21. James, *Account of an Expedition,* 16:173–174.

22. Coues, *Expeditions of Zebulon Montgomery Pike,* 2:524.

23. These recognitions are discussed in Webb, *Great Plains,* pp. 155–157; and in Goetzmann, *Exploration and Empire,* pp. 51, 62.

24. Gregg, *Commerce of the Prairies,* p. 346.

25. Cooper, *Prairie,* p. 4.

26. Although some areas of the prairie region are little affected by a lack of water, during times of drought and in the western portions on a regular basis, the desert specter reemerges, at least as a threat. Such was the case during the 1930s (see chap. 4) and will be again if the dire predictions prove true about the draining of the Ogallala Aquifer, which today supplies most of the irrigation water to the plains.

27. Jolliet, after his 1673 exploration of the Illinois and Mississippi rivers. Thwaites, *Jesuit Relations and Allied Documents,* 58:105.

28. Ibid., p. 107.

29. Boime, *Magisterial Gaze.*

30. John Reps has exhaustively researched this subject in a number of books. Most relevant to this application is *Cities on Stone.*

31. Definitions adapted from *Oxford English Dictionary,* 1971, s.v. "prospects." For more on prospect painting, see Turner, "Landscape and the 'Art Prospective'"; and Daniels, "Goodly Prospects." For its specific application to town views: Hyde, *Gilded Scenes and Shining Prospects;* and Reps, *Cities on Stone.* For the term's significance in an American context, see Alan Wallach, "Thomas Cole: Landscape and the Course of American Empire," in Truettner and Wallach, *Thomas Cole,* esp. pp. 74–75. Other studies that discuss the development of visual claiming of the American landscape, although in different ways, include Angela Miller, *Empire of the Eye;* and Truettner, *West as America.*

32. Alexander Henry, *New Light on the Early History of the Greater Northwest: The Manuscript Journals of Alexander Henry, Fur Trader of the Northwest Company, and of David Thompson, Official Geographer and Explorer of the Same Company, 1799–1814,* ed. Elliot Coues (New York: Francis P. Harper, 1897), 1:94, quoted in Thacker, *Great*

Prairie Fact, p. 22. This Alexander Henry is known as the Younger to distinguish him from his fur-trader uncle of the same name.

33. Coues, *Expeditions of Zebulon Montgomery Pike,* 2:451–458, entries for November 23–27, 1806. Pike and his party were not sightseeing but scaled the rise in order to "lay down the various branches and positions of the country."

34. Ibid., 486–497, entry for February 5, 1807.

35. Catlin, *Letters and Notes,* 1:218, letter 27.

36. James, *Account of an Expedition,* 15:183.

37. For some travelers the prairie had distinct advantages over its watery likeness. Henry Marie Brackenridge, who traveled up the Missouri River in 1811, wrote, "If the vast expanse of ocean is considered as a sublime spectacle, this is even more so; for the eye has still greater scope, and, instead of its monotony, now reposes upon the velvet green, or feeds on the endless variety of hill and dale. Instead of being closed upon in a moving prison, deprived of the use of our limbs, here we may wander at our will. The mind naturally expands, or contracts, to suit the sphere in which it exists—in the immeasurable immensity of the scene, the intellectual faculties are endured with an energy, a vigor, a spring, not to be described." Brackenridge, *Journal of a Voyage up the River Missouri, Performed in 1811* (Baltimore, 1816), cited in Thacker, *Great Prairie Fact,* p. 31.

38. James, *Account of an Expedition,* 15:184.

39. These references are frequent in prairie literature. A typical example comes from Alonzo Delano, who traveled to California from Illinois for the climatic cure in 1849: "We found the country during this day's drive very level, and little after noon we reached a plain, where there was not a tree or shrub, nor a sign of life except our own train, as far as the eye could extend. The glare of the sun upon the distant plain resembled the waves of the sea, and there were appearances of islands and groves, from the effect of the mirage." Delano, *Across the Plains,* p. 14.

40. The study of landscape and its perceptual challenges has become an interdisciplinary field that brings together art historians, landscape architects and historians, geographers, and scientists. One such collaboration, although not specifically concerning prairies, has been documented in Penning-Roswell and Lowenthal, *Landscape Meanings and Values.*

2 · PROSPECTING THE PRAIRIES

1. The conclusion of such surveys is dated here in the 1870s, even though they were conducted afterward through the efforts of the United States Geological Survey (USGS). It was, however, during the 1870s that the majority of the principal mapping of the continent was concluded, an accomplishment marked in 1879 by the reorganization of the numerous scientific surveys sponsored by the U.S. government into the one USGS. The most comprehensive studies of the expeditions before 1870 are by Goetzmann: *Army Exploration of the American West* and his more general *Exploration and Empire.* For the Great Surveys of the 1870s, see Rabbitt, *Minerals, Lands, and Geology;* and Bartlett, *Great Surveys.*

2. Although many of the individual artists who accompanied these surveys have received attention and the sizable literature on western art includes many of them and their work, no single comprehensive study has yet compiled the visual material from nineteenth-century expeditions. A monumental undertaking, such a work would need to include not only those painters who produced large easel paintings from their experiences but as well the numerous artists known only from their pub-

lished images in the countless official expedition reports. In addition to many other sources cited in this study, see Sweeney, "Artist-Explorers of the American West."

3. Thwaites, *Original Journals,* 7:247–252.

4. Had Lewis and Clark left a little later Jefferson might have recognized their need for an artist. Only a few weeks after they began their ascent of the Missouri River from Saint Louis, Jefferson was visited in Washington by Baron Alexander von Humboldt, an influential naturalist and a strong advocate of visual documentation of unexplored regions. Humboldt, a competent draftsman in his own right, had just finished a five-year expedition through South America and traveled via Philadelphia with artist Charles Willson Peale to share his findings with the president. In much of his prodigious writing in subsequent years, Humboldt would advocate the visual portrayal of landscape and was one of the first to recognize the utility of photography after it was invented in 1839. The visit is described in Peale's diary. See Lillian B. Miller, *Selected Papers,* pp. 680–710; and Friis, "Baron Alexander von Humboldt's Visit." I quote Lewis and comment on his regret in *Thomas Moran,* pp. 2–3.

5. Thwaites, *Original Journals,* 1:75. This passage echoes earlier ones, such as "Capt. Lewis and myself walked to the hill, from the top of which we had a butifull prospect of Serounding countrey, in the open Prarie we caught a racoon." Ibid., pp. 47–48.

6. This description was in regard to an area west of the Mandan villages, which would have located it in western South Dakota or eastern Wyoming, a particularly barren stretch of territory. Ibid., p. 312.

7. Ibid., p. 51.

8. The complete report for the Long expedition was compiled by Edwin James in *Account of an Expedition from Pittsburgh to the Rocky Mountains* (Philadelphia: Carey & Lea, 1823). An annotated reprint was published in volumes 14–17 of the *Early Western Travels* series, edited by Reuben Gold Thwaites. An excellent abridged version, *From Pittsburgh to the Rocky Mountains,* edited by Maxine Benson, has been issued recently. It contains a useful historical introduction as well as a bibliography and notes.

9. For all their importance as the first artists of the American West, these artists remain underresearched. For more on them, however, see McDermott, "Samuel Seymour," and Trenton and Hassrick, *Rocky Mountains,* pp. 20–30. On Peale, see Weese, "Journal of Titian Ramsay Peale," and Poesch, *Titian Ramsay Peale.* For a more recent and meditative consideration of the artists and the implications of their images, see Haltman, "Figures in a Western Landscape."

10. With private funding Peale explored South America from 1830 to 1832, perhaps inspired by his family's friend the eminent German naturalist Alexander von Humboldt, who had traveled through the Amazon region from 1799 to 1804. Manthorne, *Tropical Renaissance,* pp. 36–39. In 1838–1842 he was an important member of the Wilkes expedition, which circumnavigated the globe. Viola and Margolis, *Magnificent Voyagers.*

11. James, *Account of an Expedition,* 14:42–43.

12. I am speculating here that Seymour did not often depict prairies as pure landscape. Since so many of his works are lost, this is difficult to ascertain. After the Long expedition, Seymour seemed to drop from sight, adding to the uncertainty. Extraordinarily little is known about his life after 1820.

13. In Peale's views the animals appear more like specimens displayed than actu-

al living animals in a landscape, a practice consistent with Peale's training in his father's famous Philadelphia museum. Seymour, by contrast, did depict a number of landscapes without an emphasis on animals, in keeping with his position as draftsman. For more on the Peale Museum, see Sellers, *Mr. Peale's Museum.*

14. Weese, "Journal of Titian Ramsay Peale," pp. 159–160. It is unfortunate that the extant portion of Peale's diary ends with the party still in Missouri and not yet arrived at the real prairie. The remainder of the journal has been lost.

15. Benson, *From Pittsburgh to the Rocky Mountains,* p. 52.

16. Ibid., p. 75. Description of a scene near Le Mine River.

17. James, *Account of an Expedition,* 15:183.

18. Ibid., pp. 173–174; Say, *American Entomology,* 1:3.

19. For an excellent summary of this issue and a substantial bibliography on the subject, see Allen, "Garden-Desert Continuum."

20. Other publications about the territory and its characteristics existed, of course. For a brief review of the most important of these, see Goetzmann, *Exploration and Empire,* p. 182.

21. Irving's party began the month-long journey at Fort Gibson and spent a good deal of time in eastern Oklahoma, which is more woodland than grassland, although Irving continually calls it prairie. The party did eventually move westward through the smaller and smaller groves of blackjack and post oak (which still distinguish the central part of the state) into what Irving called "a grand prairie." Proclaiming it "one of the characteristic scenes of the Far West," he described it as "an immense extent of grassy, undulating, or as it is termed, rolling country, with here and there a clump of trees, dimly seen in the distance like a ship at sea; the landscape deriving sublimity from its vastness and simplicity." Irving, *A Tour on the Prairies,* first page of chap. 18. Originally published as vol. 1 of *The Crayon Miscellany* in 1835, *A Tour* has been reprinted many times. The edition I am using is in vol. 3 of the Illustrated Sterling Edition of Irving's works.

22. Irving, *A Tour on the Prairies,* chap. 18, p. 68.

23. Ibid., chap. 29, p. 108.

24. Thacker reports, for example, that Emerson Bennett's *Prairie Flower* (1849), which emphasized the romantic qualities of the prairies, sold more than 100,000 copies. *Great Prairie Fact,* pp. 124–125.

25. Parkman, *Oregon Trail,* p. 63.

26. Catlin, *Letters and Notes,* 1:2.

27. Truettner, *Natural Man Observed,* p. 38. *Natural Man Observed* remains the definitive study of Catlin. Truettner carefully delineates the artist's movements and the details of his efforts to promote his Indian Gallery. For Catlin's painting technique, see p. 105.

28. Ibid., pp. 81–86.

29. Ibid., p. 107.

30. Catlin, *Letters and Notes,* 1:59.

31. Ibid., 2:3.

32. Ibid., 1:218.

33. James, *Account of an Expedition,* 14:217. William Clark apparently named this spot, presumably from a preexisting Indian name. See Thwaites, *Original Journals,* 1:81.

34. Catlin, *Letters and Notes,* 2:16.

35. Ibid., 2:17.

36. For more on Kane, see Harper, *Paul Kane's Frontier;* Bushnell, "Sketches by Paul Kane"; and Kane's own *Wanderings of an Artist.*

37. Catlin, *Letters and Notes,* 1:261–262.

38. Ibid., 1:261. In his castigation of the plains as sterile, Catlin was, of course, echoing the common perception of the region as the Great American Desert. Other than several national grasslands, there is no prairie national park, although the Nature Conservancy's 36,600-acre Tallgrass Prairie Preserve, established in 1989 in Osage County, Oklahoma, was considered as a possibility in the 1980s.

39. Bodmer had studied with his uncle Johann Jakob Meier, a successful Zurich engraver and student of the Swiss-born painter Johann Heinrich Füssli (a.k.a. Henry Fuseli, 1741–1825). Goetzmann, introduction to Hunt and Gallagher, *Karl Bodmer's America,* p. 4.

40. Ibid., pp. 7–10. Catlin had gone back east in 1833 but returned to the West the next year.

41. Maximilian went so far as to publish an article in 1842 disparaging Catlin's work, and Bodmer, who met Catlin in London in the 1840s, once called him a "charlatan" for his unabashedly entrepreneurial promotions of the Indian Gallery on both sides of the Atlantic. See William J. Orr, "Karl Bodmer: The Artist's Life," in Hunt and Gallagher, *Karl Bodmer's America,* p. 362. Apparently Alfred Jacob Miller, who painted some of the same country in 1837, didn't care for Catlin's work either. In 1842 he wrote, "There is in truth . . . a great deal of humbug about Mr. George Catlin. He has published a book containing extraordinary stories and luckily for him there are but few persons who travelled over the same ground." Miller to his brother, London, February 10, 1842, cited by Carol Clark, "A Romantic Painter in the American West," in Tyler, *Alfred Jacob Miller,* p. 51.

42. Catlin, *Letters and Notes,* 1:90.

43. After their return to Europe, neither Bodmer nor the Prince ever visited the United States again. Over the next years the artist himself supervised the translation of his beautiful paintings to the hand-colored aquatint prints that lavishly and faithfully illustrated Maximilian's publication *Travels in the Interior of North America* (1839–1843). Although the book was translated into English, the paintings themselves were not seen in the United States until the 1950s.

44. Maximilian, Prince of Wied, *Travels in the Interior of North America, 1832–1834,* vols. 22–24 of Thwaites, *Early Western Travels.* The prince was also encouraged to focus on North America by his friend and fellow naturalist Fredrick Paul Wilhelm, Duke of Württemberg, who had been one of the earliest and most frequent scientific explorers of the American West, traveling there intermittently from 1822 to 1858. Unfortunately Duke Paul had not had the foresight to employ an artist to accompany him. See Goetzmann, *Exploration and Empire,* pp. 191–193.

45. For all three original translations of the publication (German, French, and English), Bodmer's pictures were bound separately from Maximilian's *Travels* in an accompanying volume titled *Atlas.* The German edition was issued in 1839. Bodmer's American pictures were exhibited in the United States for the first time in 1950, purchased by the Northern Natural Gas Company in 1959, and placed on permanent loan at the Joslyn Art Museum in Omaha. Hunt and Gallagher, *Karl Bodmer's America,* p. 27. The paintings have recently become the outright property of the museum.

46. Specifics about the paintings Miller copied and his subjects while in Europe are discussed in Tyler, *Alfred Jacob Miller,* pp. 12–16.

47. Ibid., p. 19n3, p. 20. This view is shared by Tyler.

48. Ibid., pp. 20–21, 26–27.

49. For Miller's career after his experience with Stewart, see William R. Johnston, "Back to Baltimore," in Tyler, *Alfred Jacob Miller*, pp. 65–76.

50. Irving, *A Tour on the Prairies*, pp. 111–112. Such stories are frequent throughout prairie literature and even occur more than once in Irving's book. See chap. 31, "A Hunt for a Lost Comrade."

51. Miller produced at least eleven versions of this composition, in various media. For more details, see Tyler, *Alfred Jacob Miller*, text accompanying plate 52, and the accompanying catalogue raisonné by Karen Dewees Reynolds and William R. Johnston, pp. 248–249.

52. Catlin, *Letters and Notes*, 1:218.

53. Ross, *West of Alfred Jacob Miller*, facing plate 149.

54. See Barsness, *Bison in Art*. For information on the animal itself, see Dary, "Buffalo in Kansas." Dary reports that by the late 1870s few buffalo remained. In 1889 about 122 of the estimated 1,091 live buffalo were in Kansas. The Union Pacific Railroad kept about 10 on a 240–acre ranch near Lawrence as a tourist attraction. See pp. 338–339.

55. Catlin, *Letters and Notes*, 1:199–200.

56. Miller exhibited them at the Apollo Gallery in New York before they were shipped to Scotland. Tyler, *Alfred Jacob Miller*, pp. 36–39.

57. Tyler, *Alfred Jacob Miller*, p. 36.

58. Miller did not carve the chairs but rather designed them and supervised their production. They have been recently acquired by the Autry Museum of Western Heritage in Los Angeles. I am grateful to the museum's curator, James Nottage, the discoverer of these unique chairs, for showing them to me and sharing their story.

59. Goetzmann, *Exploration and Empire*, pp. 169–171, 231–232. As Goetzmann explains, by the mid-1840s routes through the mountains to California were also established, paving the way for the flood of migration that would come with the discovery of gold in 1849. See pp. 173–177.

60. Belief in the prairies-as-desert theory is difficult to gauge. See Martyn J. Bowden, "The Perception of the Western Interior of the United States, 1800–1870: A Problem in Historical Geosophy," *Proceedings of the Association of American Geographers* 1 (1969): 16–21, cited by Emmons, *Garden in the Grasslands*, p. 5. At the same time, the prevalence of allusions to Long's expedition report, to Gregg's *Commerce of the Prairies*, and other similar sources, underscored by the persistent use of the terms "wastes" and "desert," indicates that the understanding was broad.

61. Parkman, *Oregon Trail*, p. 19. See also Dick, *Conquering the Great American Desert*, esp. pp. 3–19.

62. The literature on this subject is substantial, and a useful study of the artists who appealed most strongly to this constituency is Tyler, *American Frontier Life*.

63. Tuckerman, *Book of the Artists*, p. 425.

64. Ibid., p. 426. See also Carol Clark, "Charles Deas," in Tyler, *American Frontier Life*, p. 52. Clark explores Tuckerman's commentaries about Deas as well as considering his reliability on this question.

65. For an account of the expedition, see Carleton, *Prairie Logbooks*.

66. Harold McCracken states that the *Prairie Fire* now in the collection of the Brooklyn Museum was exhibited in the 1844 exhibition. Since it is dated 1847, this work could not have been the painting he is referring to, but since he did not cite his source I have been unable to resolve the question. McCracken, *Portrait of the Old West*, p. 99.

67. Ibid., p. 53.

68. Preuss, *Exploring with Frémont*, p. 5. Preuss continued, "The ocean has, after all, its storms and icebergs, the beautiful sunrise and sunset. But the prairie? To the deuce with such a life; I wish I were in Washington with my old girl."

69. Ibid., pp. 32, 35, 38. Frémont's attempt at daguerreotypy is reported in Preuss's diary. The final report went through no less than six printings in its early years. It is no secret that Frémont's ghostwriter was his wife, Jessie Benton Frémont. Her prose style contributed significantly to his literary success and his subsequent reputation. Goetzmann, *Exploration and Empire*, p. 248.

70. This inspiration is recounted in Frémont, *Memoirs of My Life*, p. xv. Humboldt devoted a sizable section of volume 2 of *Cosmos* to landscape representation. Other artists who traveled with Frémont were Richard and Edward Kern and their brother, Dr. Benjamin Kern, in 1849. In 1853, along with Carvalho, F. W. von Egloffstein and Max Strobel acted as topographical draftsmen. See Hine, *Edward Kern and American Expansion*. Egloffstein went on to contribute to the Pacific Railroad Survey reports and to participate in later federal surveys. Taft, *Artists and Illustrators*, pp. 258, 262.

71. Although the photographs were brought back east and even rephotographed by Mathew Brady, the plates were destroyed by fire. Engraved prints of the images were commissioned from Philadelphia artist James Hamilton and were apparently finished; Frémont, however, became distracted by his 1856 presidential campaign and the report was never published. See Carvalho, *Incidents of Travel*. For an overview of Carvalho's career, see Sturhahn, *Carvalho*.

72. Carvalho, *Incidents of Travel*, p. 58.

73. *Congressional Globe*, 30th Cong., 1st sess., p. 1011, quoted in Goetzmann, *Exploration and Empire*, p. 266. Goetzmann discusses the surveys on pp. 281–293.

74. The artists were W. P. Blake, Albert H. Campbell, James G. Cooper, F. W. von Egloffstein, Richard H. Kern, Charles Koppel, H. B. Möllhausen, Gustavus Sohon, John Mix Stanley, John C. Tidball, and John Young. See *Reports of Explorations and Surveys*. Many of the plates were printed in color lithography and in steel engraving. Many of the surveys published preliminary reports, some of which were also illustrated. For details of their many versions, variations, and inclusions, see Taft, *Artists and Illustrators*, pp. 254–269.

75. About Richard Kern's work for the Gunnison division of the Pacific Railroad Survey, for example, Taft notes, "Although observations and records were made on the crossing of the plains, the route was already so well-known that all felt the real work of the survey would commence when the Rockies were reached. . . . Probably Kern made sketches, which would be priceless at present of some, if not all, of the points suggested in the above brief review of the crossing of the Plains. They seem no longer to be extant." Taft, *Artists and Illustrators*, p. 259.

76. [Hazen], "Report of the Secretary of War," pp. 235–236.

77. Frémont, *Report of the Exploring Expedition*, p. 23.

78. Stevens wrote, "We ascended to the top of a high hill, and for a great distance ahead every square mile seemed to have a herd of buffalo upon it. Their number was variously estimated by the members of the party—some as high as half a million. I do not think it is any exaggeration to set it down at 200,000. I had heard of the myriads of these animals inhabiting these plains, but I could not realize the

truth of these accounts till to-day, when they surpassed anything I could have imagined. . . . The reader will form a better idea of this scene from the accompanying sketch, taken by Mr. Stanley on the ground, than from any description." Stevens, *Explorations and Surveys,* p. 59.

79. Stanley met Gregg when they both traveled with Col. S. C. Owen's wagon train along the Santa Fe Trail in 1846. Also on this trip was diarist Susan Shelby Magoffin, whose account has become an important example of women's writing of the period. Upon arrival in Santa Fe, some months after the beginning of the Mexican-American War, Stanley became the artist for Kearny's troops, which had just taken the city and were heading to California. Later, in Oregon, Stanley was en route to paint the portraits of Marcus and Narcissa Whitman, only to find out from friendly Indians that they had just been murdered and that his own life was in danger. He escaped and was among the first to report their death. Taft, *Artists and Illustrators,* pp. 10–12. For Stanley's work with Kearny, see Sandweiss, Stewart, and Huseman, *Eyewitness to War,* pp. 143–146.

80. Although it has not survived, this massive work consisted of forty-two episodes, in the form of a giant scroll that was unrolled for viewers at the National Theater in Washington and took two hours to view. An additional dime on top of the admission price would buy the accompanying twenty-three-page booklet entitled *Scenes and Incidents of Stanley's Western Wilds.* Apparently after its showing in the capital it was exhibited in Baltimore, Boston, and London. Taft, *Artists and Illustrators,* pp. 20–21.

81. See Taft, "John M. Stanley and the Pacific Railroad Surveys," chap. 1 in *Artists and Illustrators.*

82. Drumm, *Down the Santa Fe Trail,* p. 10. It must be recognized that for all her enthusiasm, when she wrote this Magoffin had barely begun her journey. Although her attitude is overwhelmingly positive throughout her diary, when the newness wore off she was less susceptible to the charms of prairie life: "Oh how gloomy the Plains have been to me today! . . . We have never had such a perfectly dead level before us as now. The little hillocks which formerly broke the perfectly even view have entirely disappeared. The grass is perfectly short, a real buffalo and Prairie dog and rattle snake region" (p. 47).

83. A case in point is the work of Frederic Church in the late 1850s and 1860s, exotic landscapes that were unconventional in their compositions (especially *Niagara,* 1857, Corcoran Museum of Art) and in their subject matter (as in his tropical and arctic pictures). These paintings, and others like them by artists such as Albert Bierstadt and Thomas Moran, capitalized on the taste for the unusual and were enormously popular.

84. See Groseclose, *Emanuel Leutze,* pp. 60–61, 97.

85. Samuel Bowles reported stopping at Julesburg: "We dropped General Connor, who had been our fellow passenger from Atchison, early Friday morning, at Julesburg, where he has his head-quarters for the summer, and where the Platte River forks, one branch extending north to Fort Laramie and the South Pass through the mountains, and the other marking our southerly line to Denver. Julesburg is only a village of tents and turf forts and barns [sod buildings], affording no facilities for a luxurious military life; but it is well located for General Connor's plans for protecting the commerce of the Plains from the Indians, and for punishing them for their past offenses and present threatenings against it." Bowles, *Across the Continent,* p. 25.

86. Gregg, *Commerce of the Prairies,* pp. 365–366.

87. See Taft, *Artists and Illustrators,* pp. 36–52.

88. Ibid., pp. 41, 47–51. I am grateful to Gerald Carr, Visiting Scholar, University of Delaware, for first bringing the connection of Hays's pictures to my attention and for his generous sharing of information.

89. Niçaise, *Year in the Desert,* p. 46.

90. Tuckerman, *Book of the Artists,* p. 496.

91. Gregg, *Commerce of the Prairies,* pp. 369–370.

92. Richard White, "Animals and Enterprise," in Milner, O'Connor, and Sandweiss, *Oxford History of the American West,* pp. 236–273.

93. Bierstadt in a letter published in *Crayon,* September 1859, p. 287, cited in Anderson and Ferber, *Albert Bierstadt,* p. 72. See also Trenton and Hassrick, *Rocky Mountains,* pp. 116–128, 139–149.

94. The most complete studies of these postwar surveys are Goetzmann, *Exploration and Empire;* Bartlett, *Great Surveys of the American West;* and Rabbitt, *Minerals, Lands, and Geology.*

95. See Rees, *Land of Earth and Sky,* pp. 10, 70–73; and Samuels and Samuels, *Encyclopedia of Artists,* pp. 227–228.

96. Jackson, *Time Exposure,* pp. 119–120.

97. For Jackson's career, see Hales, *William Henry Jackson.* For Jackson's work in Yellowstone, particularly in regard to his close relationship with painter Thomas Moran, see Kinsey, *Thomas Moran,* pp. 49–67.

98. Jackson remained with the Hayden survey until 1879, when it was reorganized along with the other three Great Surveys into the United States Geological Survey. At that point Jackson set up a private studio in Denver and worked as a commercial photographer, doing a great deal of his work for the Denver and Rio Grande Railroad.

99. Hales, *William Henry Jackson,* p. 33.

100. For *Graves of Travellers, Fort Kearney, Nebraska,* see Sweeney, *Themes in American Painting,* pp. 22–23; and Sweeney's more recent *Masterpieces of Western American Art,* pp. 67–69.

101. Whittredge produced more than forty oil sketches and studio paintings of the West, but most include mountains in the composition. Janson, *Worthington Whittredge,* pp. 111–129.

102. Whittredge, *Autobiography,* p. 45.

103. The best source for information on Tavernier remains Taft, *Artists and Illustrators,* pp. 95–116. Taft carefully lists all the illustrations from the trip, which were published in *Harper's Weekly* from 1873 to 1876, and documents in great detail the itinerary of the men. Tavernier had fought in the Franco-Prussian War but was apparently exiled as a Communist and emigrated to the United States. Once in California he stayed in San Francisco until 1884, when he fled to Hawaii to escape creditors. See also Samuels and Samuels, *Encyclopedia of Artists,* pp. 478–479.

104. "Go Ahead," in *Davy Crockett's Almanack.*

105. See Bernard Reilly, Jr., "The Prints of Life in the West, 1840–1860," in Tyler, *American Frontier Life,* pp. 167–192, and most especially Tyler, *Prints of the West.*

106. Warder H. Cadbury, "Arthur F. Tait," in Tyler, *American Frontier Life,* p. 111.

107. McCracken, *Portrait of the Old West,* p. 128.

108. Winthrop to Church, April 25, 1857. Frederic Church Papers, Letters Received, Olana State Historic Site, Hudson, New York.

1. More often sod house roofs had minimal timber frames, with either pole undersheathing or rough-hewn planks, which were then covered with sod. They usually leaked rather badly, and when a family could afford imported lumber, they roofed the house properly, as seen here. At the same time, however, sod-roofed houses were well insulated, and flowers bloomed on them in springtime. One woman recalled that her mother was "always throwing flower seed up on our roof; they would bloom out in damp weather." Welsch, *Sod Walls*, p. 88.

2. Cover is known for only this single painting. It is generally assumed that she was a homesteader who claimed land in Nebraska in the 1870s or 1880s.

3. During the 1870s Nebraska's population grew from approximately 123,000 to nearly half a million, and by 1890 that figure had doubled. Kansas increased its numbers even more dramatically. Athearn, *In Search of Canaan*, p. 4. See also Zabel, "To Reclaim the Wilderness." For information on the Homestead Act, see Beezley, "Homesteading in Nebraska"; and for the Timber Culture Act, see Williams, "Trees but No Timber." The Preemption Law of 1841 allowed surveyed land to be purchased for $1.25 per acre. Land could also be aquired with military bounty land warrants provided to veterans, or could simply be purchased from existing landowners. The Homestead Act gave away unsold land in 160-acre parcels; claimants could acquire additional land with a timber claim or by purchase through the Preemption Law. The only price on homesteaded land was a $10 filing fee and living on and improving the land for five years; it was ten years on a timber claim, but without the residency requirement.

4. Fencing was a serious problem for western prairie farmers. At first horses and cows were simply hobbled or tethered to picket pins that were easily moved to fresh grass, but as settlers acquired hogs and chickens, new solutions were required. Nothing was completely satisfactory until barbed wire was invented in the 1870s, but many options were tested, from sod walls to hedgerows of prickly osage orange trees. See Dick, "Fences," in *Conquering the Great American Desert*, pp. 82–92.

5. Whittredge, *Autobiography*, p. 46. Whittredge's comment is striking for its contradiction of the prevailing perception of the plains and also because it is exactly the opposite of the assessment by General Pope, with whom Whittredge traveled in 1866.

6. This is discussed in innumerable sources; see, for example, C. Howard Richardson, "Nebraska Prairies."

7. Special plows and attachments to standard plows became available to cut even lengths and thicknesses of sod for building. In addition to that expense, sod houses were usually not entirely without cost, because precut lumber, doors, windows, hinges, and stoves would be purchased to fit them out. Dick, "Sod Construction," in *Conquering the Great American Desert*, pp. 21–48; Welsch, "Nebraska Soddy."

8. See Broehl, "Plow That Broke the Prairies"; and Broehl, *John Deere's Company*.

9. Windmills had been produced in the East since at least the 1850s, but it was not until the early 1870s that midwestern manufacturers began large-scale distribution in the prairie plains region. Webb, *Great Plains*, pp. 333–341; Baker, "Irrigating with Windmills"; and Sageser, "Windmill and Pump Irrigation." Fences of various sorts were patented in record numbers after the Civil War. Although many different styles were proposed, Joseph F. Glidden, a farmer in DeKalb, Illinois, claimed to have invented barbed wire in 1874. See Webb, *Great Plains*, pp. 280–318, and Dick, *Conquering the Great American Desert*, pp. 82–92.

10. The Nebraska State Historical Society maintains a vast collection of Butcher's photographs. For more on Butcher, see Carter, *Solomon D. Butcher.* The results of the photographer's labors, although not his entire pictorial oeuvre, are found in Butcher, *Pioneer History of Custer County.*

11. Carter, *Solomon D. Butcher*, pp. 12–14.

12. Sarah Smith, Fairview, Nebraska, to her sister, January 29, 1875, cited in Welsch, *Sod Walls*, pp. 131, 133.

13. Sod corn was planted by hand, with an ax. Because the sod was so dense with prairie grass roots, it did not crumble after being broken with the plow but rather sat in thick furrows. The farmer would hack into this with his ax, to be followed by another family member, who would drop in three or four kernels and stomp on the incision to close it. The great advantage of the first year was that the corn needed no cultivating and thus no attention until it was ready for harvesting. In subsequent years, the pliability of the soil invited weeds and required more work to produce a good crop. Dick, *Conquering the Great American Desert*, p. 298.

14. Manley, "In the Wake of the Grasshoppers"; and Dick, *Conquering the Great American Desert*, pp. 191–215. The grasshopper crisis in 1874 was exacerbated by the general panic of 1873, in which the national economy bordered on a depression.

15. The literature on this subject is vast. See for example Henry Nash Smith, "The Garden and the Desert," chap. 16 in *Virgin Land;* and more recently Allen, "Garden-Desert Continuum." Perhaps the most comprehensive source, although focused on Nebraska, is Dick, *Conquering the Great American Desert.*

16. The Nebraska Immigrant Association, for example, was established in 1864. See Emmons, *Garden in the Grasslands;* and Zabel, "To Reclaim the Wilderness," p. 323. Samuel Bowles is just one of many journalists who traveled and was courted by railroads to promote the regions through which their lines ran. See my discussion of some of these arrangements in *Thomas Moran*, pp. 68–92.

17. Henry Nash Smith, *Virgin Land*, p. 175.

18. Regarding the tax law, see Dick, *Conquering the Great American Desert*, p. 118, citing *Laws, Joint Resolutions, and Memorials Passed at the Seventh Session of the Legislative Assembly of the Territory of Nebraska . . . 1860* (Nebraska City: Thomas Morton, 1861), p. 45. For the nickname, see Dick, *Conquering the Great American Desert*, p. 129. Dick also notes, with some amusement, the remarkably harsh penalties for cutting trees in Nebraska after the Civil War. His entire chapter, "Trees," pp. 116–140, makes entertaining and informative reading about this and other nuances of the complex tree culture in the western prairies.

19. The area consisted of 206,000 acres. See Dick, *Conquering the Great American Desert*, pp. 129–132.

20. Farnham, *Life in Prairie Land*, pp. iii–iv; 76.

21. Morton, in an address to the Horticultural Society in Lincoln, Nebraska, January 4, 1872, cited in James Olson, "Arbor Day," p. 9. Arbor Day was established in Nebraska in 1872 by the State Board of Agriculture. It was decreed an annual event in 1874 and officially recognized and made a legal holiday by the state legislature in 1885. See also Dick, *Conquering the Great American Desert*, pp. 122–124.

22. U.S. Congress, House, "Report of Secretary of War John B. Floyd," in *Documents of the House of Representatives*, 35th Cong., 2nd sess., serial 998 (Washington, D.C.: James B. Steedman, printer, 1858), p. 641.

23. Henry Nash Smith, "Rain Follows the Plow." For an extended treatment of prairie boosterism, see Emmons, *Garden in the Grasslands*, and Dary, "The Selling of the Great American Desert," chap. 11 in *Entrepreneurs of the Old West.*

24. Gregg, *Commerce of the Prairies,* p. 362.

25. Spearman, "Great American Desert," p. 244.

26. Wilber, *Great Valleys and Prairies,* p. 68.

27. Gilpin's most famous book is *Mission of the North American People,* but see also his *Central Gold Region,* p. 120.

28. Crofutt described the work in great detail, concluding, "This picture as the design of the author of the *Tourist*—is National, and illustrates in the most artistic manner, all those gigantic results of American brains and hands, which have caused the mighty wilderness to blossom like the rose." Crofutt, *New Overland Tourist and Pacific Coast Guide,* annex p. 1.

29. Crofutt's first guidebook was titled simply *Great Transcontinental Railroad Guide,* and the title changed regularly with each substantial edition. For a complete listing of these as well as more on Crofutt's work, see Fifer, *American Progress.*

30. Charles Russell Lowell, cited in Overton, *Burlington West,* p. 159. *Dairy and Farm Journal* of West Liberty, Iowa (January 1883), cited by Dick, *Conquering the Great American Desert,* p. 177. For more on the efforts of some railroads in promoting interest in western land through art and publications, see my *Thomas Moran,* chaps. 4, 5, 7–9.

31. There are many studies of the transcontinental railroad, but for an excellent, focused examination of its impact on settlement, see Combs, "Union Pacific Railroad."

32. Waud was an important illustrator for *Harper's Weekly* during the Civil War and afterward in the West. Biographers Peggy and Harold Samuels speculate that Waud derived his view for *Building the Union Pacific* from a photograph, but offer little explanation. In any event, he did travel into Nebraska in 1868 and continued to produce similar scenes for *Harper's,* including a series from the Dakotas as late as the early 1880s. Samuels and Samuels, *Encyclopedia of Artists,* pp. 513–514.

33. Crofutt, *New Overland Tourist,* p. 32.

34. El Comancho (Walter Shelley Phillips), *The Old Timer's Tale* (Chicago: Canterbury Press, 1929), p. 7, cited in Dick, *Conquering the Great American Desert,* p. 218.

35. Bowles, *Across the Continent,* pp. 12–13.

36. Ibid., pp. 14–15.

37. Ibid., pp. 18–19.

38. Although it contained many interesting commentaries about what was already a familiar trip, Bowles's *Across the Continent* was a thinly disguised promotion of the transcontinental railroad and its feasibility, and of the development that would occur once the route was completed. See esp. p. 273.

39. For more on town development, see Dary, *Entrepreneurs of the Old West,* esp. chap. 12, "The Business of Towns," pp. 249–266; and Hudson, *Plains Country Towns.*

40. Gardner was one of the principal photographers of Mathew Brady's photographic corps and as such became one of the most important documenters of the Civil War. See Walther, "Landscape Photographs."

41. Nichols, her husband, and their sons staked a claim about twenty miles from town. Gambone, "Forgotten Feminist of Kansas."

42. Reps's numerous books on the subject are unparalleled in their thoroughness, their numerous primary references, and their reproduction of early printed town views. See especially his *Cities on Stone, Forgotten Frontier, Town Planning in Frontier America,* and, the most monumental, *Views and Viewmakers.*

43. For more on the grid system as applied to the United States territories, see Hildegard Johnson, *Order upon the Land.*

44. Butcher, *Pioneer History of Custer County,* pp. 339–342, 364. It should be recognized that Comstock, at the time Butcher photographed it, was the newest town in Nebraska. Many others were, of course, older and therefore much more monumental by 1904.

45. Wister, *Virginian,* p. 12.

46. Stevenson, *Across the Plains,* p. 50.

47. Humphrey, *Following the Prairie Frontier* (Minneapolis, 1931), p. 9, cited in Hine, *Community on the American Frontier,* p. 94.

48. Bowles, *Across the Continent,* p. 24.

49. Schilissel, *Women's Diaries,* pp. 112–113.

50. Pennell was photographer Albert Southworth's schoolmate and a pupil of Samuel F. B. Morse's. Records have him ordering photographic equipment in Charleston, where he taught at a private school. Sturhahn, *Carvalho,* p. 6.

51. See Thompson, Huseboe, and Looney, *Common Land;* Center for Great Plains Studies, *Ethnicity on the Great Plains;* Hine, *Community on the American Frontier;* and Shortridge, "Heart of the Prairie."

52. I know of no black prairie landscape artists of this period. For a discussion of some women artists in the Great Plains, see my essay "Cultivating the Grasslands: Women Painters in the Great Plains," in Trenton, *Independent Spirits.*

53. Isaksson, *Bishop Hill.* Bishop Hill was founded in 1846 and its community formally dissolved in 1860. It remains today an important historic site in central Illinois. For more on the colony, see Mikelsen, "Bishop Hill Colony," pp. 5–80.

54. Mikelsen, "Bishop Hill Colony," p. 54. Although the colony's early efforts were manual, as Krans reveals, the Jansonites did mechanize as soon as possible, buying their first harvester in 1849. See p. 107.

55. Carter, *Solomon D. Butcher,* p. 43.

56. My source for this statistic is Luchetti and Olwell, *Women of the West,* p. 45. The forces behind and the development of this early black migration into the prairies were complex. For more on the subject, see Katz, *Black West,* Pease and Pease, *Black Utopias,* Athearn, *In Search of Canaan,* and Painter, *Exodusters.* Athearn reports that in 1860 Kansas had a population of 625 free blacks and two slaves. In 1870 the freedmen numbered 17,108, and by 1880 the figure had risen to 43,107. See p. 75. For a discussion of black towns in Oklahoma, see Mozell Hill, "The All-Negro Communities of Oklahoma," *Journal of Negro History* 31 (July 1946), cited in Hine, *Community on the American Frontier,* pp. 178–179; see also pp. 194–196.

57. It is interesting, although not surprising, that in Butcher's *Pioneer History of Custer County* the section on Westerville makes no mention of blacks in Nebraska. Pp. 214–218.

58. *Missouri Republican* (St. Louis), March 15, 1879, cited in Athearn, *In Search of Canaan,* p. 18.

59. Lawrence had been founded only a short time before by the New England Emigrant Aid Company, an abolitionist group that sought to fill the territory with antislavery sentiment. Nichols, her husband, and their sons staked a claim about twenty miles from town. Nichols, letter to the *Springfield Daily Republican,* January 8, 1855, cited in Gambone, "Forgotten Feminist of Kansas," p. 41.

60. See discussions of these problems throughout Athearn, *In Search of Canaan.*

61. Discussion of women in the prairies and plains has been more extensive

among historians and literary scholars than among art historians. See, for example, Kolodny, *Land before Her*; Jeffrey, *Frontier Women* and "There Is Some Splendid Scenery"; Riley, *Female Frontier*; Fairbanks, *Prairie Women*; Luchetti and Olwell, *Women of the West*; and Stratton, *Pioneer Women*. The contributions of women artists in the American West (although not necessarily landscape views of the West) are examined in Trenton, *Independent Spirits*.

62. Many of Nichols's papers are reprinted in Gambone, "Forgotten Feminist of Kansas," serialized in eight parts in the *Kansas Historical Quarterly* beginning in 1973. This passage is from part 2 (Summer 1973), pp. 221–222. Nichols (1810–1885) was quite eloquent in her reactions to the prairie landscape. "But to Kanzas itself. At first let me say with emphasis,—my highest anticipations of the country—its soil, its natural facilities, its climate—are realized. I did not like Illinois, with its flat prairie and accompanying swamp. I was not pleased with Missouri, as seen from the river. Kanzas City where our party landed is in Missouri, five miles from the territorial line. It is a home-sick place, as my eye ever rested upon—We were all in haste to get away, and when we emerged from the forest border—prairie on our left, on our right a line of forest both extending as far as the eye could see, the change was expressly grateful. Kanzas passed before me—*Wisconsin* in all the beautiful natural features which attracted me to that noble state.—Kanzas has fewer streams, but more springs than Wisconsin; and in the whole distance from the Missouri line to this place I saw no sign of swamp or slough. The air is soft and warm." Part 1 (Spring 1973), p. 32.

63. Butcher, *Pioneer History of Custer County*, p. 370, and Carter, *Solomon D. Butcher*, p. 44.

64. The law required that homesteaders build a dwelling and live on their land for six months out of a year for five years in order to "prove up" and qualify for ownership. There were many ingenious ways of getting around this, not all of which were legal. Among the more inventive were the placing of miniature houses on the claim while the homesteader lived elsewhere most of the time, and the building of a single house on the property line, with beds on each side. In that situation both homesteaders could thus truthfully say that they "lived and slept" on their own land.

65. Little is known of Cover's life, but for more on her, see Truettner, *West as America*, pp. 227–228, 351.

66. Bowles, *Across the Continent*, p. 8.

67. Cooper uses the image three times in chap. 4: "Profiting by the high fog which grew in the bottoms, they had worm'd their way through the matted grass, like so many treacherous serpents stealing on their prey"; "the wily snake is not more certain or noiseless than was his approach." Cooper, *Prairie*, pp. 49–50, 53. "Kaufmann" is also spelled "Kauffman" in some sources.

68. Originally constructed for the Corn Palace Exposition, which was intended to rival similar festivals in neighboring cities (Sioux City, Iowa, and Plankinton, South Dakota, especially), the Corn Palace in Mitchell has been the site of numerous fairs, concerts, and other social activities over the years. The present Corn Palace is the third such structure in that town and is touted as the only surviving example of this uniquely American form of vernacular architecture. Apart from a foyer gallery (with photographs of each Corn Palace since 1892) and large corn murals, its interior is essentially a modern sports arena. The exterior, however, while also structurally modern, is annually redecorated with the traditional grains of the region. *World's Only Corn Palace*.

69. *Grand Island Daily Independent*, August 20, 1890, cited in Dick, *Conquering the Great American Desert*, p. 153.

70. Most of the major railroads that ran through the central agricultural region had special cars dressed out as rolling museums. One example was the Northern Pacific train billed as a "Fair on Wheels," which in 1882 made a tour from Minneapolis through several cities and towns. Visited by more than 400,000 people, it displayed fruits, grains, minerals, stuffed animals, timber products, and potted plants, all products of the territory through which the railroad ran. For photographs of one of these cars, see Nolan, *Northern Pacific Views*; or Kinsey, *Thomas Moran*, p. 74.

71. Spearman, "Great American Desert," pp. 243–244.

72. Richter, *Sea of Grass*, pp. 3–4.

73. Garland, *Son of the Middle Border*.

74. For more on the phenomenon, see Weber, *Midwestern Ascendancy in American Writing*, and of course Thacker, *Great Prairie Fact*.

75. George William Curtis, *Lotus-Eating: A Summer Book* (1852), cited in Thacker, *Great Prairie Fact*, pp. 121–122.

76. Elizabeth Tuttle Holsman taught at the University of Nebraska in 1893. Already by that time the school had a long tradition of fostering careers in painting for women, both as faculty members and as students. Holsman also continued her own studies at the Art Institute of Chicago in 1898. *Still Waters* won a prize at the second annual Northwestern Artists Exhibition in Saint Paul in 1916. See Gerdts, *Art across America*, 2:310; and my own "Cultivating the Grasslands: Women Painters in the Great Plains," in Trenton, *Independent Spirits*, pp. 242–273.

77. Eliza Swift, "On the Prairie," 1917, quoted in Garner, *Reclaiming Paradise*, p. 16.

78. Charles Theodore Greener was from Faulkton, in north-central South Dakota. He studied at the University of North Dakota at Grand Forks and then at Galesburg, Illinois, Boston, Cincinnati, and Minneapolis. He, like Elizabeth Holsman, exhibited at the Northwestern Artists Annual Exhibition in Saint Paul in the 1910s. See Gerdts, *Art across America*, 3:83; *Charles Greener Paintings*; and Stuart, *Art of South Dakota*, pp. 23, 40.

79. In his *Pioneer History of Custer County*, Solomon Butcher reproduced one of his photographs that depicts an even smaller girl, surrounded by enormous pumpkins, squashes, and gourds. His title is *Custer County's Best Crop*. See p. 142.

80. See William T. Anderson, "Plowing and Painting the Prairie."

81. Stuart, *Art of South Dakota*, pp. 21–22, 39.

82. Butcher, *Pioneer History of Custer County*, p. 370.

4 · REGIONAL RECONCILIATIONS, 1920–1940s

1. Studies on the American Scene movement, on Regionalism, and on the various federal programs that fostered it are numerous. A few of the most comprehensive include Baigell, *American Scene*; Heller and Williams, *Regionalists*; Park and Markowitz, *Democratic Vistas*; and Marling, *Wall to Wall America*. Baigell particularly makes rather strong distinctions between Regionalism and Social Realism as movements within the American Scene emphasis of the 1930s, but because the Regionalists were the most dominant artists of that time in the prairie states, I am using that term to discuss them.

2. For more on Wood, see Corn, *Grant Wood*; and Dennis, *Grant Wood*. For Hogue, see DeLong, *Nature's Forms*; and Stewart, *Lone Star Regionalism*.

3. Hogue wrote to Thomas M. Beggs on February 8, 1946, about *Crucified Land,* "The red soil from the area south of Denton was chosen as in keeping with the symbolical meaning of the land crucified. This is an abandoned field once farmed by the guy who plowed downhill, inviting water erosion to eat through the rows. All furrows point to the tractor which represents man's misuse of the land. . . . The rain at the upper left has just passed, leaving everything wet and glistening and leaving the overalls on the scarecrow hugging tight to the 2 x 4 support which thus becomes a dominant cross. . . . The whitish-green needle grass moves in and takes over where the soil is depleted." Quoted in DeLong, *Nature's Forms,* p. 130.

4. *Crucified Land* was first exhibited in the Carnegie International Exhibition of 1939, where it was hailed as one of Hogue's "series of sermons on conservation." "Paintings in International Art Show Reflect World Turmoil," *Pittsburgh Post-Gazette,* October 19, 1939, cited in DeLong, *Nature's Forms,* p. 130. For information on Iowa's circumstances during the Depression, see Sage, "Rural Iowa," and Wall, "Iowa Farmer in Crisis."

5. *Cultivator and Country Gentleman* 56 (April 23, 1891), cited in Emmons, *Garden in the Grasslands,* p. 166.

6. David Danbom, *Resisted Revolution,* pp. 3–50, esp. pp. 36–37. Oklahoma was granted statehood in 1907.

7. Ibid., pp. 120–121, 132–136.

8. [Edward O. Moe and Carl C. Taylor], *Culture of a Contemporary Rural Community: Irwin, Iowa* (Washington, D.C.: USDA, Bureau of Agricultural Economics, December 1942), p. 10, cited in Danbom, *Resisted Revolution,* p. 133.

9. Athearn, *Mythic West,* esp. chaps. 5 and 6, "The Dreaming Is Finished" and "Colonialism: The Enduring Dilemma."

10. Rölvaag, *Giants in the Earth,* p. 249.

11. Although the development of Hogue's conception for *Mother Earth* seems clear from his statements and drawings, it is also intriguing to speculate that he might have seen Arthur Rothstein's very similar photograph that appeared in Nixon, *Forty Acres and Steel Mules,* facing p. 79, identified only with the caption "Through repeated crops of cotton, the soil of this Alabama farm has been 'sold in annual installments.'" The photograph does not, of course, contain the overtly gendered symbolism of Hogue's painting, but both share the prominence of the plow in the foreground and the billowy eroded landscape behind.

12. Gendered references to the earth are age-old. "Virgin land," "Mother Earth," "husbanding the land," and "raping the land" are only a few of the most common metaphors.

13. Hogue to Boyer Galleries, August 31, 1938, cited in DeLong, *Nature's Forms,* p. 7.

14. These are illustrated in DeLong, *Nature's Forms,* pp. 120–123.

15. Hogue interview with DeLong, July 1980, cited in DeLong, *Nature's Forms,* p. 19.

16. Kolodny, *Lay of the Land;* Henry Nash Smith, *Virgin Land.*

17. Wood painted the picture for the Iowa State Fair, and at its close Marshall Fields III purchased the work. Deere and Company acquired the picture from the Field collection in 1966. I am grateful to Lawrence Jonson, curator of the Deere Art Collection, for his correspondence with me about this painting. *Fall Plowing's* appeal for the corporation seems obvious enough, but it is interesting that the implicit promise of Wood's painting had a direct relevance to the company's contemporary marketing strategy. In July 1931 the comptroller T. F. Wharton wrote to Charles Wiman, enclosing a *Chicago Journal of Commerce* article that said, "A thing that is bought or sold has no value unless it contains that which cannot be bought or sold. Look for the Priceless Ingredient." Wharton wrote, "This applies to John Deere. It is up to us to keep together this organization that puts the quality in John Deere goods, and provides this Priceless Ingredient." Wiman replied, "That's true—but the 'Priceless Ingredient' must not cost too much or no one can afford to buy it." Broehl, *John Deere's Company,* pp. 517–518.

18. Two members of the distinguished Iowa farm family published *Wallaces' Farmer:* Henry C. Wallace was the secretary of agriculture under Harding, and Henry A. Wallace took the job under Franklin Roosevelt. Henry A. worked with Hoover in food relief efforts after World War I. He went on to become vice president during FDR's third term (1941–1945).

19. Hogue's own view would have supported this last speculation. He was quite pointed in his criticism of mishandling of the land.

20. Bonnifield reports that in 1915 there were approximately 3,000 tractors in Kansas; by the beginning of the Depression there were 66,275, and that number only increased throughout the 1930s. Bonnifield, *Dust Bowl,* p. 49.

21. A thorough history of the development and marketing of the plow and its successors in the prairies is found in Broehl, *John Deere's Company.* Rothstein took a course from economist Roy Stryker at Columbia University in 1934; when his teacher became interested in his photographs, they collaborated, with Rothstein illustrating Stryker's book on agriculture. From that association, Rothstein was the first artist Stryker hired when he became head of the Resettlement Administration (later the FSA). In 1940 Rothstein signed on with *Look* magazine, but when the United States entered the war, he became a photographer for the Army Signal Corps in the Pacific. After the war he returned to *Look,* where he directed the publication's photography until 1971. He was one of the founders of the American Society of Magazine Photographers and an associate editor of *Parade Magazine* from 1972 until his death.

22. Merritt Mauzey was raised on a cotton farm in Nolan County, Texas. He worked in the cotton industry for many years, first as a farmer, then as a clerk for a small cotton company in Sweetwater, then for a cotton exporter in Dallas. There he studied at the Dallas Art Institute and exhibited for the first time at the Texas Centennial Exposition. He was a founding member of the Lone Star Printmakers and devoted much of his later career to lithography; he won a Guggenheim Fellowship in 1946 and wrote and illustrated six children's books. Stewart, *Lone Star Regionalism,* pp. 114–115. For more on Mauzey's work, see Tracy, *Catalogue of the Merritt Mauzey Collection.*

23. Worster, *Rivers of Empire,* pp. 156–169, 173.

24. For an extensive and detailed discussion of these techniques, see Dick's chapters "Dry Farming" and "Irrigation," in *Conquering the Great American Desert,* pp. 355–417; and Bonnifield, *Dust Bowl,* pp. 40–43.

25. Dick, *Conquering the Great American Desert,* pp. 365–366. See also *Campbell's 1907 Soil Culture Manual.*

26. John L. Cowan, "Dry Farming: The Hope of the West," *Century Magazine* 72 (July 1906): 444–446, cited in Dick, *Conquering the Great American Desert,* p. 371.

27. The boundaries of the Dust Bowl are debatable. In 1935 journalists located it within the five-state junction where the panhandles of Texas and Oklahoma border southwestern Kansas, southeastern Colorado, and northeastern New Mexico. The following year the soil conservation reconnaissance limited it to twenty coun-

ties of the area, excluding New Mexico. In 1934, however, dust storms had been serious enough even in the humid corn-belt states of Iowa and Wisconsin to drift plowed fields. See Bonnifield, *Dust Bowl,* pp. 2–3, 59, 70.

28. Edwin Rosskam, postscript to Anderson, *Home Town,* p. 144.

29. Tugwell, Munro, and Stryker, *American Economic Life.* Stryker's project was part of the Resettlement Administration from 1935 to 1937, under the FSA from 1937 to 1942, and then within the Domestic Operations branch of the Office of War Information. See Hurley, *Portrait of a Decade;* Fleischhauer and Brannan, *Documenting America,* pp. vii, 2–5. Recent attention to the FSA photographs has been intense. For another excellent study with a sizable bibliography, see Daniel et al., *Official Images.*

30. See Fleischhauer and Brannan, *Documenting America,* p. 1119. One of the most interesting discussions of the methods Stryker used to inspire and instruct his photographers is found in Ganzel, *Dust Bowl Descent.* Ganzel, a photographer, has made a "rephotographic survey" of many of the FSA photographs.

31. Jacobsen, "Time and Vision," p. 16. For more on the dual nature of the FSA photographs and the care with which they should be read, see Lawrence W. Levine, "The Historian and the Icon: Photography and the History of the American People in the 1930s and 1940s"; and Alan Trachtenberg, "From Image to Story: Reading the File," both in Fleischhauer and Brannan, *Documenting America,* pp. 15–42 and 43–73.

32. Lange is one of the most famous of the FSA photographers, and much has been written about her and her work. For a sizable bibliography, as well as a useful biography, see Ohrn, *Dorothea Lange.*

33. Homer to Senator Arthur Capper, December 17, 1938, Agriculture, General Correspondence folder, Box 32, Arthur Capper Papers, Kansas State Historical Society, Topeka, cited in Beddow, "Depression and New Deal," pp. 142–143. Such complaints or observations about mechanization are ubiquitous. *Dallas Farm News,* for example, published letters throughout the Depression: "Each tractor means from one to three farmers on WPA or other government job at starvation wages. There are thousands of families that have been driven from the farm who would rather farm than do anything else, but there isn't any land to rent. Why not? The tractor farmer has rented or leased it all." February 7, 1939, cited in Lange and Taylor, *American Exodus,* p. 71.

34. Lange and Taylor, *American Exodus. Tractored Out* was photographed in Childress County, in the Texas panhandle. Another contributor to the displacement of tenant farmers was, ironically, early New Deal programs that encouraged farmers to idle some of their land to alleviate overproduction and consequently to raise prices. The Agricultural Adjustment Administration, for example, paid farmers to let fields lie fallow. This benefited landowners but severely hurt tenant farmers and sharecroppers, who depended on that production for their livelihood. See Fleischhauer and Brannan, *Documenting America,* p. 2.

35. Nixon, *Forty Acres and Steel Mules,* p. 6. Nixon was director of the Louisiana Rural Rehabilitation Corporation, and his book is devoted to agricultural problems in the South, but the challenges of mechanization were felt throughout the prairie region as well.

36. Lange and Taylor, *American Exodus,* p. 75. Taylor was a labor economics professor at Berkeley in the 1930s. For more on his work, see his book *On the Ground in the Thirties.*

37. Morris, *Home Place,* p. 132.

38. Gerald Nemanic and Harry White, "Interview with Wright Morris," *Great Lakes Review* 1 (Winter 1975): 7, cited in Jacobsen, "Time and Vision," p. 16. See also Alinder, *Wright Morris,* and Phillips and Szarkowski, *Wright Morris.*

39. Although the rise of the oil culture on the southern plains has been written about extensively, for its relationship specifically to the landscape and people of the Dust Bowl area, see Bonnifield, *Dust Bowl,* pp. 30–38, 98–102.

40. See Bonnifield, *Dust Bowl,* pp. 84–86.

41. See Rothstein's *Corn Withered by Heat and Chewed by Grasshoppers, Terry, Montana* (1939, Library of Congress).

42. Condra was a state geologist and director of conservation and survey at the University of Nebraska. In 1929 his office began a study of the state's water resources, especially of ground water, and throughout the 1930s, 1940s, and early 1950s he supervised the project, which included photographs such as Hufnagle's. They are in the Condra Collection at the Nebraska State Historical Society.

43. Rölvaag, *Giants in the Earth,* pp. 344, 349.

44. Schwieder and Fink, "Plains Women," p. 81.

45. For more on this subject, see Bonnifield's chapter "1930s Weather," in *Dust Bowl,* pp. 61–86.

46. Joe Jones lived much of his life and produced many works in Saint Louis. The Saint Louis Art Museum owns a number of his paintings. Little has been written about this important artist, but for more, see Iarocci, "Changing American Landscape"; and Marling, "Joe Jones" and "Workers, Capitalists, and Booze."

47. Corn, *Grant Wood,* p. 108.

48. Bachelder, address in *Journal of the Proceedings of the Forty-Second Annual Session of the National Grange of the Patrons of Husbandry, Washington, D.C., 1908* (Concord, N.H.: Rumford Printing, 1908, p. 11, cited in Danbom, *Resisted Revolution,* p. 21.

49. J. C. Gerrond to Kansas representative Clifford Hope, January 6, 1935, General Correspondence (1932–1933) folder, Box 11, Clifford Hope Papers, Kansas State Historical Society, Topeka, cited in Beddow, "Depression and New Deal," pp. 143–144.

50. See also Dennis, *Grant Wood,* p. 227; and Cummings, *Twentieth-Century Drawings,* p. 53.

51. Curry first received acclaim in 1928 when *Baptism in Kansas* was exhibited at the Corcoran Gallery. It was admired in the *New York Times* and then purchased by the Whitney Museum of American Art shortly after its exhibition. A student of Harvey Dunn's, Curry began his career as a commercial illustrator.

52. Cone, a native of Cedar Rapids, Iowa, was a lifelong friend of Wood's. They sketched together, went to Paris together in 1920 (Cone had served in France during World War I), where they sketched on their own outdoors and on rainy days in the museums, and later worked to establish the Stone City Art Colony. Cone taught for many years at Coe College in Cedar Rapids. Dennis, *Grant Wood,* pp. 61–63; Czestochowski, *Marvin D. Cone* and *Marvin D. Cone and Grant Wood.*

53. Curry started his studies at the Kansas City Art Institute and the Chicago Art Institute (1916–1918) and then moved to Leonia, New Jersey, in 1919 to study with South Dakotan Harvey Dunn. Although he visited his family in Kansas, he lived the rest of his life in the East. In addition to *Spring Shower,* Curry's *Sunrise* (1934) and *Morning* (1936–1941), as well as a number of drawings and studies, were inspired by the scenery of the Heart Ranch. See Schmeckebier, *John Steuart Curry's Pageant,* pp. 135–136, 143–149.

54. The post office murals and other commissions in the Section of Painting and Sculpture were decided by competition; artists would submit their works anonymously to be selected by the local jury. The other programs were the Public Works of Art Project (PWAP) of 1933–1934, the Federal Arts Project (FAP) 1935–1943, and the Treasury Relief Art Projects (TRAP) 1935–1939. For more on the section, see Park and Markowitz, *Democratic Vistas,* pp. 6–7, 12–13. This source also lists the section's murals and sculptures by state in its appendix. Photographs of many of these works, if not all, are found in the National Archives in Washington.

55. Jones to Watson, August 17, 1939, Anthony, Kansas, General Services Administration, cited in Park and Markowitz, *Democratic Vistas,* p. 49. Jones painted four post office murals altogether; they include *Turning a Corner* in Anthony, Kansas, and *Harvest* in Charleston, Missouri.

56. "Head of Art Class in Old Court House Will Oppose Ouster," *Saint Louis Post Dispatch,* December 14, 1934. I am grateful to my former graduate student Louisa Iarocci, whose excellent seminar paper on Jones led me to much of this information.

57. Jones's murals are reproduced in Park and Markowitz, *Democratic Vistas,* p. 159; Marling, *Wall to Wall America,* p. 122; and Baigell, *American Scene,* p. 48. The 905 liquor stores commissioned a total of twenty-four murals from various artists. The murals were apparently removed to a warehouse in 1946 and were rediscovered in 1984 when the company went out of business. Twenty-two of the murals are presently in the collection of the Haggerty Museum of Art in Milwaukee. See Iarocci, "Changing American Landscape," p. 73; and Marling, "Workers, Capitalists, and Booze."

58. By 1938 Jones had begun moving away from his former political radicalism. He married Grace Adams Mallincrodt, the former wife of the pharmaceutical millionaire, and moved east permanently, settling in New Jersey. Iarocci, "Changing American Landscape," p. 74.

59. Excellent monographs exist for all these artists. To name but a few, see Henry Adams, *Thomas Hart Benton;* Kendall, *Rethinking Regionalism;* Corn, *Grant Wood;* Dennis, *Grant Wood;* Czestochowski, *Marvin D. Cone;* Czestochowski, *Marvin D. Cone and Grant Wood;* and DeLong, *Nature's Forms.*

60. Thomas Hart Benton, "Form and the Subject," *Arts* 5 (June 1924): 303–308, and "New York Exhibition," *Arts* 6 (December 1926): 343–345, cited in Henry Adams, *Thomas Hart Benton,* pp. 123–124.

61. Grant Wood, "Revolt against the City," pamphlet, Iowa City, Iowa, 1935, reprinted in Dennis, *Grant Wood,* pp. 229–235; quote on p. 231.

62. Shortridge, *Middle West,* p. 59. Shortridge notes that President Roosevelt himself wrote about the trend in "Back to the Land," *Review of Reviews* 84 (October 1931): 63–64.

63. Henry Adams, *Thomas Hart Benton,* pp. 216–220. "The U.S. Scene," *Time,* December 24, 1934, 24–27.

64. Many photographs were taken at this event, but only one was reproduced in the *Time* article. It depicted Curry and Wood wearing overalls, smoking, and clowning next to a large tree, p. 24.

65. Photographs often reveal the contradictory personas these artists embodied. In portraits of Grant Wood, for example, he is often depicted wearing overalls as he poses next to his canvases or with his students, but his shoes are at odds with the costume; he seems to have favored two-tone wing tips that clash sharply with his down-home image and reveal him as the sophisticate he more truly was.

66. Benton, *American in Art,* p. 173.

67. Mrs. Henry J. Allen to William Allen White, December 16, 1931, Curry Papers, Archives of American Art, roll 166, cited in Kendall, *Rethinking Regionalism,* p. 31. Kendall reports that Allen's comments were published in the *Kansas City Times* on May 13, 1933.

68. Grace M. Shields of Cedar Rapids, "Open Forum," *Des Moines Register,* December 21, 1930, cited in Corn, *Grant Wood,* p. 131.

69. Henry Adams, *Thomas Hart Benton,* pp. 201–205, 258–262.

70. Grant Wood, in the brochure for the Stone City Art Colony, 1932, microfilm 1216, frame 337, Archives of American Art, Washington, D.C., cited in Corn, *Grant Wood,* p. 40.

71. Kendall, *Rethinking Regionalism,* pp. 84–85.

72. Harry Hopkins, *Spending to Save: The Complete Story of Relief* (New York: W. W. Norton, 1936), p. 148, cited in Schuyler, "Federal Drought Relief," p. 418.

73. *The Future of the Great Plains* (Report of the Great Plains Committee to the House of Representatives, 75th Cong. 1st sess., doc. no. 144, Washington, D.C., 1937), pp. 74–75.

74. See Tobey, *Saving the Prairies,* p. 205; and Schuyler, "Federal Drought Relief," pp. 420–421.

75. Marion Post Wolcott (1910–1990) studied at the New School for Social Research, New York University, and the University of Vienna, where she earned her B.A. in 1934. Back in the United States she studied photography with Ralph Steiner in 1935 and worked as a free-lancer. From 1927 to 1938 she was a staff photographer for the *Philadelphia Evening News Bulletin,* and from 1938 to 1941 she worked in the Documentary Photography Section of the FSA. After 1942 she began raising a family, returning to photography in 1974 as a free-lancer. Sally Stein, introduction to Wolcott, *Marion Post Wolcott.*

76. D. A. Savage, *Drought Survival of Native Grass Species in the Central and Southern Plains, 1935,* U.S. Department of Agriculture Technical Bulletin, no. 549, Washington, D.C., 1937; and *Methods of Reestablishing Buffalo Grass on Cultivated Land in the Great Plains,* USDA circular no. 328, Washington, D.C., 1934, cited in Bonnifield, *Dust Bowl,* p. 158.

77. Levine, "The Historian and the Icon," in Fleischhauer and Brannan, *Documenting America,* p. 24.

5 · COMPETING PROSPECTS

1. The major proponent of Abstract Expressionism as landscape is Rosenblum, *Modern Painting.*

2. Arthur Wesley Dow, *Composition,* 5th ed. (New York: Baker & Taylor, 1903), p. 32, cited in Eldredge, *Georgia O'Keeffe: American and Modern,* p. 160.

3. O'Keeffe to Anita Pollitzer, September 11, 1916; Charles Eldredge interview with O'Keeffe, quoted in Eldredge, *Georgia O'Keeffe,* p. 166.

4. Willard, "Portrait: Georgia O'Keeffe." For an extended discussion of the influence of O'Keeffe's background on her lifelong interest in natural subjects, see Eldredge, *Georgia O'Keeffe,* pp. 190–194.

5. Henry Adams, *Thomas Hart Benton,* p. 342.

6. One of the most insightful considerations of this trend from a cultural and regional perspective is Dayton Duncan's *Miles from Nowhere.* Duncan consciously sought out those counties that contained less than two people per square mile, the

criterion for frontier status according to the United States Census. In 1890 the Census declared the frontier officially closed since no territory remained so sparsely populated, but Duncan and others have noted that many areas in the West have regained that level of vacancy.

7. Simson, "Art Sinsabaugh."

8. Karmel, "Art Sinsabaugh at Daniel Wolf." In later years Sinsabaugh either cropped his images during printing in a more traditional fashion or printed them full frame, but in his early work he often trimmed the actual negatives.

9. Sinsabaugh served as a U.S. Army Air Force photographer in the far East during World War II. In 1945 he returned to Chicago and worked as a free-lance photographer. There he studied with Laszlo Moholy-Nagy, Harry Callahan, and Aaron Siskind at the Institute of Design at the Illinois Institute of Technology, earning his B.A. in 1949 and a master's in 1967. From 1951 to 1959 he taught at the Institute of Design; from 1959 he was professor of art at the University of Illinois at Champaign and head of the Department of Photography and Cinematography. The Sinsabaugh Archive containing the bulk of his work was established at the Indiana University in 1978. See Jonathan Williams, "Homage to Art Sinsabaugh," and Thornton, "Art Sinsabaugh's Landscapes."

10. Jenkins, *New Topographics*, p. 7.

11. Gohlke, "Thoughts on Landscape," in *Frank Gohlke*, p. 5.

12. Gohlke, *Measure of Emptiness*.

13. A native of Wichita Falls, Texas, Gohlke began serious photography during his third year of graduate school at Yale with the encouragement of Walker Evans. He studied with Paul Caponigro in 1967–1968, moved to Minnesota in 1971, and began to photograph the regional environment. Apart from his well-known grain elevator series, he also worked on the Seagram Courthouse project, a monumental series for the Tulsa, Oklahoma, airport, and a series of views after the Mount Saint Helens eruption. Gohlke has taught photography in Minneapolis, in various colleges and workshops, and in the graduate program at Yale.

14. The confrontational aspect, as well as the interest in framing and format that dominates so much of contemporary prairie photography, was a central component of the power of one of Gohlke's major commissions, a series of photographic murals of the Oklahoma prairies and landscape for the Tulsa International Airport in the early 1980s. See Silberman, "Our Town."

15. Robert Adams, *To Make It Home*, p. 157. See also Robert Adams, *Prairie*.

16. Conversation with Robert Adams, August 1995. For a sizable bibliography, see Robert Adams, *To Make It Home*, p. 173.

17. Robert Adams, *To Make It Home*, p. 171.

18. Plowden, *Floor of the Sky*, p. 112; John G. Mitchell, introduction to Plowden, *Floor of the Sky*, p. 13.

19. Stephen Jay Gould, "Form and Scale in Nature and Culture: Modern Landscape as Necessary Integration," in Forresta, Gould, and Marling, *Between Home and Heaven*, p. 75.

20. For an examination of the subject in a context other than prairies, see Kozloff, "Ghastly News from Epic Landscapes."

21. Forresta, Gould, and Marling, *Between Home and Heaven*, p. 47.

22. Evans's work in 1995 included the Joliet Arsenal documentation but also that of a suburban subdivision called Prairie Crossing, north of Chicago.

23. See Arthur, *Spirit of Place;* and Rosenblum, Sims, and Messinger, *Landscape in Twentieth-Century Art*. Within a prairie context, see Mutel and Swander, *Land of the Fragile Giants*.

24. Morris, *Home Place*, p. 76.

25. For an extended photographic consideration and cultural analysis of the subject, see Gohlke, *Measure of Emptiness*, pp. 15–24; and John C. Hudson's essay in the same volume, "The Grain Elevator: An American Invention," pp. 88–101.

26. The best study of water use in the West is Worster, *Rivers of Empire*, esp. pp. 111–125.

27. Mark Jannot, "Artist Provocateur," p. 85.

28. Brown often uses an unusual perspective that allows him to see more than a linear range. Speaking about the genesis of this, he recalled touring a flea market with friends early in his career: "What they were finding were things that reinforced their growing point of view which was a simultaneous flattening of space, 'Look at that amazing thing that uses two or three different layers of perspective—not Renaissance—but isometric.'" Lawrence, *Roger Brown*, pp. 93–94.

29. Among the pioneer ecologists of the prairies was Aldo Leopold, who stated simply, "We abuse land because we regard it as a commodity belonging to us." His *Sand County Almanac* broke new ground in the understanding of the prairies and the central United States as an environment to be valued for more than simply economic gain. For a history of the scientific field, see Tobey, *Saving the Prairies*.

30. Pyne, *Fire in America*.

31. Terry Evans, *Prairie*, p. 14.

32. Heat-Moon, *Prairy Erth*, p. 28.

33. Fields, "Lost Horizons," p. 60.

34. While the interest in conserving the prairies is encouraging, it should be recognized that even these never-plowed regions have been damaged as ecosystems and much work is still required to help them regain their integrity. For the Konza Prairie, see O. J. Reichman, *Konza Prairie*. This is an exceptionally readable study of the prairie biosphere of the Flint Hills region. For the Oklahoma Tallgrass Prairie Preserve, one of the largest and most recent prairie reserves (established on the old Barnard-Chapman Ranch in 1989), see Madson, *Tallgrass Prairie;* Jordan, "Playing God," pp. 110–116. Madson's book and his other notable prairie text, *Where the Sky Began*, have extensive appendices that provide thorough information about the various prairie preserves throughout the central United States.

35. For a sampling of the problems encountered in setting aside even small areas of prairie preserves, see Wallach, "Return of the Prairie"; Drobney, "Iowa Prairie Rebirth"; and Matthews, "Plains."

36. Forresta, Gould, and Marling, *Between Home and Heaven*, p. 44.

37. Norris, *Dakota*, pp. 3, 7.

38. Interview with Gary Irving, August 18, 1995.

39. Bial and Irving, *Beneath an Open Sky*, Preface.

40. *James D. Butler*.

41. Nordland, *Harold Gregor*, pp. 4–9.

42. Arthur, *Spirit of Place*, p. 99.

43. Winn grew up in Metamora, Illinois, which has a large population of Mennonites and has been greatly influenced by that tradition, although he describes his own faith as "orthodox Christian in the puritan tradition." He has traveled extensively throughout northern Europe and lived for several years in Finland near the hometown of his wife. He recalls seeing the exhibition "American Light" at the

National Gallery of Art as a major turning point in his work. See *James Winn;* Arthur, "James Winn"; and Keith James Smith, *In a New Light.*

44. Spector, "Under Midwestern Eyes."

45. Interview with James Butler, August 1995.

46. Interview with Genie Hudson Patrick, August 1995. In addition to the landscape around her home in Iowa City, Patrick paints the landscape of Mexico, where she travels regularly. See Mutel and Swander, *Land of the Fragile Giants,* p. 114.

47. Interviews with Jacobshagen, August 1993, November 1994, May 1995, August 1995. See also Deeds, *Valley Series;* Melissa Rountree interview in *Keith Jacobshagen;* and *Two of a Kind.*

48. *Heartland Painters.*

49. Nordland, *Harold Gregor,* pp. 4–5.

50. Spero, "Tracing Ana Mendieta," p. 76.

51. Mendieta's father remained in prison until the early 1970s when he finally immigrated to the United States. In 1985 Mendieta was killed when she fell from a window in her New York apartment building. Her companion, the sculptor Carl Andre, was indicted for her murder but was acquitted. I am very grateful to Ignazio Mendieta for speaking with me about his sister.

52. Interview with Hans Breder, August 1995. See also Galligan, "Ana Mendieta"; Kuspit, "Ana Mendieta"; and Ken Johnson, "Ana Mendieta."

53. Gerster, *Amber Waves of Grain,* p. 19.

54. Ibid., p. 241.

55. Herd, *Crop Art,* pp. 11, 15.

56. Herd specifically cites a 1989 trip to Costa Rica as the inspiration for the series and plans portraits that will represent other nations within the American continents. Herd, *Crop Art,* pp. 56–57.

57. Morris, "Origins," p. 164.

58. Dickens, "Jaunt to the Looking-Glass Prairie," pp. 177–184.

SELECTED BIBLIOGRAPHY

Adams, Alexander B. *Sunlight and Storm: The Great American Plains.* New York: Putnam, 1977.

Adams, Henry. *Thomas Hart Benton: An American Original.* New York: Knopf, 1989.

Adams, Robert. *Prairie: Photographs.* Denver: Denver Art Museum, 1978.

———. *To Make It Home: Photographs of the American West, 1965–1986.* New York: Aperture Foundation, 1989.

Aldrich, Bess Streeter. *A Lantern in Her Hand.* New York: D. Appleton & Co., 1928.

Alinder, James, ed. *Wright Morris: Photographs and Words.* Carmel, Calif.: Friends of Photography, 1982.

Allen, John L. "The Garden-Desert Continuum: Competing Views of the Great Plains in the Nineteenth Century." *Great Plains Quarterly* 5 (Fall 1985): 207–220.

Anderson, Nancy K., and Linda S. Ferber. *Albert Bierstadt: Art and Enterprise.* New York: Hudson Hills Press for Brooklyn Museum, 1990.

Anderson, Sherwood. *Home Town.* New York: Alliance Book, 1940.

Anderson, William T. "Plowing and Painting the Prairie: Dakota Farm Boy Harvey Dunn Portrayed Brave Pioneers in a Harsh Land." *American West* 22 (May 1985): 38–43.

[Arthur, John.] *James Winn.* New York: Sherry French Gallery, 1988.

———. *Spirit of Place: Contemporary Painting and the American Tradition.* Boston: Bulfinch Press, Little, Brown & Co., 1989.

Athearn, Robert G. *In Search of Canaan: Black Migration to Kansas, 1879–1880.* Lawrence: Regents Press of Kansas, 1978.

———. *The Mythic West in Twentieth-Century America.* Lawrence: University Press of Kansas, 1986.

Baigell, Matthew. *The American Scene: American Painting of the 1930's.* New York: Praeger, 1974.

Baker, T. Lindsay. "Irrigating with Windmills on the Great Plains." *Great Plains Quarterly* 9 (Fall 1989): 216–230.

Barsness, Larry. *The Bison in Art: A Graphic Chronicle of the American Bison.* Fort Worth, Texas: Amon Carter Museum, 1977.

Barter, Judith A., and Lynn E. Springer. *Currents of Expansion: Painting in the Midwest, 1820–1840.* St. Louis, Mo.: St. Louis Art Museum, 1977.

Bartlett, Richard. *Great Surveys of the American West.* Norman: University of Oklahoma Press, 1962.

Beddow, James B. "Depression and New Deal: Letters from the Plains." *Kansas Historical Quarterly* 43. (Summer 1977): 140–153.

Beezley, William H. "Homesteading in Nebraska, 1862–1872." *Nebraska History* 53 (Spring 1972): 59–75.

Bellow, Saul. "Illinois Journey." *Holiday* 22 (September 1957).

Benson, Maxine, ed. *From Pittsburgh to the Rocky Mountains: Major Stephen H. Long's Expedition, 1819–1820.* Golden, Colo.: Fulcrum, 1988.

Benton, Thomas Hart. *An American in Art.* Lawrence: University Press of Kansas, 1969.

Bermingham, Ann. *Landscape and Ideology: The English Rustic Tradition, 1740–1860.* Berkeley: University of California Press, 1986.

Bial, Raymond, and Gary Irving. *Beneath an Open Sky: Panoramic Photographs by Gary Irving.* Urbana: University of Illinois Press, 1990.

Billington, Ray Allen. *Land of Savagery, Land of Promise.* New York: W. W. Norton, 1981.

Blouet, Brian W., and Frederick C. Luebke, eds. *The Great Plains: Environment and Culture.* Lincoln: University of Nebraska Press, 1979.

Boime, Albert. *The Magisterial Gaze: Manifest Destiny and American Landscape Painting, c. 1830–1865.* Washington, D.C.: Smithsonian Institution Press, 1991.

Bonnifield, Matthew Paul. *The Dust Bowl: Men, Dirt, and Depression.* Albuquerque: University of New Mexico Press, 1979.

Bowles, Samuel. *Across the Continent: A Summer's Journey to the Rocky Mountains, the Mormons, and the Pacific States.* Springfield, Mass: Samuel Bowles & Co.; New York: Hurd & Houghton, 1866.

Brigham, Albert P. "A Geographer's Geography Lesson on the Prairies." *Journal of Geography* 16 (1918): 167–170.

Broehl, Wayne G., Jr. *John Deere's Company: A History of Deere and Company and Its Times.* New York: Doubleday & Co., 1984.

———. "The Plow That Broke the Prairies." *American History Illustrated* 19 (January 1985): 16–19.

Bryant, William Cullen. "The Prairie." *United States Review and Literary Gazette* 2 (July 1827): 306–307.

Bushnell, David I., Jr. "Sketches by Paul Kane in the Indian Country, 1845–1848." *Smithsonian Miscellaneous Collections* 99 (1941): 1–25.

Butcher, Solomon D. *Pioneer History of Custer County, Nebraska, and Short Sketches of Early Days in Nebraska.* Broken Bow, Nebr.: S. D. Butcher & Ephraim S. Finch, 1901.

Campbell, Hardy Webster. *Campbell's 1907 Soil Culture Manual.* Lincoln, Nebr.: H. W. Campbell, 1907.

Carleton, J. Henry. *The Prairie Logbooks, Dragoon Campaigns to the Pawnee Villages in 1844.* Ed. Louis Pelzer. Chicago: Caxton Club, 1943.

Carlson, Allen. "On Appreciating Agricultural Landscapes." *Journal of Aesthetic and Art Criticism* 43 (Spring 1985): 301–312.

Carter, John. *Solomon D. Butcher: Photographing the American Dream.* Lincoln: University of Nebraska Press, 1985.

Carvalho, Solomon. *Incidents of Travel and Adventure in the Far West, with Colonel Frémont's Last Expedition across the Rocky Mountains: Including Three Months' Residence in Utah, and a Perilous Trip across the Great American Desert to the Pacific.* 1857. Reprint, New York: Arno Press, 1973.

Cather, Willa. *My Antonia.* 1918. Reprint, Boston: Houghton Mifflin, 1977.

Catlin, George. *Letters and Notes on the Manners, Customs, and Conditions of the North American Indians.* 2 vols. 1841. Reprint, New York: Dover, 1973.

Cayton, Andrew R. L., and Peter S. Onuf. *The Midwest and the Nation: Rethinking the History of an American Region.* Bloomington: Indiana University Press, 1990.

Center for Great Plains Studies. *Ethnicity on the Great Plains.* Lincoln: University of Nebraska Press, 1980.

———. *The Great Plains: Perspectives and Prospects.* Lincoln: University of Nebraska Press, 1981.

Charles Greener Paintings. Brookings: South Dakota Memorial Museum, 1986.

Clark, Kenneth. *Landscape into Art.* Rev. ed. New York: Harper & Row, 1976.

Coen, Rena Neumann. *Painting and Sculpture in Minnesota, 1820–1914.* Minneapolis: University of Minnesota Press, 1976.

Cohen, Ralph, ed. *Studies in Eighteenth-Century British Art and Aesthetics.* Berkeley: University of California Press, 1985.

Collins, Scott L., and Linda Wallace, eds. *Fire in North American Tallgrass Prairies.* Norman: University of Oklahoma Press, 1990.

Combs, Barry B. "The Union Pacific Railroad and the Early Settlement of Nebraska, 1868–1880." *Nebraska History* 50 (Spring 1969): 1–26.

Contemporary Midwest Landscape. Indianapolis: Herron Gallery, Indianapolis Center for Contemporary Art, 1986.

Cooper, James Fenimore. *The Prairie: A Tale.* Ed. and intro. James P. Elliot. Albany: State University of New York Press, 1985.

Contreras, Belisario R. *Tradition and Innovation in New Deal Art.* Cranbury, N.J.: Associated University Presses, 1983.

Corn, Wanda. *Grant Wood: The Regionalist Vision.* New Haven: Yale University Press, 1983.

Cosgrove, Denis. *Social Formation and Symbolic Landscape.* London: Croom Helm, 1984.

Costello, David. *The Prairie World.* Minneapolis: University of Minnesota Press, 1969.

Coues, Elliott, ed. *The Expeditions of Zebulon Montgomery Pike.* 2 vols. Reprint, New York: Dover, 1987.

Craven, Thomas. "Our Art Becomes American: We Draw Up Our Declaration of Independence." *Harper's Magazine* 171 (September 1935): 439.

Crofutt, George. *Crofutt's New Overland Tourist and Pacific Coast Guide.* Chicago: Overland Publishing, 1878–1879.

Cronon, William. *Changes in the Land.* New York: Hill & Wang, 1983.

———. *Nature's Metropolis: Chicago and the Great West.* New York: W. W. Norton, 1991.

Cronon, William, George Miles, and Jay Gitlin, eds. *Under an Open Sky: Rethinking America's Western Past.* New York: W. W. Norton, 1992.

Cummings, Paul. *Twentieth-Century Drawings from the Collection of the Whitney Museum.* New York: W. W. Norton, Whitney Museum of Art, 1987.

Czestochowski, Joseph S. *Marvin D. Cone: An American Tradition.* New York: Dutton, 1985.

———. *Marvin D. Cone and Grant Wood: An American Tradition.* Cedar Rapids, Iowa: Cedar Rapids Museum of Art, 1990.

Danbom, David. *The Resisted Revolution: Urban America and the Industrialization of Agriculture, 1900–1930.* Ames: Iowa State University Press, 1979.

Daniel, Pete, Merry Forresta, Maren Stange, and Sally Stein. *Official Images: New Deal Photography.* Washington, D.C.: Smithsonian Institution Press, 1987.

Daniels, Stephen. *Fields of Vision: Landscape Imagery and National Identity in England and the United States.* Princeton: Princeton University Press, 1993.

———. "Goodly Prospects: English Estate Portraiture, 1670–1730." In *Mapping the Landscape: Essays on Art and Cartography,* ed. Nicholas Alfrey and Stephen Daniels, 9–17. Nottingham: University Art Gallery, Castle Museum, 1990.

Daniels, Stephen, and Denis Cosgrove. *The Iconography of Landscape.* Cambridge: Cambridge University Press, 1988.

Dary, David. "The Buffalo in Kansas." *Kansas Historical Quarterly* 39 (Autumn 1973): 305–344.

———. *Entrepreneurs of the Old West.* New York: Knopf, 1986.

Davis, Ann, and Robert Thacker. "Pictures and Prose: Romantic Sensibility and the Great Plains in Catlin, Kane, and Miller." *Great Plains Quarterly* 6 (Winter 1986): 3–20.

Davy Crockett's Almanack of Wild Sports in the West: Life in the Backwoods, Sketches of Texas, and Rows on the Mississippi. Nashville, Tenn.: Heirs of Col. Davy Crockett, 1838.

Deeds, Daphne. *The Valley Series: Recent Paintings by Keith Jacobshagen.* Lincoln, Nebr.: Sheldon Memorial Art Gallery, 1988.

Delano, Alonzo. *Across the Plains and among the Diggings.* 1853. Reprint, New York: Wilson-Erickson, 1936.

DeLong, Lea Rosson. *Nature's Forms, Nature's Forces: The Art of Alexandre Hogue.* Norman: University of Oklahoma Press, with Philbrook Museum of Art, 1984.

Dennis, James. *Grant Wood: A Study in American Art and Culture.* Columbia: University of Missouri Press, 1986.

Dick, Everett. *Conquering the Great American Desert: Nebraska.* Nebraska State Historical Society Publications, vol. 27. Lincoln, 1975.

Dickens, Charles. "A Jaunt to the Looking-Glass Prairie and Back." In *American Notes: A Journey.* 1842. Reprint, New York: Fromm International Publishing, 1985.

Dillon, Richard H. "Stephen Long's Great American Desert." *Proceedings of the American Philosophical Society* 3 (April 1967): 93–108.

Dodge, Richard Irving. *The Plains of North America and Their Inhabitants.* 1876. Reprint, ed. Wayne R. Kime, Newark: University of Delaware Press, 1989.

Dondore, Dorothy Anne. *The Prairie and the Making of Middle America: Four Centuries of Description.* Cedar Rapids, Iowa: Torch Press, 1926.

Drobney, Pauline M. "Iowa Prairie Rebirth: Rediscovering Natural Heritage at Walnut Creek National Wildlife Refuge." *Restoration and Management Notes* 12 (Summer 1994): 16–22.

Droze, Wilmon Henry. *Trees, Prairies, and People: A History of Tree Planting in the Plains States.* Denton: Texas Woman's University, 1977.

Drumm, Stella M., ed. *Down the Santa Fe Trail and into Mexico: The Diary of Susan Shelby Magoffin, 1846–1847.* New Haven: Yale University Press, 1926.

Duncan, Dayton. *Miles from Nowhere: Tales from America's Contemporary Frontier.* New York: Viking, 1993.

Duncan, Patricia D. *Tallgrass Prairie: The Inland Sea.* Kansas City, Mo.: Lowell Press, 1978.

Eldredge, Charles C. *Georgia O'Keeffe: American and Modern.* New Haven: Yale University Press, with Intercultura, Fort Worth, and Georgia O'Keeffe Foundation, Abiquiu, N.Mex., 1993.

Emmons, David M. *Garden in the Grasslands: Boomer Literature of the Central Great Plains.* Lincoln: University of Nebraska Press, 1971.

Engel, Leonard, ed. *The Big Empty: Essays on the Land as Narrative.* Albuquerque: University of New Mexico Press, 1994.

Evans, David Allan. *What the Tallgrass Says.* Sioux Falls, S.Dak.: Center for Western Studies, Augustana College, 1982.

Evans, Terry. *Prairie: Images of Ground and Sky.* Lawrence: University Press of Kansas, 1986.

Fairbanks, Carol. *Prairie Women: Images in American and Canadian Fiction.* New Haven: Yale University Press, 1986.

Fairbanks, Carol, and Sara Brooks Sundberg. *Farm Women on the Prairie Frontier: A Sourcebook for Canada and the United States.* Metuchen, N.J.: Scarecrow Press, 1983.

Farnham, Eliza W. *Life in Prairie Land.* 1846. Reprint, Urbana: University of Illinois Press, 1988.

Fields, Wayne. "Beyond Definition: A Reading of *The Prairie.*" In *James Fenimore Cooper: A Collection of Critical Essays.* Englewood Cliffs, N.J.: Prentice Hall, 1979.

———. "Lost Horizons." *American Heritage* 39 (April 1988): 55–64.

Fifer, J. Valerie. *American Progress: The Growth of the Transport, Tourist, and Information Industries in the Nineteenth-Century West, Seen through the Life and Times of George A. Crofutt, Pioneer and Publicist of the Transcontinental Age.* Chester, Conn.: Globe Pequot Press, 1988.

Fischer, Christiane, ed. *Let Them Speak for Themselves: Women in the American West, 1849–1900.* New York: E. P. Dutton, 1978.

Fisher, Ron. *Heartland of a Continent: America's Plains and Prairies.* Washington, D.C.: National Geographic Society, 1991.

Fleischhauer, Carl, and Beverly W. Brannan, eds. *Documenting America, 1935–1943.* Berkeley: University of California Press, 1988.

Forresta, Merry A., Stephen Jay Gould, and Karal Ann Marling. *Between Home and Heaven: Contemporary American Landscape Photography.* Washington, D.C.: National Museum of American Art, with University of New Mexico Press, 1992.

Francis, R. Douglas, and Howard Palmer, eds. *The Prairie West: Historical Readings.* Edmonton, Alta.: Pica Pica Press, 1985.

Frémont, John Charles. *Memoirs of My Life.* Chicago: 1887.

———. *Report of the Exploring Expedition to the Rocky Mountains in the Year 1842, and to Oregon and North California in the Years 1843–1844.* Washington, D.C.: Blair & Rivers, 1845. Reprint, intro. Herman J. Viola and Ralph E. Ehrenberg. Washington, D.C.: Smithsonian Institution Press, 1988.

Friis, Herman R. "Baron Alexander von Humboldt's Visit to Washington, D.C., June 1, through June 13, 1904." *Records of the Columbia Historical Society* 60 (1960–1962): 1–35.

Galligan, Gregory. "Ana Mendieta: A Retrospective." *Arts* 62 (April 1988): 48–49.

Gambone, Joseph G. "The Forgotten Feminist of Kansas: The Papers of Clarinda I. H. Nichols, 1854–1885." *Kansas Historical Quarterly* 39 (Spring 1973): 12–57, (Summer 1973): 220–261.

Ganzel, Bill. *Dust Bowl Descent.* Lincoln: University of Nebraska Press, 1984.

Garner, Gretchen. *Reclaiming Paradise: American Women Photograph the Land.* Duluth, Minn.: Tweed Museum of Art, 1987.

Gaston, W. L., and A. R. Humphrey. *History of Custer County, Nebraska.* Lincoln, Nebr.: Western Publishing & Engraving, 1919.

Garland, Hamlin. *Boy Life on the Prairie.* New York: Macmillan, 1899.

———. *Son of the Middle Border.* New York: Collier & Son, 1917.

Gates, Paul Wallace. *Landlords and Tenants on the Prairie Frontier: Studies in American Land Policy.* Ithaca, N.Y.: Cornell University Press, 1973.

Gerdts, William H. *Art across America: Two Centuries of Regional Painting, 1710–1920.* 3 vols. New York: Abbeville Press, 1990.

Gerster, Georg. *Amber Waves of Grain: America's Farmlands from Above.* New York: Harper Weldon Owen, 1990.

Geske, Norman A., ed. *The American Painting Collection of the Sheldon Memorial Art Gallery.* Lincoln: University of Nebraska Press, 1988. Gilpin, William. *Three Essays: On Picturesque Beauty, On Picturesque Travel, and On Sketching Landscape.* London, 1792.

Gilpin, William. *Three Essays: On Picturesque Beauty, On Picturesque Travel, and On Sketching Landscape.* London, 1792.

Gilpin, William. *The Central Gold Region, the Grain, Pastoral, and Gold Regions of North America, with Some New Views of Its Physical Geography; and Observations on the Pacific Railroad.* Philadelphia: Sower, Barnes & Co.; St. Louis, Mo.: E. K. Woodward, 1860.

———. *Mission of the North American People: Geographical, Social, and Political.* 2nd ed. Philadelphia: J. B. Lippincott & Co., 1874.

Glazer, Sidney. *The Middle West: A Study of Progress.* New York: Bookman Associates, 1962.

Goddard, Frederick B. *Where to Emigrate, and Why.* New York: Goddard, 1869.

Goetzmann, William H. *Army Exploration in the American West, 1803–1863.* New Haven: Yale University Press, 1959.

———. *Exploration and Empire: The Explorer and the Scientist in the Winning of the American West.* 1966. Reprint, Austin: Texas State Historical Association, 1993.

Gohlke, Frank. *Frank Gohlke: Landscapes from the Middle of the World, Photographs 1972–1987.* San Francisco: Friends of Photography, Museum of Contemporary Photography, 1988.

———. *Measure of Emptiness: Grain Elevators in the American Landscape.* Baltimore: Johns Hopkins University Press, 1992.

Gregg, Josiah. *Commerce of the Prairies; or, The Journal of a Santa Fe Trader, during Eight Expeditions across the Great Western Prairies, and a Residence of Nearly Nine Years in Northern Mexico.* 1844. Reprint, ed. Max L. Moorhead, Norman: University of Oklahoma Press, 1954.

Groseclose, Barbara. *Emanuel Leutze, 1816–1868: Freedom Is the Only King.* Washington, D.C.: Smithsonian Institution Press, 1975.

Hales, Peter B. *William Henry Jackson and the Transformation of the American Landscape.* Philadelphia: Temple University Press, 1988.

Haltman, Kenneth. "Figures in a Western Landscape: Reading the Art of Titian Ramsay Peale from the Long Expedition to the Rocky Mountains, 1819–1820." Ph.D. diss., Yale University, 1992.

Hammond, George P., and Agapita Rey, eds. *Narratives of the Coronado Expedition, 1540–1542.* 2 vols. Albuquerque, N.Mex.: Quivira Society, 1940.

Harper, J. Russell, ed. *Paul Kane's Frontier.* Austin: University of Texas Press, 1971.

Havighurst, Walter, ed. *Land of the Long Horizons.* New York: Coward-McCann, 1960.

[Hazen, Lt. William B.] "Report of the Secretary of War on the Several Pacific Railroad Explorations." *North American Review* 82 (January 1856): 211–236.

Heartland Painters: James Butler, Keith Jacobshagen, James Winn. Chicago: Frumkin & Struve Gallery, 1985.

Heat-Moon, William Least. *Prairy Erth: A Deep Map.* Boston: Houghton Mifflin, 1991.

Hefferman, James A. W. *The Re-Creation of Landscape: A Study of Wordsworth, Coleridge, Constable, and Turner.* Hanover: University Press of New England, 1985.

Heller, Nancy, and Julia Williams. "John Steuart Curry: The American Farmlands." *American Artist* 40 (January 1976): 46–51.

———. *The Regionalists: Painters of the American Scene.* New York: Watson-Guptil, 1976.

Herd, Stan. *Crop Art and Other Earthworks.* New York: Harry N. Abrams, 1994.

Hine, Robert V. *Community on the American Frontier: Separate but Not Alone.* Norman: University of Oklahoma Press, 1980.

———. *Edward Kern and American Expansion.* New Haven: Yale University Press, 1962.

Hodge, Frederick W., and Theodore H. Lewis, eds. *Spanish Explorers in the Southern United States, 1528–1543.* 1907. Reprint, New York: Barnes & Noble, 1946.

Hudson, John C. *Plains Country Towns.* Minneapolis: University of Minnesota Press, 1985.

Humboldt, Alexander von. *Cosmos: A Sketch of a Physical Description of the Universe.* Trans. E. C. Otté. 2 vols. New York: Harper & Bros., 1850.

Hunt, David C., and Marsha V. Gallagher. Intro. William H. Goetzmann. Biog. William J. Orr. *Karl Bodmer's America.* Lincoln: Joslyn Art Museum, University of Nebraska Press, 1984.

Hurley, Jack. *Portrait of a Decade: Roy Stryker and the Development of Documentary Photography in the Thirties.* Baton Rouge: Louisiana State University, 1972.

Hurt, R. Douglas. *The Dust Bowl: An Agricultural and Social History.* Chicago: Nelson-Hall, 1981.

Hussey, Christopher. *The Picturesque: Studies in a Point of View.* 1927. London: Frank Cass & Co., 1967.

Hyde, Ralph. *Gilded Scenes and Shining Prospects: Panoramic Views of British Towns, 1575–1900.* New Haven: Yale Center for British Art, 1985.

Iarocci, Louisa. "The Changing American Landscape: The Art and Politics of Joe Jones." *Gateway Heritage* 12 (Fall 1991): 68–75.

Irving, Washington. *A Tour on the Prairies.* Vol. 3 of *Works of Washington Irving.* Boston: Dana Estes & Co., 1900.

Isaksson, Olov. *Bishop Hill, Ill.: A Utopia on the Prairie.* Trans. Albert Read. Stockholm, Sweden: LT Publishing, 1969.

Jackson, William Henry. *Time Exposure: The Autobiography of William Henry Jackson.* New York: Van Rees Press, 1940. Reprint, Albuquerque: University of New Mexico Press, 1986.

Jacobsen, Joanne. "Time and Vision in Wright Morris's Photographs of Nebraska." *Great Plains Quarterly* 7 (Winter 1986): 3–21.

James D. Butler: A Sense of Place. Chicago: Struve Gallery, 1989.

James, Edwin, comp. *Account of an Expedition from Pittsburgh to the Rocky Mountains, Performed in the Years 1819 and '20.* Vols. 14–17 of *Early Western Travels, 1748–1846,* ed. Reuben Gold Thwaites. Cleveland: A. H. Clark Co., 1905.

James Winn. Chicago: Frumkin & Struve Gallery, n.d.

Jannot, Mark. "Artist Provocateur." *Chicago Magazine,* October 1994.

Janson, Anthony F. *Worthington Whittredge.* New York: Cambridge University Press, 1989.

Jeffrey, Julie Roy. *Frontier Women: The Trans-Mississippi West, 1840–1880.* New York: Hill & Wang, 1979.

———. "There Is Some Splendid Scenery: Women's Responses to the Great Plains Landscape." *Great Plains Quarterly* 8 (Spring 1988): 69–78

Jenkins, William. *The New Topographics: Photographs of a Man-Altered Landscape.* Rochester, N.Y.: International Museum of Photography at George Eastman House, 1975.

Joe Jones: Recent Work. New York: Association of American Artists Galleries, 1951.

Johnson, Hildegard. *Order upon the Land: The U.S. Rectangular Land Survey and the Upper Mississippi Country.* New York: Oxford University Press, 1976.

Johnson, Ken. "Ana Mendieta at the New Museum of Contemporary Art." *Art in America* 76 (March 1988): 153–154.

Jordan, Teresa. "Playing God on the Lawns of the Lord." In *Heart of the Land: Essays on the Last Great Places,* ed. Joseph Barbato and Lisa Weinerman. New York: Pantheon Books, 1994.

Kane, Paul. *Wanderings of an Artist among the Indians of North America from Canada's Vancouver Island and Oregon through the Hudson's Bay Company's Territory and Back Again.* 1859. Reprint, Toronto: NC Press, 1974.

Karmel, Pepe. "Art Sinsabaugh at Daniel Wolf." *Art in America* 68 (November 1980): 141.

Katz, William L. *The Black West.* Garden City, N.Y.: Doubleday, 1973.

Keith Jacobshagen. Overland Park, Kans.: John County Community College, 1993.

Kendall, M. Sue. *Rethinking Regionalism: John Steuart Curry and the Kansas Mural Controversy.* Washington, D.C.: Smithsonian Institution Press, 1986.

Ketner, Joseph D. II, and Michael J. Tammenga. *The Beautiful, the Sublime, and the Picturesque: British Influences on American Landscape Painting.* St. Louis, Mo.: Washington University Gallery of Art, 1984.

Kinsey, Joni Louise. "Not So Plain: Art of the American Prairies." *Great Plains Quarterly* 15 (Summer 1995): 185–200.

———. *Thomas Moran and the Surveying of the American West.* Washington, D.C.: Smithsonian Institution Press, 1992.

Kolodny, Annette. *The Land before Her: Fantasy and Experience of the American Frontiers, 1630–1860.* Chapel Hill: University of North Carolina Press, 1984.

———. *The Lay of the Land: Metaphor as Experience and History in American Life and Letters.* Chapel Hill: University of North Carolina Press, 1975.

Kozloff, Max. "Ghastly News from Epic Landscapes." *American Art* 5 (Winter-Spring 1991): 108–131.

Kuspit, Donald. "Ana Mendieta." *Artforum* 26 (February 1988): 144.

Lamar, Howard. "Seeing More Than Earth and Sky: The Rise of a Great Plains Aesthetic." *Great Plains Quarterly* 9 (Spring 1989): 69–77.

Lange, Dorothea, and Paul Schuster Taylor. *An American Exodus: A Record of Human Erosion.* Rev. ed. New Haven: Yale University Press, 1969.

Lawrence, Sidney. *Roger Brown*. New York: George Braziller, Hirshhorn Museum and Sculpture Garden, Smithsonian Institution, 1987.

Leopold, Aldo. *Sand County Almanac*. New York: Oxford University Press, 1949.

Luchetti, Cathy, and Carol Olwell. *Women of the West*. St. George, Utah: Antelope Island Press, 1982.

McCoubrey, John, ed. *American Art, 1700–1960: Sources and Documents*. Englewood Cliffs, N.J.: Prentice Hall, 1965.

McCracken, Harold. *Portrait of the Old West*. New York: McGraw-Hill, 1952.

McDermott, John Francis. "Samuel Seymour: Pioneer Artist of the Plains and Rockies." *Annual Report of the Smithsonian Institution, 1950*. Washington, D.C.: Government Printing Office, 1951.

Madson, John. *Tallgrass Prairie*. Helena, Mont.: Falcon Press, 1993.

———. *Where the Sky Began: Land of the Tallgrass Prairie*. Boston: Houghton Mifflin, 1982.

Manley, Robert N. "In the Wake of the Grasshoppers: Public Relief in Nebraska, 1874–1875." *Nebraska History* 44 (September 1963): 255–275.

Manning, Richard. *Grassland: The History, Biology, Politics, and Promise of the American Prairie*. New York: Penguin, 1995.

Manthorne, Katherine Emma. *Tropical Renaissance: North American Artists Exploring Latin America, 1839–1879*. Washington, D.C.: Smithsonian Institution Press, 1989.

Marling, Karal Ann. "Joe Jones, Regionalist, Communist, Capitalist." *Journal of the Decorative and Propaganda Arts, 1875–1940* 4 (Spring 1987): 46–58.

———. *Wall to Wall America: A Cultural History of Post Office Murals in the Great Depression*. Minneapolis: University of Minnesota Press, 1982.

———. "Workers, Capitalists, and Booze: The Story of the 905 Murals." In *Joe Jones and J. B. Turnbull: Visions of the Midwest in the 1930s*. Milwaukee: Patrick & Beatrice Haggerty Museum of Art, 1987.

Marx, Leo. *The Machine in the Garden: Technology and the Pastoral Ideal in America*. New York: Oxford University Press, 1964.

Matthews, Anne. "The Plains." *New York Times Magazine,* June 24, 1990.

———. *Where the Buffalo Roam: The Storm over the Revolutionary Plan to Restore America's Great Plains*. New York: Grove Weidenfeld, 1992.

Maurer, Evan M., ed. *Visions of the People: A Pictorial History of Plains Indian Life*. Minneapolis: Minneapolis Institute of Arts, 1993.

Meinig, D. W. *The Interpretation of Ordinary Landscapes*. New York: Oxford University Press, 1979.

Mikelsen, Michael A. "The Bishop Hill Colony: A Religious Communistic Settlement in Henry County, Illinois." In *Church and State: Columbus and America,* Johns Hopkins University Studies in Historical and Political Science, vol. 10, no. 1. Baltimore: Johns Hopkins University Press, 1892.

Miller, Angela. *Empire of the Eye: Landscape Representation and American Cultural Politics, 1825–1875*. Ithaca, N.Y.: Cornell University Press, 1993.

Miller, Lillian B., ed. *The Selected Papers of Charles Willson Peale and His Family*. Vol. 2, part 2. New Haven: Yale University Press, with National Portrait Gallery, 1988.

Milner, Clyde A. II, Carol A. O'Connor, and Martha A. Sandweiss, eds. *The Oxford History of the American West*. New York: Oxford University Press, 1994.

Morris, Wright. *The Home Place*. 1948. Reprint, Lincoln: University of Nebraska Press, 1968.

———. "Origins: Reflections on Emotion, Memory, and Imagination." In Robert E. Knoll, ed., *Conversations with Wright Morris: Critical Views and Responses*. Lincoln: University of Nebraska Press, 1977.

———. "Our Endless Plains." *Holiday* 24 (July 1958).

Mutel, Cornelia F., and Mary Swander, eds. *Land of the Fragile Giants: Landscapes, Environments, and Peoples of the Loess Hills*. Iowa City: University of Iowa Press, 1994.

Nelson, Paula. *After the West Was Won: Homesteaders and Town-Builders in Western South Dakota, 1900–1917*. Iowa City: University of Iowa Press, 1986.

Niçaise, Auguste. *A Year in the Desert*. Trans. Edward J. Kowrach. Fairfield, Wash.: Ye Galleon Press, 1980. Originally published as *Une année au désert scènes et récits du far-west Américain* (Chalons, France, 1864).

Nixon, Herman Clarence. *Forty Acres and Steel Mules*. Chapel Hill: University of North Carolina Press, 1938.

Nolan, Edward. *Northern Pacific Views: The Railroad Photography of F. J. Haynes, 1876–1905*. Helena: Montana Historical Society Press, 1983.

Nordland, Gerald. *Harold Gregor*. Rockford, Ill.: Rockford Art Museum, 1993.

Norris, Kathleen. *Dakota: A Spiritual Geography*. Boston: Houghton Mifflin, 1993.

Nottage, James H. *Prairie Visions: Art of the American West*. Topeka: Kansas State Historical Society, 1984.

Ohrn, Karin Becker. *Dorothea Lange and the Documentary Tradition*. Baton Rouge: Louisiana State University Press, 1980.

Olson, James. "Arbor Day: A Pioneer Expression of Concern for the Environment." *Nebraska History* 53 (Spring 1972): 1–13.

Olson, Steven. *The Prairie in Nineteenth-Century American Poetry*. Norman: University of Oklahoma Press, 1994.

An Open Land: Photographs of the Midwest, 1852–1982. Chicago: Art Institute of Chicago, 1983.

Overton, Richard C. *Burlington West: A Colonization History of the Burlington Railroad*. Cambridge: Harvard University Press, 1941.

Painter, Nell Irvin. *Exodusters: Black Migration to Kansas after Reconstruction*. New York: Knopf, 1977.

Park, Marlene, and Gerald E. Markowitz. *Democratic Vistas: Post Offices and Public Art in the New Deal*. Philadelphia: Temple University Press, 1984.

Parkman, Francis. *The Oregon Trail*. 1849. Reprint, New York: Mentor, 1950.

Pease, William H., and Jane H. Pease. *Black Utopias*. Madison: University of Wisconsin Press, 1963.

Penning-Roswell, Edmund C., and David Lowenthal, eds. *Landscape Meanings and Values*. London: Allen & Unwin, 1986.

Petersen, Erik Helmer. "The New Agricultural History: The American Prairie Agriculture in a Wider Context." *American Studies in Scandinavia* 13, no. 2 (1981): 71–79.

Phillips, Sandra S., and John Szarkowski. *Wright Morris: Origin of a Species*. San Francisco: San Francisco Museum of Modern Art, 1992.

Plowden, David. Intro. John G. Mitchell. *Floor of the Sky: The Great Plains*. San Francisco: Sierra Club, 1972.

———. *A Sense of Place*. New York: W. W. Norton, State Historical Society of Iowa, 1988.

Poesch, Jessie. *Titian Ramsay Peale (1799–1885) and His Journals from the Wilkes Expedition*. Philadelphia: American Philosophical Society, 1961.

"The Prairie: Its Loneliness and Its Awesome Immensity Shape a Distinctive Way of American Life." *Life* 33 (December 15, 1952): 116–125.

Preuss, Charles. *Exploring with Frémont: The Private Diaries of Charles Preuss, Cartographer for John C. Frémont on His First, Second, and Fourth Expeditions to the Far West*. Trans. and ed. Erwin G. Gudde and Elisabeth K. Gudde. Norman: University of Oklahoma Press, 1958.

Pyne, Stephen J. *Fire in America: A Cultural History of Wildland and Rural Fire*. Princeton: Princeton University Press, 1982.

Quantic, Diane Dufva. "The Unifying Thread: Connecting Place and Language in Great Plains Literature." *American Studies* 32 (Spring 1991): 67–83.

Rabbitt, Mary C. *Minerals, Lands, and Geology for the Common Defence and General Welfare, Vol. 1: Before 1879*. Washington, D.C.: U.S. Geological Survey, Government Printing Office, 1979.

Rees, Ronald. "In a Strange Land: Homesick Pioneers on the Canadian Prairie." *Landscape* 26, no. 9 (1982): 1–9.

———. *Land of Earth and Sky: Landscape Painting of Western Canada*. Saskatoon, Sask.: Western Producer Prairie Press, 1984.

———. *New and Naked Land: Making the Prairies Home*. Saskatoon, Sask.: Western Producer Prairie Books, 1988.

Reichman, Jessica. "Kansas Landscape Photography." *Journal of the West* 28 (January 1989): 24–28.

Reichman, O. J. *Konza Prairie: A Tallgrass Natural History*. Lawrence: University Press of Kansas, 1987.

Reid, Robert. *Picturing Minnesota, 1936–1943: Photographs from the Farm Security Administration*. St. Paul: Minnesota Historical Society, 1989.

Reports of Explorations and Surveys, to Ascertain the Most Practicable and Economical Route for a Railroad from the Mississippi River to the Pacific Ocean. 12 vols. Washington, D.C.: Government Printing Office, 1855–1861.

Reps, John. *Cities on Stone: Nineteenth-Century Lithograph Images of the Urban West*. Fort Worth, Texas: Amon Carter Museum, 1976.

———. *The Forgotten Frontier: Urban Planning in the American West before 1900*. Columbia: University of Missouri Press, 1981.

———. *Town Planning in Frontier America*. 1969. Reprint, Columbia: University of Missouri Press, 1980.

———. *Views and Viewmakers of Urban America: Lithographs of Towns and Cities in the United States and Canada, Notes on the Artists and Publishers, and a Union Catalogue of Their Work, 1825–1925*. Columbia: University of Missouri Press, 1984.

Retzinger, Jean. "Still, All Day Long, Nebraska: Reading Landscape as a Cultural Text." Ph.D. diss., University of Iowa, 1992.

Richardson, Albert Deane. *Beyond the Mississippi: From the Great River to the Great Ocean*. Hartford, Conn.: American Publishing Co., 1867.

Richardson, C. Howard. "The Nebraska Prairies: Dilemma to Early Territorial Farmers." *Nebraska History* 50 (Winter 1969): 359–372.

Richter, Conrad. *Sea of Grass*. New York: Knopf, 1937.

Riley, Glenda. *The Female Frontier: A Comparative View of Women on the Prairie and the Plains*. Lawrence: University Press of Kansas, 1988.

Rodman, W. Paul. *The Far West and the Great Plains in Transition, 1859–1900*. New York: Harper & Row, 1988.

Rölvaag, O. E. *Giants in the Earth: A Saga of the Prairies*. New York: Harper & Brothers, 1929.

Rosenblum, Robert. *Modern Painting and the Northern Romantic Tradition: From Friederich to Rothko*. New York: Harper & Row, 1975.

Rosenblum, Robert, Lowery Stokes Sims, and Lisa M. Messinger. *The Landscape in Twentieth-Century Art: Selections from the Metropolitan Museum of Art*. New York: American Federation of Arts, with Rizzoli International Publications, 1991.

Ross, Marvin C., ed. *The West of Alfred Jacob Miller*. Rev. ed. Norman: University of Oklahoma Press, 1968.

Sadler, Barry, and Allen Carlson, eds. *Environmental Aesthetics: Essays in Interpretation*. Victoria, B.C.: University of Victoria, 1982.

Sage, Leland L. "Rural Iowa in the 1920s and 1930s: Roots of the Farm Depression." *Annals of Iowa* 47 (Fall 1983): 91–103.

Sageser, A. Bower. "Windmill and Pump Irrigation on the Great Plains, 1890–1910." *Nebraska History* 48 (Summer 1967): 107–118.

Samuels, Peggy, and Harold Samuels. *Encyclopedia of Artists of the American West*. 1976. Reprint, New York: Castle, 1985.

Sandweiss, Martha A., Rick Stewart, and Ben W. Huseman. *Eyewitness to War: Prints and Daguerreotypes of the Mexican War, 1846–1848*. Fort Worth, Texas: Amon Carter Museum, Smithsonian Institution Press, 1989.

Say, Thomas. *American Entomology; or, Descriptions of the Insects of North America*. 3 vols. Philadelphia: Samuel Augustus Mitchell, 1824–1828.

Schilissel, Lillian. *Women's Diaries of the Westward Journey*. New York: Schocken Books, 1992.

Schmeckebier, Lawrence F. *John Steuart Curry's Pageant of America*. New York: American Artists Group, 1943.

Schuyler, Michael W. "Federal Drought Relief Activities in Kansas, 1934." *Kansas Historical Quarterly* 42 (Winter 1976): 403–424.

Schwieder, Dorothy, and Deborah Fink. "Plains Women: Rural Life in the 1930s." *Great Plains Quarterly* 9 (Spring 1988): 79–88.

Sellers, Charles Coleman. *Mr. Peale's Museum: Charles Willson Peale and the First Popular Museum of Natural Science and Art*. New York: W. W. Norton, 1980.

Shortridge, James R. "The Emergence of the 'Middle West' as an American Regional Label." *Annals of the Association of American Geographers* 74 (June 1984): 209–220.

———. "The Heart of the Prairie: Culture Areas in the Central and Northern Great Plains." *Great Plains Quarterly* 8 (Fall 1988): 206–221.

———. *The Middle West: Its Meaning in American Culture*. Lawrence: University Press of Kansas, 1989.

———. "The Vernacular Middle West." *Annals of the Association of American Geographers* 75 (March 1985): 48–57.

Silberman, Robert. "Our Town." *Art in America* 73 (July 1985): 100–107.

Simson, Emily. "Art Sinsabaugh." *Artnews* 83 (April 1984): 167.

Smillie, Benjamin. *Visions of the New Jerusalem: Religious Settlement on the Prairies*. Edmonton, Alta.: Newest Press, 1983.

Smith, Henry Nash. "Rain Follows the Plow: The Notion of Increased Rainfall for the Great Plains, 1844–1880." *Huntington Library Quarterly* 10 (February 1947): 169–193.

————. *Virgin Land: The American West as Symbol and Myth.* Cambridge: Harvard University Press, 1950.

Smith, J. Russell. *North America: Its People and the Resources, Development, and Prospects of the Continent as an Agricultural, Industrial, and Commerical Area.* New York: Harcourt, Brace, 1925.

Smith, Keith James. *In a New Light: Three Views of the Heartland, Paintings and Drawings by George Atkinson, James D. Butler, and James Winn.* Springfield: Illinois State Museum, 1988.

Spain and the Plains: Myths and Realities of Spanish Exploration and Settlement on the Great Plains. Niwot, Colo.: University Press of Colorado, 1994.

Spearman, Frank H. "The Great American Desert." *Harper's New Monthly Magazine* 77 (July 1888): 232–245.

Spector, Buzz. "Under Midwestern Eyes." *Artforum* 25 (October 1986): 112–115.

Spero, Nancy. "Tracing Ana Mendieta." *Artforum* 30 (April 1992): 75–77.

Stein, Roger B. "Packaging the Great Plains: The Role of the Visual Arts." *Great Plains Quarterly* 5 (Winter 1985): 5–23.

Steinbeck, John. *The Grapes of Wrath.* 1939. Reprint, New York: Bantam, 1946.

Steiner, Michael C. "Regionalism in the Great Depression." *Geographical Review* 73 (1983): 430–446.

Stevens, Isaac I. *Explorations and Surveys for a Railroad Route from the Mississippi River to the Pacific Ocean. War Department. Route near Forty-Seventh and Forty-Ninth Parallels, Explored by Isaac I. Stevens, Governor of Washington Territory, in 1853–5.* House Misc. Doc., 36th Cong., 1st session, 1860.

Stevenson, Robert Louis. *Across the Plains, with Other Memories and Essays.* Vol. 9 of *The Works of Robert Louis Stevenson.* New York: Davos Press, 1906.

Stewart, Rick. *Lone Star Regionalism: The Dallas Nine and Their Circle, 1928–1945.* Austin: Texas Monthly Press, Dallas Museum of Art, 1985.

Stratton, Joanna L. *Pioneer Women: Voices from the Kansas Frontier.* New York: Simon & Schuster, 1981.

Stryker, Roy E., and Nancy Wood. *In This Proud Land: America 1935–1943 as Seen in the FSA Photographs.* 1973. Reprint, New York: Galahad Books, 1975.

Stuart, Joseph. *The Art of South Dakota.* Brookings: South Dakota State University, 1974.

Sturhahn, Joan. *Carvalho, Artist-Photographer-Adventurer-Patriot: Portrait of a Forgotten American.* Merrick, N.Y.: Richwood Publishing, 1976.

Sweeney, J. Gray. "The Artist-Explorers of the American West: 1860–1880." Ph.D. diss., University of Indiana, 1975.

————. *Masterpieces of Western American Art.* New York: M&M Books, 1991.

————. *Themes in American Painting.* Grand Rapids, Mich.: Grand Rapids Art Museum, 1977.

Taft, Robert. *Artists and Illustrators of the Old West, 1850–1900.* Princeton: Princeton University Press, 1953.

Taylor, Paul Schuster. *On the Ground in the Thirties.* Salt Lake City, Utah: Peregrine Books, 1983.

Thacker, Robert. *The Great Prairie Fact and Literary Imagination.* Albuquerque: University of New Mexico Press, 1989.

Thompson, Harry F., Arthur R. Huseboe, and Sandra Olsen Looney. *A Common Land, a Diverse People: Ethnic Identity on the Prairie Plains.* Sioux Falls, S.Dak.: Nordland Heritage Foundation, 1986.

Thornton, Gene. "Art Sinsabaugh's Landscapes." *Camera* 58 (April 1979): 36–37.

Thwaites, Reuben Gold, ed. *The Jesuit Relations and Allied Documents: Travels and Explorations of the Jesuit Missionaries in New France, 1610–1791.* 73 vols. Cleveland, Ohio: Burrows Brothers, 1899.

————. *Original Journals of the Lewis and Clark Expedition, 1804–1806.* 7 vols. New York: Dodd, Mead & Co., 1904.

Tobey, Ronald C. *Saving the Prairies: The Life Cycle of the Founding School of American Plant Ecology, 1895–1955.* Berkeley: University of California Press, 1981.

Tracy, Warren. *The Catalogue of the Merritt Mauzey Collection in the Library of the University of Southern Mississippi.* Hattiesburg: University of Southern Mississippi Press, 1972.

Trenton, Patricia, ed. *Independent Spirits: Women Painters in the American West, 1890–1945.* Berkeley: University of California Press, Gene Autry Museum, 1995.

Trenton, Patricia, and Peter H. Hassrick. *The Rocky Mountains: A Vision for Artists in the Nineteenth Century.* Norman: University of Oklahoma Press, 1983.

Truettner, William H. *The Natural Man Observed: A Study of Catlin's Indian Gallery.* Washington, D.C.: Smithsonian Institution Press, Amon Carter Museum, and National Collection of Fine Arts, 1979.

————, ed. *The West as America: Reinterpreting Images of the Frontier.* Washington, D.C.: Smithsonian Institution Press, 1991.

Truettner, William H., and Alan Wallach. *Thomas Cole: Landscape into History.* New Haven: Yale University Press, National Museum of American Art, 1994.

Tuckerman, Henry T. *Book of the Artists: American Artist Life.* New York: G. P. Putnam & Son, 1870.

Tugwell, Rexford G., Thomas Munro, and Roy E. Stryker. *American Economic Life.* New York: Harcourt, Brace, 1925.

Turner, James. "Landscape and the 'Art Prospective' in England, 1584–1660." *Journal of the Warburg and Courtauld Institutes* 42 (1979): 290–293.

Two of a Kind: Keith Jacobshagen and John Spence. Kearney: Museum of Nebraska Art, 1994.

Tyler, Ron. *Prints of the West.* Golden, Colo.: Fulcrum, 1994.

————, ed. *Alfred Jacob Miller: Artist on the Oregon Trail.* Fort Worth, Texas: Amon Carter Museum, 1982.

————, ed. *American Frontier Life: Early Western Painting and Prints.* New York: Abbeville Press, Amon Carter Museum, and Buffalo Bill Historical Center, 1987.

"The U.S. Scene." *Time,* December 24, 1934.

Viola, Herman J., and Carolyn Margolis, eds. *Magnificent Voyagers: The U.S. Exploring Expedition, 1838–1842.* Washington, D.C.: Smithsonian Institution Press, 1985.

Wall, Joseph F. "The Iowa Farmer in Crisis, 1920–1936." *Annals of Iowa* 47 (Fall 1983): 91–103.

Wallach, Bret. "The Return of the Prairie." *Landscape* 28, no. 3 (1985): 1–5.

Walther, Susan Danly. "The Landscape Photographs of Alexander Gardner and Andrew Joseph Russell." Ph.D. diss., Brown University, 1983.

Webb, Walter Prescott. *The Great Plains.* 1931. Reprint, Lincoln, Nebr.: University of Nebraska Press, 1981.

Weber, Ronald. *The Midwestern Ascendancy in American Writing.* Bloomington: Indiana University Press, 1992.

Weese, A. O. "The Journal of Titian Ramsay Peale, Pioneer Naturalist." *Missouri Historical Review* 41 (January 1947): 147–163.

Welsch, Roger. "The Nebraska Soddy." *Nebraska History* 48 (Winter 1967): 335–342.

———. *Sod Walls: The Story of the Nebraska Sod House.* Broken Bow, Nebr.: Purcells, 1968.

White, C. Albert. *A History of the Rectangular Survey System.* Washington, D.C.: Government Printing Office, 1983.

Whitman, Walt. *Specimen Days.* 1882. Reprint, Boston: David R. Godine, 1971.

Whittredge, Worthington. *The Autobiography of Worthington Whittredge, 1820–1910.* 1942. Reprint, ed. John Baur, New York: Arno Press, 1969.

Wilber, Charles Dana. *The Great Valleys and Prairies of Nebraska and the Northwest.* Omaha: Daily Republican, 1881.

Willard, Charlotte. "Portrait: Georgia O'Keeffe." *Art in America* 51 (October 1963): 95.

Williams, Burton J. "Trees but No Timber: The Nebraska Prelude to the Timber Cultural Act." *Nebraska History* 53 (Spring 1972): 77–86.

Williams, Jonathan. "An Homage to Art Sinsabaugh." *Aperture* 95 (Summer 1984): 2–4.

Williams, Raymond. *The Country and the City.* New York: Oxford University Press, 1973.

Wister, Owen. *The Virginian: A Horseman of the Plains.* 1902. Reprint, New York: Grosset & Dunlap, 1929.

Wolcott, Marion Post. Intro. Sally Stein. *Marion Post Wolcott: FSA Photographs.* Carmel, Calif.: Friends of Photography, 1983.

Wolf, Daniel, ed. *The American Space: Meaning in Nineteenth-Century Landscape Photography.* Middletown, Conn.: Wesleyan University Press, 1983.

Wooden, Howard E. *American Art of the Great Depression: Two Sides of the Coin.* Wichita, Kans.: Wichita Art Museum, 1985.

World's Only Corn Palace: A Treasury of Rare Historical Photographs of One of America's Finest Examples of Folk Art. Mitchell, S.Dak.: Dakotaland, 1992.

Worster, Donald. *Dust Bowl: The Southern Plains in the 1930s.* New York: Oxford University Press, 1979.

———. *Rivers of Empire: Water, Aridity, and the Growth of the American West.* New York: Pantheon Books, 1985.

———. *Under Western Skies: Nature and History in the American West.* New York: Oxford University Press, 1992.

Wrede, Stuart, and William Howard Adams, eds. *Denatured Visions: Landscape and Culture in the Twentieth Century.* New York: Museum of Modern Art, 1991.

Zabel, Orville H. "To Reclaim the Wilderness: The Immigrant's Image of Territorial Nebraska." *Nebraska History* 46 (December 1965): 315–324.

INDEX

Page references to illustrations of works by listed artists appear in italics.

■ ■ ■

This book was set as digitized PostScript files in Quark Express 3.31. The typefaces are Image Club Inc.'s Publicity Gothic and Monotype's Columbus. The book was printed on 135 gsm Leykam paper at C.S. Graphics in Singapore.